THE ART OF

Harry Potter™

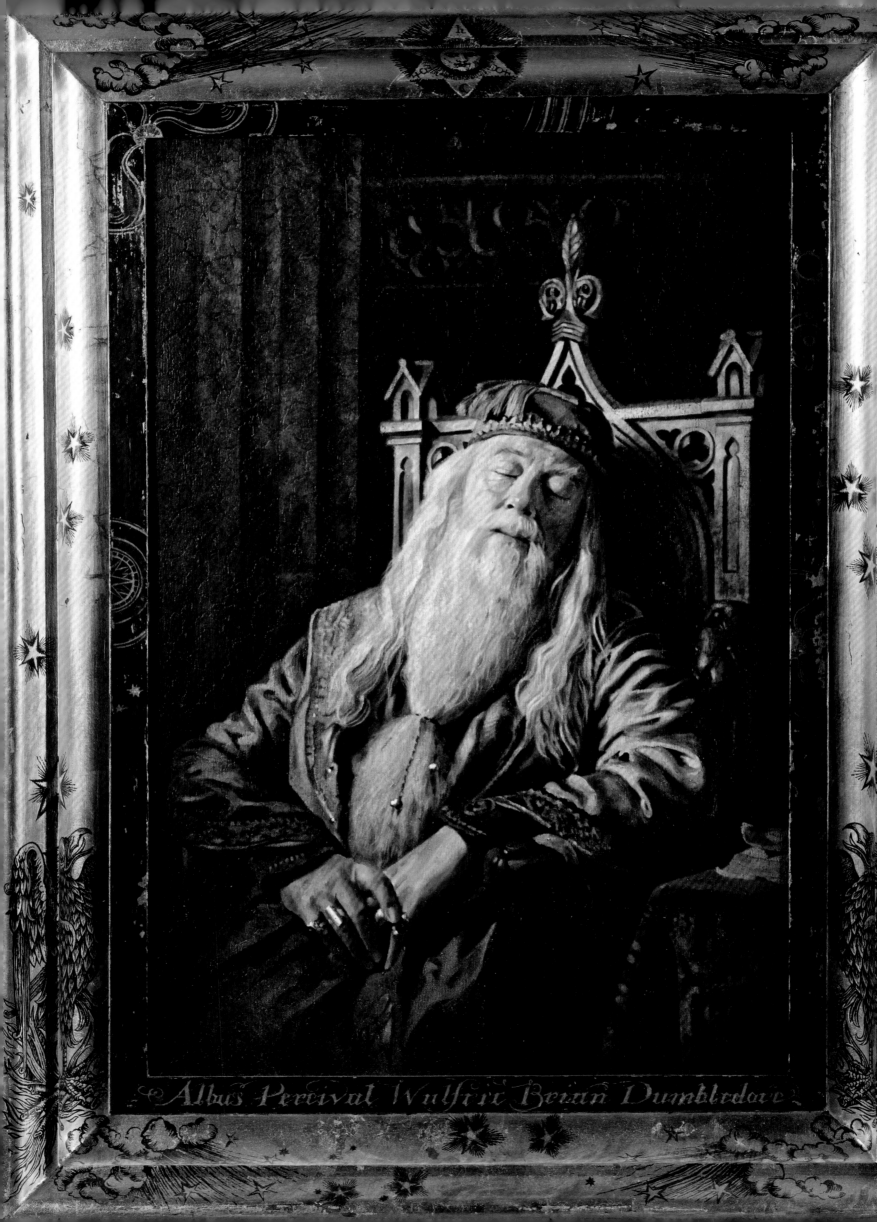

Albus Percival Wulfric Brian Dumbledore

THE ART OF

Harry Potter™

Marc Sumerak

HARPER DESIGN
An Imprint of HarperCollins Publishers

An Insight Editions Book

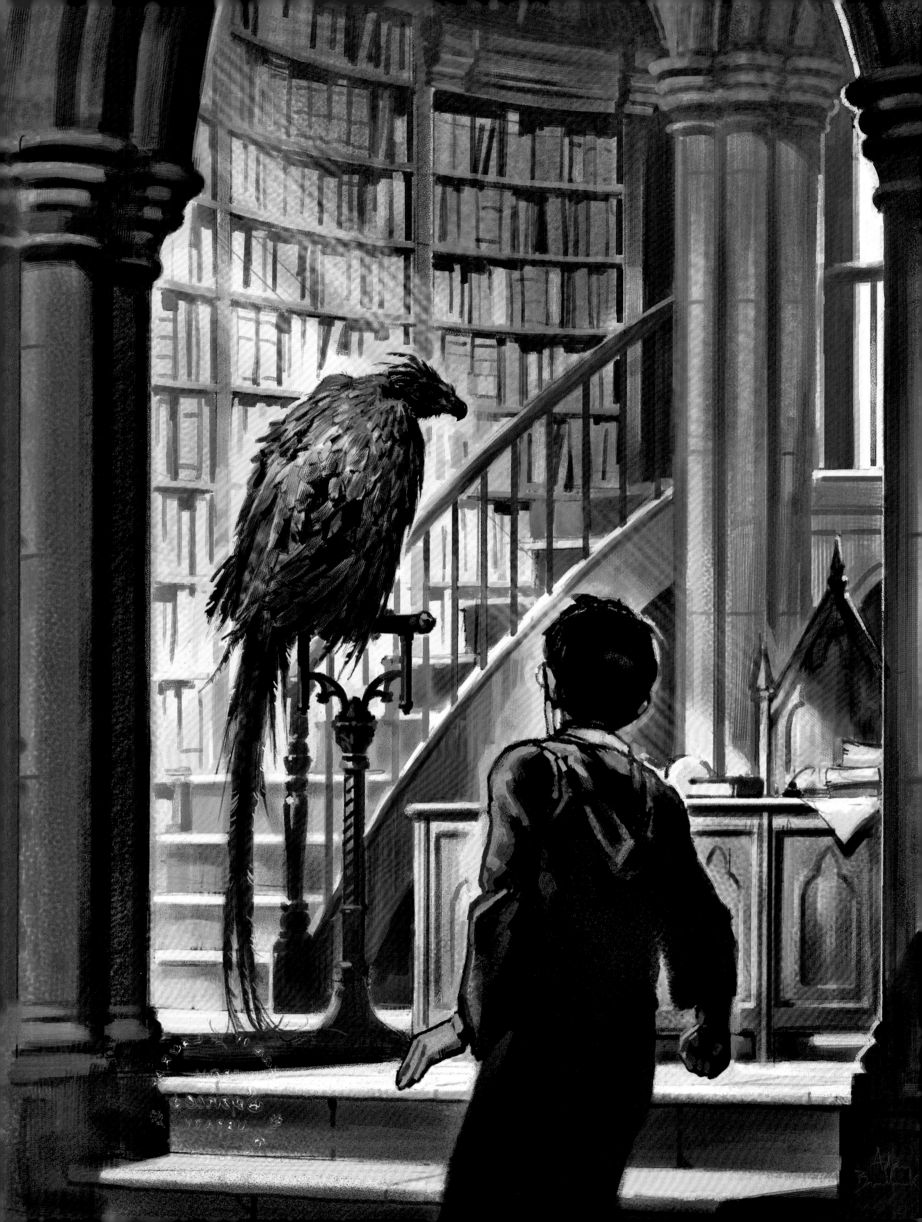

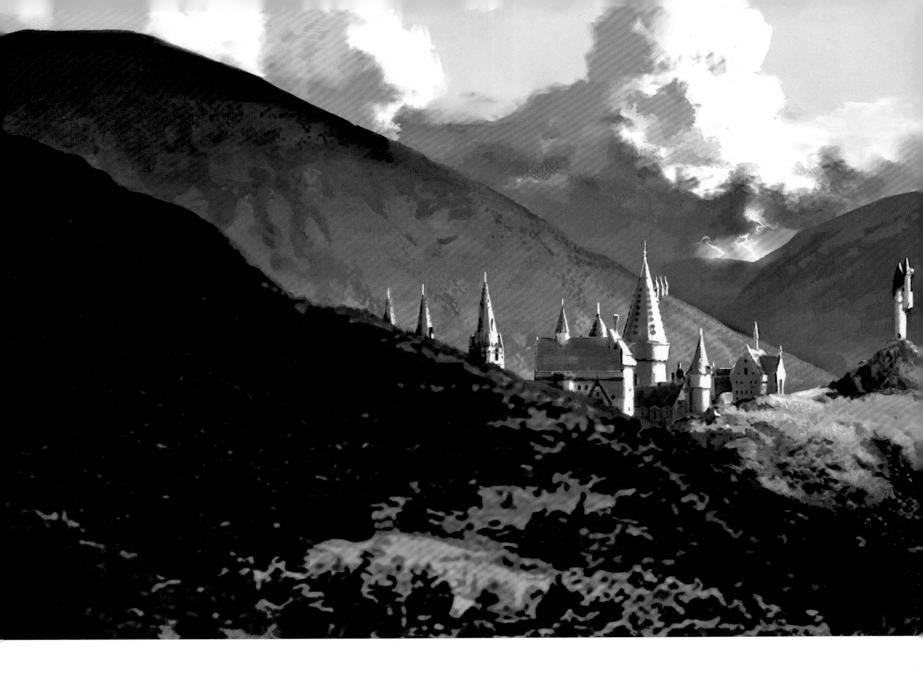

INTRODUCTION

IN THE PAGES of her best-selling series of novels, author J.K. Rowling used her words to paint images of Harry Potter's wizarding world directly into the minds of her readers. When the time came to bring those images to life on to the silver screen, though, the wand was passed to Academy Award–winning production designer Stuart Craig and his team of artists, designers, and craftspeople.

Under Craig's guidance, designers translated Rowling's words into the lush images found within these pages, exploring and defining—through innumerable sketches, digital paintings, and more—how the beloved characters and iconic locations from the series would be interpreted on film.

From the original film of the series, *Harry Potter and the Sorcerer's Stone*, to *Fantastic Beasts and Where to Find Them*, Craig has served as a consistent guiding force, making sure that all the larger-than-life concepts dreamed up by Rowling are realized in a way that fits seamlessly into the wizarding world.

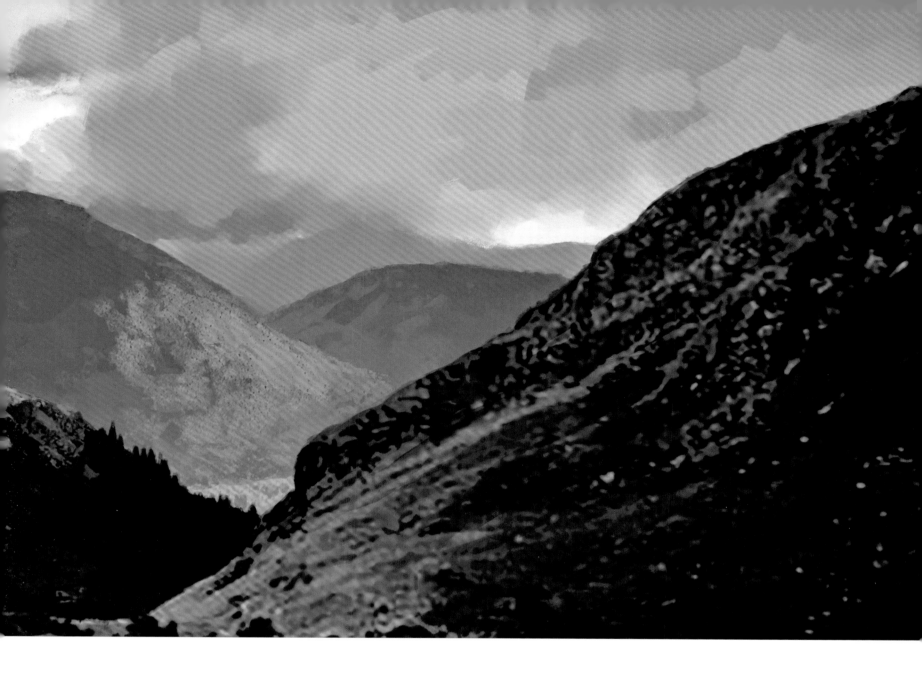

But Craig wasn't alone in his journey to Hogwarts. He had with him some of the most talented movie magicians to ever sketch, sculpt, and set design, including concept artists Andrew Williamson, Adam Brockbank, Paul Catling, Rob Bliss, and Dermot Power; graphic designers Miraphora Mina and Eduardo Lima; creature effects designer Nick Dudman; costume designer Jany Temime; and an Academy Award–nominated set decorator, the late Stephenie McMillan. Together, they would become the driving artistic forces for every visual aspect of the films, from Horcruxes to Hippogriffs.

While the tone of the films evolved over time, taking a noticeably darker turn, the foundation that Craig and his team had built for the wizarding world remained strong thanks to carefully balanced elements of fantasy and reality.

"There's a danger in creating something that's completely fantasy," Craig says, "which is that you lose any reference to reality. The whole thing becomes so extraordinary and out of touch with anything real. And that isn't the style of these movies. The style of these movies is: Although there's magic all over the place . . . Hogwarts is a very physical, very real, very solid place."

In fact, Hogwarts became an even more real and solid place when Warner Bros. secured a dedicated soundstage, Leavesden Studios outside of London, for the entirety of the series. This allowed commonly used sets—such as Hogwarts's Great Hall and Diagon Alley—to be built once and left standing for the duration of the film series' filming, saving the design team time and money while creating stronger continuity.

"It's comforting to go back to the same place," Craig says. "As long as you deliver the new stuff when you need to. And the spectacle when you need to."

And that spectacle was never lacking. Enormous set pieces like the Chamber of Secrets and the Ministry of Magic. Amazing characters like Rubeus Hagrid and He-Who-Must-Not-Be-Named. Terrifying creatures like Acromantula and Dementors. Memorable props like the Goblet of Fire and an endless assortment of wands and broomsticks. Each and every design created by the production team worked in perfect unison to mesmerize audiences and draw them deeper into the experience.

As you will witness in the pages that follow, what Stuart Craig and his remarkable team of artists were able to achieve was nothing short of pure magic.

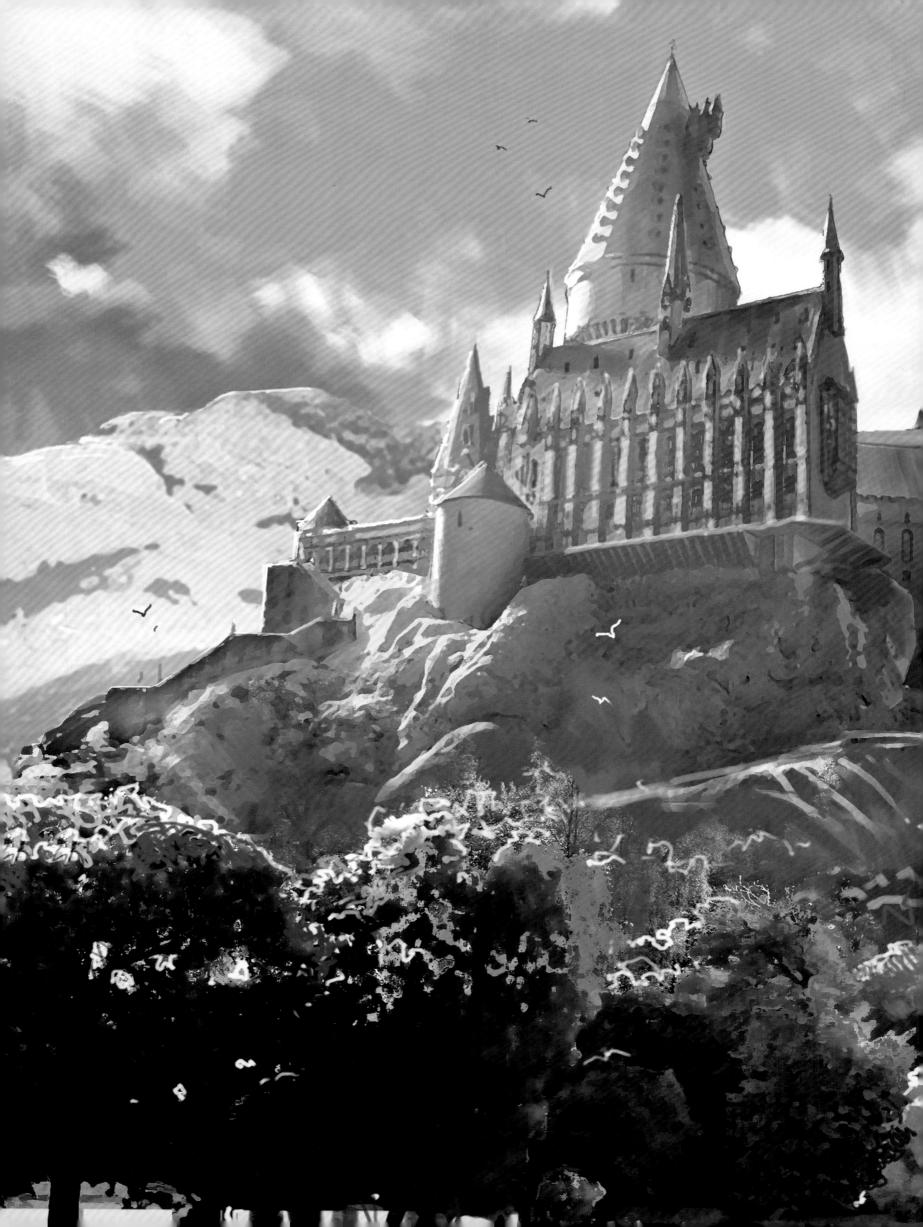

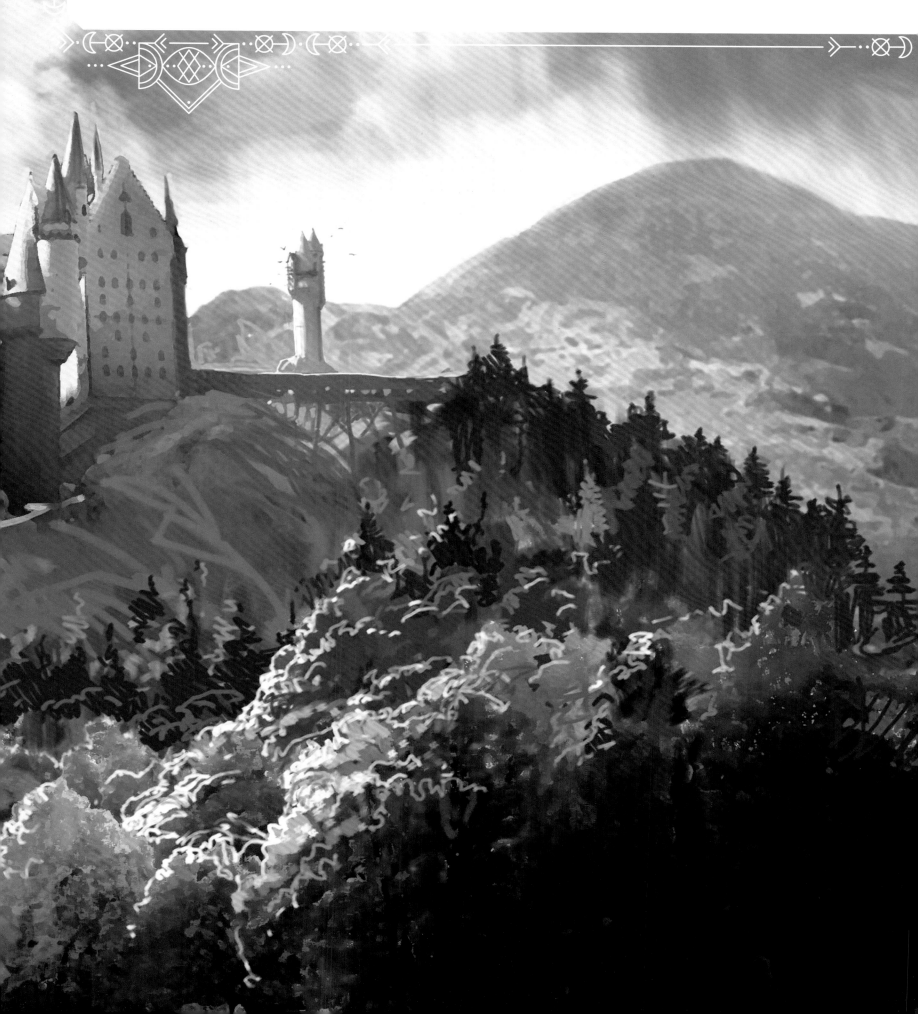

CHAPTER 1
THE WIZARDING WORLD

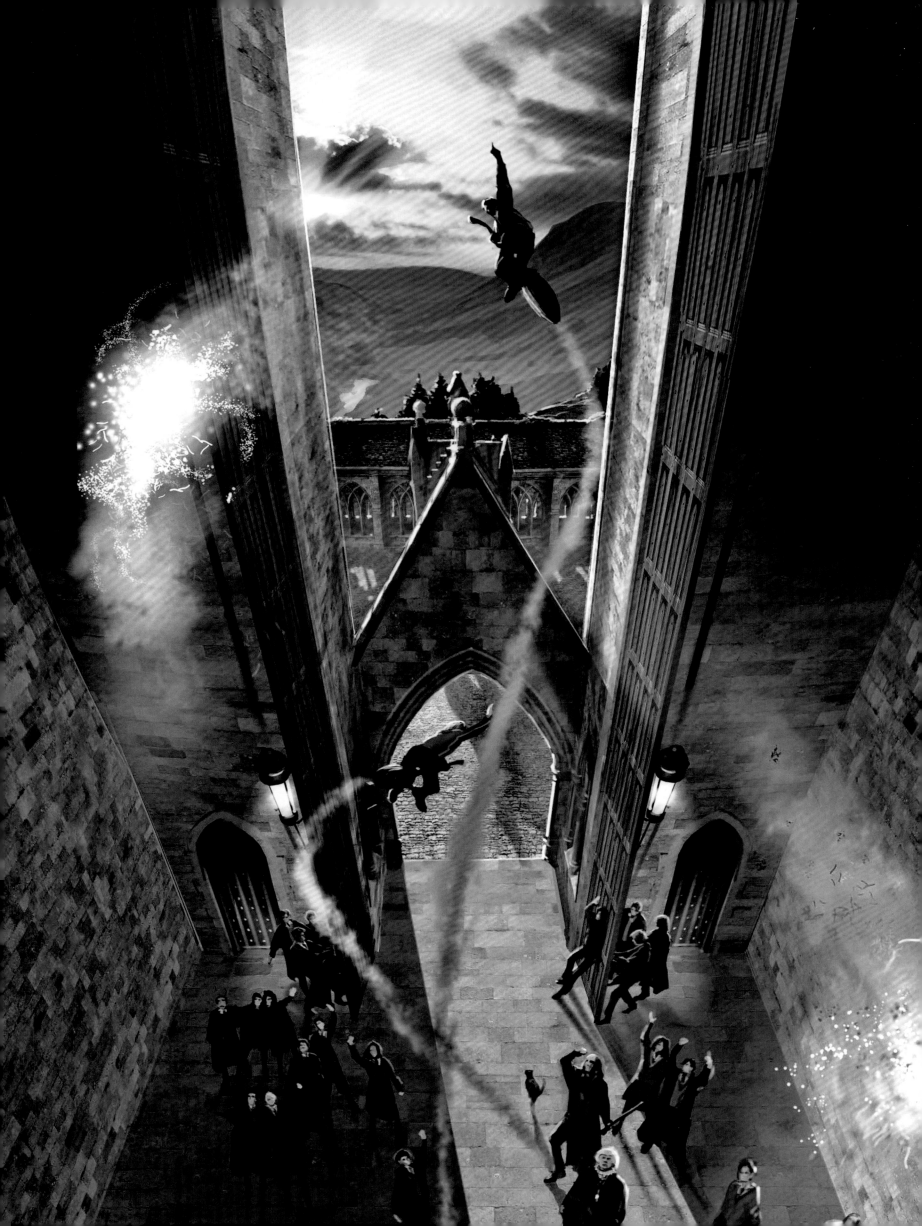

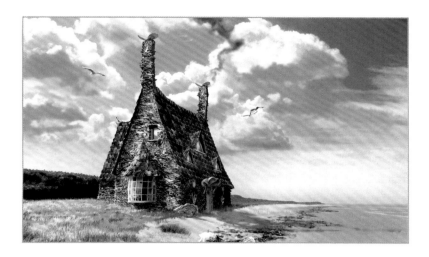

The most wondrous thing in the world of Harry Potter may in fact be the world itself. From dark forests and secret caverns to ancient castles and hidden alleys, there is magic teeming in every unique location that our young heroes visit. As head of the art department, production designer Stuart Craig was tasked with making sure that these sensational settings didn't lose their luster as they were translated from page to screen.

Similar to most other creative aspects of the films, set designs began as a series of detailed sketches and concept art. And one of the most important sketches came not from the film's design team, but from J.K. Rowling herself.

During their first meeting to discuss the visual identity of the films, Craig asked the author a number of questions to gain a better understanding of the wizarding world that he was going to help bring to life on the big screen. Without hesitation, Rowling grabbed a pen and paper and sketched out a map that told Craig everything he would need to know about Hogwarts School of Witchcraft and Wizardry. While perhaps not as elaborate as the Marauder's Map that would one day unveil every nook and cranny of the school grounds, Rowling's initial sketch detailed the location's most important elements—from the Forbidden Forest and the Whomping Willow to the Quidditch pitch and Hagrid's hut. Craig held on to Rowling's sketch and referenced it frequently throughout the years.

While Rowling may not have provided the concept sketches for the other locations in the films, it was her written words that inspired the team of artists working under Craig to bring these iconic settings to life. From the gravity-defying lean of Diagon Alley to the distorted dimensions of Grimmauld Place, the concept art for each locale explored fascinating ways to infuse the films' settings with magic.

Once a basic form was agreed upon, a miniature design model was constructed to convey the basic concept to the film's director and design team. The simplicity of the early design model was extremely important in helping Craig and his team determine if the set piece was doing its job in the most effective and efficient manner possible.

"My philosophy is that two ideas per set are all you're permitted," Craig says. "If you get into three or four different ideas for one set, you will end up with a weakened and unsatisfactory set. The best sets have one strong idea—at the most two."

This clarity of purpose was one of the many reasons that Craig preferred to build a set from the ground up rather than use existing real-world locations.

"The real world is always cluttered," Craig says. "And clutter is not good for telling a story in a theatrical way. You need to get rid of whatever's extraneous and just keep it simple."

Of course, as the series progressed, the designs for the sets often evolved as well. Popular settings such as the Great Hall and the Dark Arts classroom were frequently redressed for special celebrations, changes of season, and new inhabitants, which helped to keep familiar locations feeling fresh and exciting. Meanwhile, retired sets were often completely repurposed and reimagined as entirely new locales. Even the iconic exterior of Hogwarts itself gained a few new towers over the course of the series.

"They've been changed for no better reason than that it would just be nice to improve on them," Craig says, noting that this is "part of the ongoing magical regeneration, from one film to another."

PAGES 10–11: Artwork by Andrew Williamson for *Harry Potter and the Order of the Phoenix.*

OPPOSITE: Fred and George Weasley toss fireworks from their brooms in artwork by Andrew Williamson for *Harry Potter and the Order of the Phoenix.*

TOP: Concept art by Andrew Williamson for Shell Cottage for *Harry Potter and the Deathly Hallows – Part 2.*

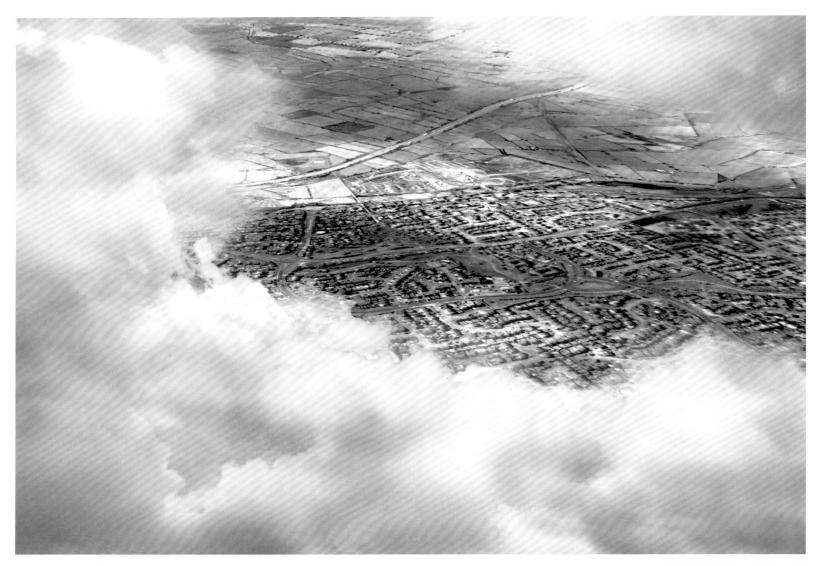

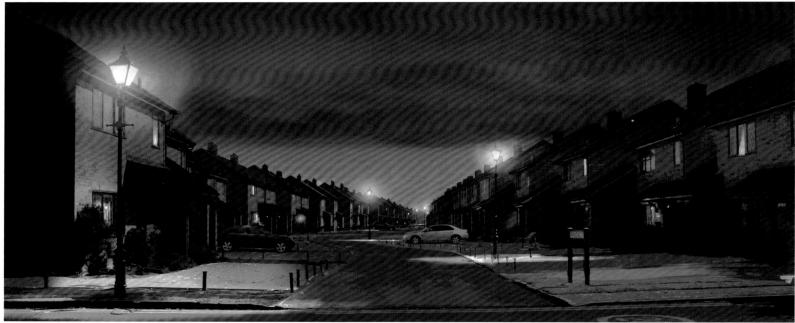

TOP AND OPPOSITE TOP: Aerial views by Andrew Williamson of the suburban neighborhood of Little Whinging for *Harry Potter and the Order of the Phoenix.*

ABOVE: A look down Privet Drive by Andrew Williamson for *Harry Potter and the Order of the Phoenix.*

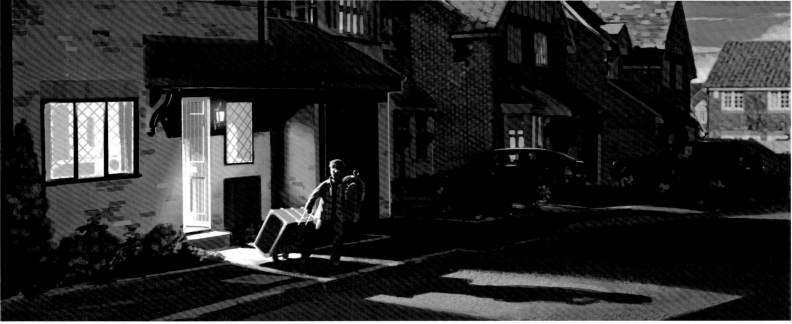

ABOVE: Harry Potter leaves the Dursley house in *Harry Potter and the Prisoner of Azkaban* when he blows up Aunt Marge. Art by Adam Brockbank.

FOLLOWING PAGES: Concept art from *Harry Potter and the Sorcerer's Stone* shows how the Dursleys try to avoid Harry's invitations to Hogwarts by going to the Hut-on-the-Rock.

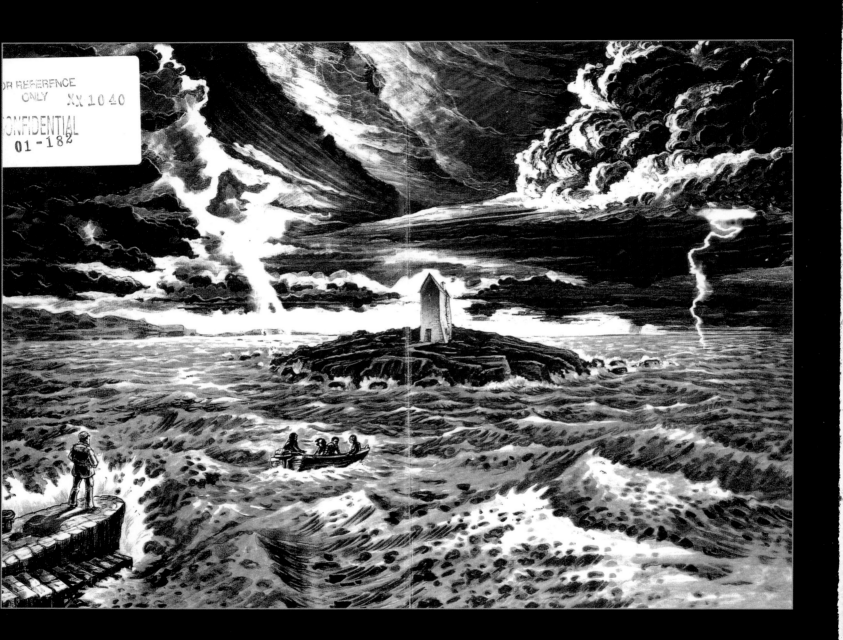

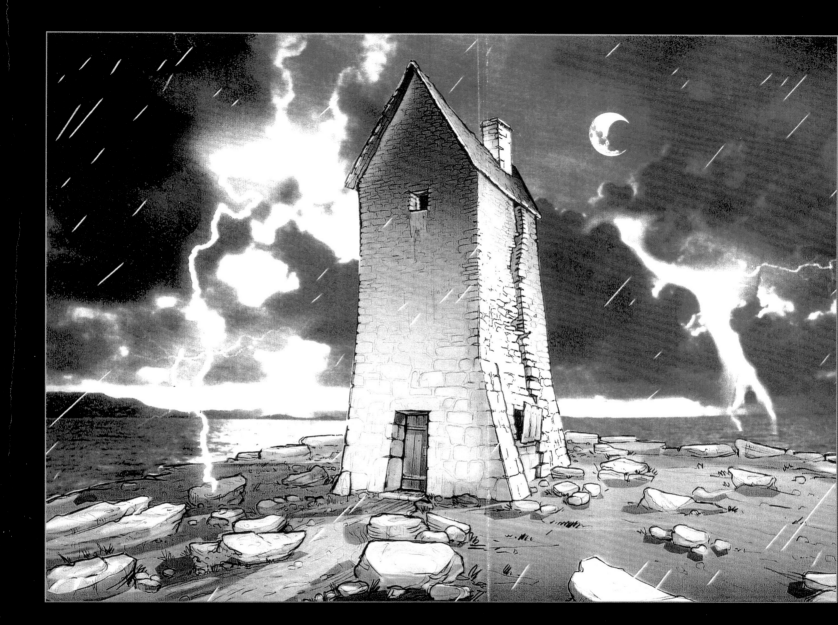

ABOVE AND OPPOSITE TOP: Death Eaters begin their attack on London in *Harry Potter and the Half-Blood Prince.* Art by Andrew Williamson.

OPPOSITE MIDDLE: Concept art by Andrew Williamson of the ethereal King's Cross station where Harry encounters Dumbledore in *Harry Potter and the Deathly Hallows – Part 2.*

"We're in King's Cross, you say? I think, if you so desire, you'll be able to board a train."

–Professor Dumbledore, *Harry Potter and the Deathly Hallows - Part 2*

DIAGON ALLEY

TOP AND ABOVE: Computer-generated models map out Knockturn Alley with its towering chimneys. Harry Potter, Ron Weasley, and Hermione Granger spy Draco Malfoy entering Borgin and Burkes from a rooftop here in *Harry Potter and the Half-Blood Prince*.

OPPOSITE: Stuart Craig's preproduction sketch of Diagon Alley, one of the first sets created for *Harry Potter and the Sorcerer's Stone*, gave Gringotts its iconic lean.

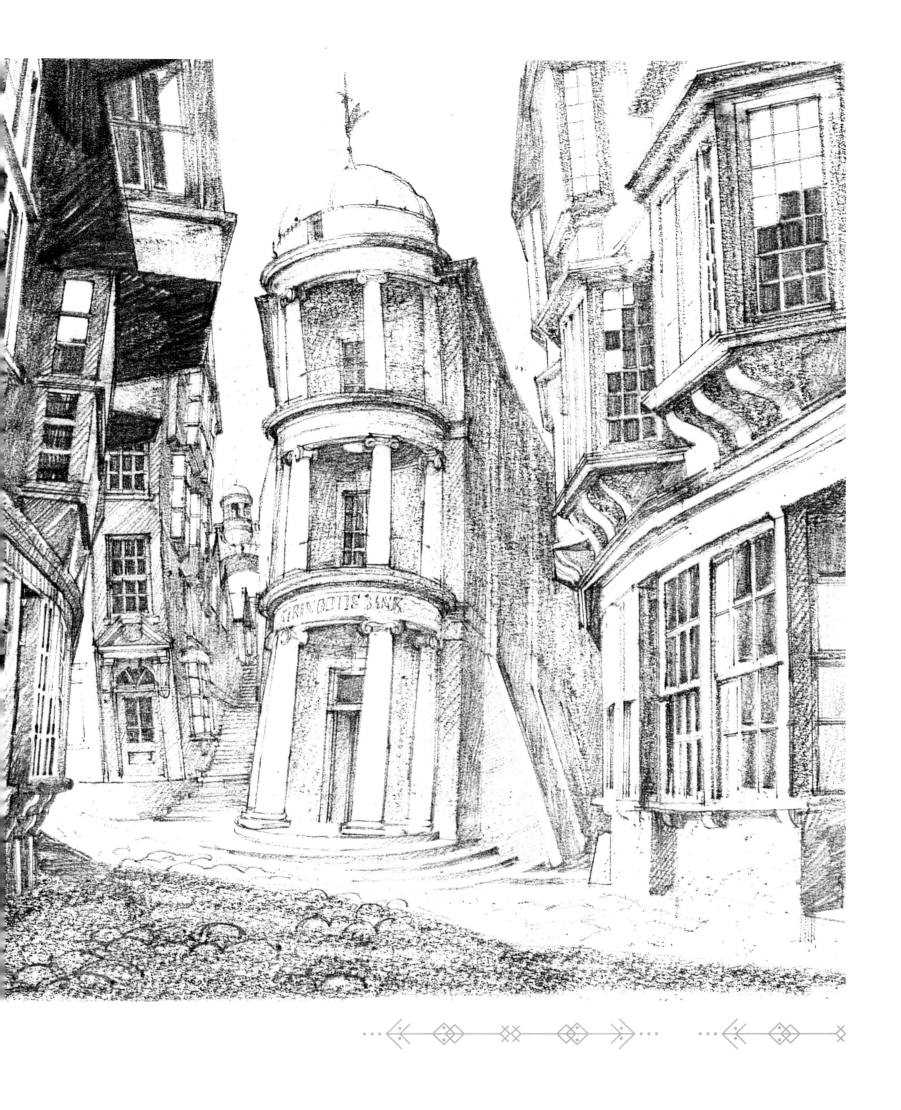

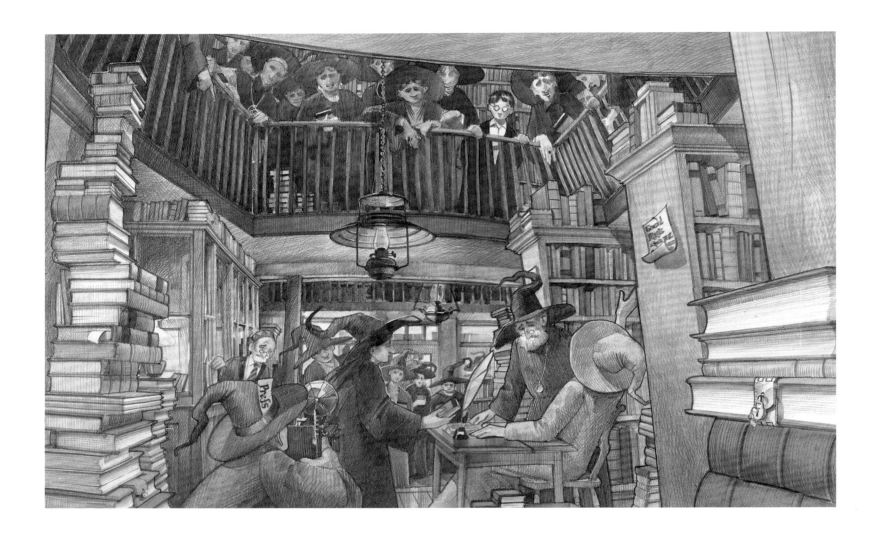

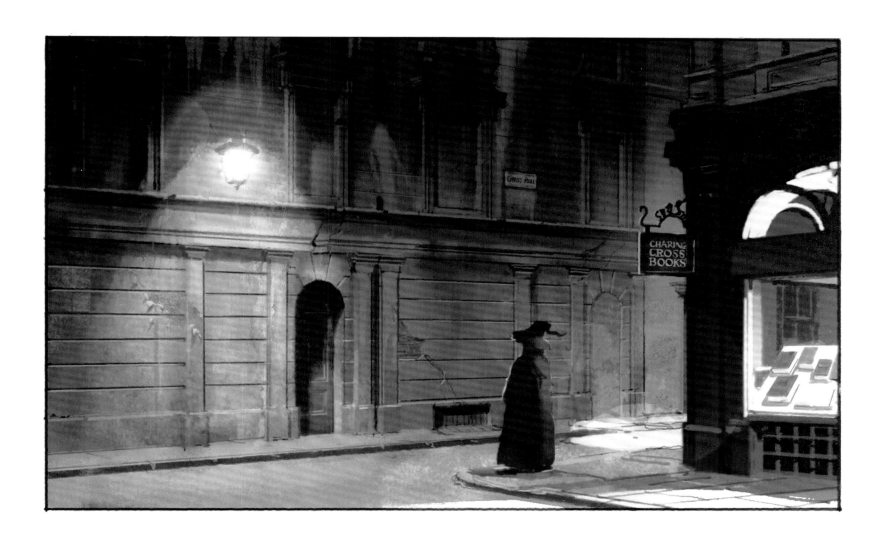

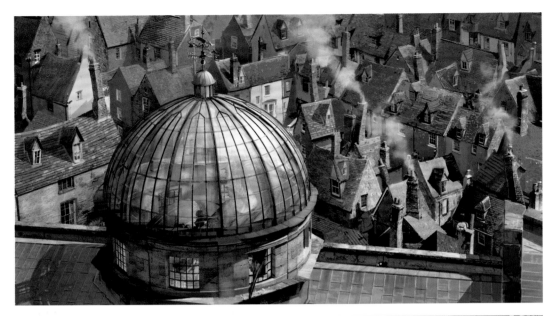

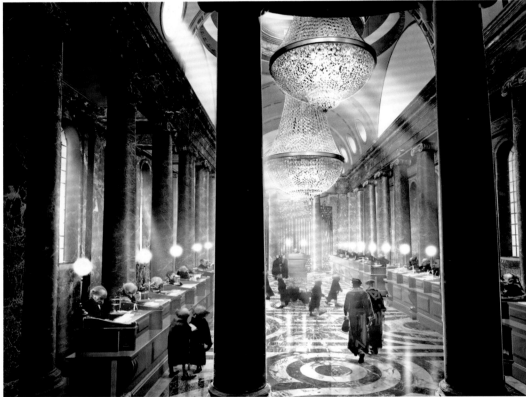

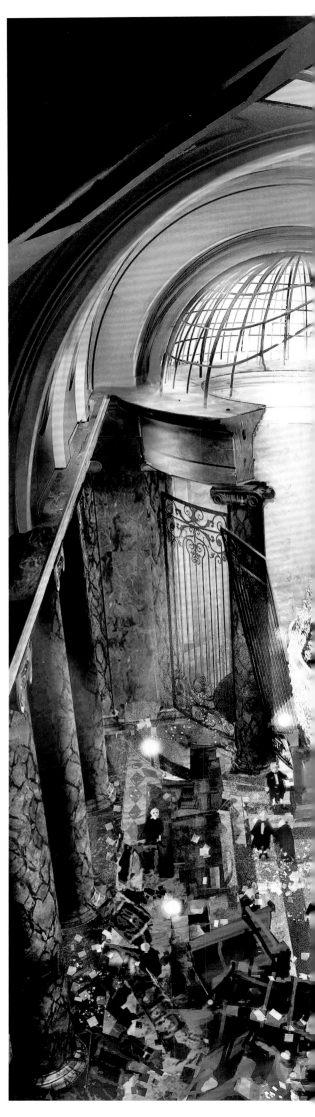

OPPOSITE: *In Harry Potter and the Deathly Hallows – Part 2*, Harry, Ron, and Hermione escape from Gringotts Wizarding Bank on a Ukrainian Ironbelly dragon as portrayed by Andrew Williamson.

TOP AND MIDDLE: Placid views of Gringotts by Andrew Williamson before the dragon breaks through both floor and ceiling as it flees; both for *Harry Potter and the Deathly Hallows – Part 1*.

ABOVE: The Gringotts Wizarding Bank seal, as created by the graphics department.

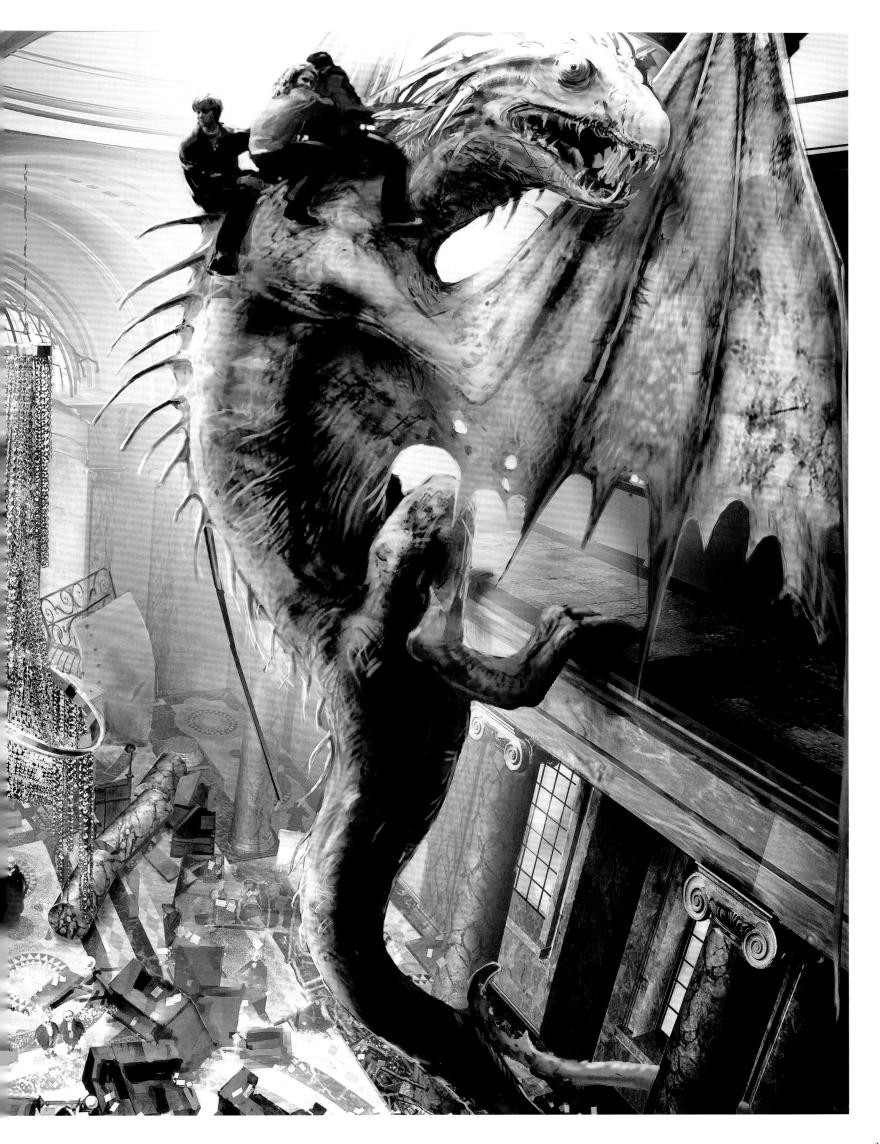

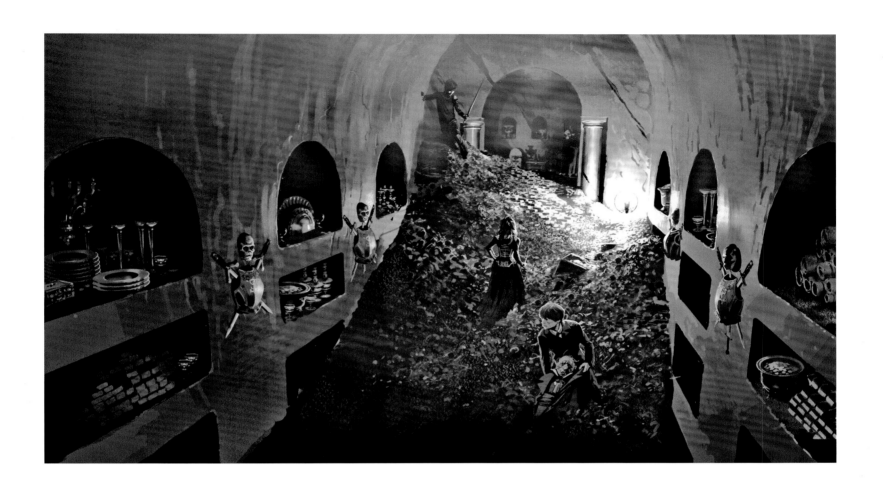

"They've added the Gemino Curse—
everything you touch will multiply."

–Griphook, *Harry Potter and the Deathly Hallows - Part 2*

HOGWARTS CASTLE

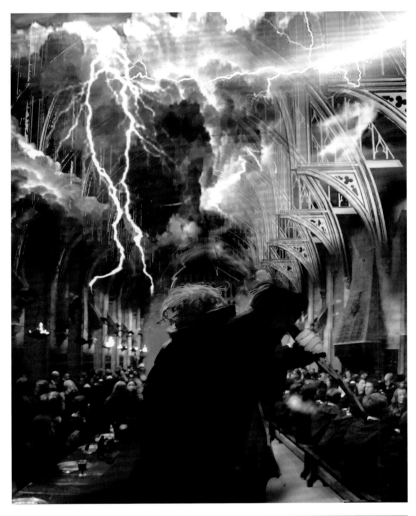

RIGHT: Professor Alastor Moody makes an electric entrance into the Great Hall in *Harry Potter and the Goblet of Fire*, as depicted by Paul Catling.

BELOW: Fred and George Weasley interrupt Harry's O.W.L. exams with a display of fireworks. Art by Andrew Williamson for *Harry Potter and the Order of the Phoenix*.

OPPOSITE: As a safety measure against the escaped Sirius Black in *Harry Potter and the Prisoner of Azkaban*, students gather under a celestial sky in the Great Hall. Composite of film still and digital art by Dermot Power.

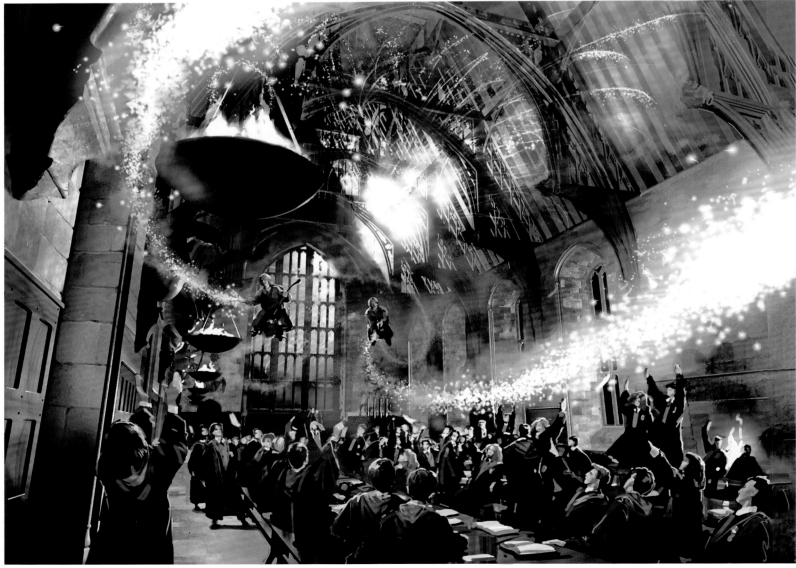

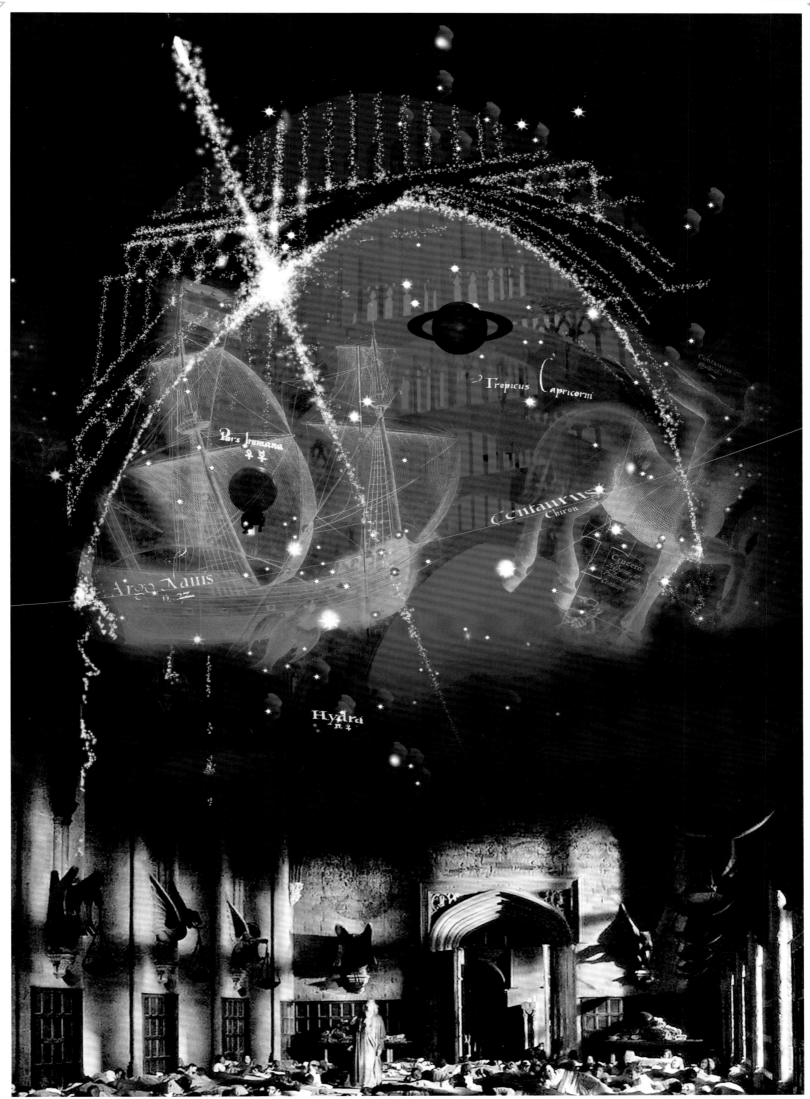

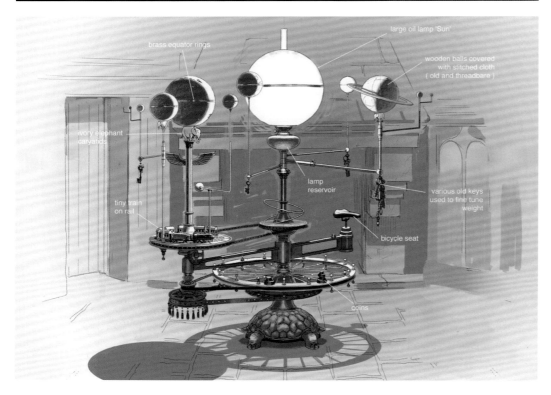

TOP: Andrew Williamson depicts Harry and Professor Dumbledore atop the Astronomy Tower before they leave to pursue a Horcrux in *Harry Potter and the Half-Blood Prince*.

MIDDLE: Harry, Ron, and Hermione watch Dumbledore's phoenix, Fawkes, fly away from Hogwarts after Dumbledore's death. Art by Andrew Williamson for *Harry Potter and the Half-Blood Prince*.

ABOVE: Concept art by Andrew Williamson of an orrery seen in Dumbledore's office throughout the films.

OPPOSITE: A study by Andrew Williamson of Dumbledore as he sits quietly in the Astronomy Tower after sending Harry to get Snape for him in *Harry Potter and the Half-Blood Prince*.

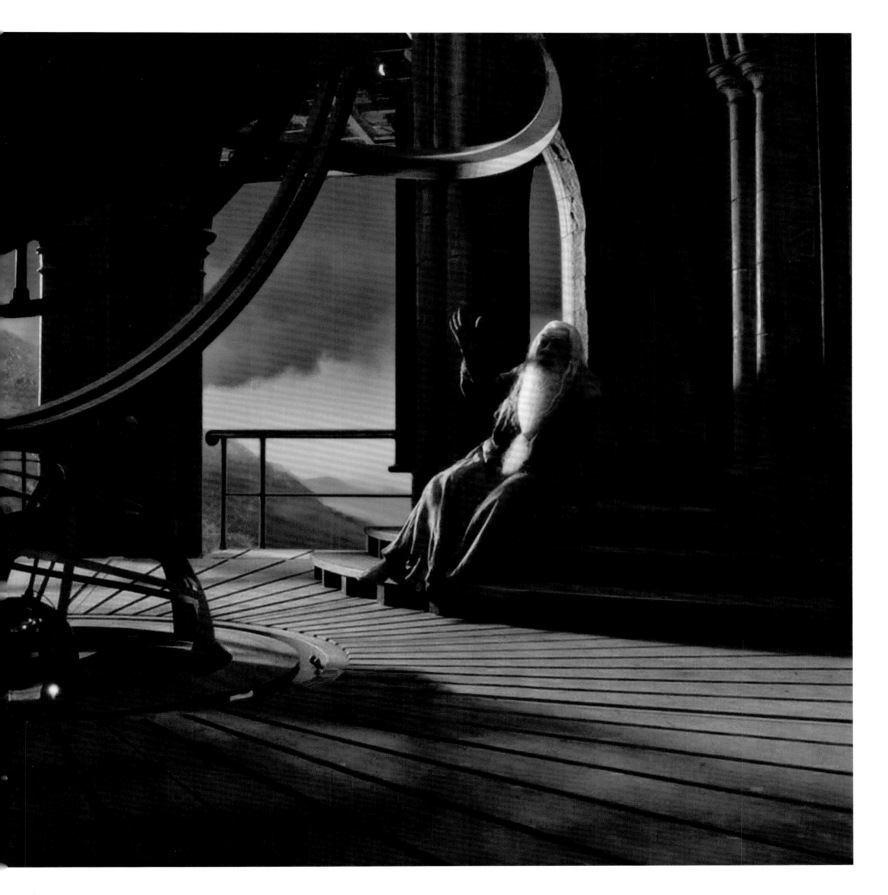

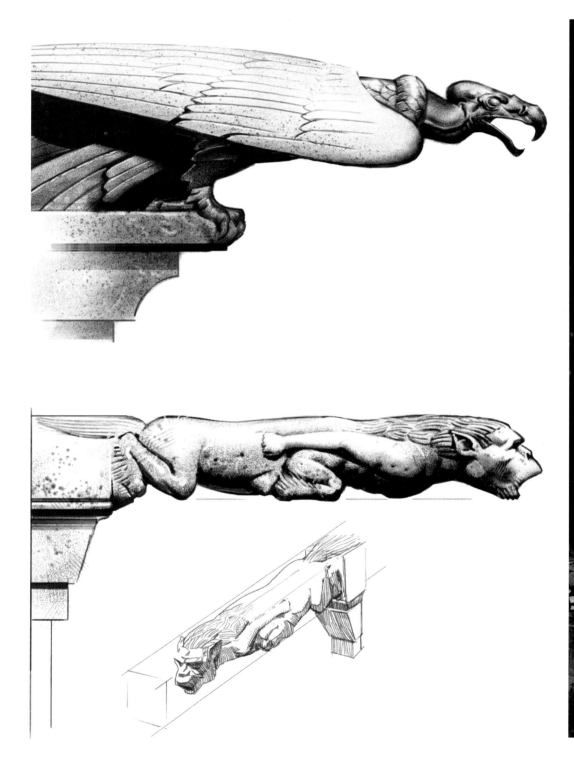

ABOVE: Gargoyle studies by Adam Brockbank.

OPPOSITE: Students are stopped at the gates of Hogwarts to be scanned for Dark items in concept art by Andrew Williamson for *Harry Potter and the Half-Blood Prince*.

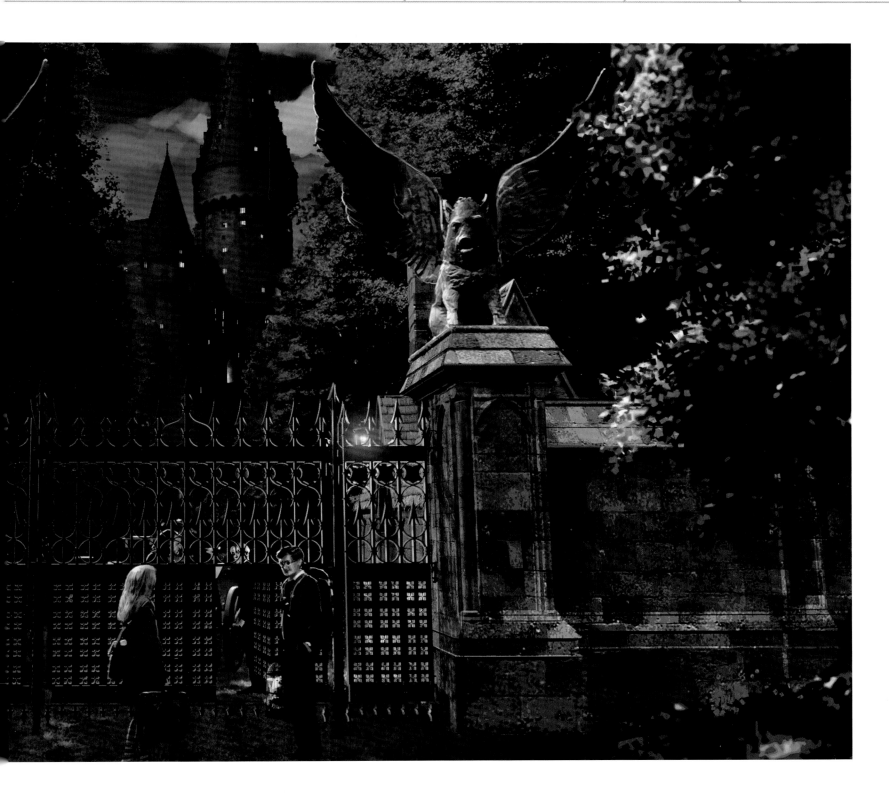

THESE PAGES: Harry and Hermione in the Hogwarts library, complete with floating books. Artwork by Adam Brockbank for *Harry Potter and the Half-Blood Prince*.

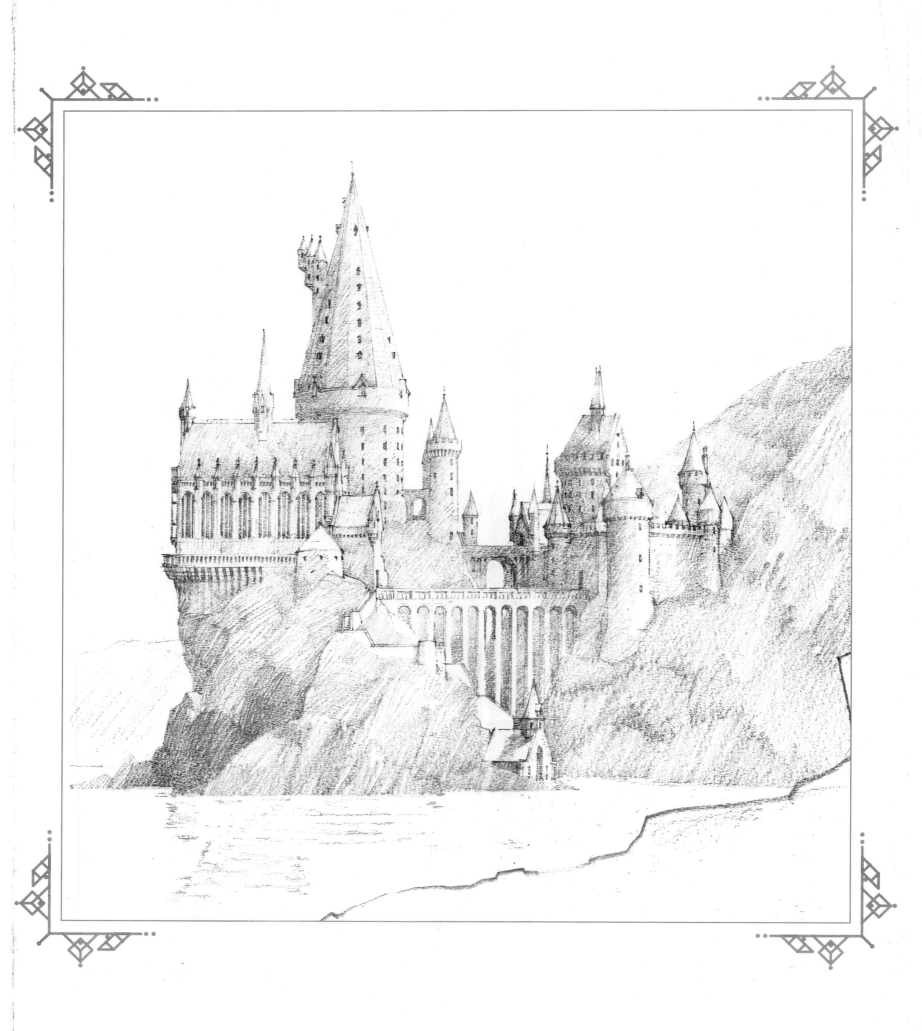

THESE PAGES: An early sketch of Hogwarts castle by production designer Stuart Craig; visual development art of Hogwarts by Dermot Power.

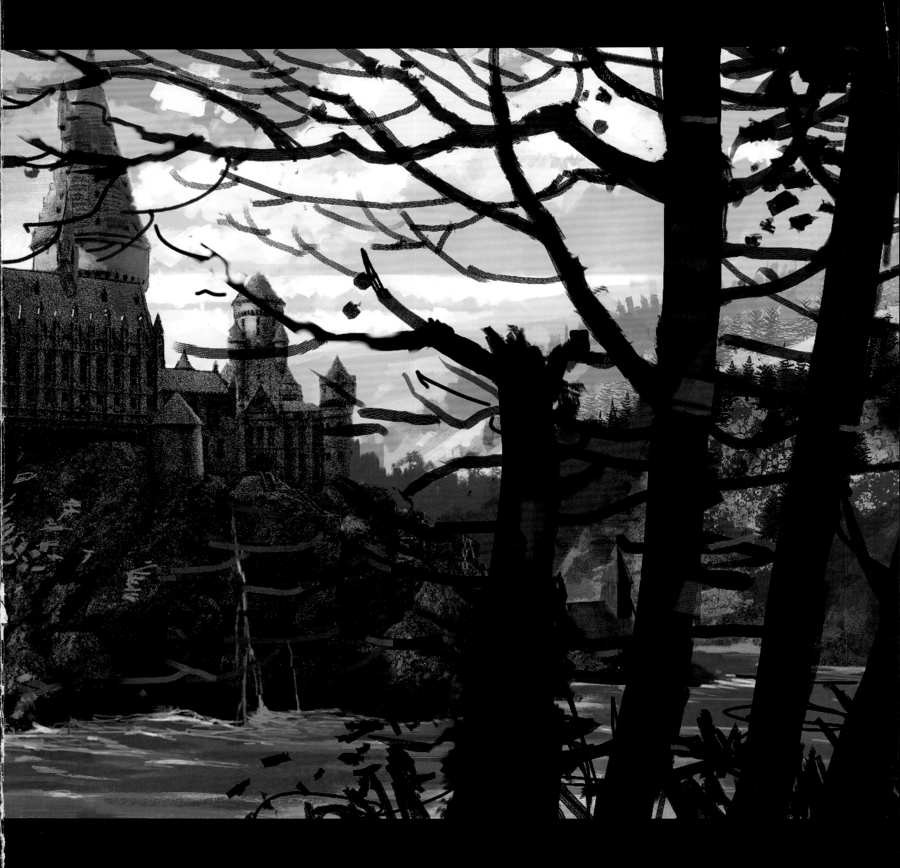

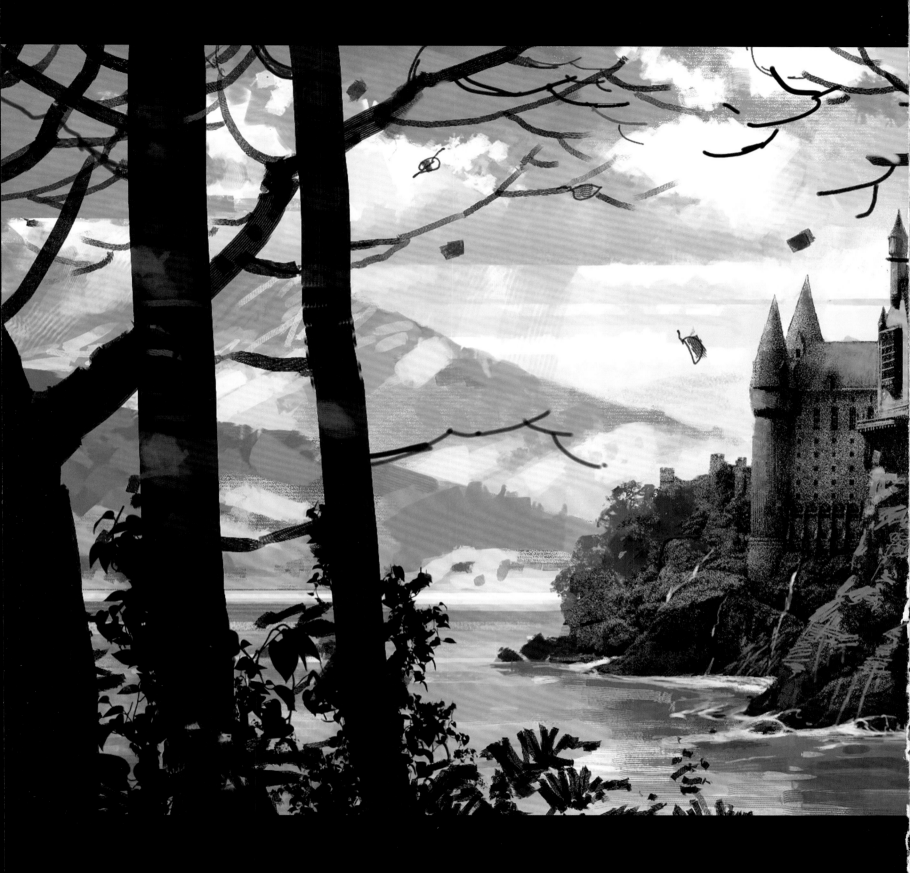

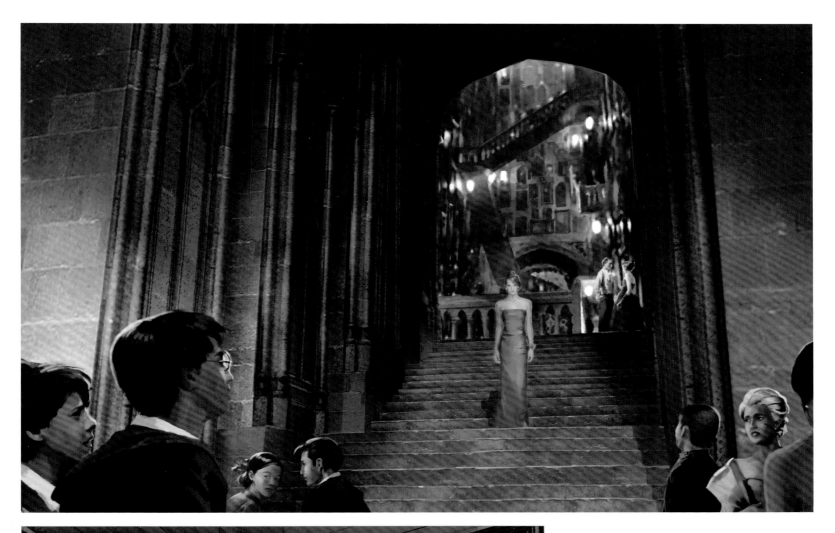

TOP: Hermione arrives at the Yule Ball in *Harry Potter and the Goblet of Fire*. Andrew Williamson painted her dress periwinkle blue, as it was described in the novel.

LEFT: Study by Andrew Williamson of the Entrance Hall with marble staircases visible in the background.

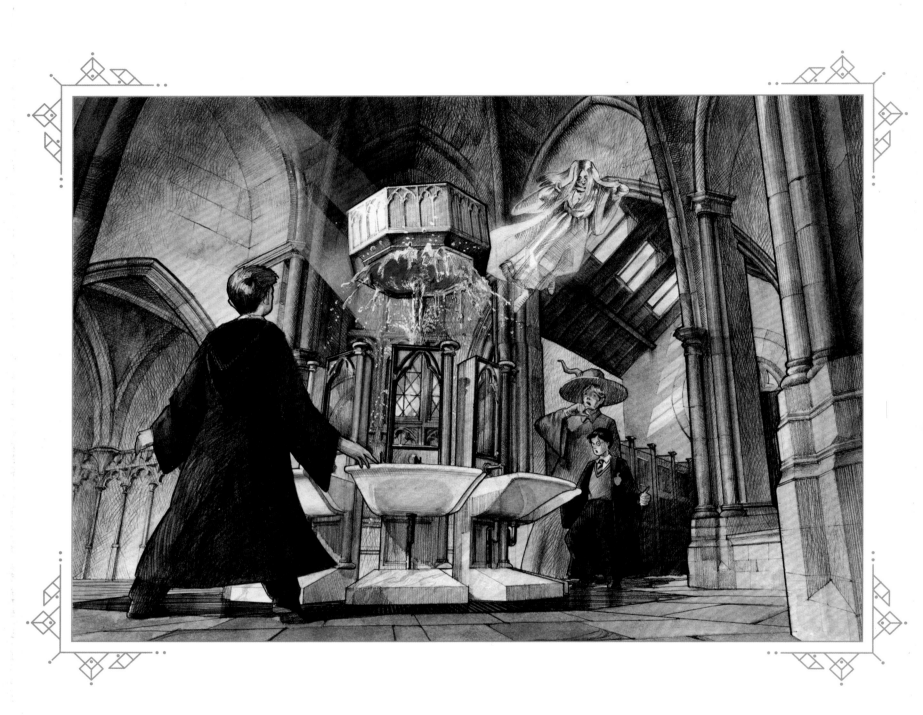

ABOVE: Harry and Ron unlock the entrance to the Chamber of Secrets as Professor Lockhart looks on in *Harry Potter and the Chamber of Secrets*. Andrew Williamson floated Moaning Myrtle above the sinks, though she was not in the scene in the movie.

OPPOSITE: Stained glass windows by Adam Brockbank for *Harry Potter and the Goblet of Fire*. The mermaid resides in the Prefects' bathroom, where Harry deciphers the clue for the second task. Neville Longbottom stops near the window on the right after a difficult Defense Against the Dark Arts class.

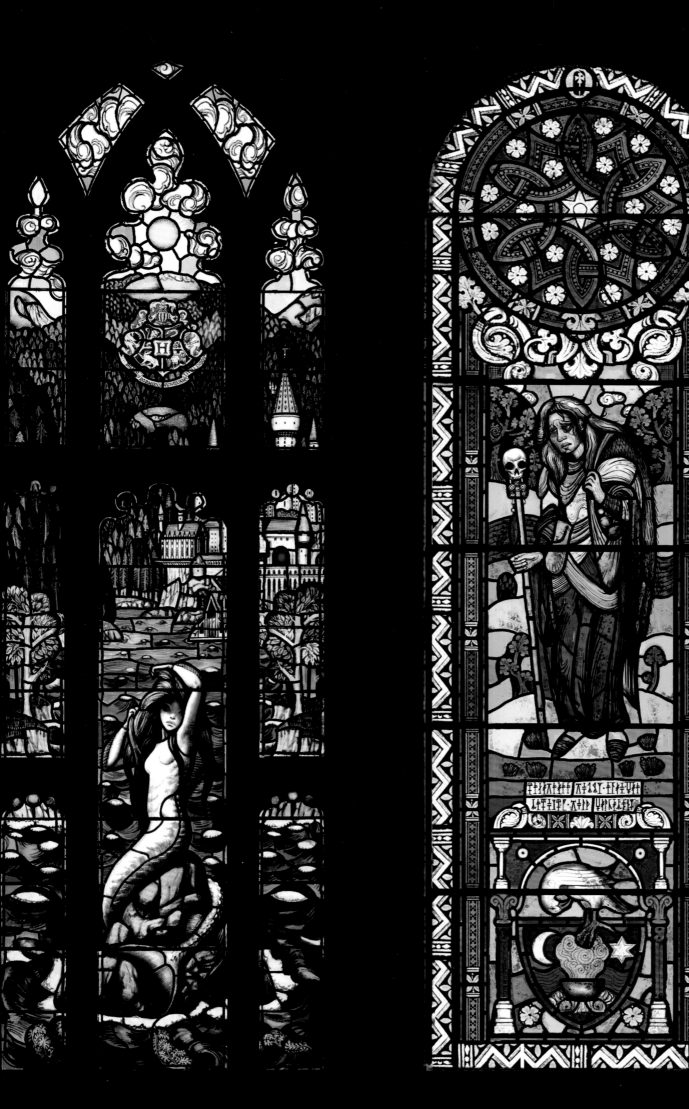

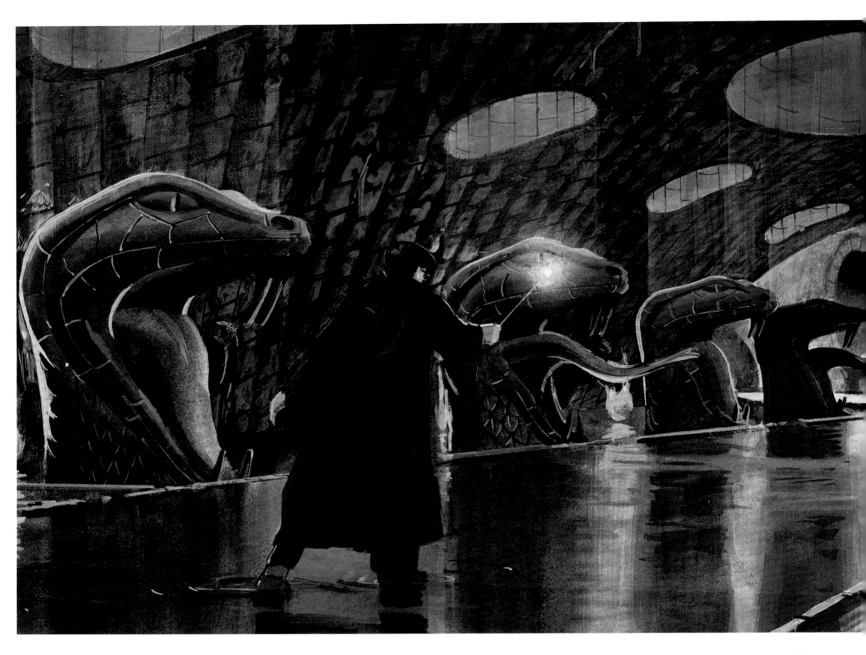

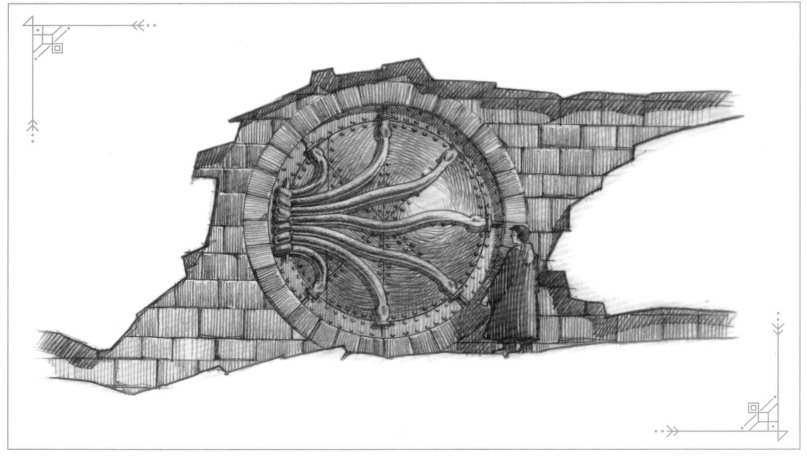

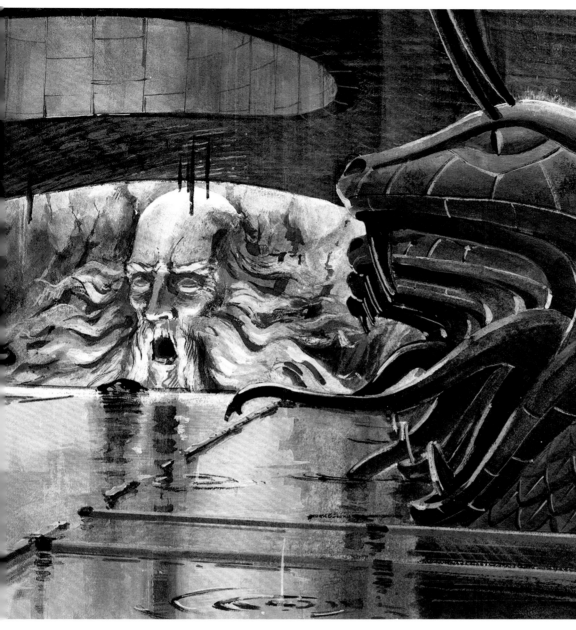

Harry Potter enters the Chamber of Secrets in the film of the same name.

LEFT: Harry approaches the Chamber through a snakehead-lined corridor. Art by Andrew Williamson.

OPPOSITE BOTTOM: Concept art by Andrew Williamson of the Chamber's elaborate door.

BELOW: Another view of the passageway by Andrew Williamson that includes Ron Weasley, who did not appear in this scene of the film. Ron was actually barricaded from entering by a rockslide that trapped him and Professor Lockhart.

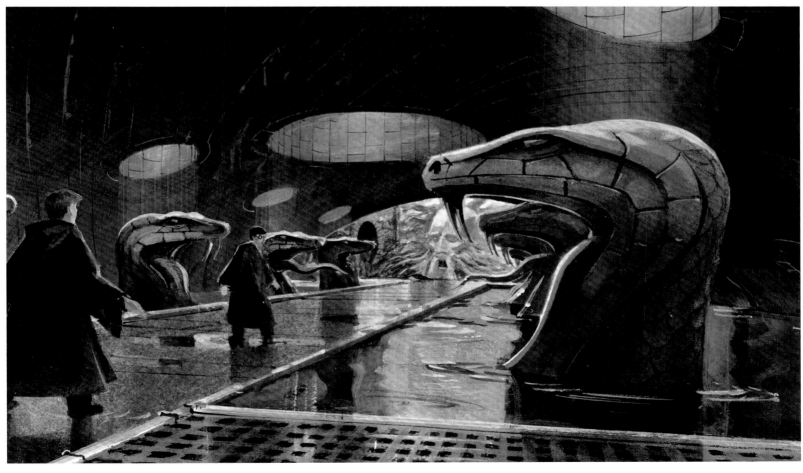

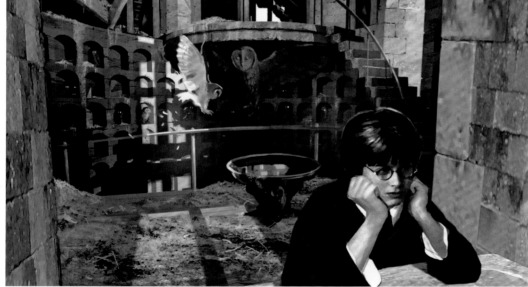

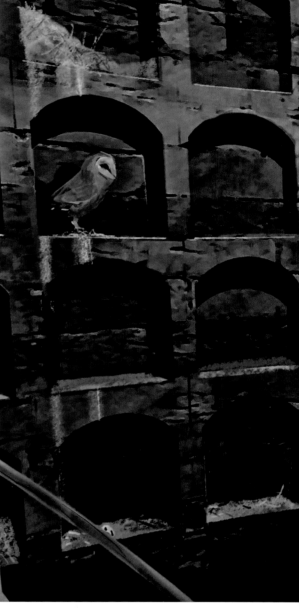

THESE PAGES: Andrew Williamson portrays different views of the Owlery at Hogwarts. It is here that Harry encounters Cho Chang and discovers she already has a date for the Yule Ball in *Harry Potter and the Goblet of Fire*.

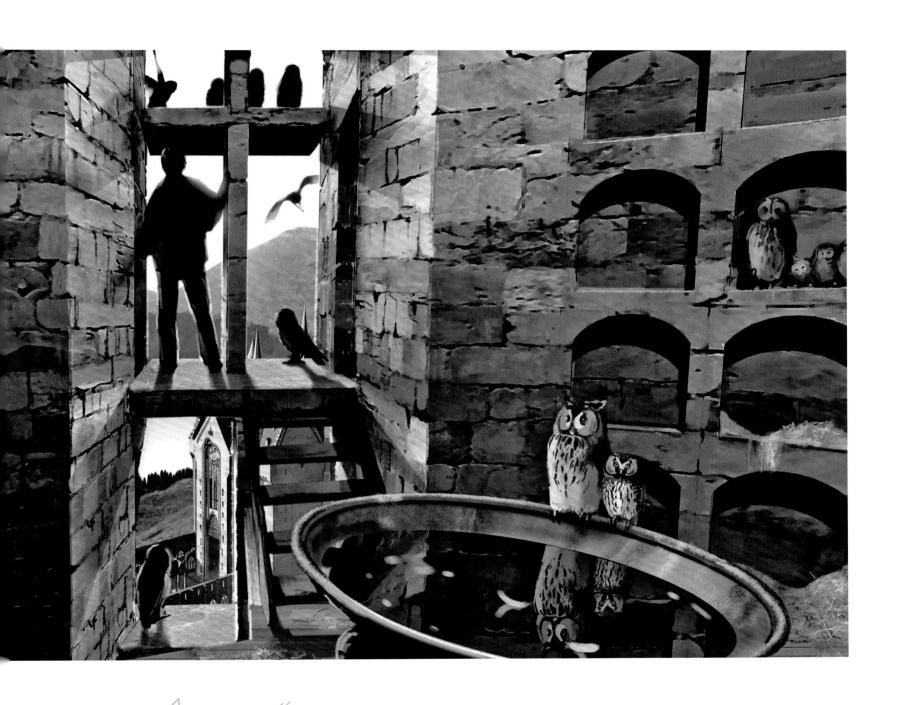

"Cho? Um, I was just wondering if maybe
you wanted to go to the ball with me?"
—Harry Potter, *Harry Potter and the Goblet of Fire*

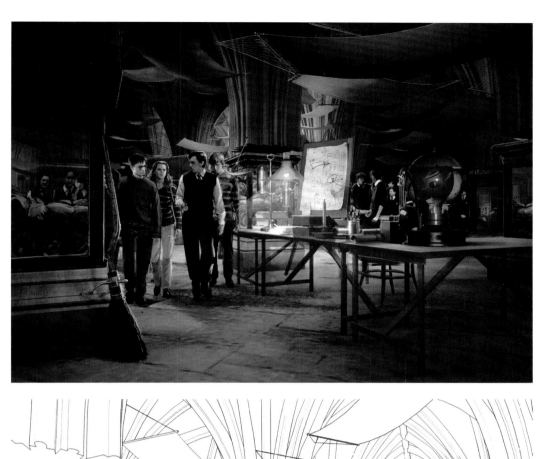

Concept art by Andrew Williamson of the Room of Requirement for *Harry Potter and the Deathly Hallows – Part 2.*

OPPOSITE: Harry, Ron, and Hermione search the Room of Requirement for Ravenclaw's diadem.

TOP: Harry, Hermione, and Neville in the Room of Requirement when Harry returns to Hogwarts for the final battle.

ABOVE: Preliminary sketch for the placement of hammocks used by the students hiding in the Room of Requirement.

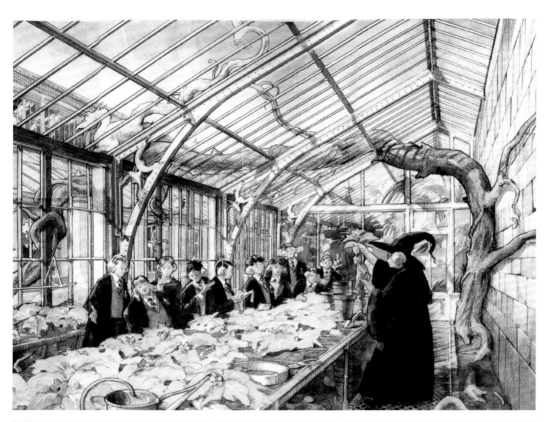

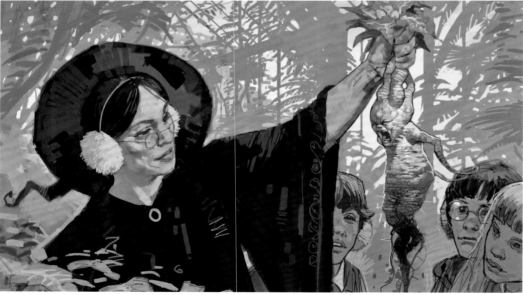

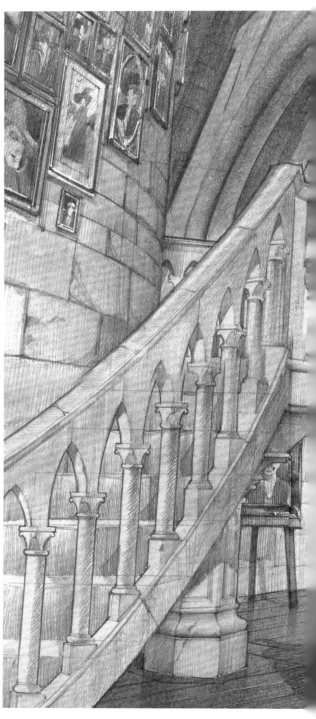

TOP: Greenhouse Three depicted by Andrew Williamson, where the second-years repot Mandrakes under the tutelage of Professor Sprout in *Harry Potter and the Chamber of Secrets*.

ABOVE: A close-up of Professor Sprout wearing earmuffs as auditory protection against the shrieking Mandrakes, artwork by Dermot Power.

OPPOSITE: Professor Lockhart teaches Defense Against the Dark Arts in *Harry Potter and the Chamber of Secrets*. Art by Andrew Williamson.

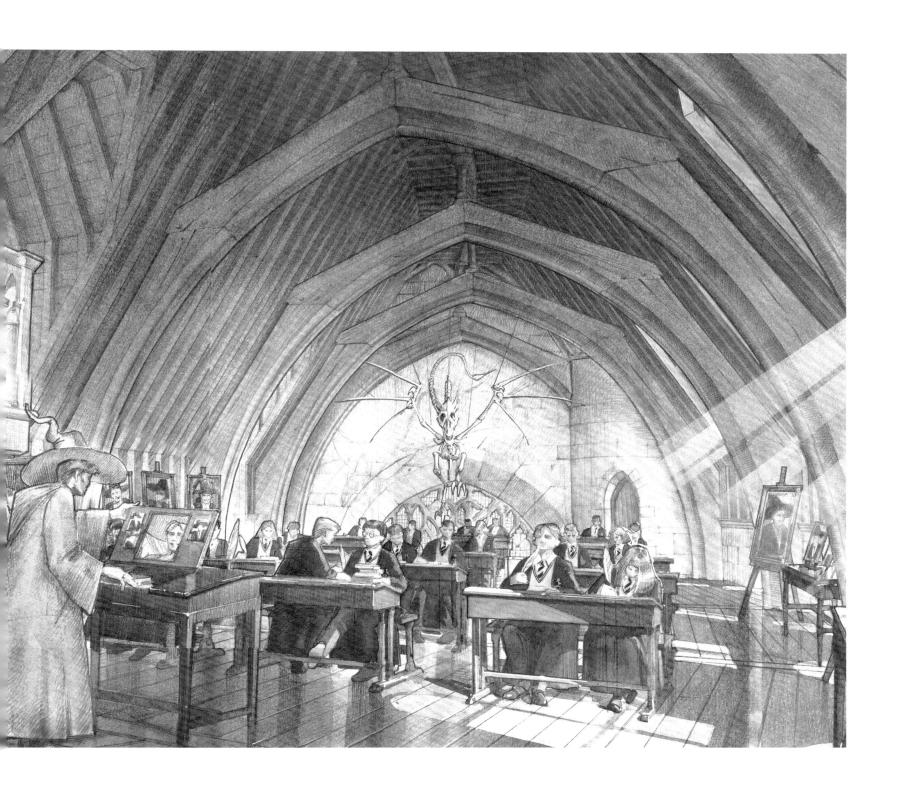

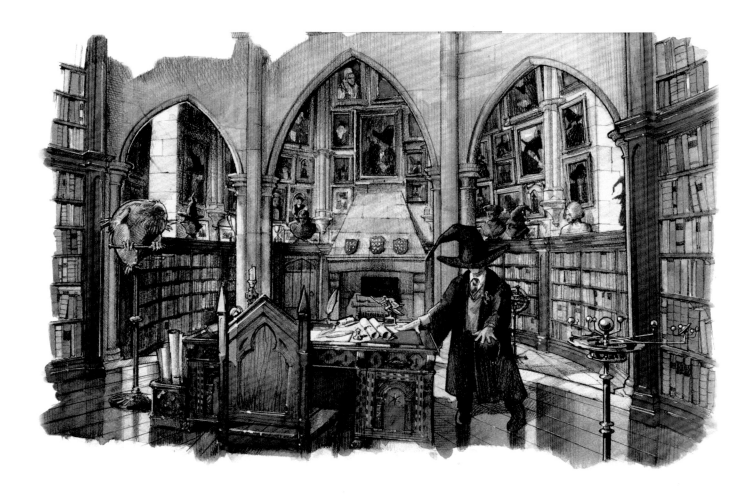

ABOVE: Harry Potter wears the Sorting Hat as he awaits
Professor Dumbledore in the Headmaster's office, for *Harry
Potter and the Chamber of Secrets* by Andrew Williamson.
Harry talks to the Hat in the film but does not try it on.

OPPOSITE: Another view of Harry in Dumbledore's office by
Andrew Williamson.

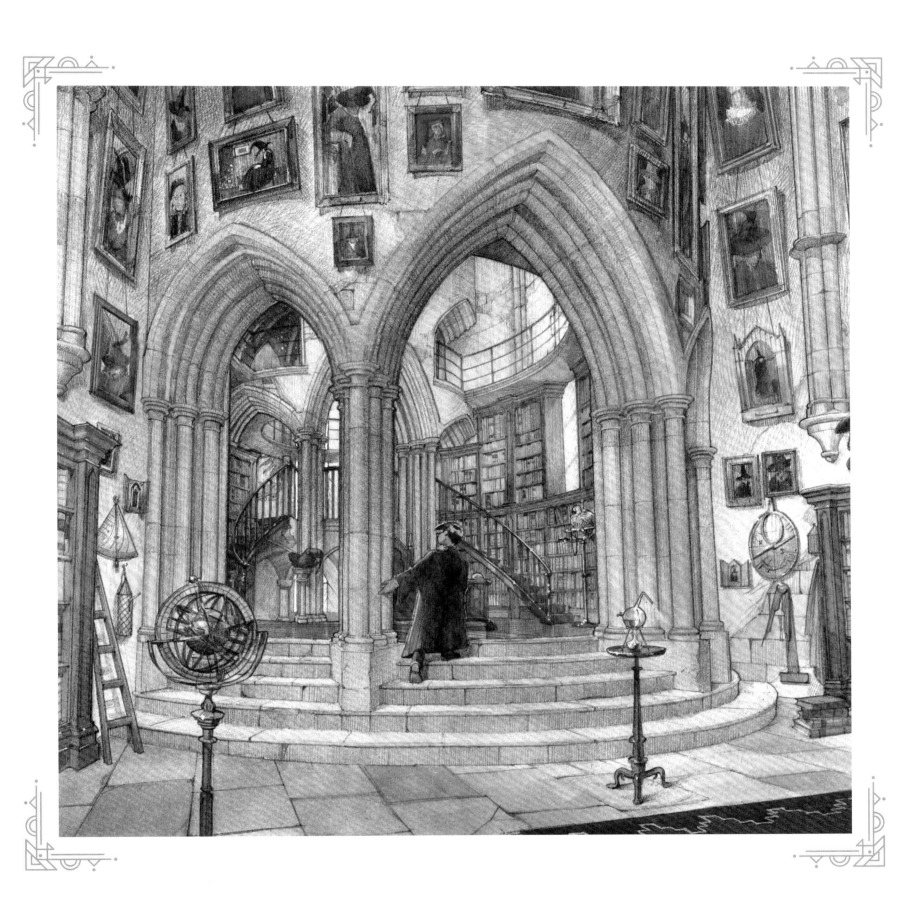

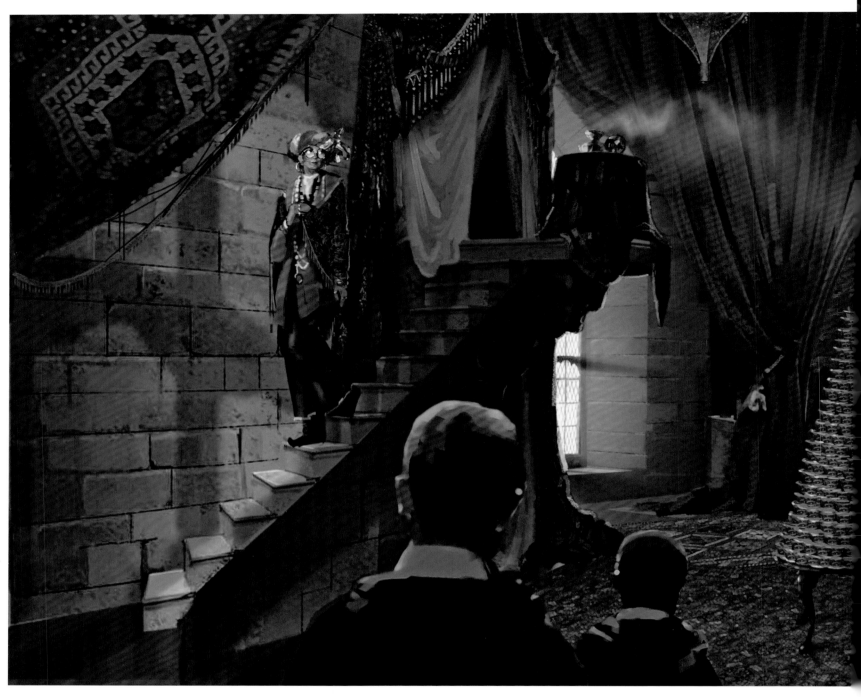

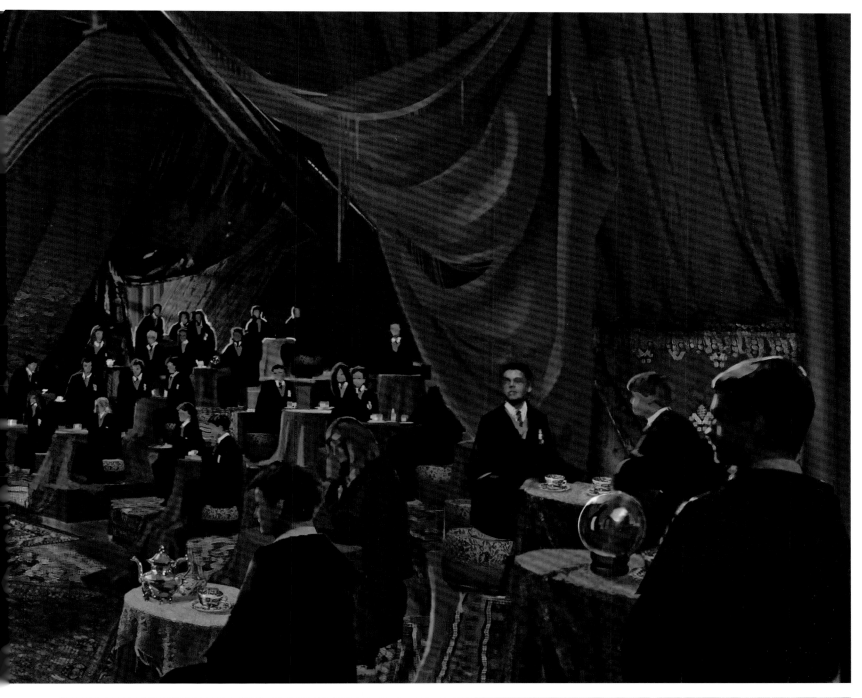

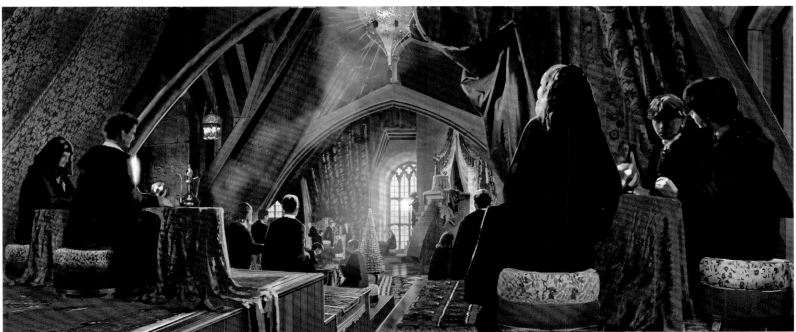

THESE PAGES: Concept artist Andrew Williamson portrays Divination Professor Trelawney's attic classroom as lavishly draped in exotic, jewel-toned fabrics for *Harry Potter and the Prisoner of Azkaban*.

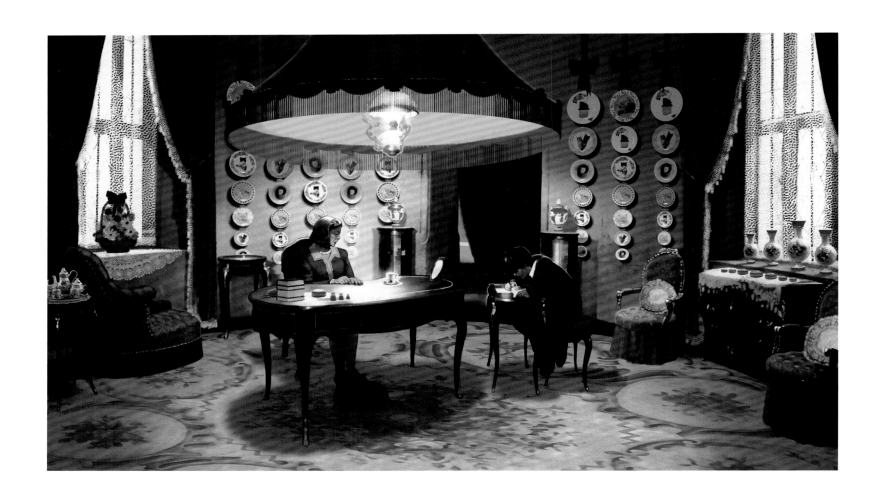

ABOVE: Professor Dolores Umbridge oversees Harry's detention in her office in *Harry Potter and the Order of the Phoenix*. A study in pink by Adam Brockbank.

OPPOSITE: A selection of the cat plates adorning Professor Umbridge's office, which were digitally composited by Hattie Storey. Forty different cats and kittens modeled.

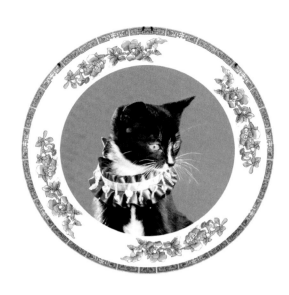

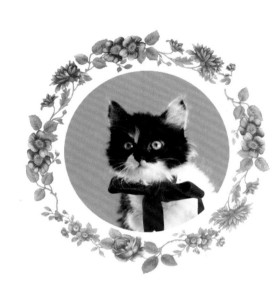

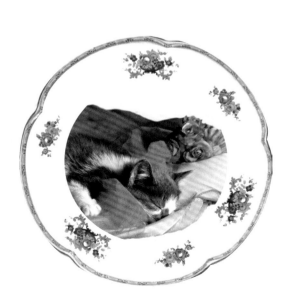

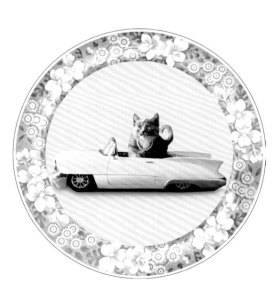

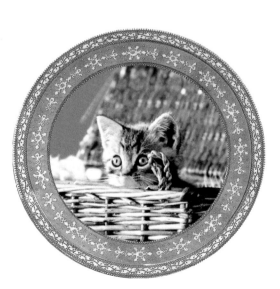

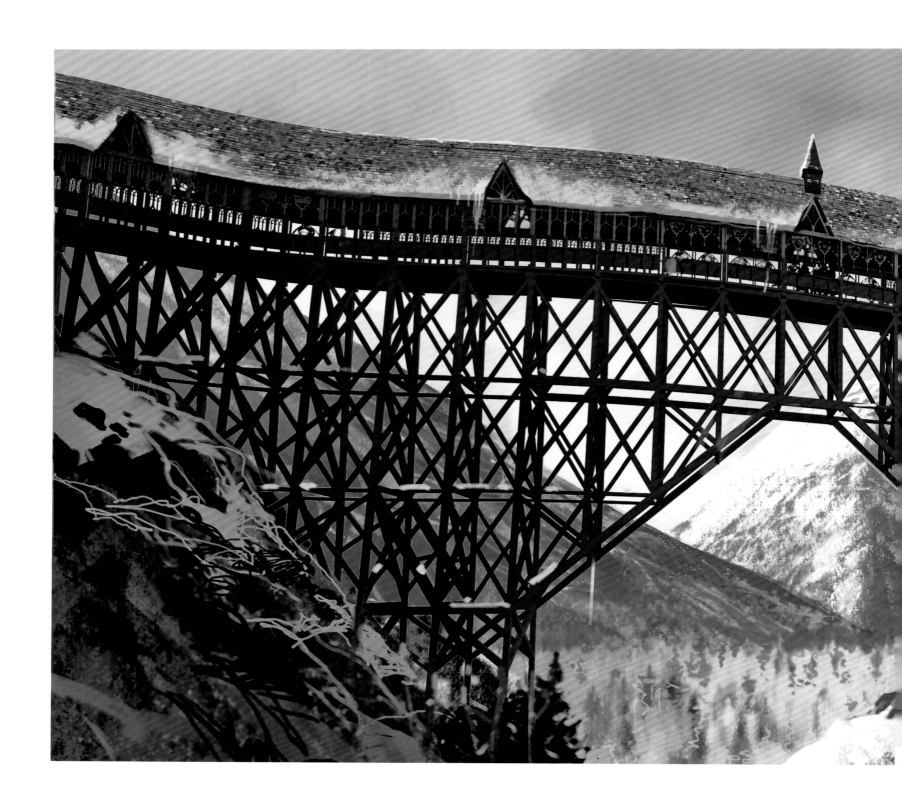

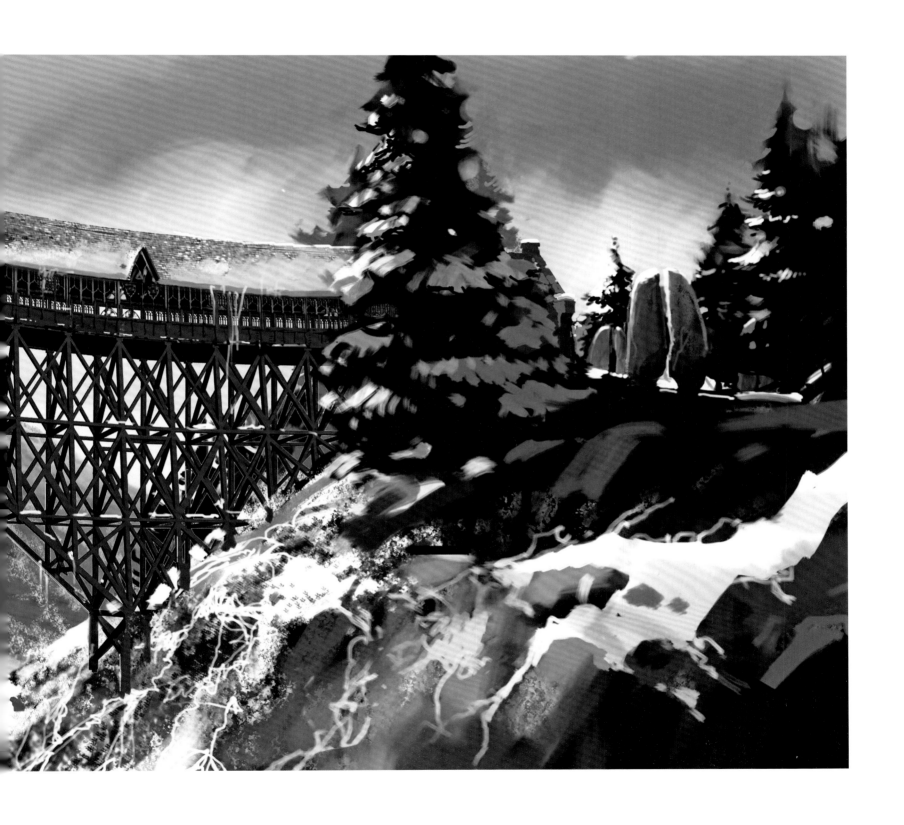

ABOVE: Painting by Andrew Williamson of the covered bridge, and, to the right, the Stone Circle, during wintertime in *Harry Potter and the Order of the Phoenix*.

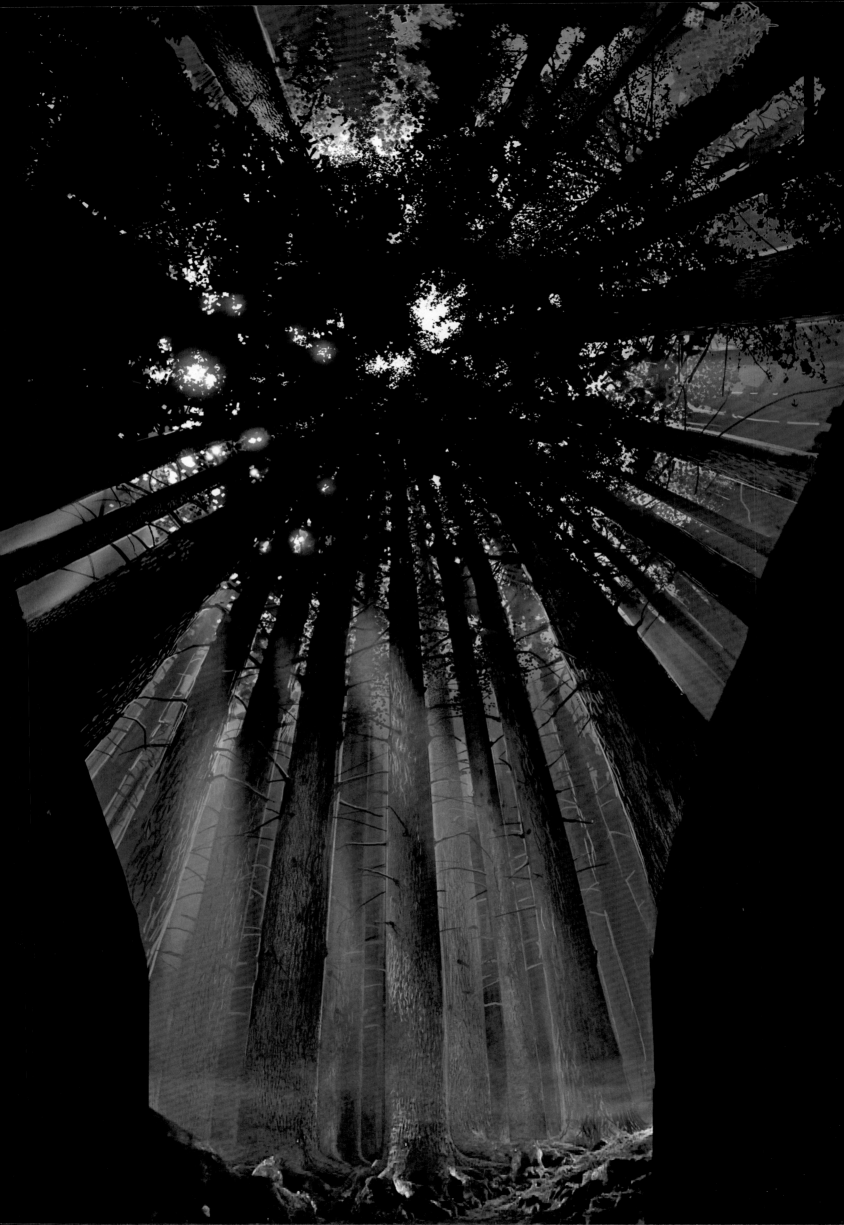

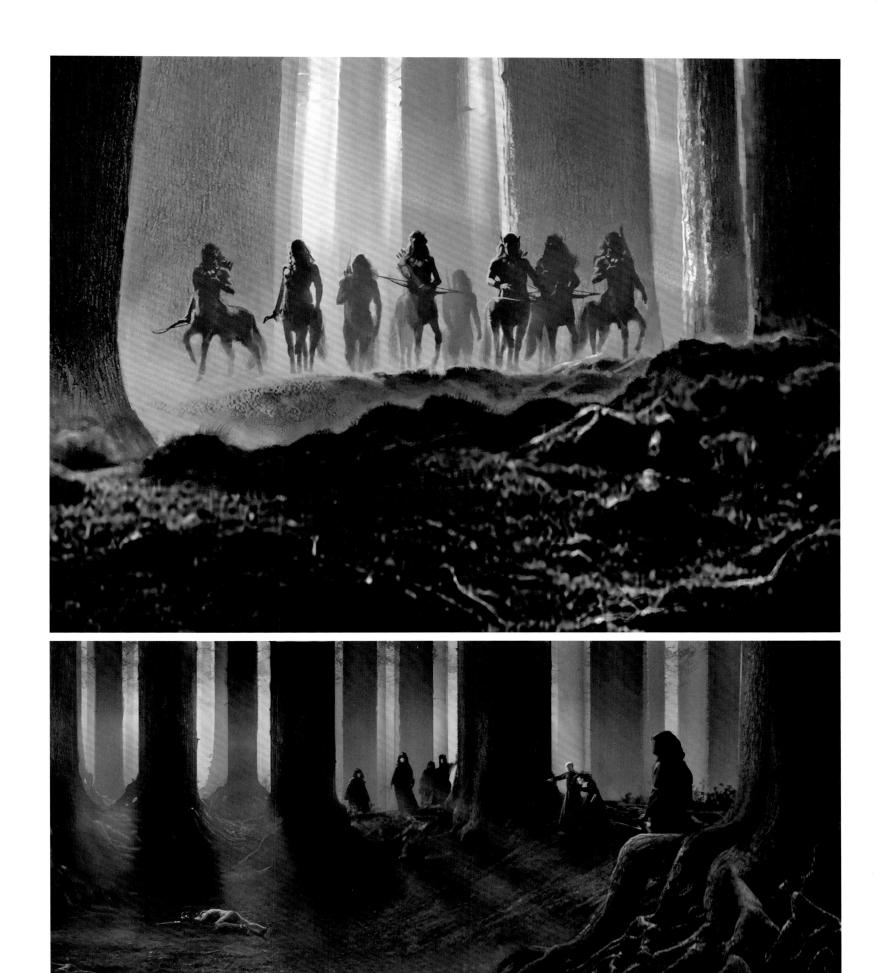

OPPOSITE: A view upward to the canopy of the Forbidden Forest by Andrew Williamson for *Harry Potter and the Order of the Phoenix* showcases shadows and beams of light.

TOP: Centaurs amass in the Forbidden Forest in *Harry Potter and the Order of the Phoenix*, by Andrew Williamson.

ABOVE: Voldemort and his Death Eaters surround Harry's fallen body in *Harry Potter and the Deathly Hallows – Part 2* after the Dark Lord casts the Killing Curse at him. Art by Andrew Williamson.

FOLLOWING PAGES: Adam Brockbank shows different views of Albus Dumbledore's burial near the Black Lake for *Harry Potter and the Half-Blood Prince*. The scene was not filmed for the movie.

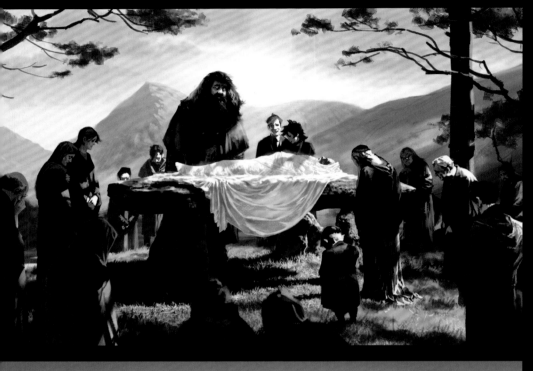
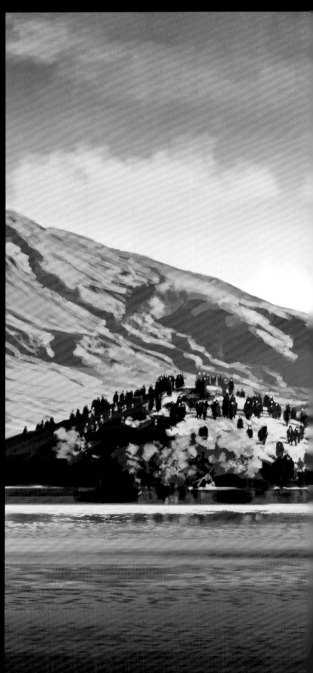
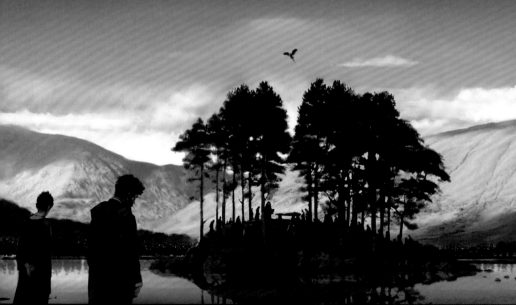

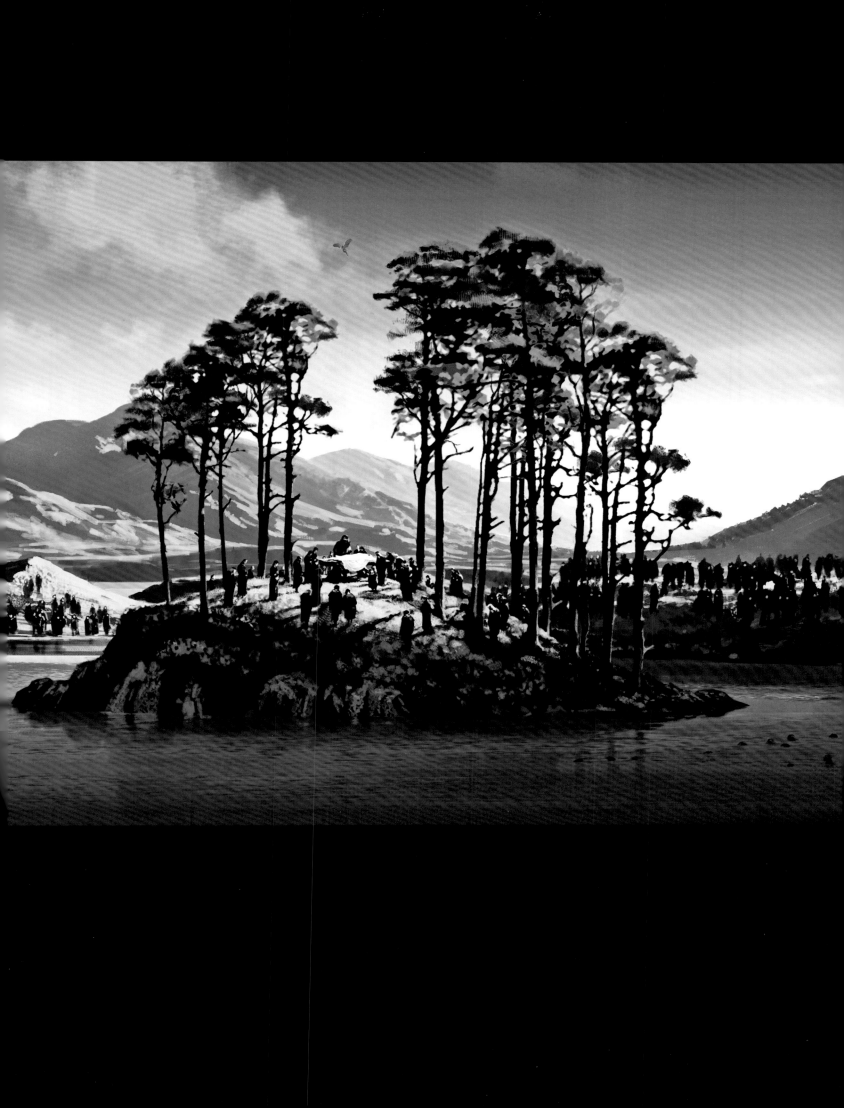

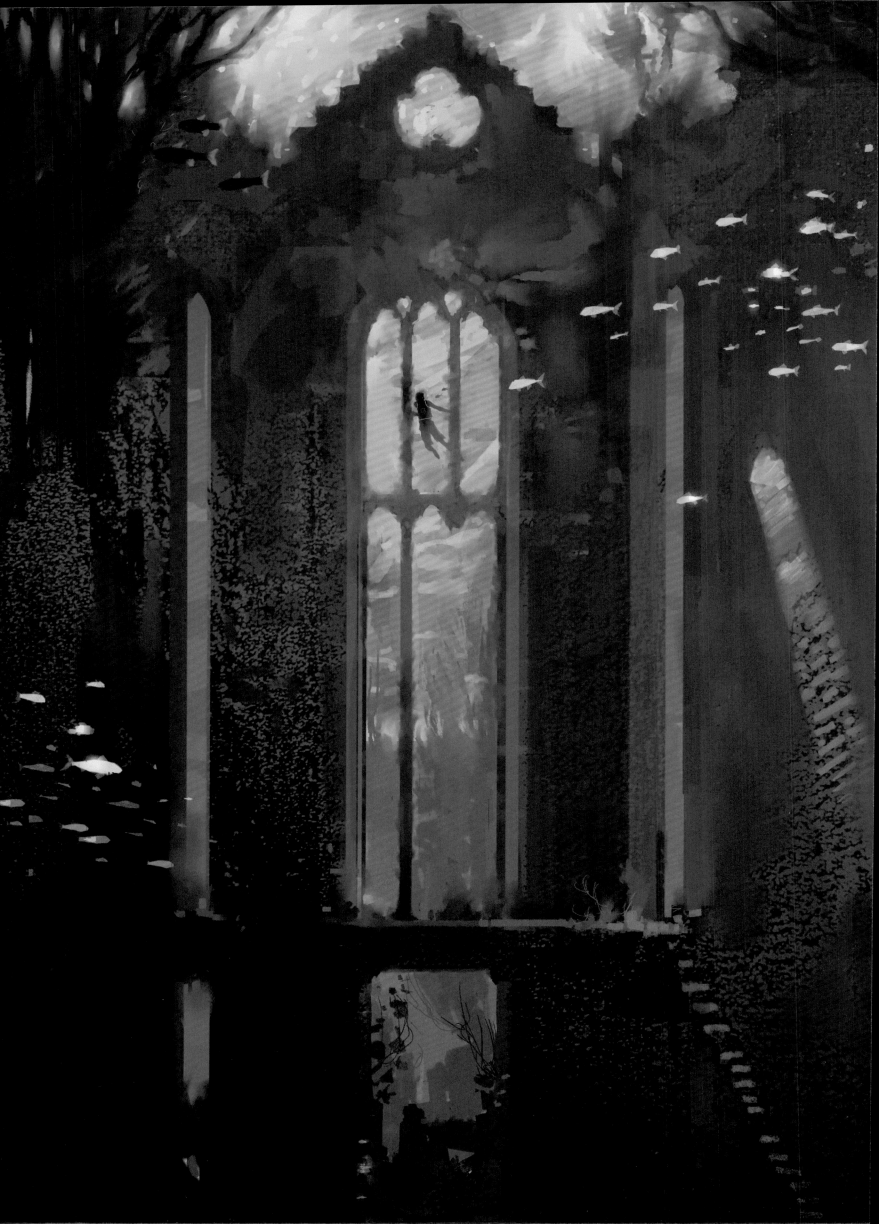

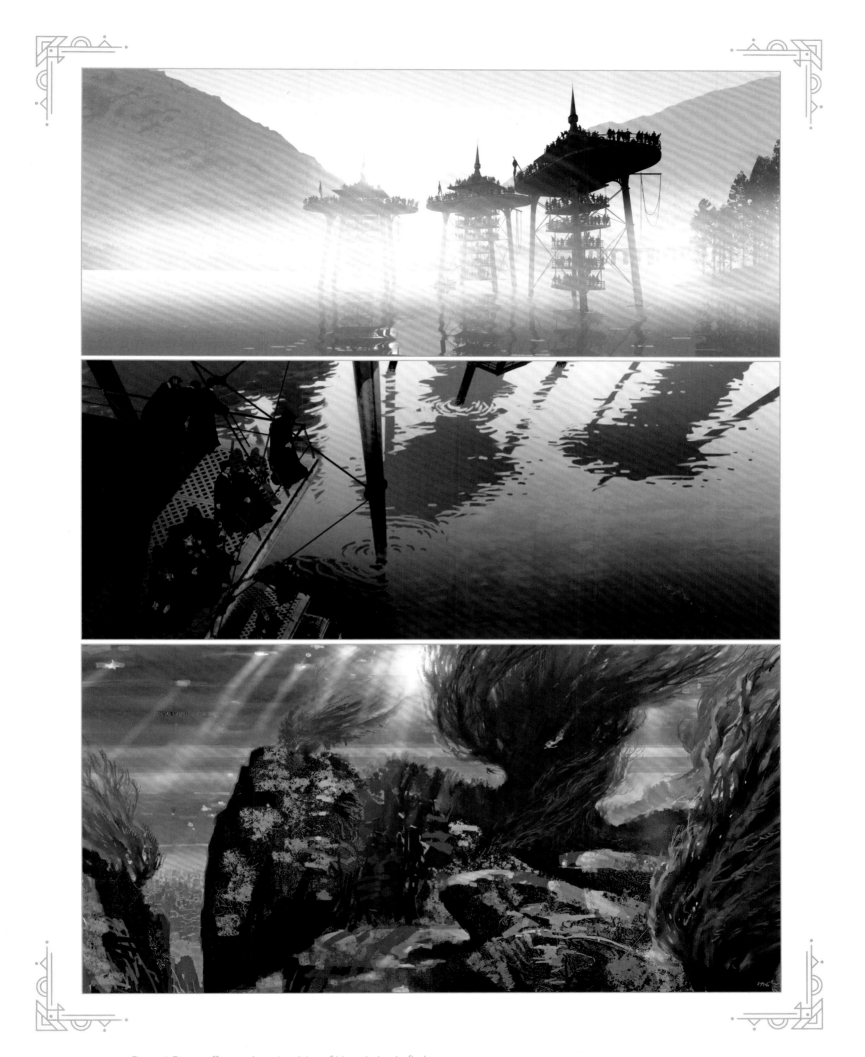

OPPOSITE AND ABOVE: Dermot Power offers underwater vistas of Harry trying to find what he needs to retrieve in order to win the second task.

TOP AND MIDDLE: Crowded viewing towers precariously balance above the Black Lake as viewers watch the second task of the Triwizard Tournament. Concept art by Andrew Williamson for *Harry Potter and the Goblet of Fire*.

FOLLOWING PAGES: Andrew Williamson's concept art of Harry swimming past ruins and kelp during the second task.

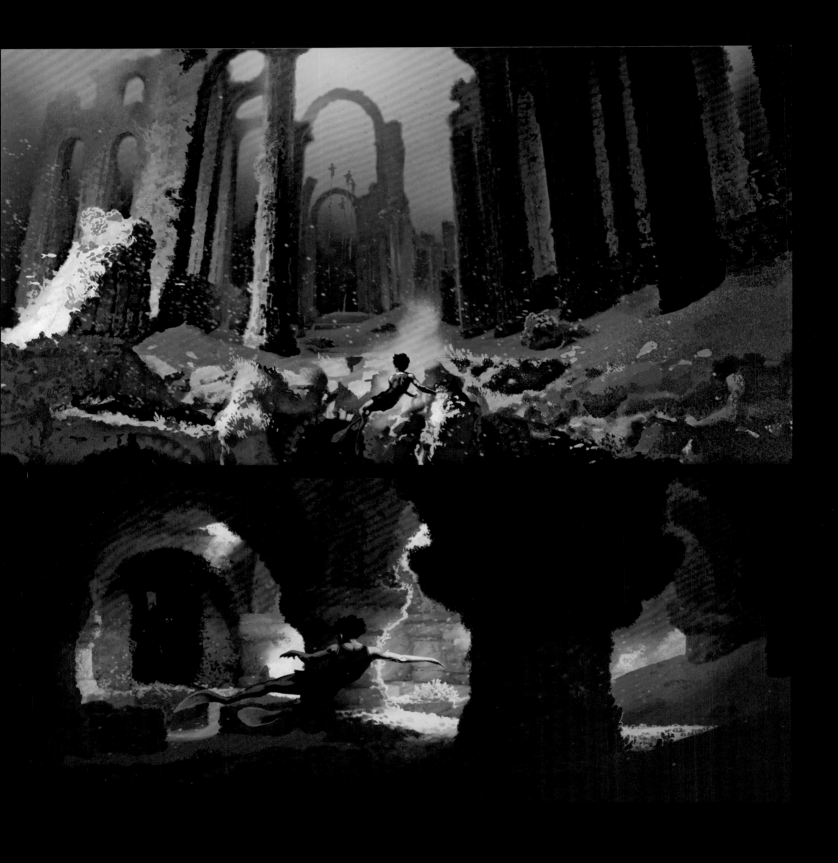

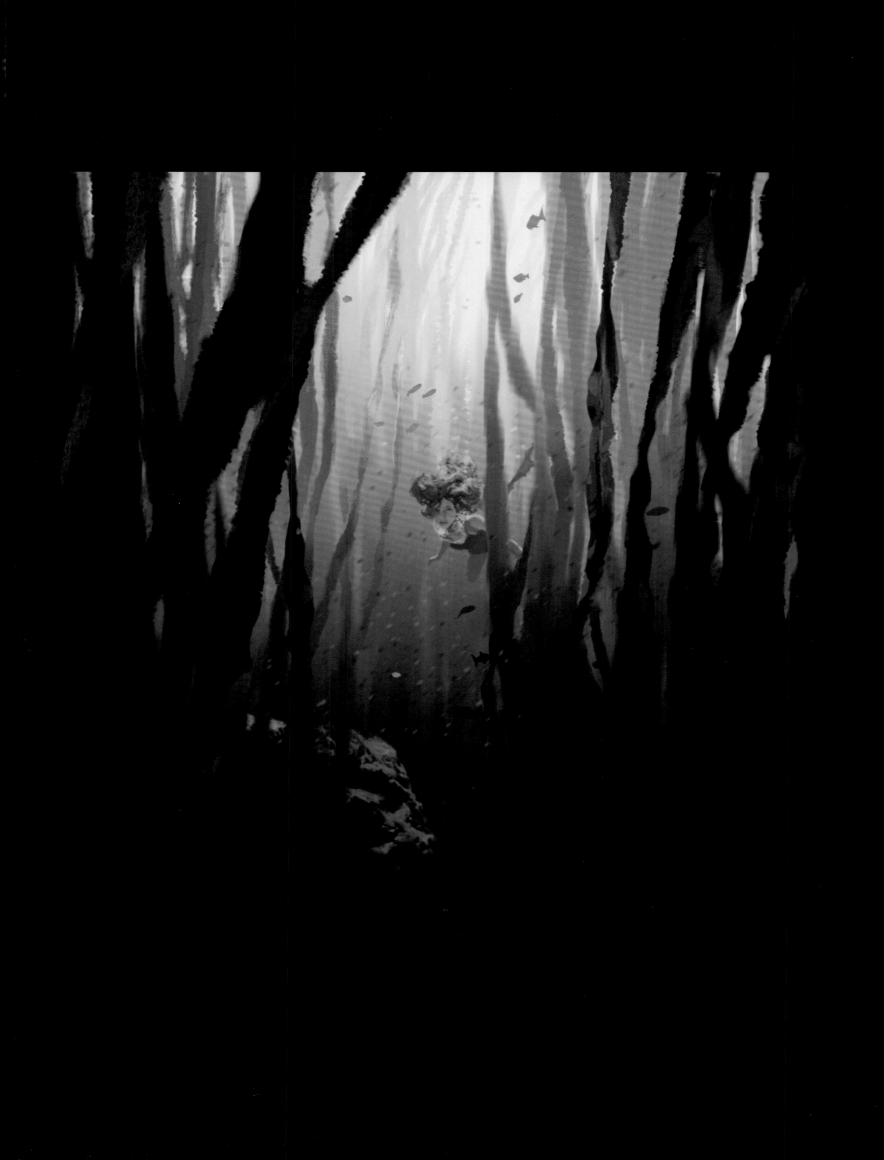

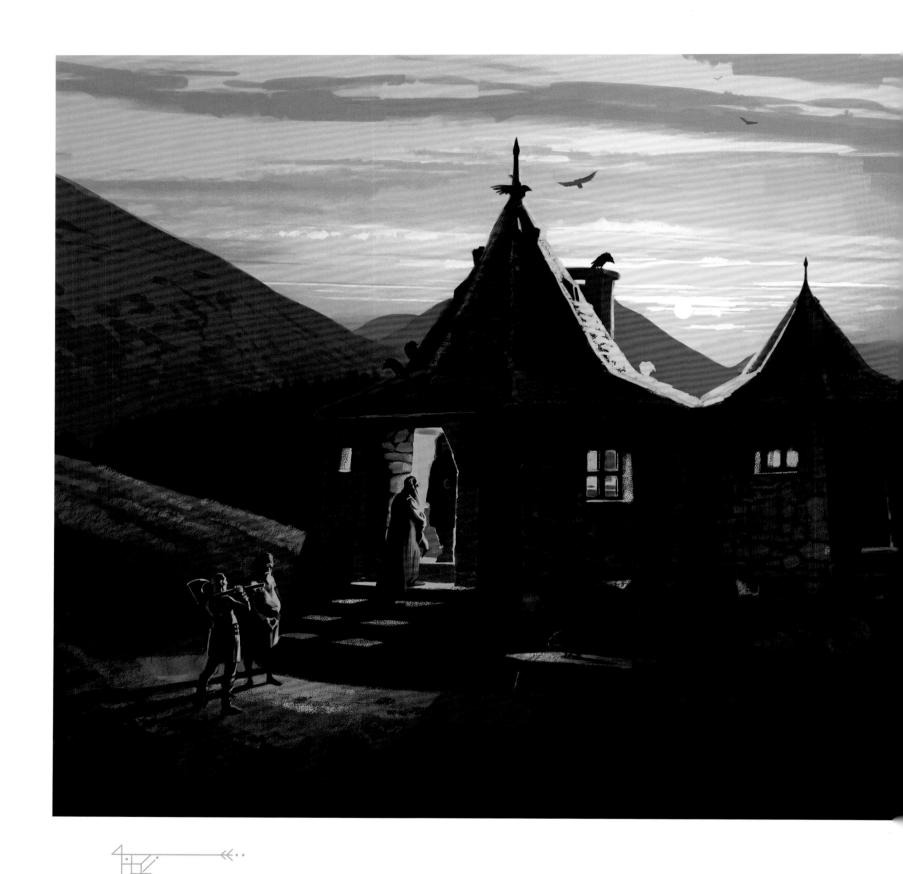

"Remember what Dumbledore said. If we succeed,
more than one innocent life could be spared."

–Hermione Granger, *Harry Potter and the Prisoner of Azkaban*

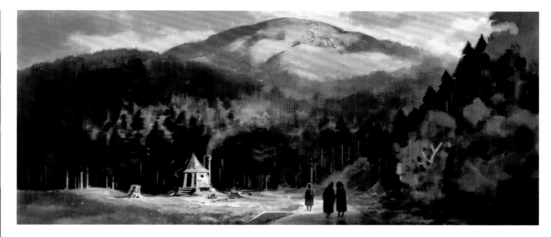

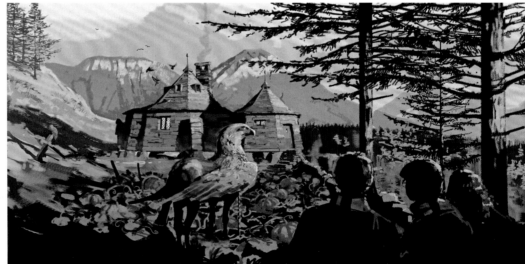

OPPOSITE: Dumbledore and the Minister for Magic pay an unwanted call on Hagrid in *Harry Potter and the Prisoner of Azkaban* as his doomed Hippogriff, Buckbeak, hides in the pumpkin patch. Concept art by Adam Brockbank.

TOP: Harry, Ron, and Hermione visit Hagrid's hut many times throughout the films. Concept art by Adam Brockbank for *Harry Potter and the Chamber of Secrets*.

MIDDLE AND ABOVE: The hut acquired a second room in *Harry Potter and the Prisoner of Azkaban*, as sketched by Andrew Williamson, who also painted a view of Harry, Ron, and Hermione watching Buckbeak's fate being determined.

PAGE 68, TOP LEFT AND BOTTOM LEFT: Detailed views of the exterior and interior of the courtyard beside the Great Hall by Andrew Williamson for *Harry Potter and the Goblet of Fire*.

PAGE 69: A serene view of Hogwarts from the forest on the other side of the Black Lake by Dermot Power for *Harry Potter and the Chamber of Secrets*.

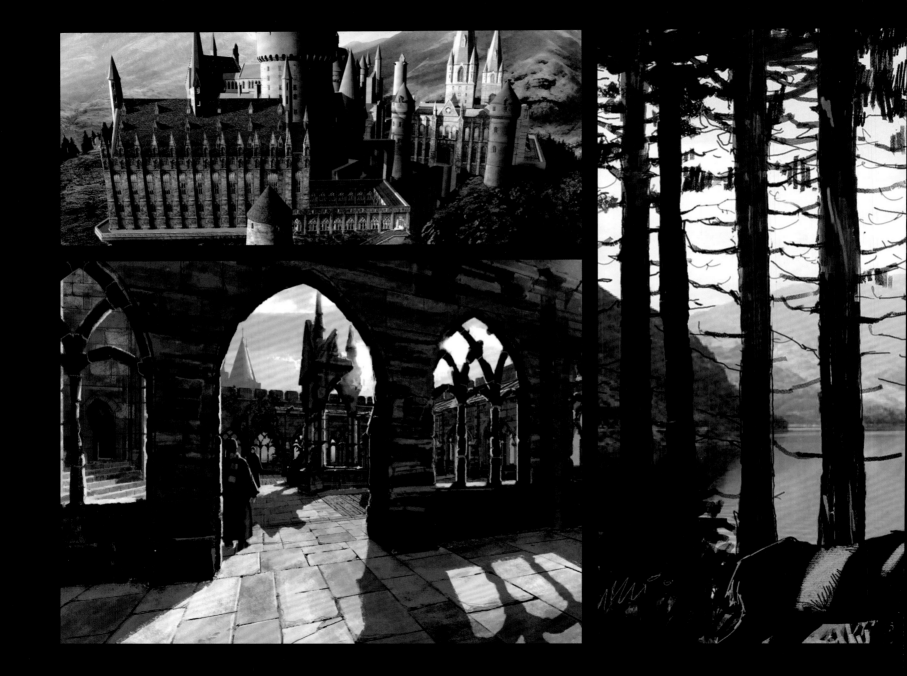

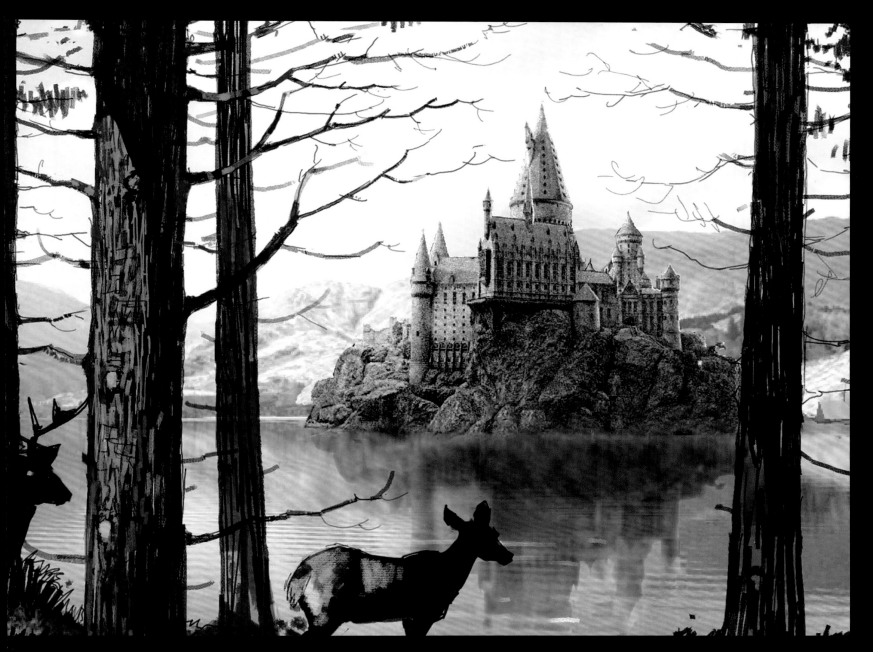

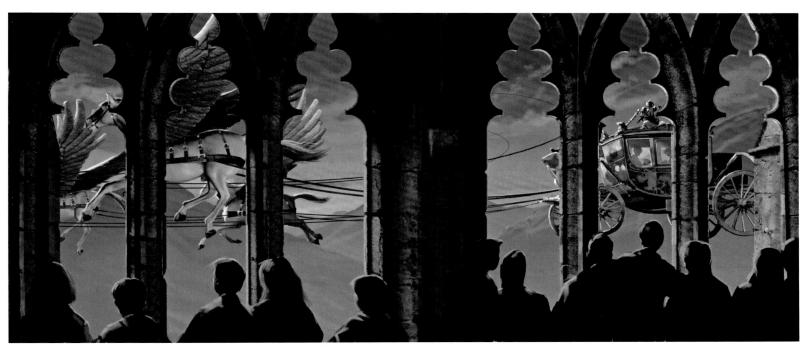

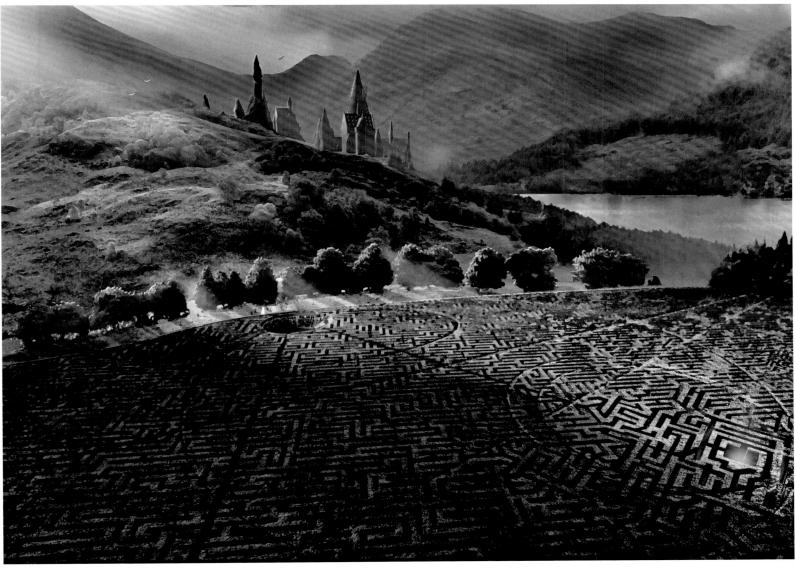

OPPOSITE: The Hogwarts Express steams through the Scottish Highlands toward Hogwarts castle. Art by Adam Brockbank for *Harry Potter and the Order of the Phoenix.*

TOP: Concept art of the arrival of the Beauxbatons Academy students by Andrew Williamson for *Harry Potter and the Goblet of Fire.*

ABOVE: Concept art of the maze for the third task of the Triwizard Tournament by Andrew Williamson for *Harry Potter and the Goblet of Fire.*

71

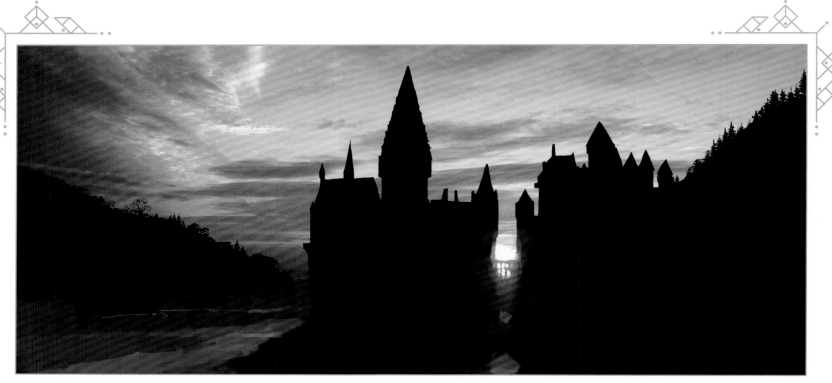

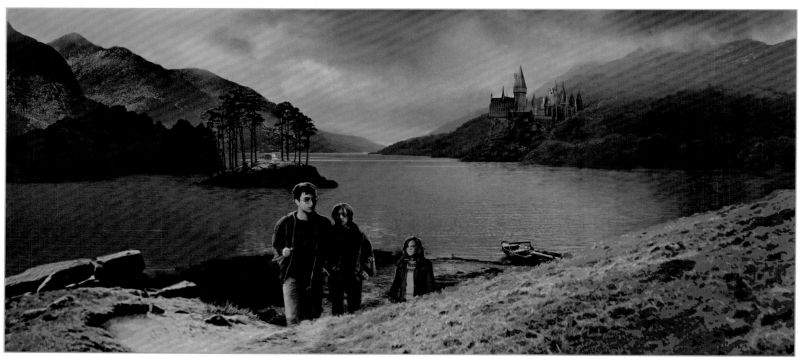

TOP: Hogwarts castle at sunset, by Dermot Power for *Harry Potter and the Chamber of Secrets.*

ABOVE: With the site of Dumbledore's burial behind them, Harry, Ron, and Hermione walk beside the lake in *Harry Potter and the Half-Blood Prince* in art created by Andrew Williamson. This scene did not appear in the film.

OPPOSITE: Andrew Williamson depicts the Hogwarts Express approaching the castle for *Harry Potter and the Half-Blood Prince.*

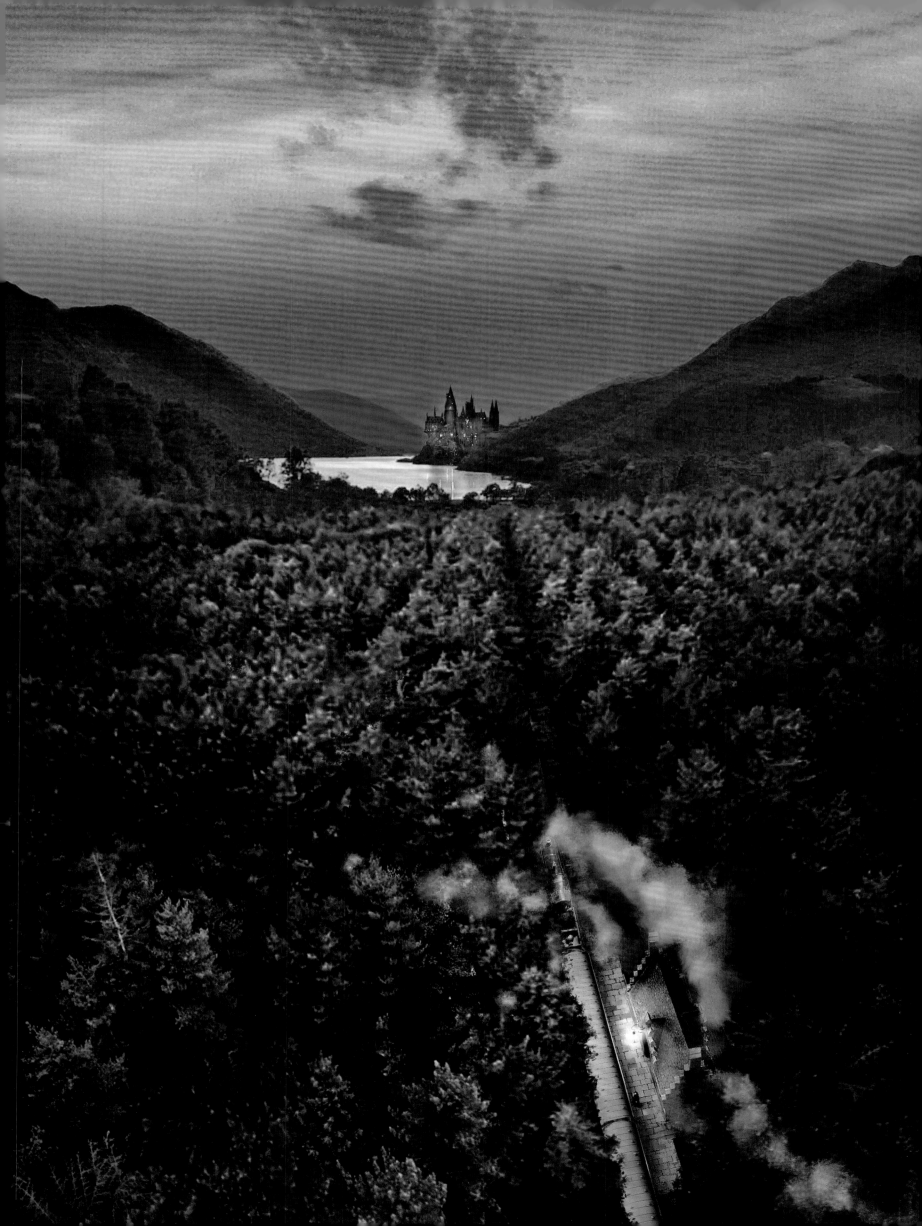

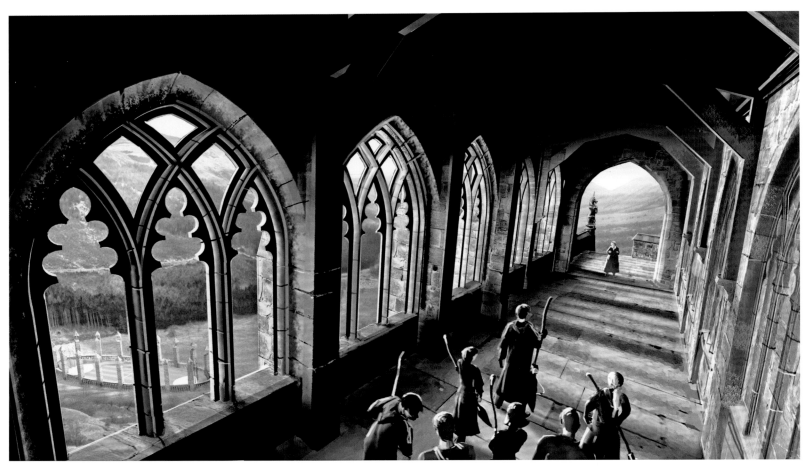

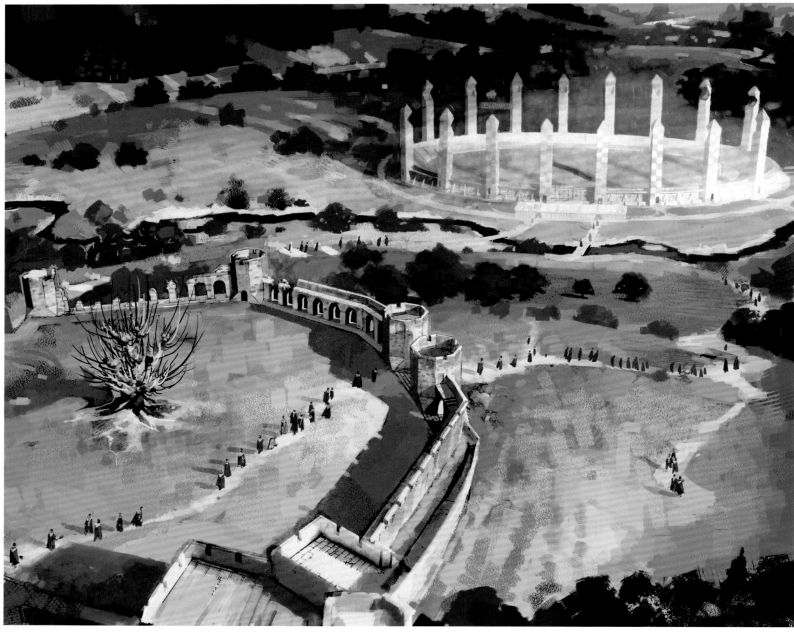

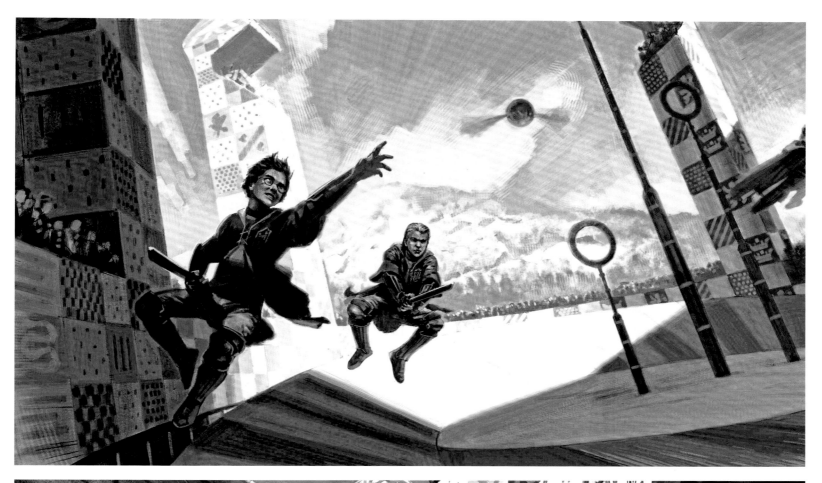

Quidditch, the favorite sport of wizards and witches, incited
thrilling rivalries between the houses of Hogwarts.

TOP LEFT: The Whomping Willow in winter by Adam Brockbank for *Harry Potter and the Prisoner of Azkaban.*

ABOVE: A sketch of the Whomping Willow by Rob Bliss.

OPPOSITE: The Whomping Willow moved to a different location for *Harry Potter and the Prisoner of Azkaban.* Art by Andrew Williamson.

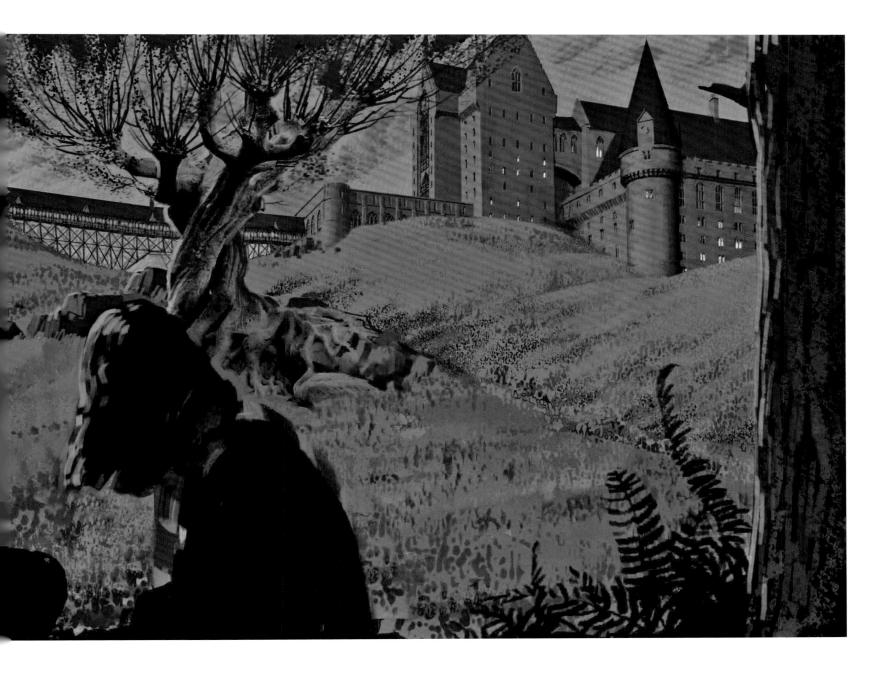

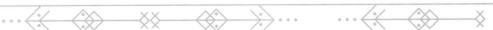

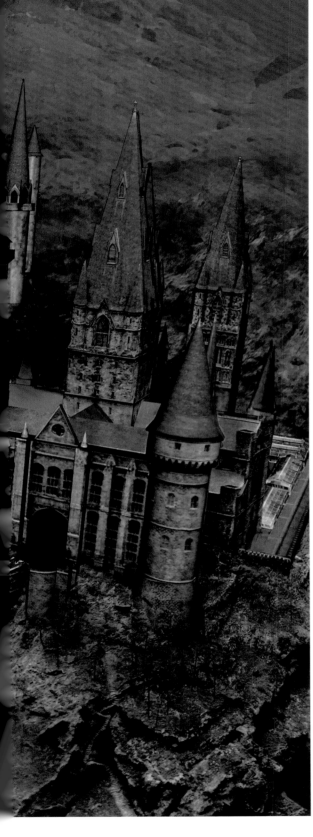

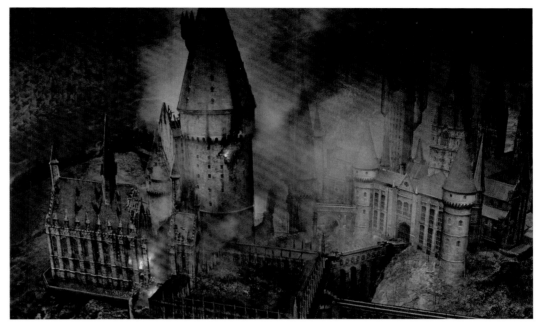

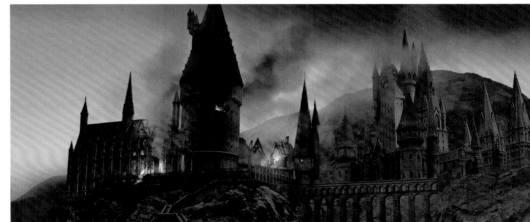

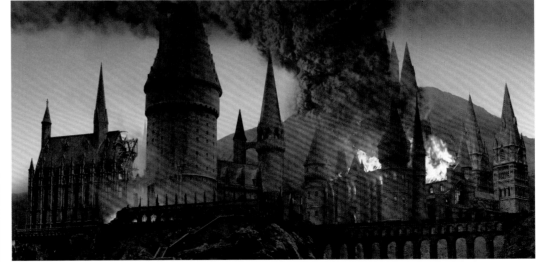

THESE PAGES: Andrew Williamson depicts Hogwarts castle as it burns during the Battle of Hogwarts in *Harry Potter and the Deathly Hallows – Part 2*.

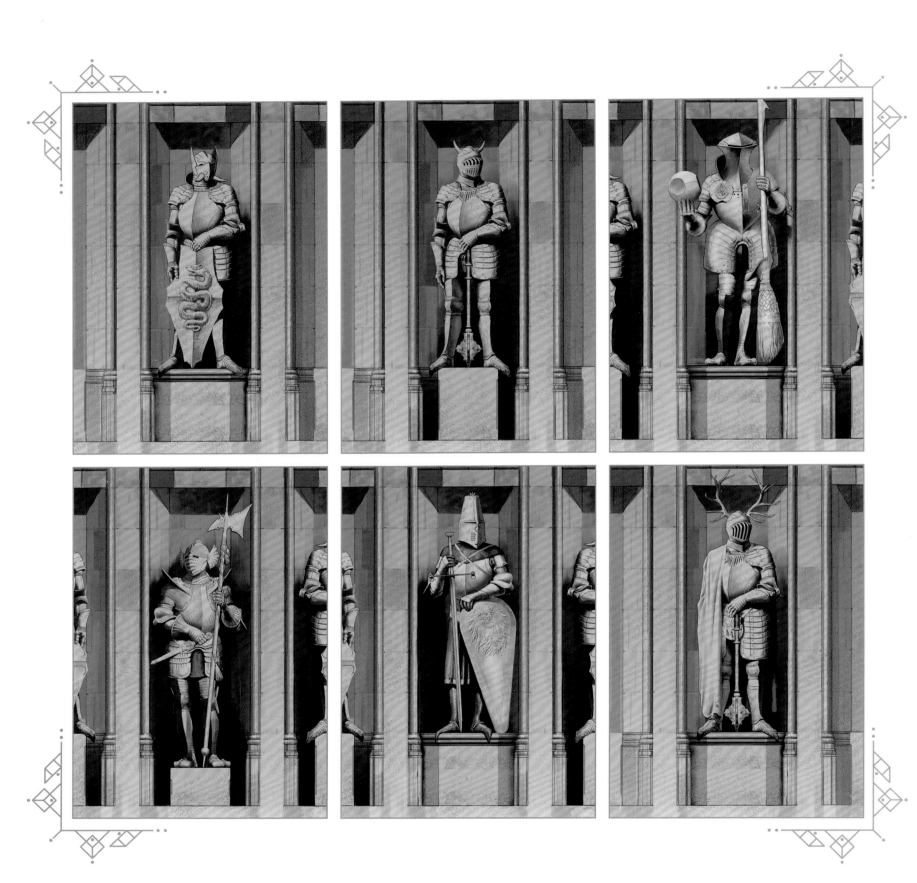

ABOVE: The fighting knights of Hogwarts castle, by Adam Brockbank. The knights are brought to life after Professor McGonagall casts the spell *Piertotum Locomotor* in *Harry Potter and the Deathly Hallows – Part 2*.

OPPOSITE: A sketch by Dermot Power of the statue of the architect of Hogwarts, which resides in front of the Great Hall, for *Harry Potter and the Chamber of Secrets*.

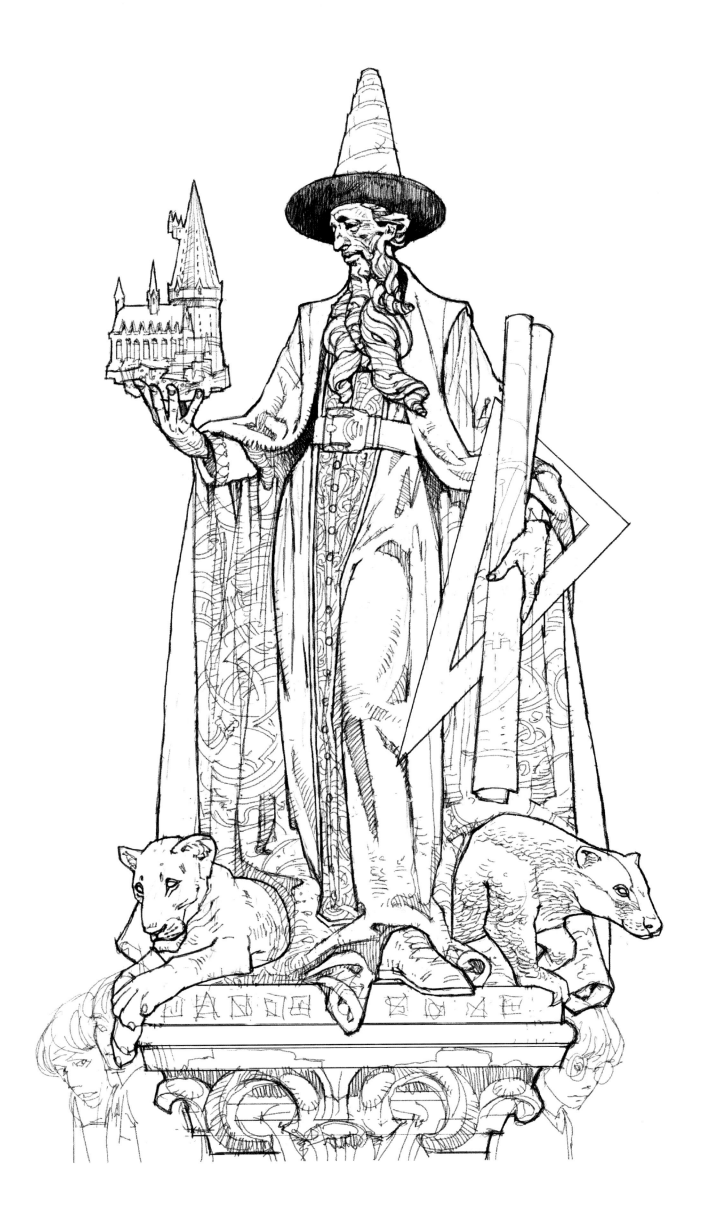

HOGSMEADE

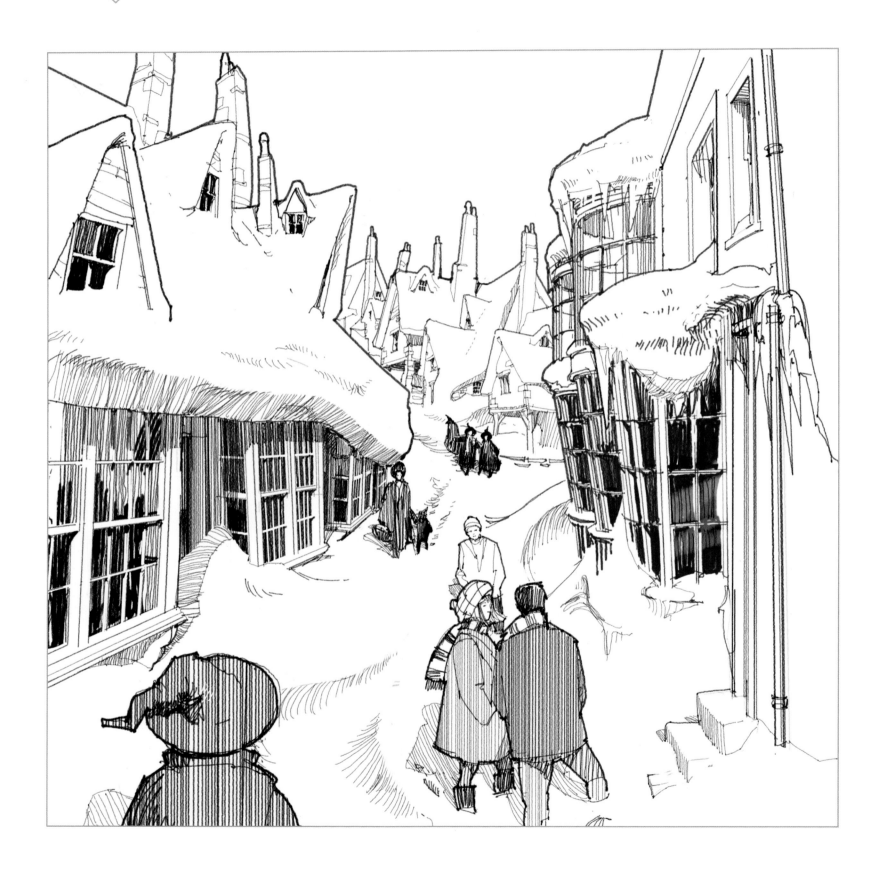

THESE PAGES: Harry and Hermione head to the Three Broomsticks pub in Hogsmeade, where they will meet Professor Slughorn in *Harry Potter and the Half-Blood Prince*, in black-and-white and color art by Andrew Williamson.

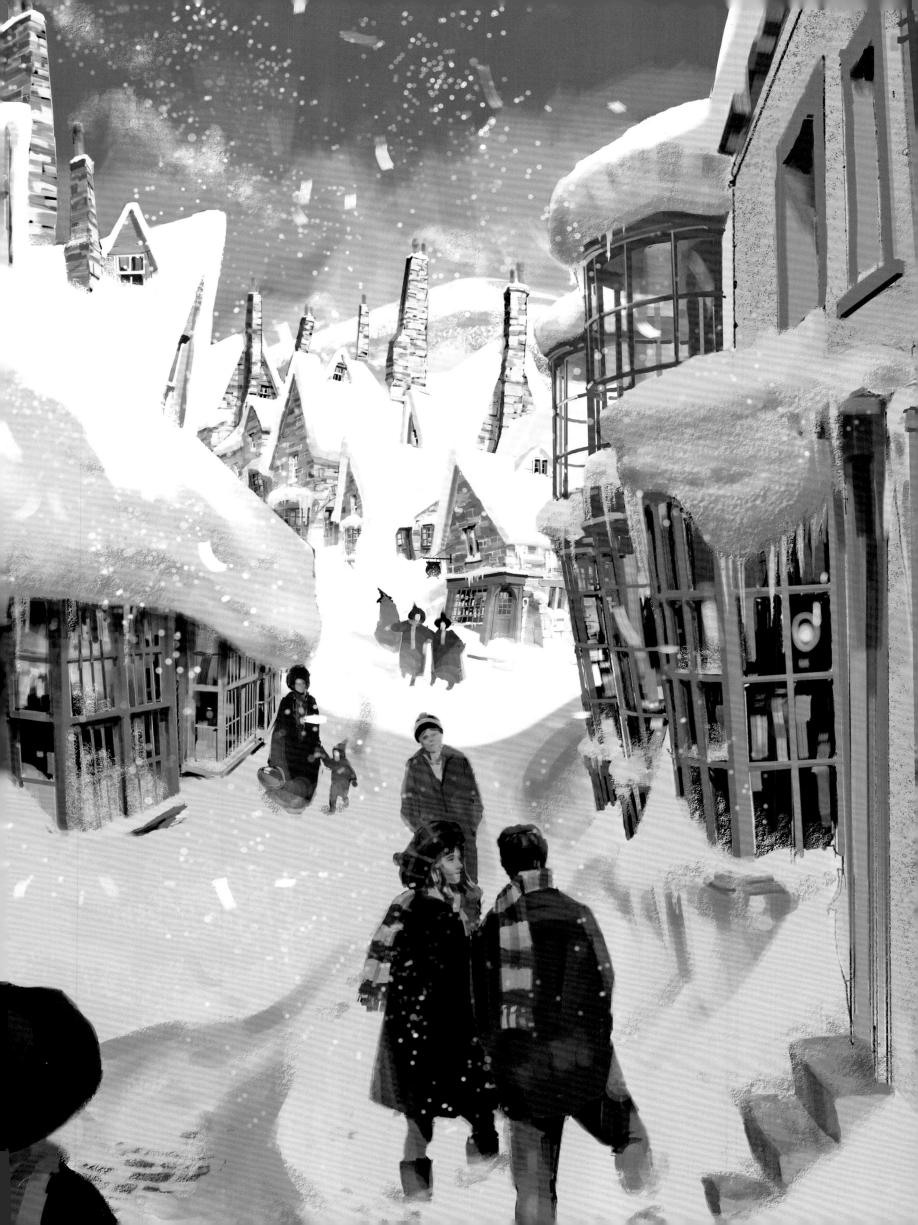

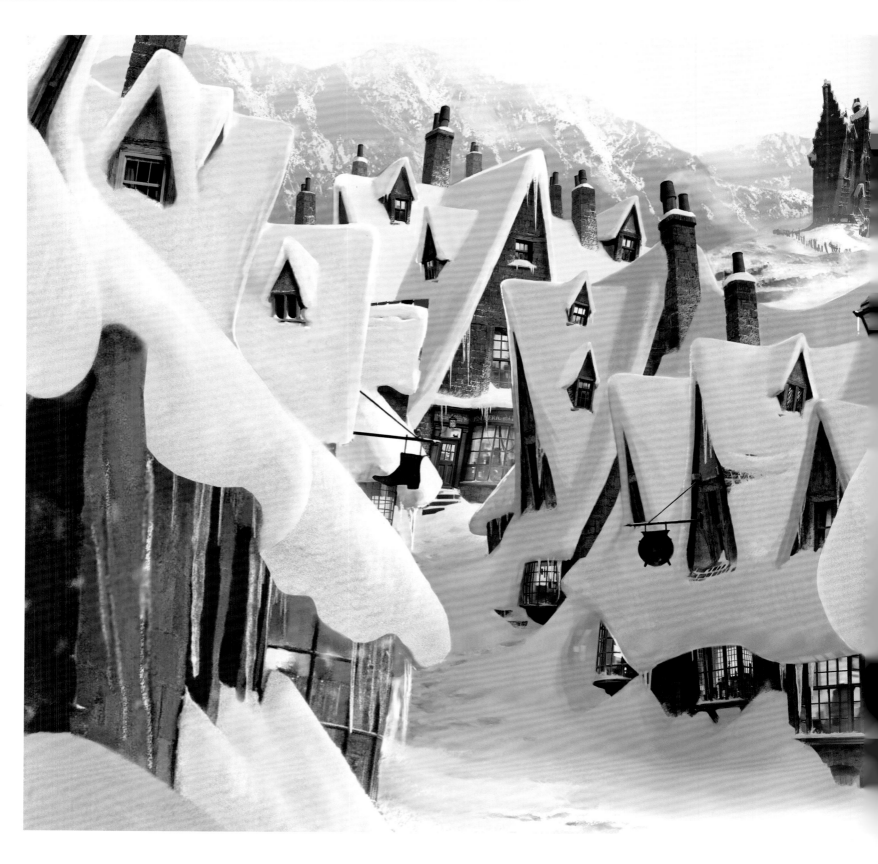

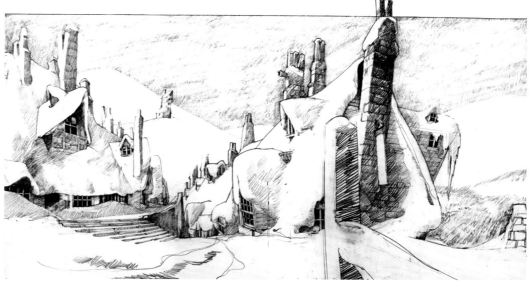

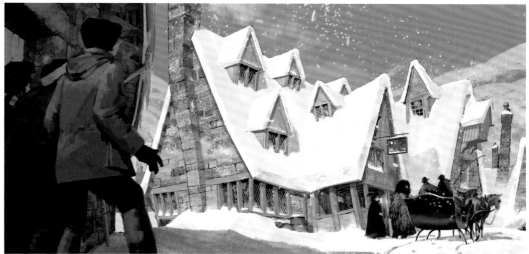

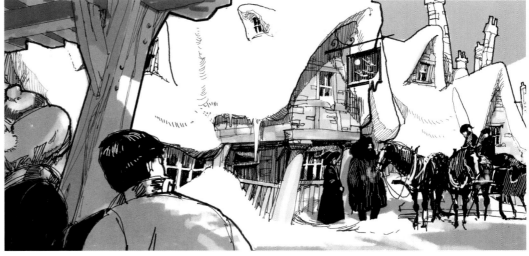

OPPOSITE: Hogsmeade is perpetually above the snow line, as painted by Andrew Williamson.

TOP: The first sketch of Hogsmeade by Stuart Craig, for *Harry Potter and the Prisoner of Azkaban*.

MIDDLE AND ABOVE: Harry, Ron, and Hermione watch Hagrid and Professor McGonagall go into the Three Broomsticks, sketched and painted by Andrew Williamson for *Harry Potter and the Prisoner of Azkaban*.

PAGE 86: Ron and Hermione walk toward the Shrieking Shack, the most haunted building in England, by Adam Brockbank for *Harry Potter and the Prisoner of Azkaban*.

PAGE 87: Harry, Ron, and Hermione about to enter the Hog's Head, where they will form Dumbledore's Army. Concept art by Andrew Williamson for *Harry Potter and the Order of the Phoenix*.

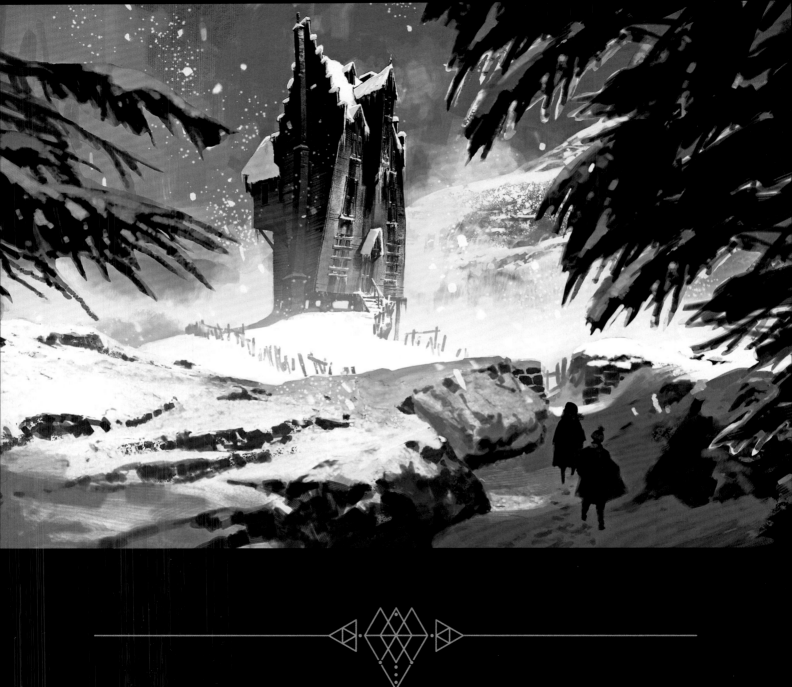

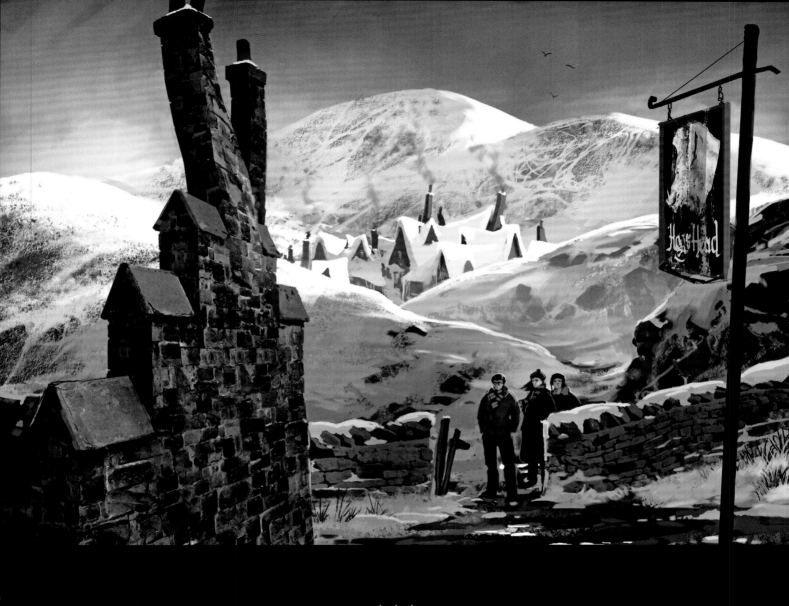

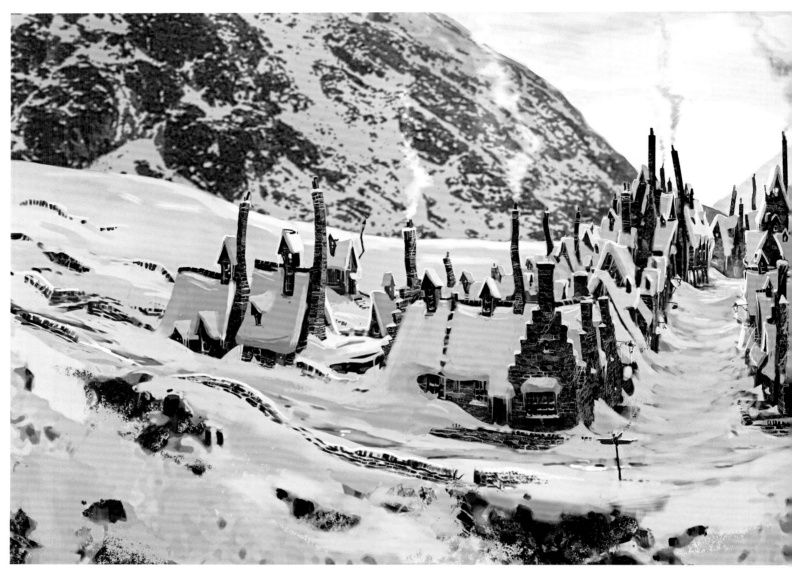

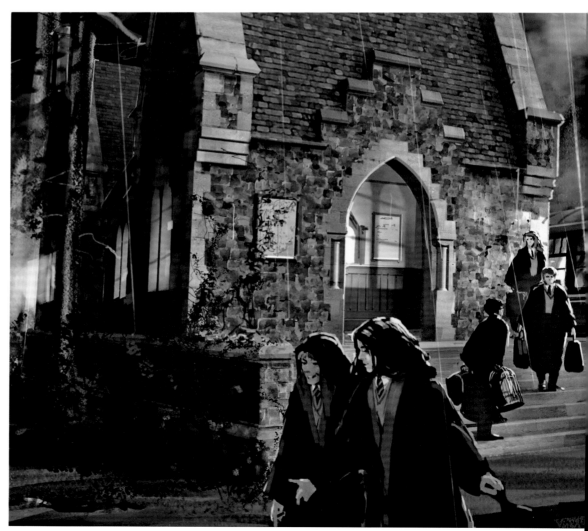

TOP: The wizarding village of Hogsmeade.

RIGHT: Students debark at Hogsmeade Station by Andrew Williamson for *Harry Potter and the Order of the Phoenix*.

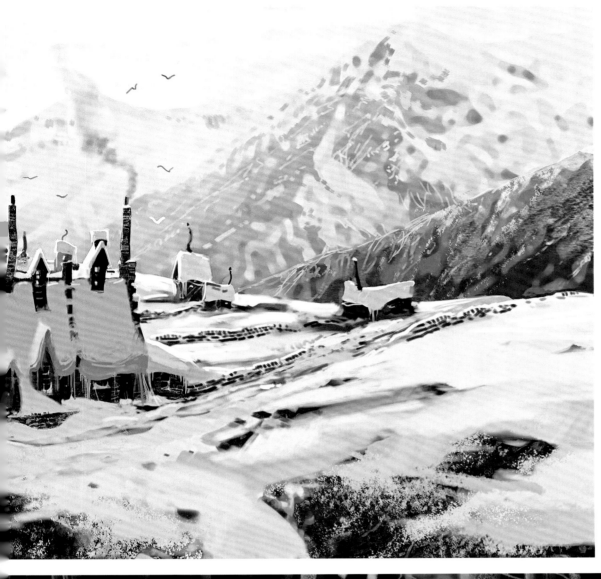

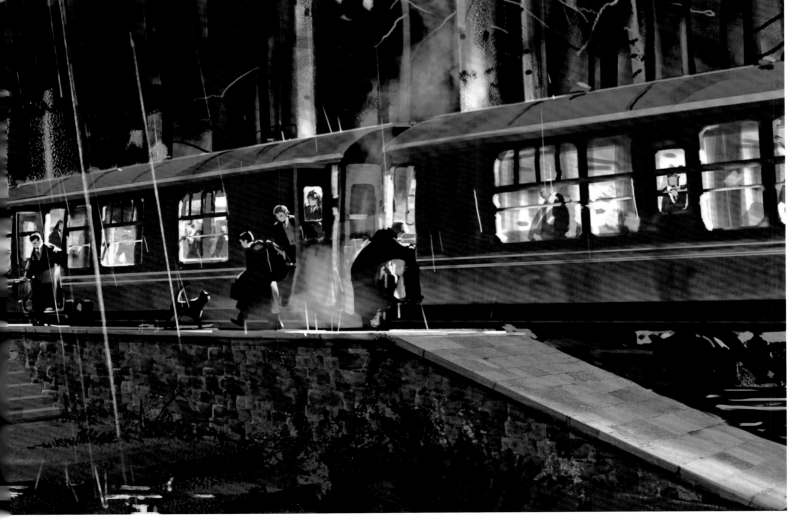

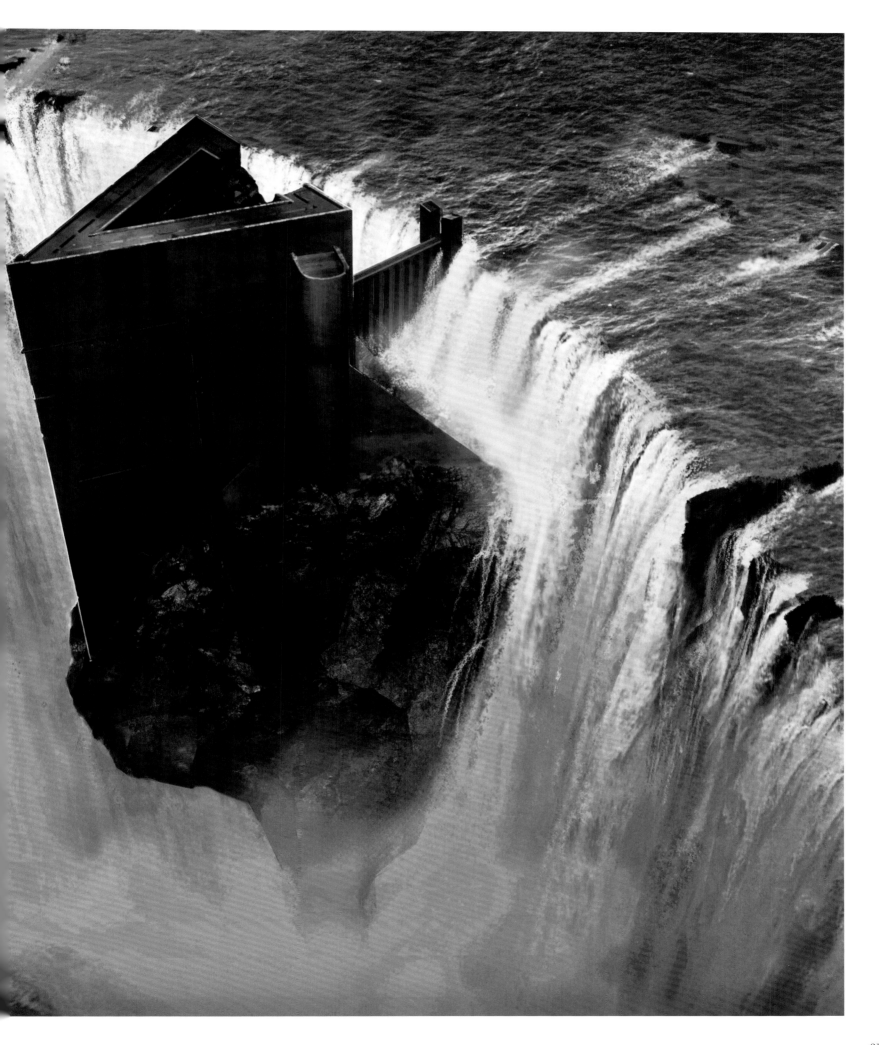

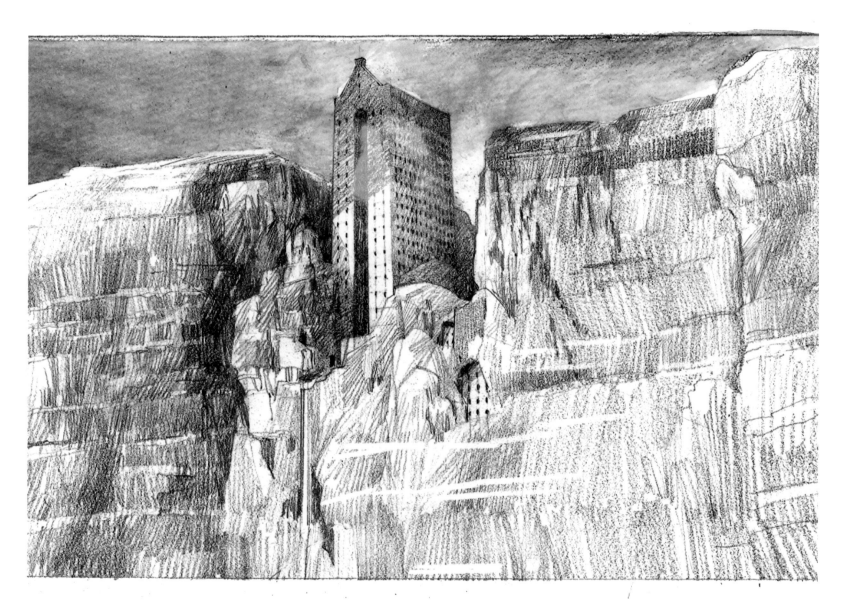

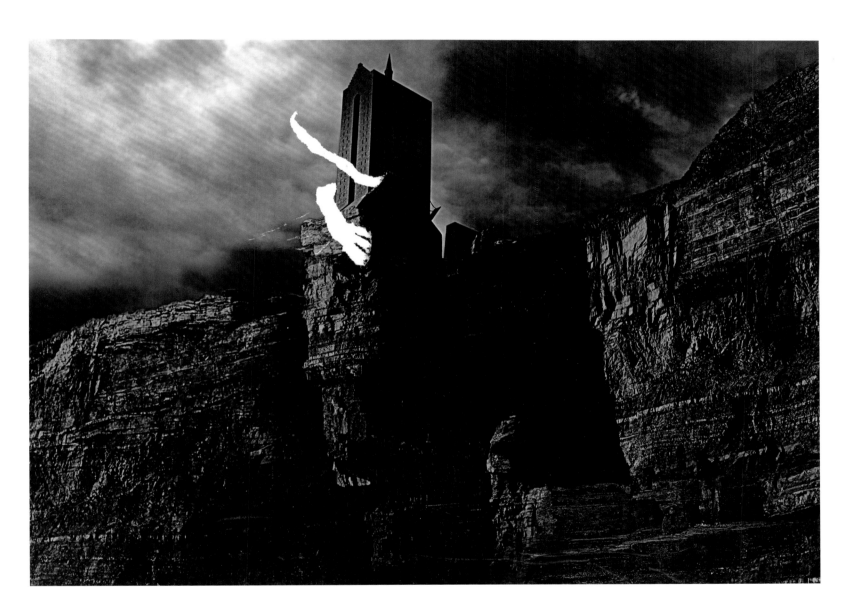

PAGE 90, TOP: The first sketch of Azkaban prison, by production designer Stuart Craig, for *Harry Potter and the Order of the Phoenix.*

PAGE 90, MIDDLE AND BOTTOM, AND PAGE 91: Andrew Williamson follows Craig's sketch, but the final setting for the prison was on an island in a stormy sea.

THESE PAGES: A sketch and painting of Nurmengard prison, where Gellert Grindelwald was imprisoned, and where Voldemort tortured him for information about the Elder Wand, as seen in *Harry Potter and the Deathly Hallows – Part 2.*

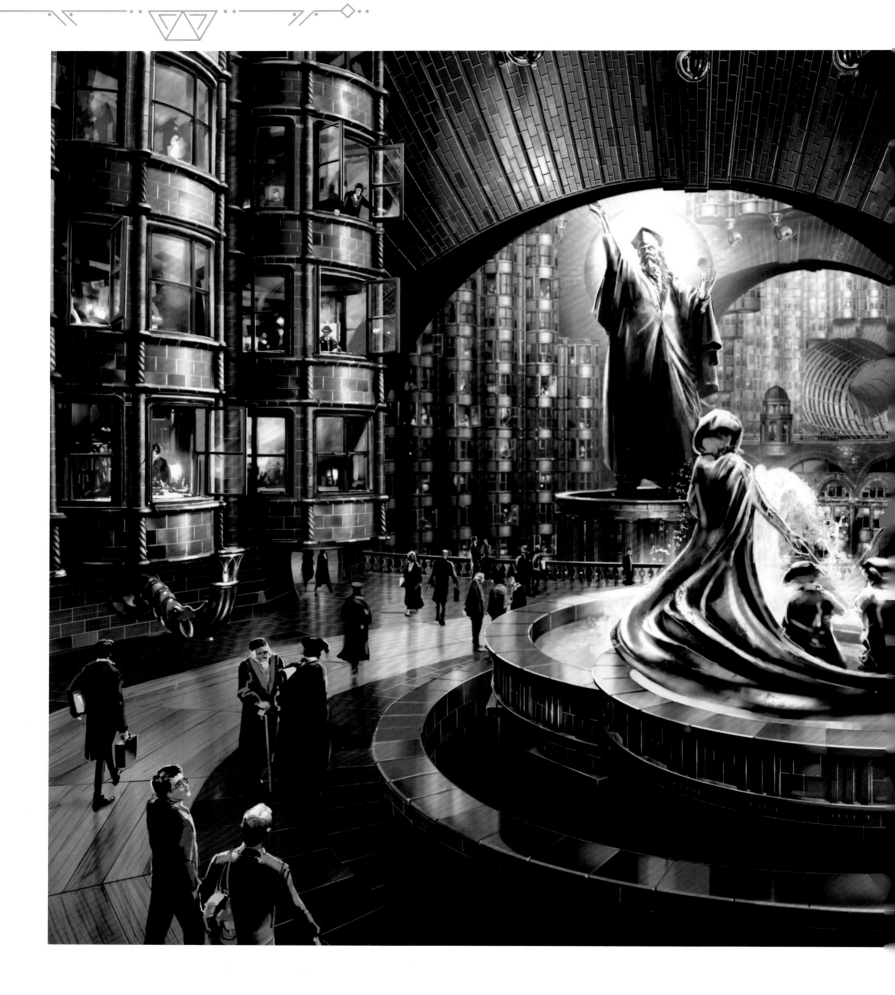

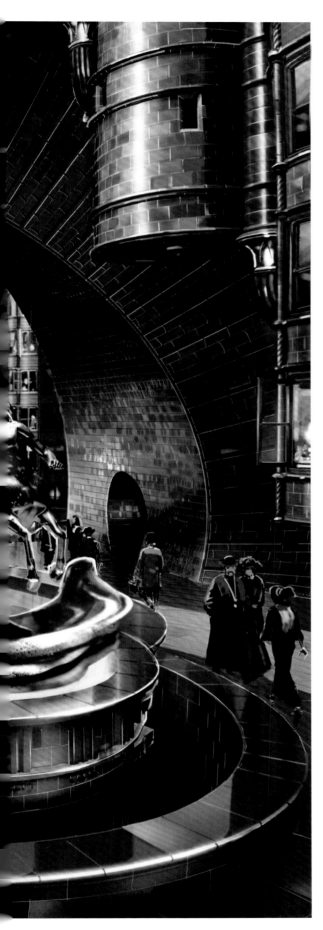

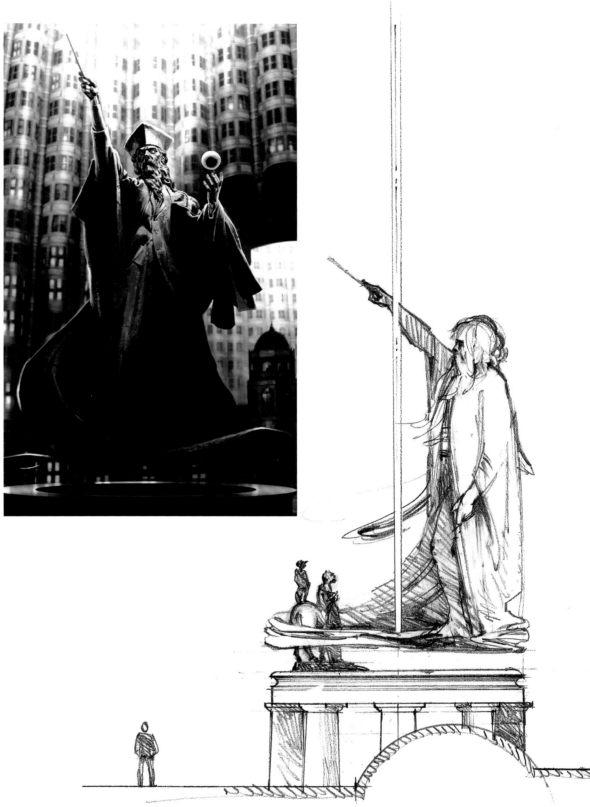

OPPOSITE: The Atrium of the Ministry of Magic, featuring the Fountain of the Magical Brethren, painted by Andrew Williamson as first seen in *Harry Potter and the Order of the Phoenix*.

TOP: A closer view of the Wizard, who floats above his pedestal here, by Adam Brockbank.

ABOVE: A side-view sketch of a possible Wizard statue.

FOLLOWING PAGES, CLOCKWISE FROM TOP LEFT: The Ministry of Magic courtroom, as first seen by Harry Potter in the Pensieve, illustrated by Andrew Williamson for *Harry Potter and the Goblet of Fire*; Harry finds himself on trial in *Harry Potter and the Order of the Phoenix*, by Andrew Williamson; Harry gets a closer view of the trial of the Death Eaters in *Harry Potter and the Goblet of Fire*, as painted by Andrew Williamson; a detailed view of an elevator in the Ministry of Magic by Adam Brockbank for *Harry Potter and the Order of the Phoenix*.

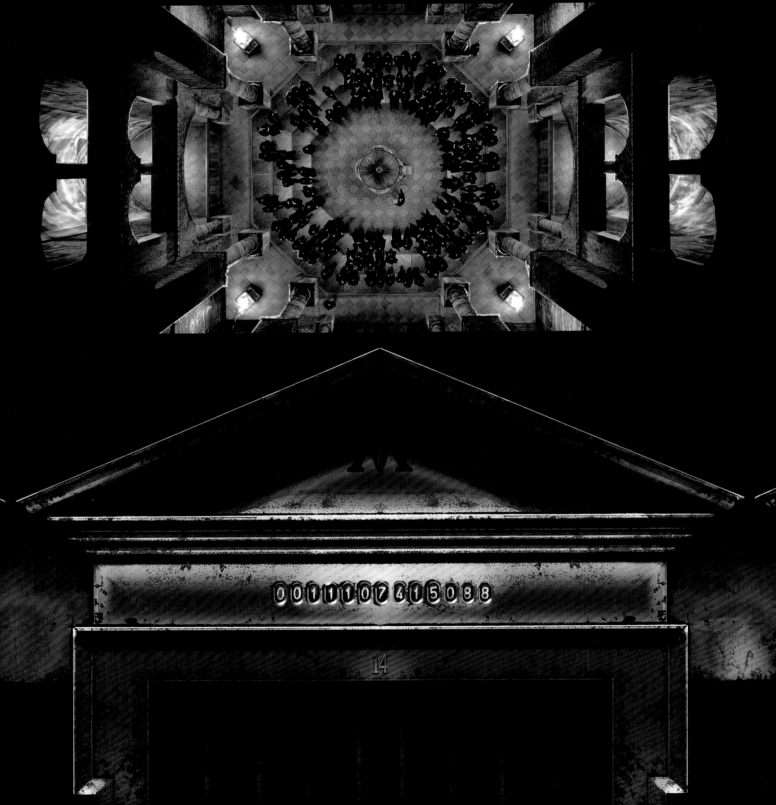

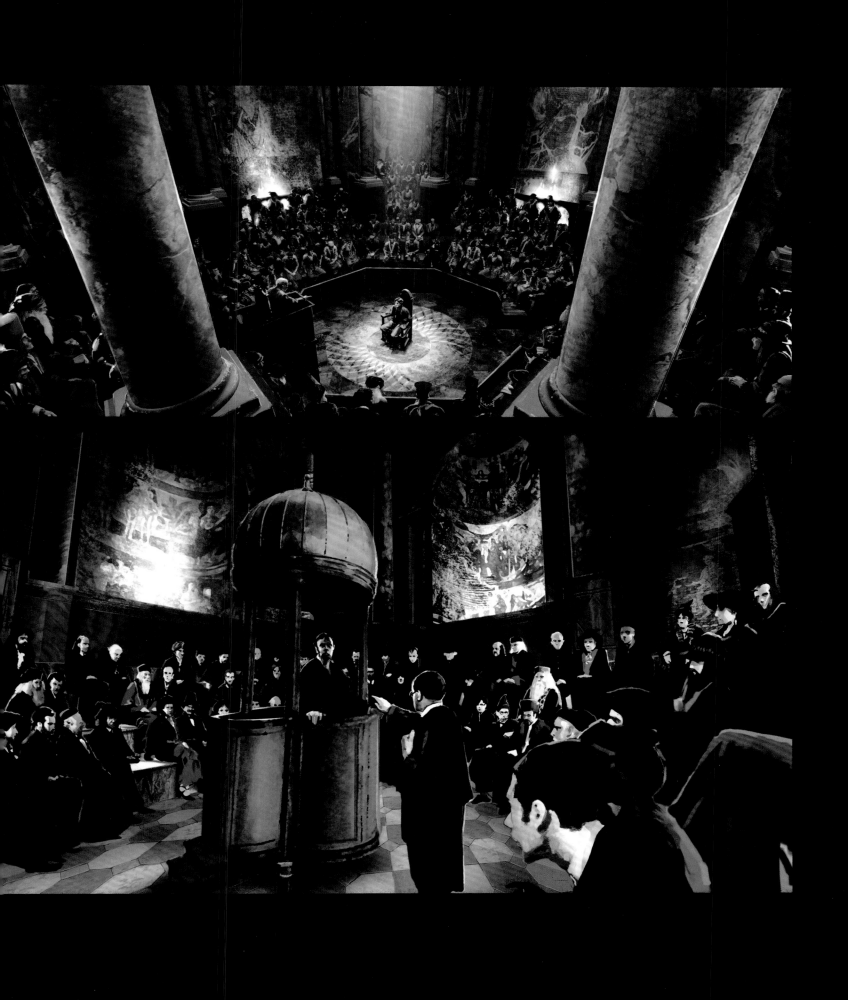

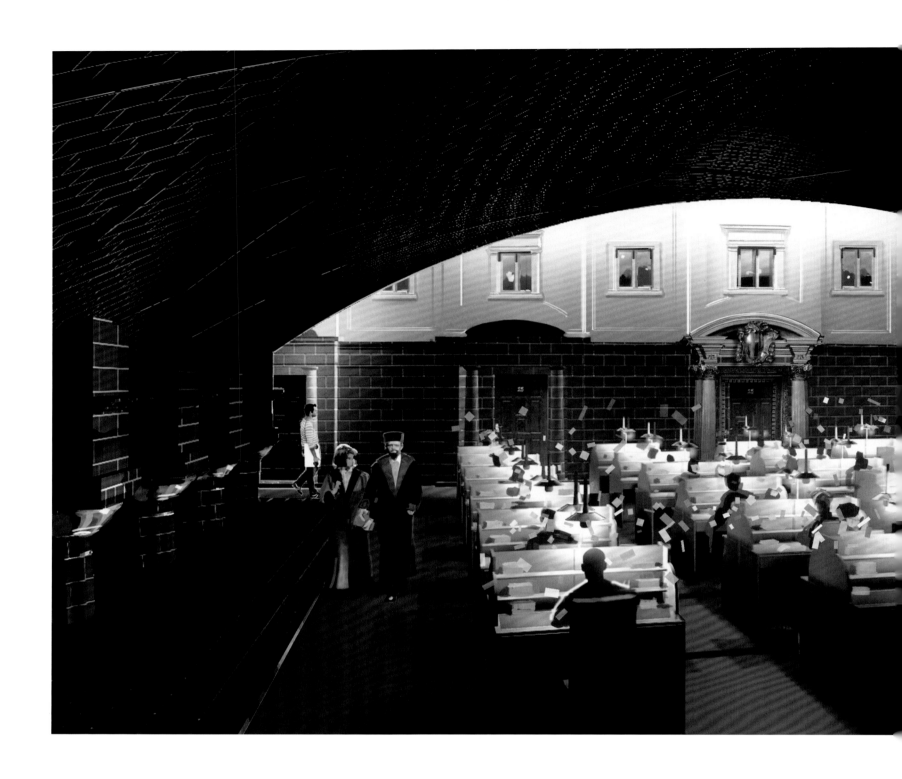

"Accio locket!"

—Harry Potter,
Harry Potter and the Deathly Hallows - Part 1

ABOVE: Office of the Muggle-born Registration
Commission, as supervised by Dolores Umbridge.
Concept art by Andrew Williamson for *Harry Potter
and the Deathly Hallows – Part 1*.

OPPOSITE BOTTOM: Umbridge's office at the Ministry
displays her familiar decorations of kitten plates
on pink walls in Andrew Williamson's depiction for
Harry Potter and the Deathly Hallows – Part 1.

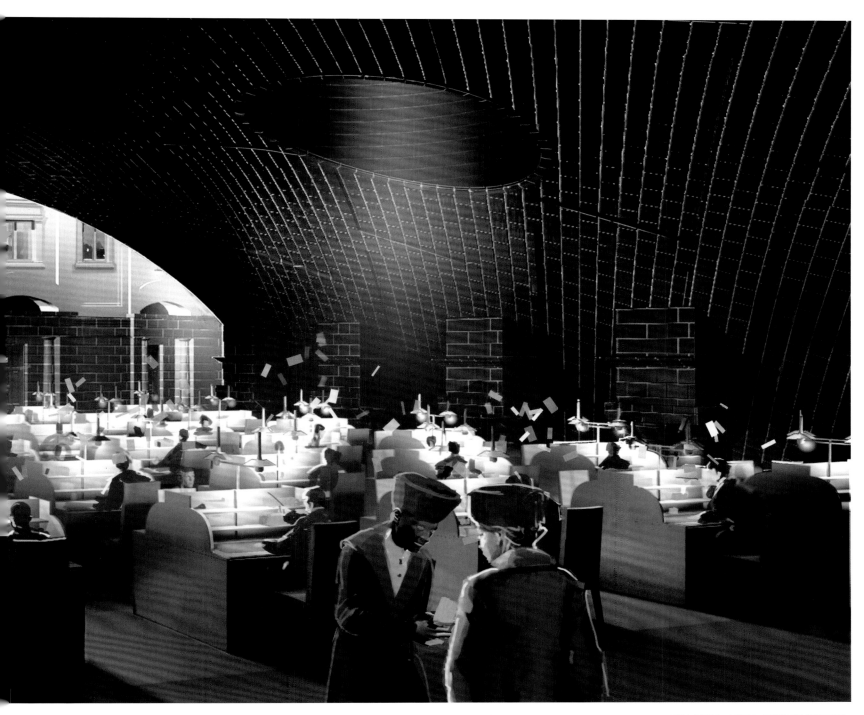

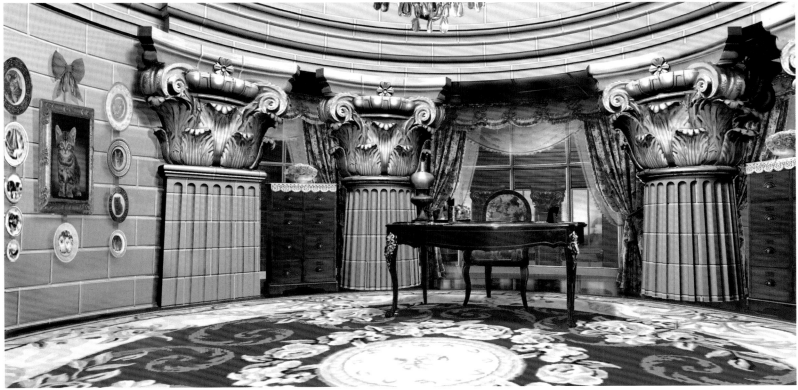

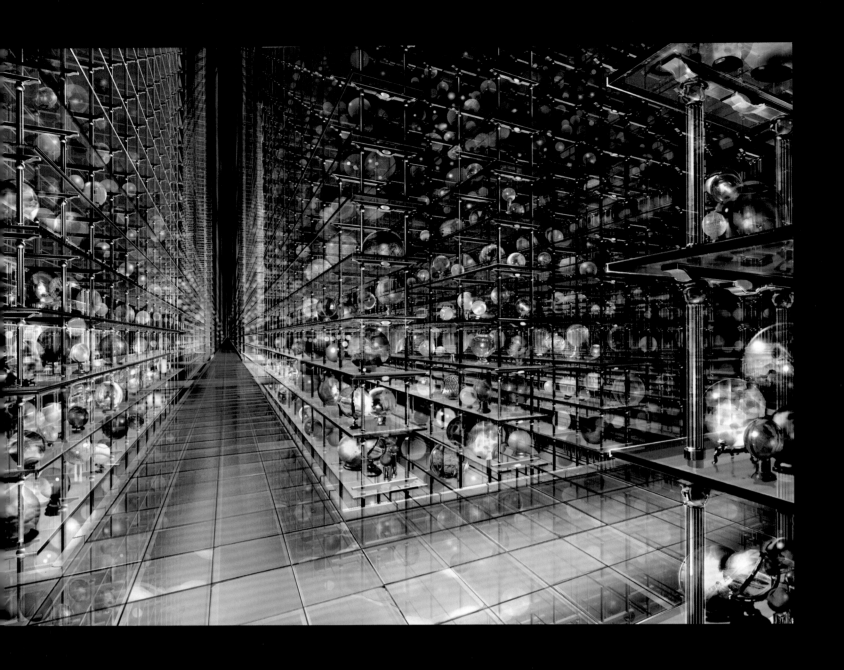

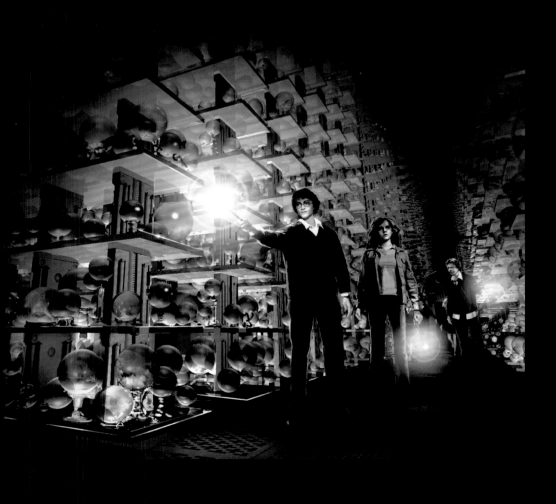

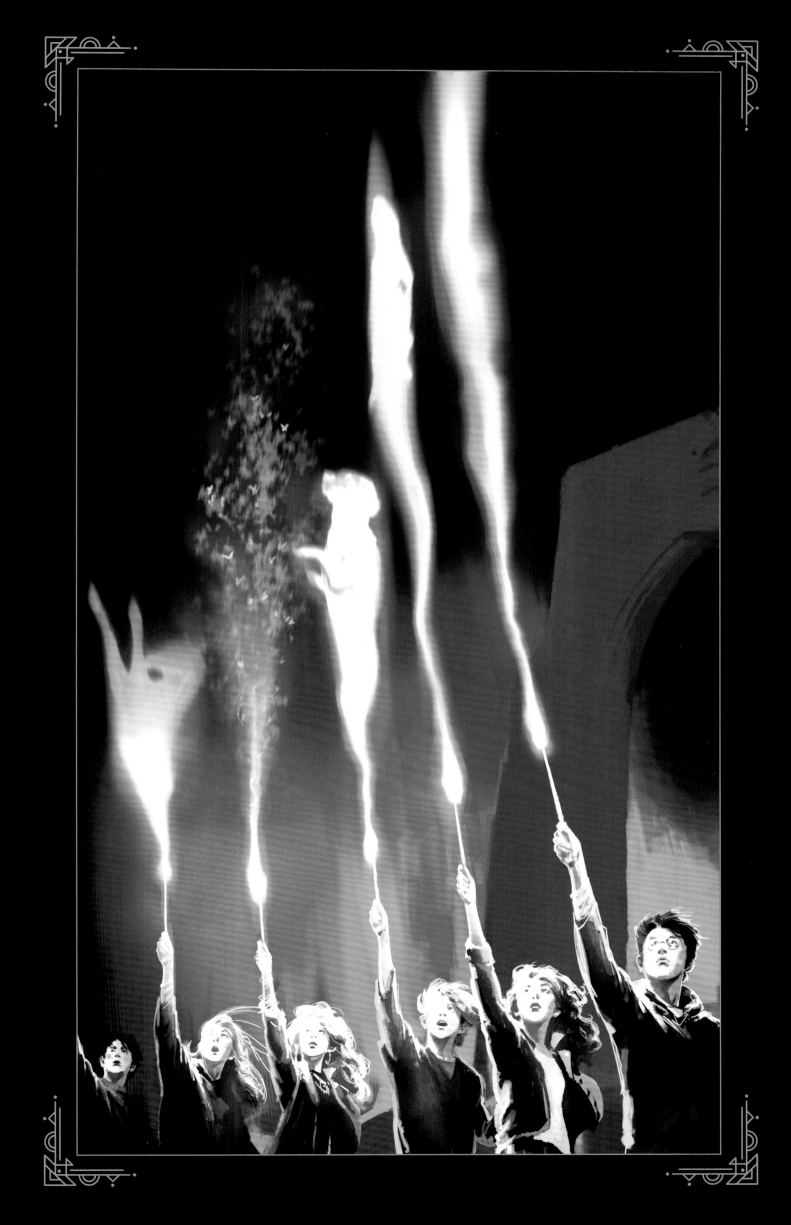

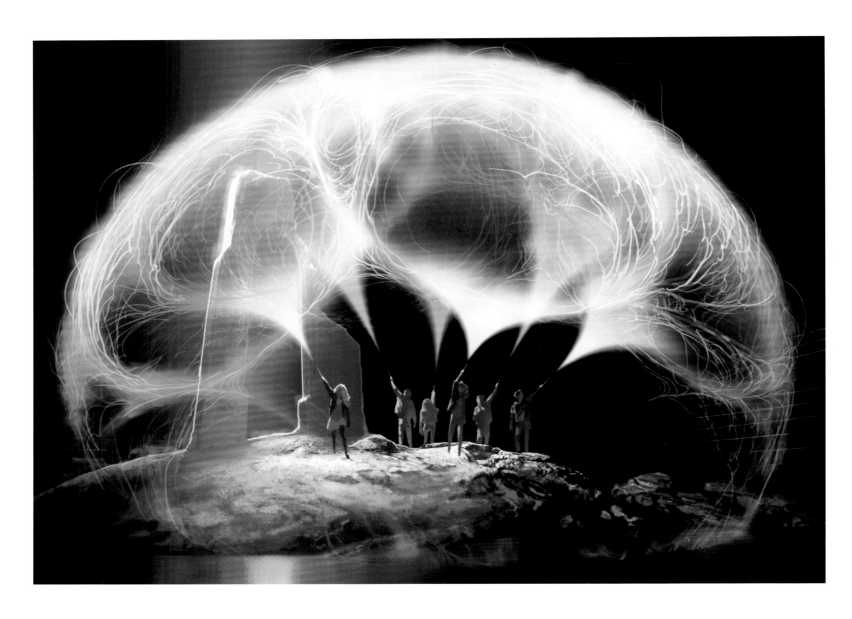

PAGE 100: In *Harry Potter and the Order of the Phoenix*, Harry and Hermione explore the Hall of Prophecy at the Department of Mysteries in the Ministry of Magic. Andrew Williamson shows the shelves and shelves of orbs in his concept art.

PAGE 101: Members of Dumbledore's Army cast the *Expecto Patronum* spell to summon their Patronuses for *Order of the Phoenix*.

ABOVE: Adam Brockbank's concept art portraying Dumbledore's Army creating a Patronus shield in the Death Chamber for *Order of the Phoenix*. Dumbledore's Army did not use their Patronuses in the Death Chamber in the film.

OPPOSITE: Andrew Williamson shows the moment when Bellatrix Lestrange casts the *Avada Kedavra* curse at Sirius Black, sending him through the Veil, in *Order of the Phoenix*.

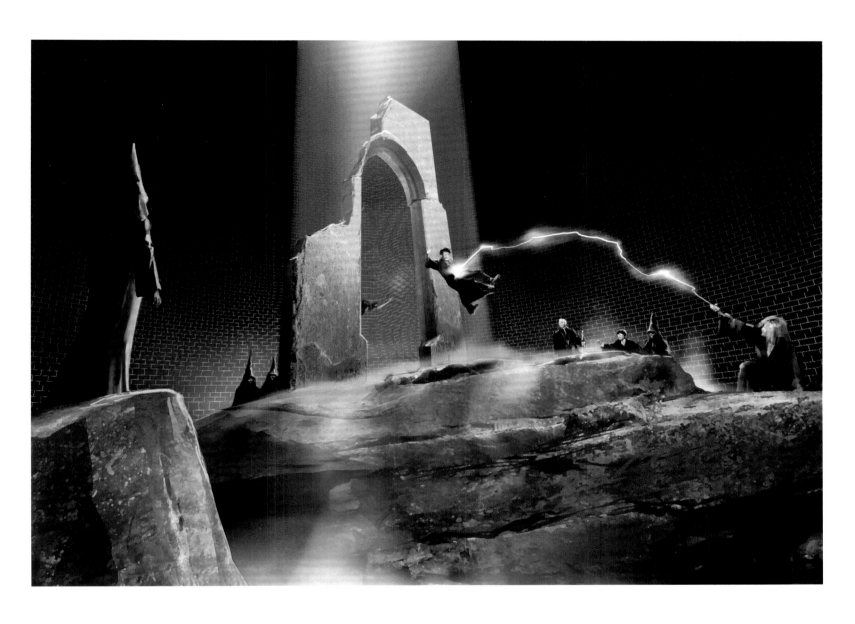

WIZARDING HOMES

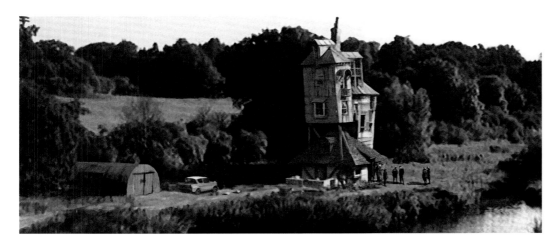

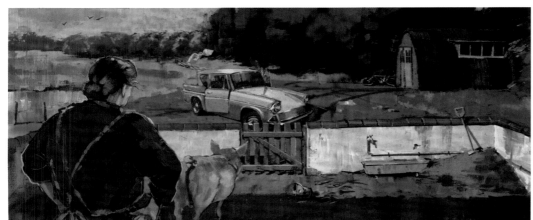

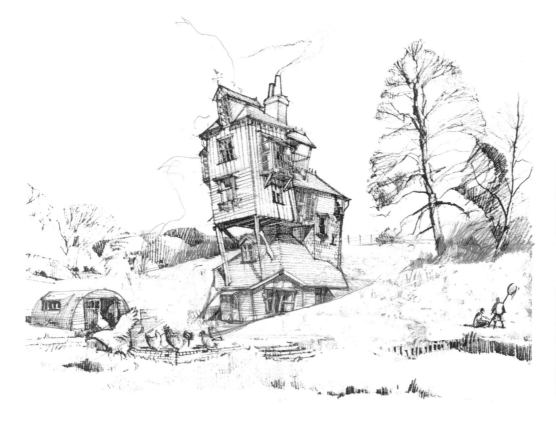

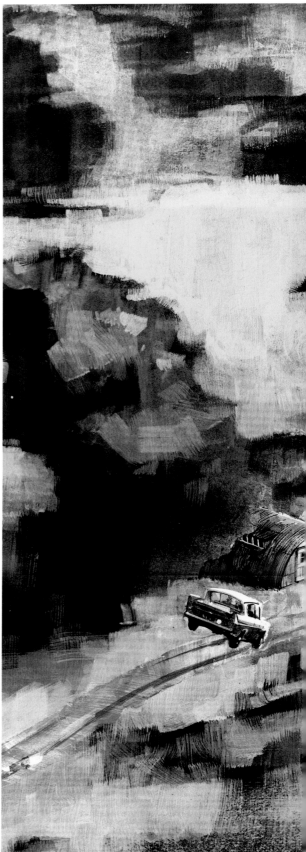

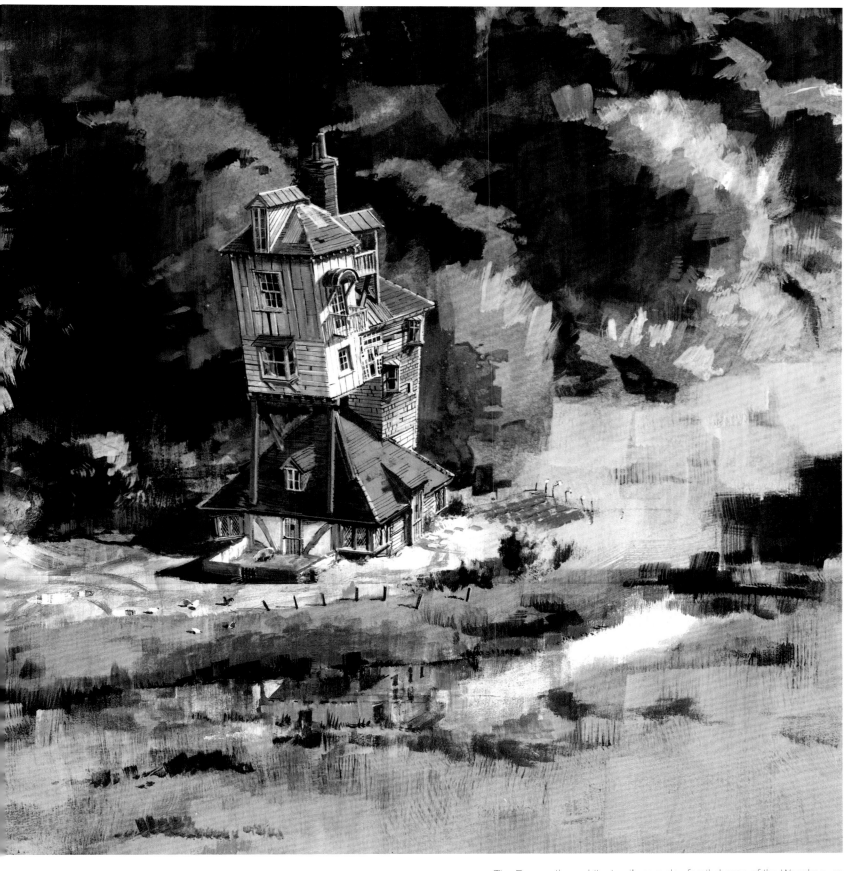

OPPOSITE TOP: The Burrow, the architecturally complex family home of the Weasleys, as illustrated by Andrew Williamson for *Harry Potter and the Goblet of Fire*

OPPOSITE MIDDLE: Andrew Williamson portrays Molly Weasley about to confront her son Ron about taking his father's car in *Harry Potter and the Chamber of Secrets*. In the film, Ron, Harry, and the twins, Fred and George, are already in the house when she chides them.

OPPOSITE BOTTOM: The first sketch of The Burrow for *Chamber of Secrets* by Stuart Craig.

ABOVE: Ron's view of the flying Ford Anglia's descent toward The Burrow in *Chamber of Secrets*. Artwork by Andrew Williamson.

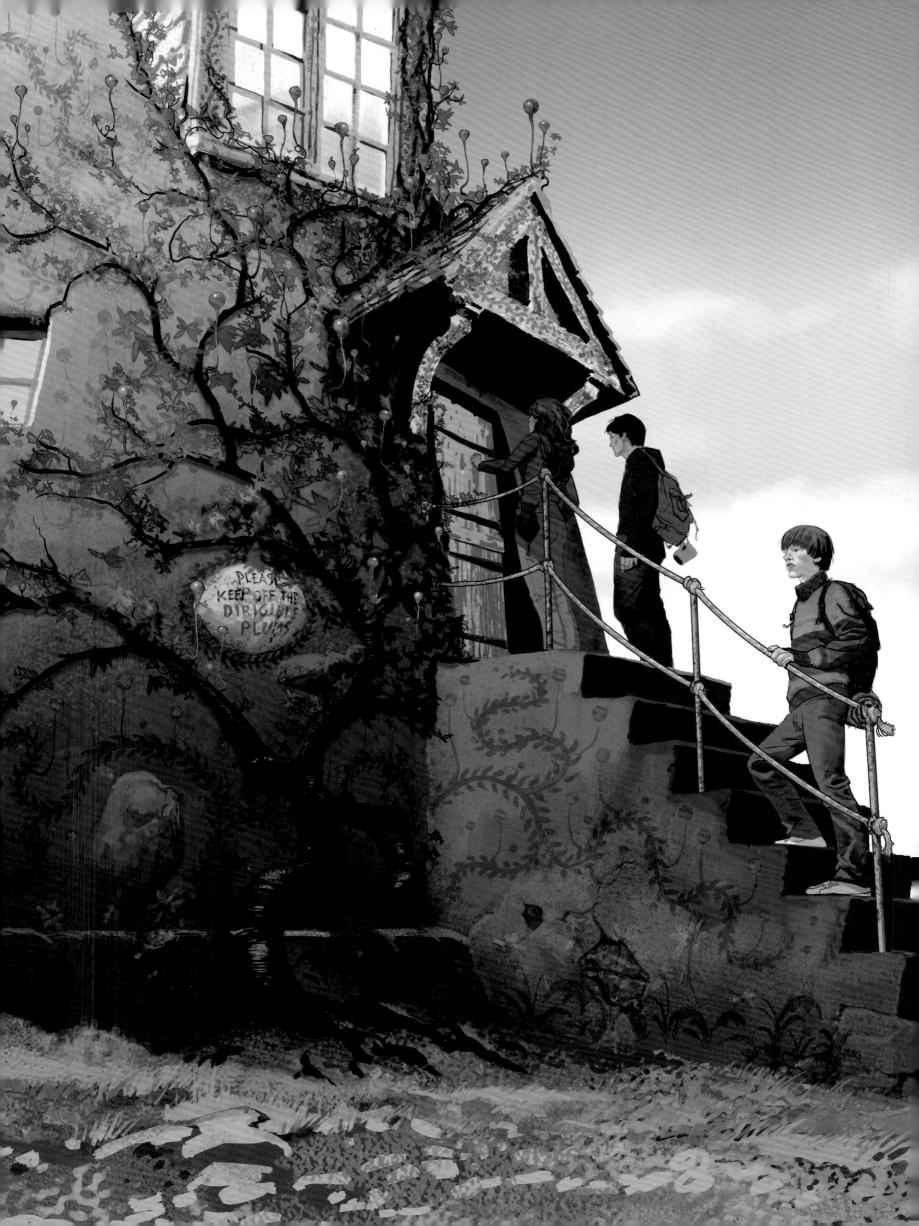

OPPOSITE: Hermione, Harry, and Ron approach the Lovegood House for help, as seen in *Harry Potter and the Deathly Hallows – Part 1*. Art by Adam Brockbank.

TOP: Adam Brockbank depicts the house perched on its hill, with kites flying above it.

ABOVE: A sketch by Stuart Craig of the Lovegood House, noted for resembling a rook chess piece.

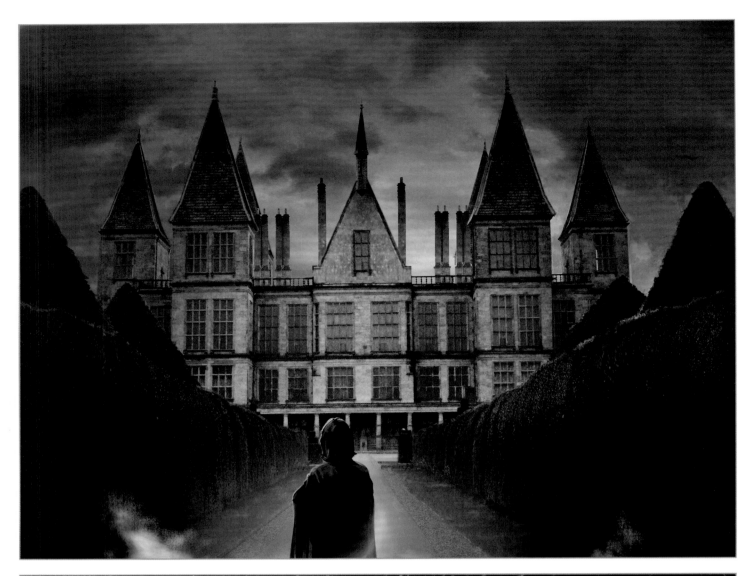

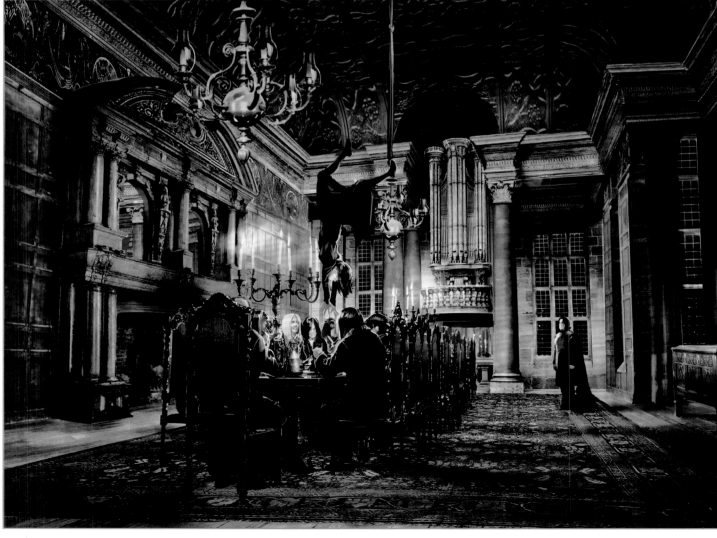

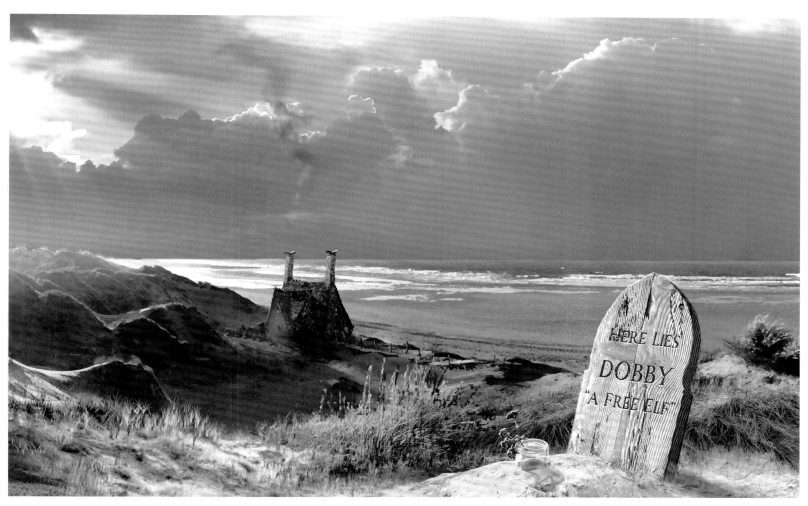

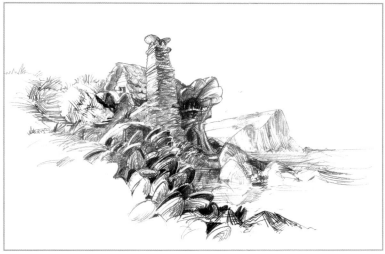

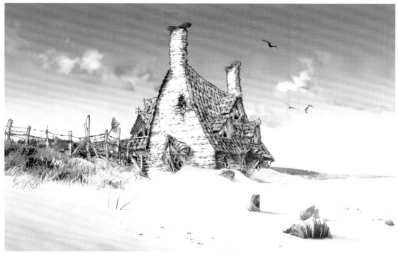

"Such a beautiful place to be with friends . . .
Dobby is happy to be with
his friend Harry Potter."

—Dobby, *Harry Potter and the Deathly Hallows - Part 1*

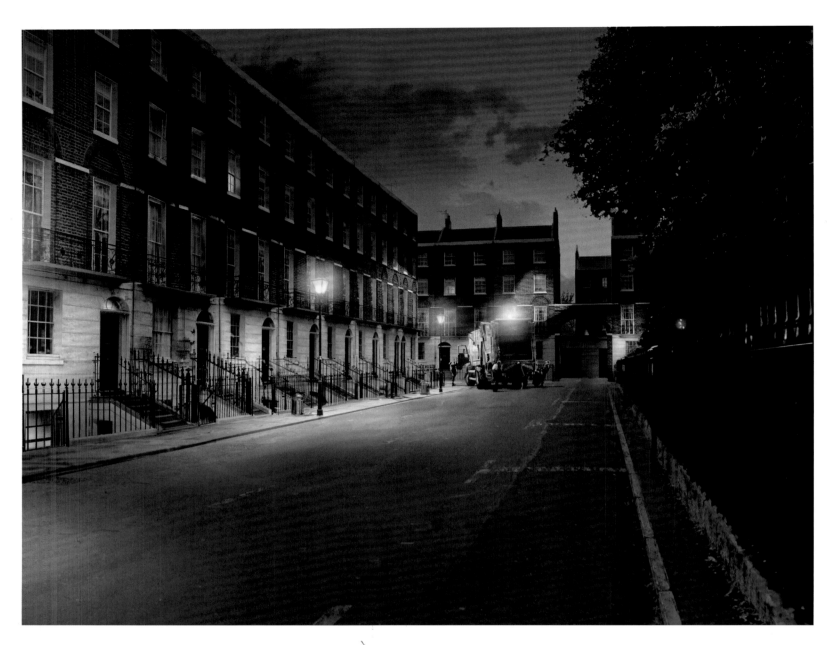

CLOCKWISE FROM OPPOSITE LEFT: Number twelve, Grimmauld Place, the family home of the House of Black as painted by Andrew Williamson for *Harry Potter and the Order of the Phoenix*; the Weasley family spends Christmas at Sirius's home, with the addition of Nymphadora Tonks and Remus Lupin, who did not celebrate it with them in the film, art by Adam Brockbank; the facade of Grimmauld Place opens to reveal number twelve as detailed by Andrew Williamson; a sketch of Grimmauld Place by Stuart Craig.

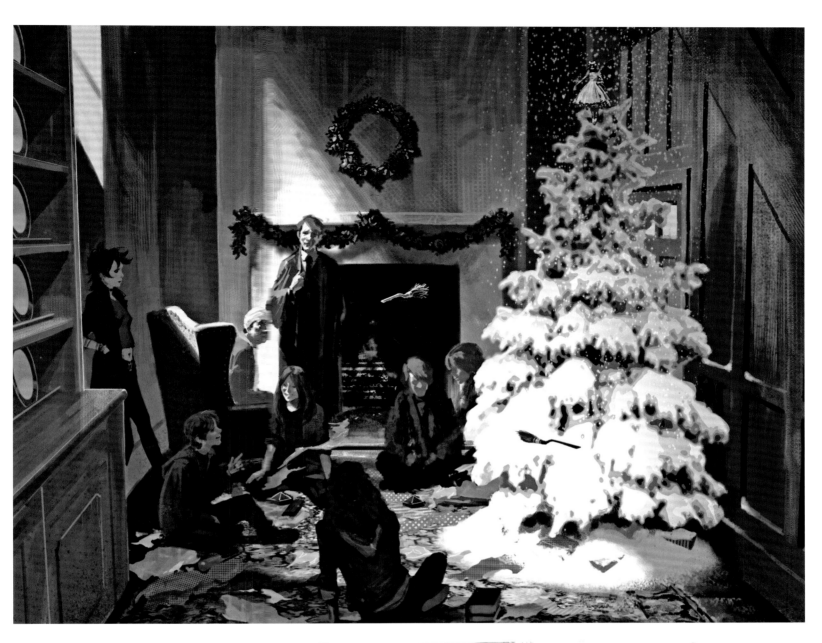

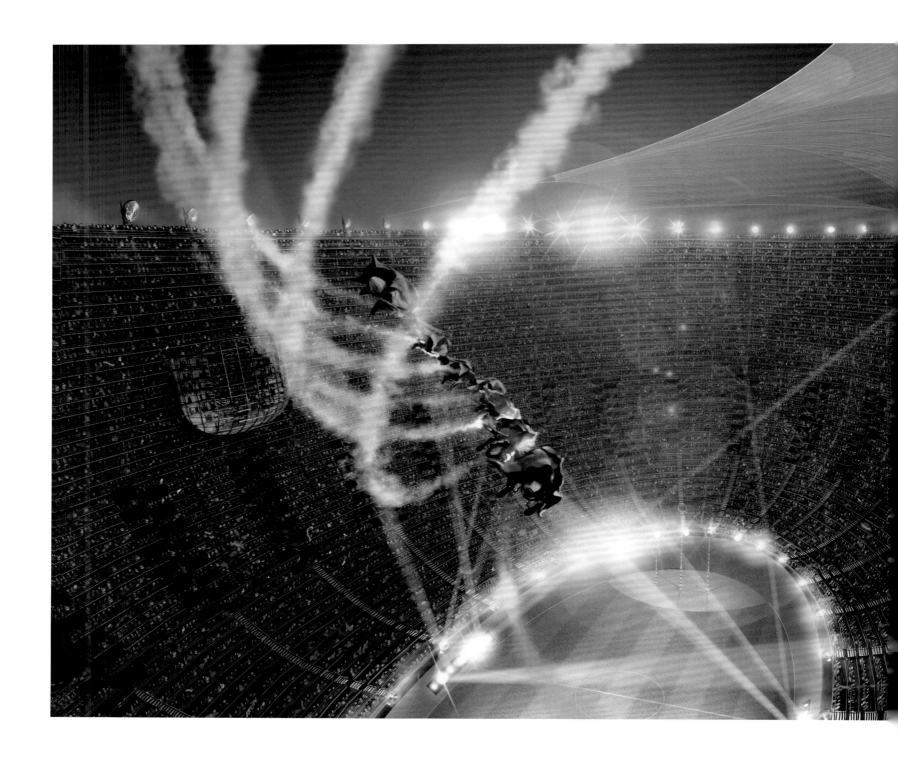

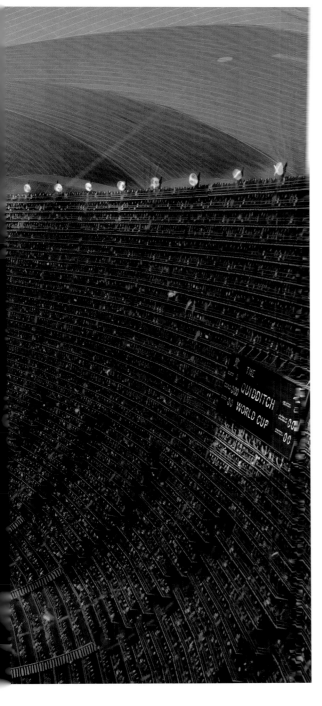

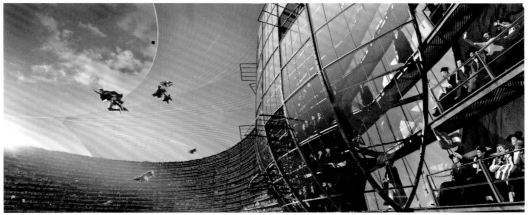

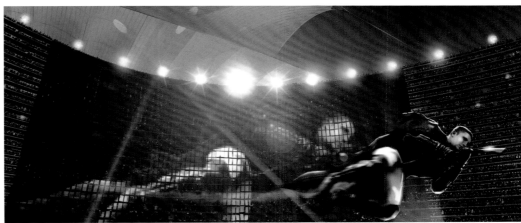

THESE PAGES: Andrew Williamson illustrates the best views above the stadium hosting the 422nd Quidditch World Cup, as seen in *Harry Potter and the Goblet of Fire*.

113

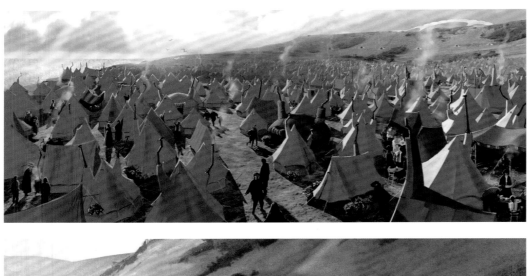

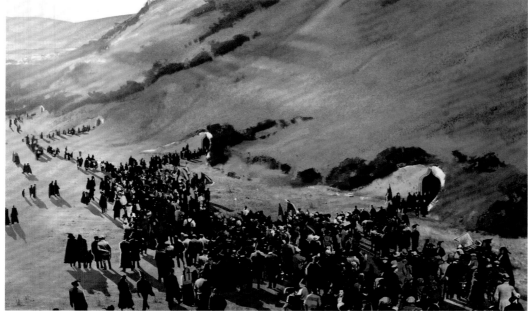

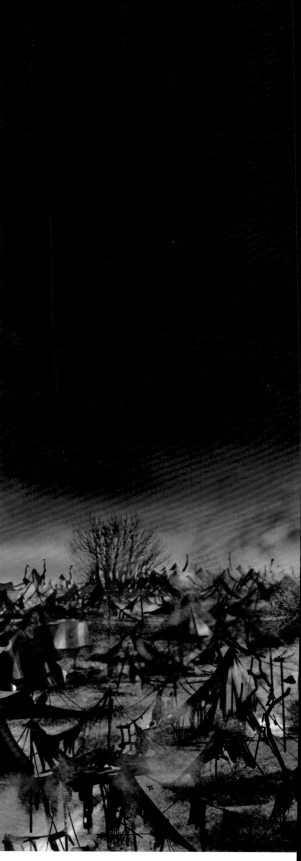

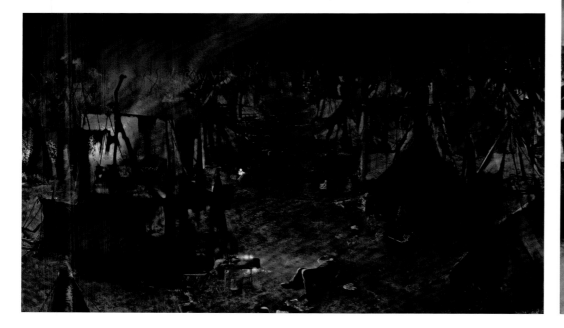

The campgrounds beside the Quidditch World Cup arena. All artwork by Andrew Williamson for *Harry Potter and the Goblet of Fire*.

TOP AND MIDDLE: Myriad tents house the wizards who file into the stadium for the much-anticipated match.

ABOVE AND OPPOSITE: Voldemort's Death Eaters invade the camp at night, burning the tents and casting the *Morsmordre* spell, conjuring the Dark Mark in the sky.

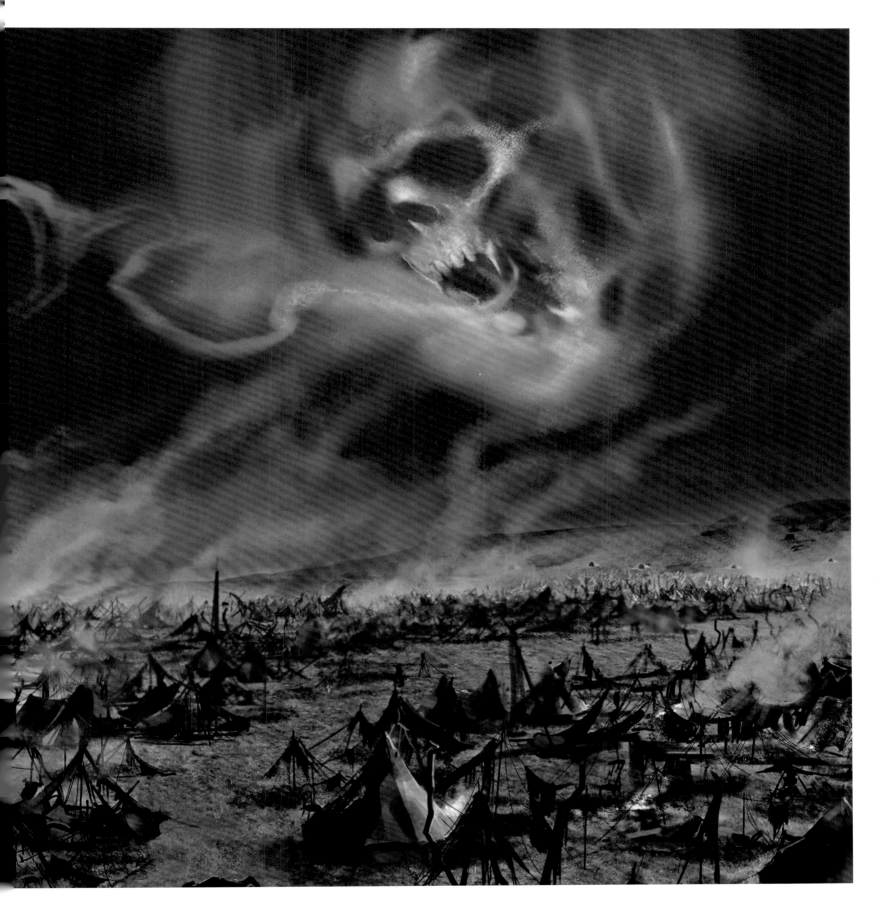

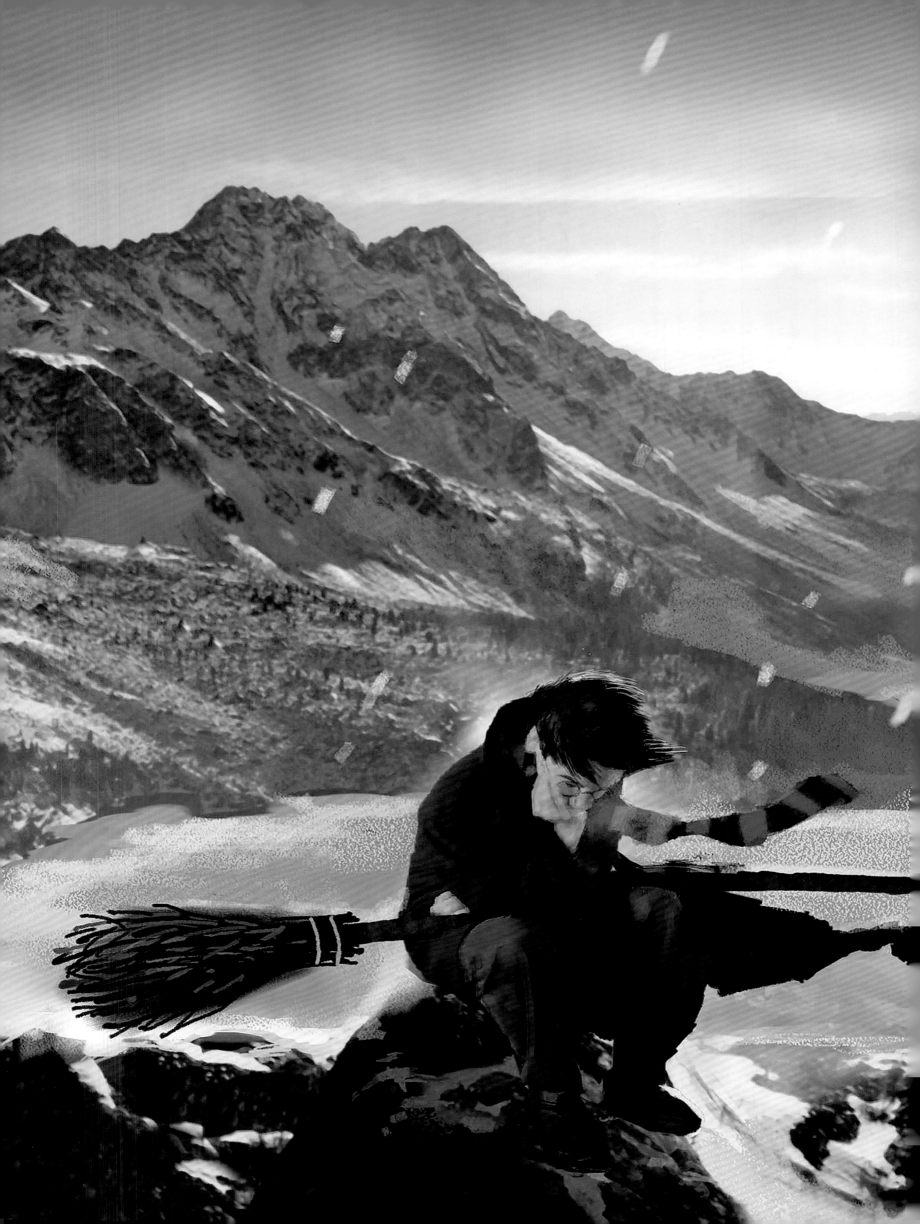

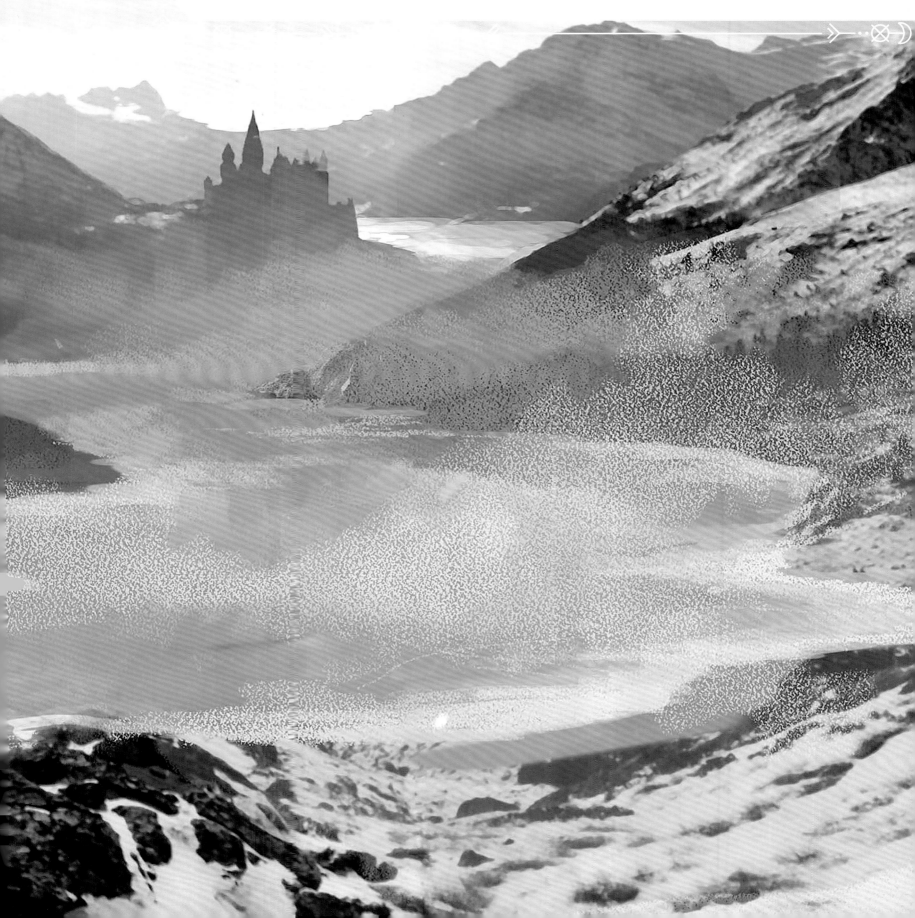

CHAPTER 2
WIZARDS, WITCHES, AND MUGGLES

Once the films' stunning set pieces had been designed and constructed, the next logical step was to fill those locations with a cast of interesting characters. In the case of Hogwarts, the young students wandering its ancient halls happened to be as magical as the school itself. It was up to costume designer Jany Temime, who joined the series with its third film, to make sure that none of these young witches and wizards disappeared into a sea of strikingly similar school uniforms.

"Ron is very different than Harry," Temime says. "Hermione is very different, but also Neville and all the Weasleys; they all come from different backgrounds. They have their own thing, what they like. And that was not only for their normal clothes but also their uniforms."

Temime and her wardrobe team offered subtle ways, including different sweaters and custom accessories, to help each of the students personalize their iconic Hogwarts attire. These individual differences became more pronounced as the films continued and the students of Hogwarts grew older.

"I always thought that in the third year you start dressing the way you like," Temime says, "rather than how your mom tells you to dress. And it's so important to be cool and to be yourself, and you start being an individual . . . wanting to have your own clothes, your own look."

Focusing on the individuality of each student was also something that interested David Yates, who directed the final four films in the franchise.

"It was very important to him that the kids were showing their personalities, their doubts about

growing, their problems about becoming adults," Temime says. "David was very concerned about the psychology of each character."

Even more attention had to be paid to each individual student's apparel as the story moved them outside of the confines of Hogwarts's halls and further into the wizarding world.

"That was the biggest challenge, actually," Temime says, "to dress them in a very cool way and at the same time to have something magical about it."

As the young students continued to grow and change, their wardrobes evolved with them.

"What was most exciting to see was the kids growing," Temime adds, "becoming adults and being able to wear clothes with a little bit more of self-assurance."

Temime's design influence stretched far beyond the Hogwarts student body and deep into both the magical and Muggle realms. Her stunning aesthetic choices can be clearly witnessed in everything from the soft blues of the Beauxbatons uniforms to the aggressive pinks of Dolores Umbridge. No matter the character, their wardrobe matches their personality perfectly.

While Temime's memorable designs effortlessly spanned from simple and straightforward to lavish and luxurious depending on the requirements of the scene, they all shared one common foundation that she deemed absolutely essential: "It's so important for an actor to feel comfortable in what they're wearing," she says. "If you don't feel comfortable in what you're wearing, you just cannot wear it, and you cannot create."

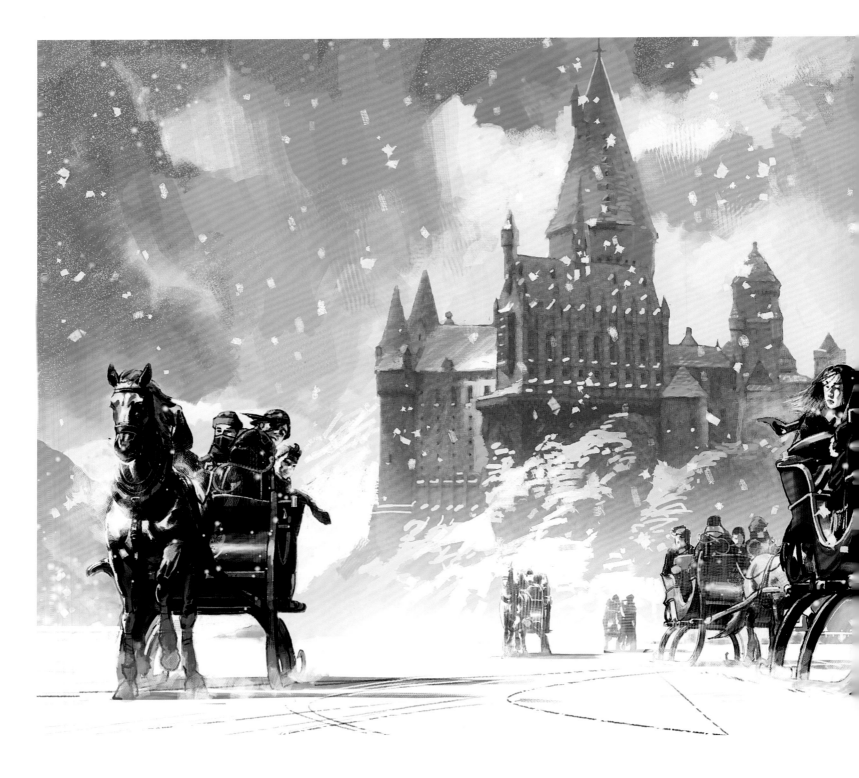

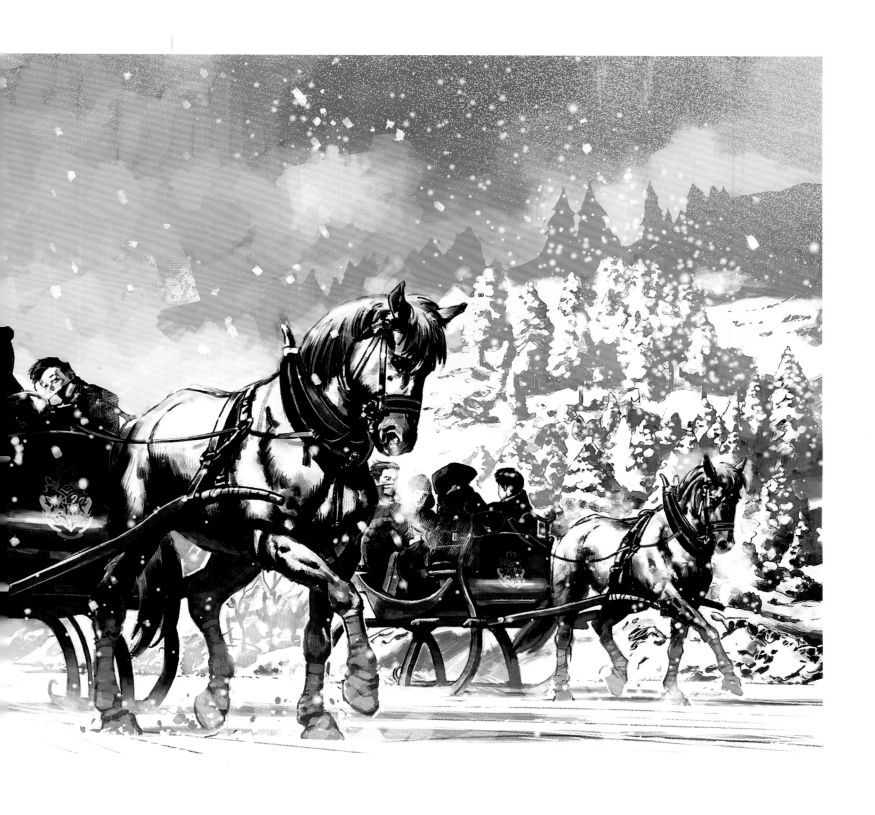

PAGES 116–117: Dermot Power depicts Harry Potter lost in thought after flying to the opposite side of the lake from Hogwarts. This scene was not realized for the screen.

PAGE 118: Alastor "Mad-Eye" Moody arrives at Hogwarts in inclement weather, as portrayed by Adam Brockbank for *Harry Potter and the Goblet of Fire*.

PAGE 119: Aunt Marge blows up and starts to float away from the Dursley house in *Harry Potter and the Prisoner of Azkaban*. Art by Dermot Power.

ABOVE: Adam Brockbank's visual development art of Hogwarts students taking a winter sleigh ride in a scene not filmed for *Harry Potter and the Chamber of Secrets*.

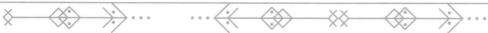

ABOVE: Harry and the Gryffindor team played
Quidditch in a driving rainstorm in *Harry Potter and
the Prisoner of Azkaban*. Adam Brockbank soaks
the players in his artwork.

OPPOSITE: Costume designer Jany Temime
redesigned the players' uniforms with position
numbers and more padding for the hard-hitting play
in *Harry Potter and the Half-Blood Prince*. Drawing
by Mauricio Carneiro.

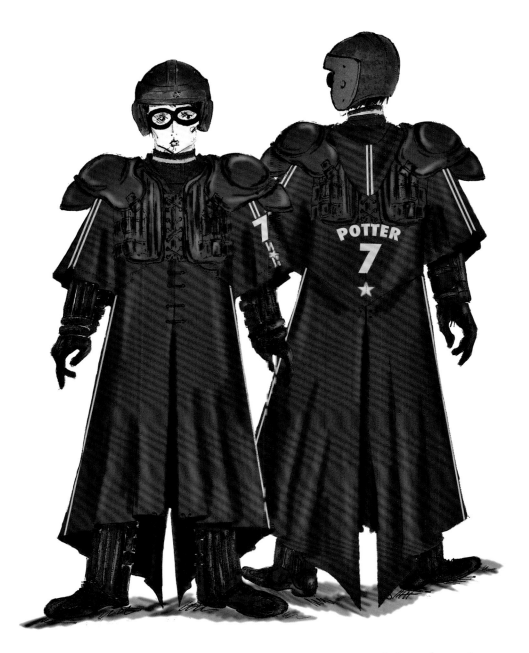

Quidditch Team

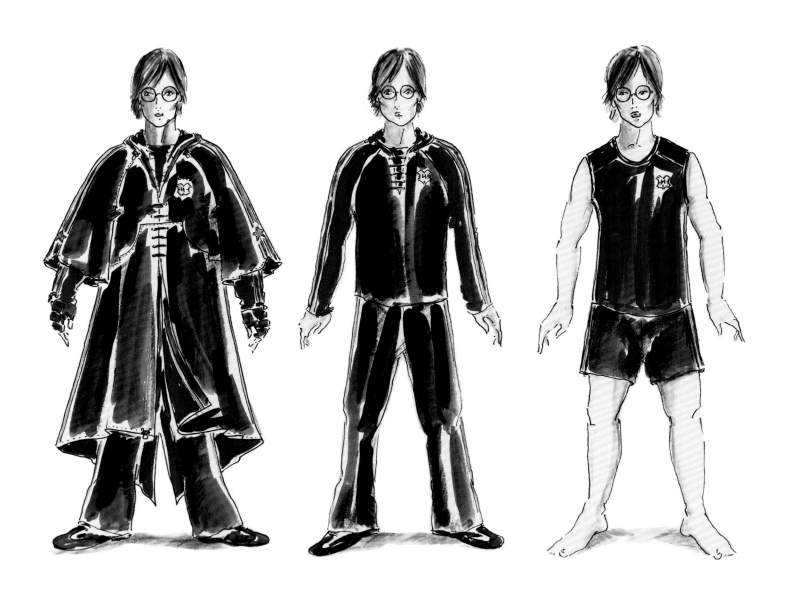

"Dragons? That's the first task? You're joking."

—Harry Potter, *Harry Potter and the Goblet of Fire*

ABOVE: The champions' outfits for the Triwizard Tournament in *Harry Potter and the Goblet of Fire* were designed to accommodate each of the tasks, which included flying and swimming. Design by Jany Temime, drawn by Mauricio Carneiro.

OPPOSITE: When Jany Temime took over costuming duties, she reconceived the Hogwarts robes so that each student's House could be easily identified. Design by Jany Temime, drawn by Laurent Guinci.

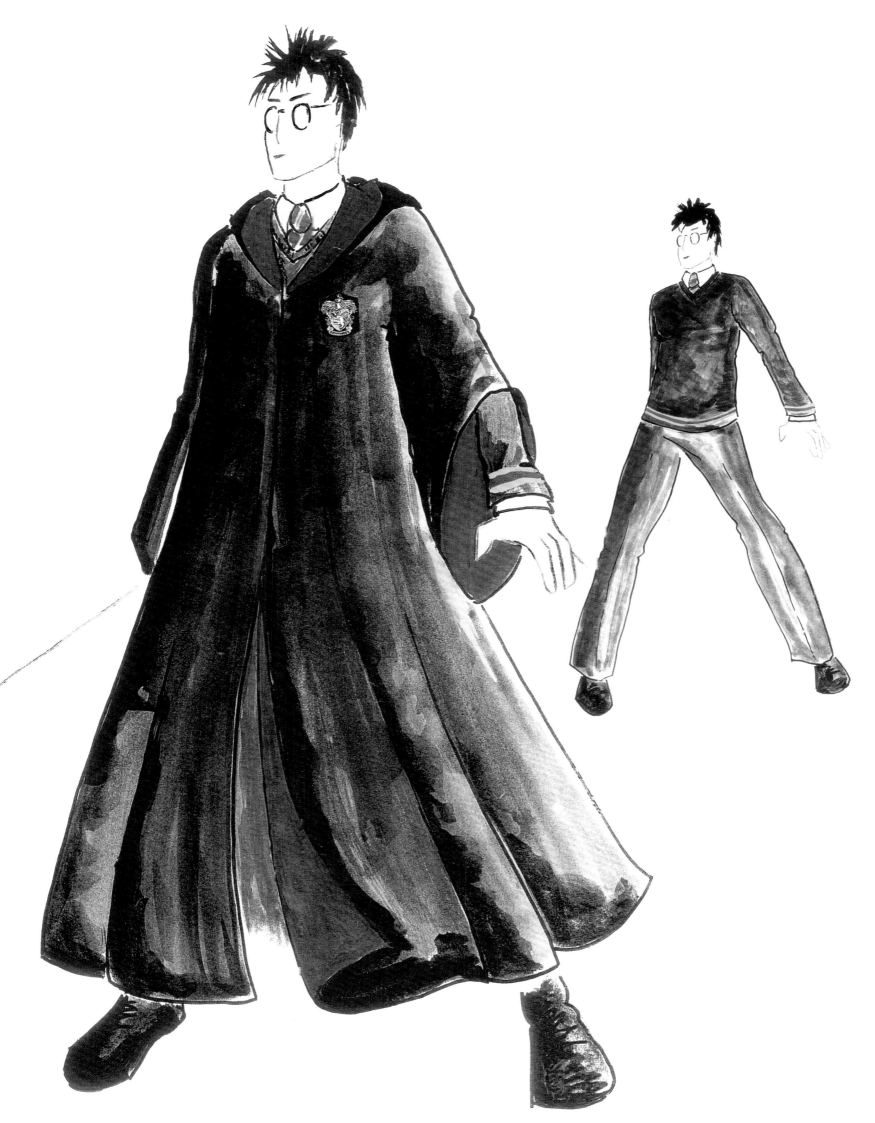

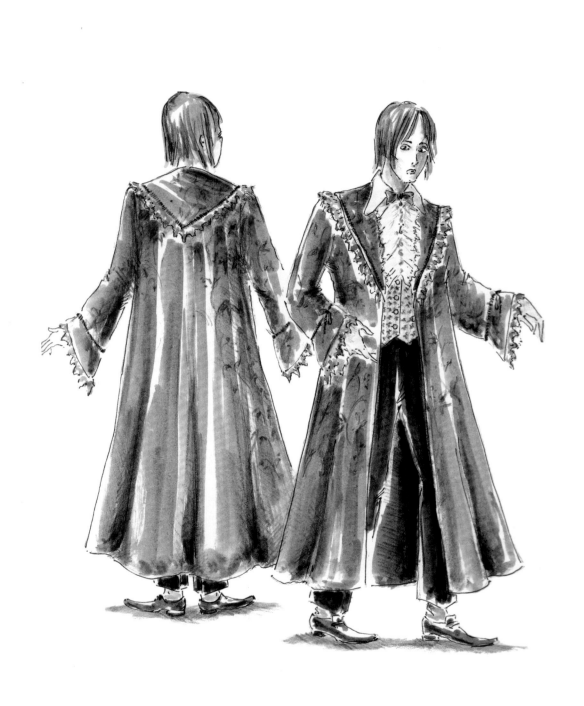

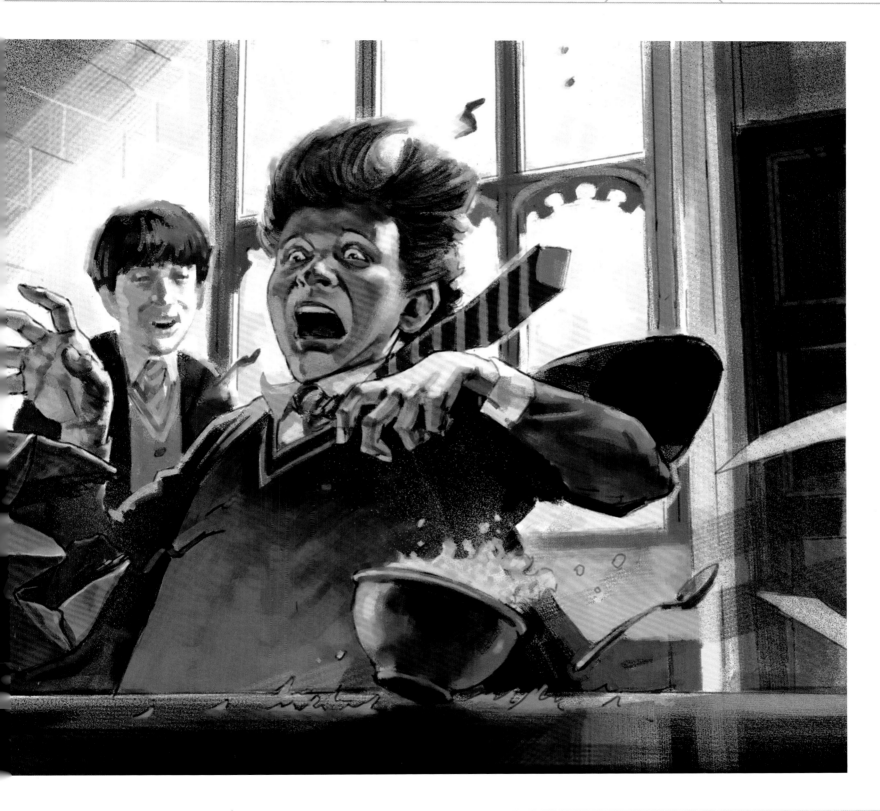

OPPOSITE: Ron Weasley's dress robes for the Yule Ball in *Harry Potter and the Goblet of Fire* were . . . unique. Design by Jany Temime, drawn by Mauricio Carneiro.

ABOVE: Adam Brockbank portrays the chaos that ensues when Ron Weasley receives a Howler from his mother in *Harry Potter and the Chamber of Secrets*.

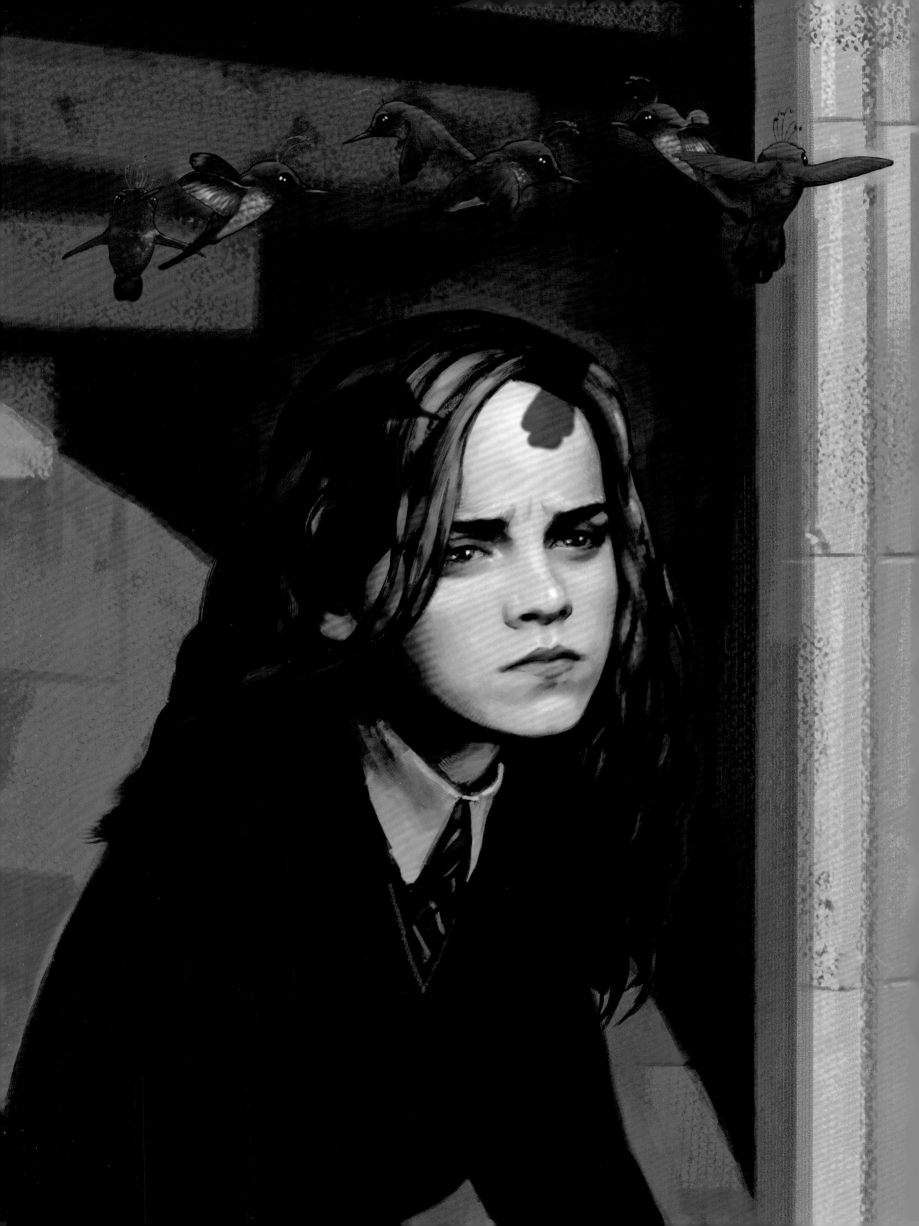

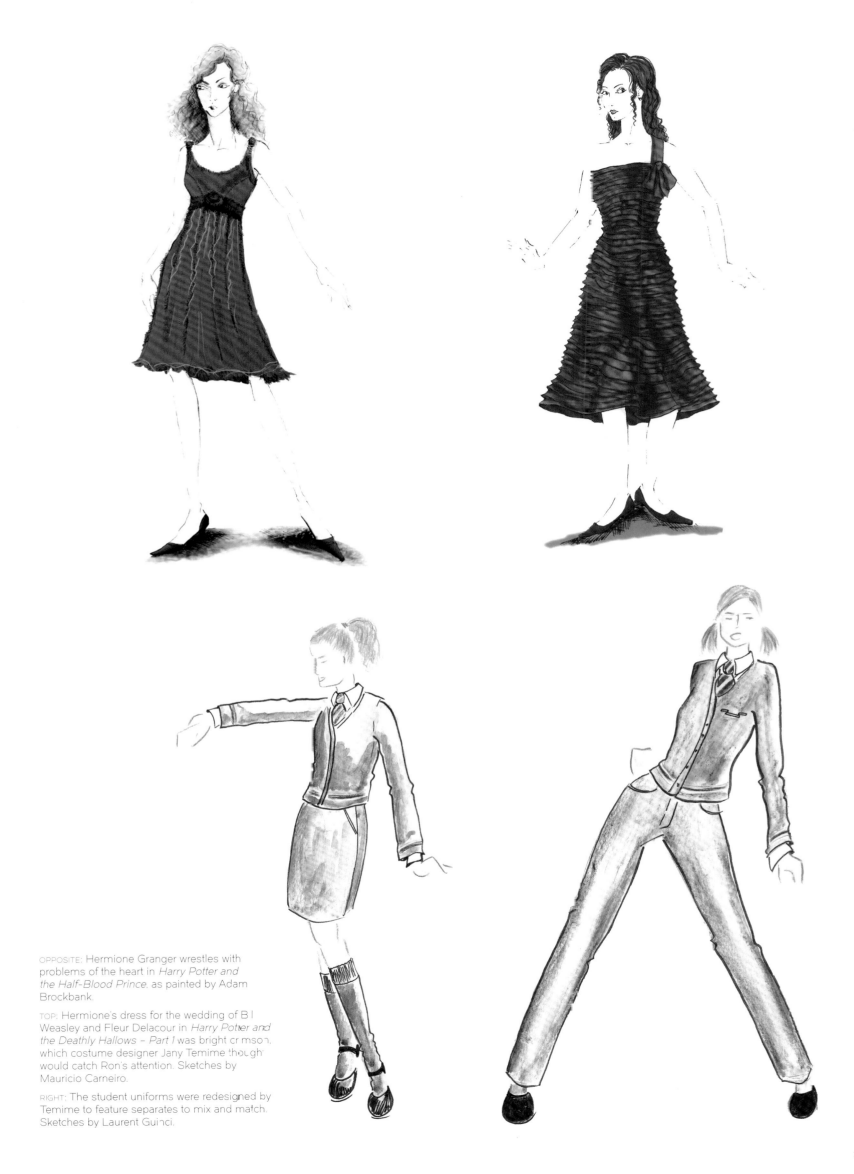

OPPOSITE: Hermione Granger wrestles with problems of the heart in *Harry Potter and the Half-Blood Prince*, as painted by Adam Brockbank.

TOP: Hermione's dress for the wedding of Bill Weasley and Fleur Delacour in *Harry Potter and the Deathly Hallows – Part 1* was bright crimson, which costume designer Jany Temime thought would catch Ron's attention. Sketches by Mauricio Carneiro.

RIGHT: The student uniforms were redesigned by Temime to feature separates to mix and match. Sketches by Laurent Guinci.

ABOVE: Ginny Weasley's gown for the Yule Ball in *Harry Potter and the Goblet of Fire* was atypical of the Weasley color palette. Design by Jany Temime, drawn by Mauricio Carneiro.

OPPOSITE: Luna Lovegood supported the Gryffindor Quidditch team by wearing a lion hat to games. Concept art by Adam Brockbank for *Harry Potter and the Half-Blood Prince*.

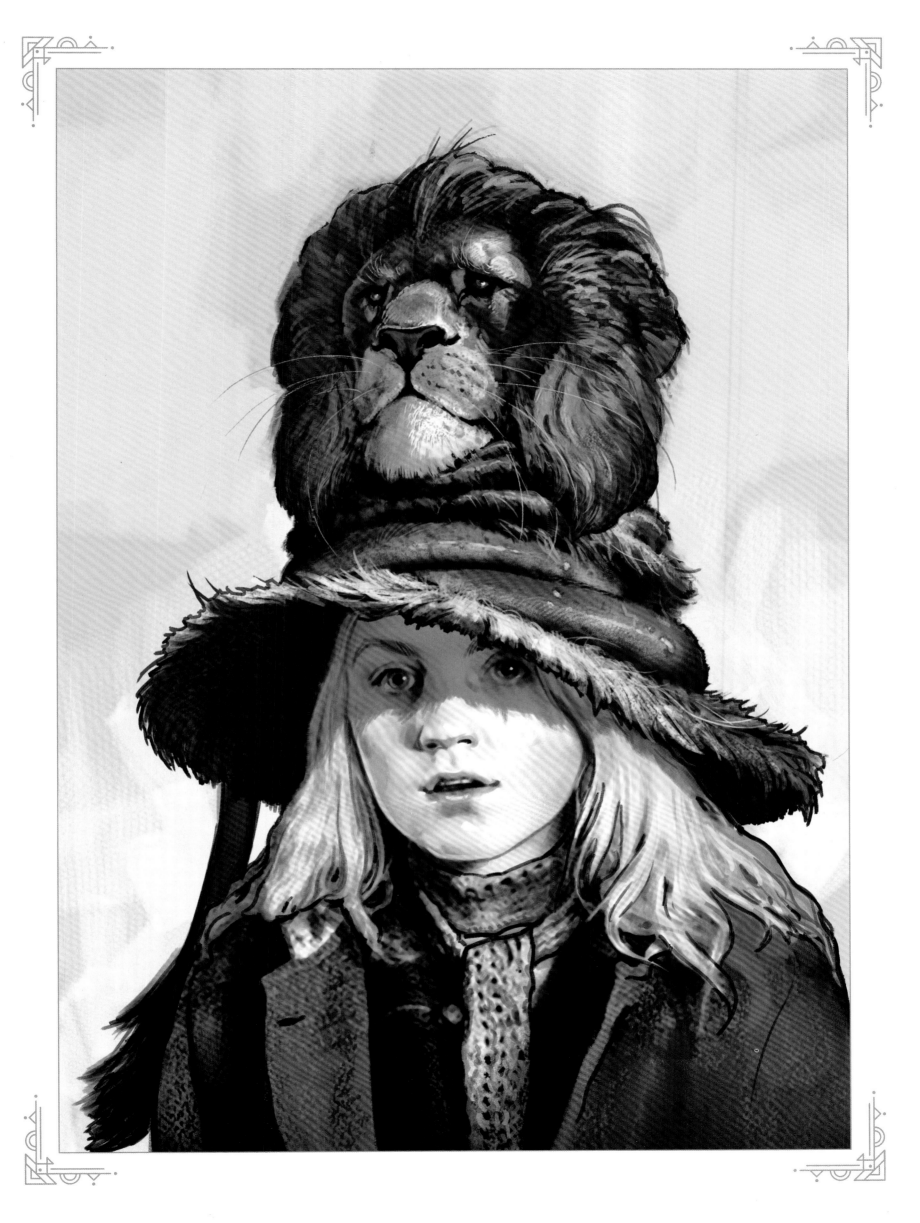

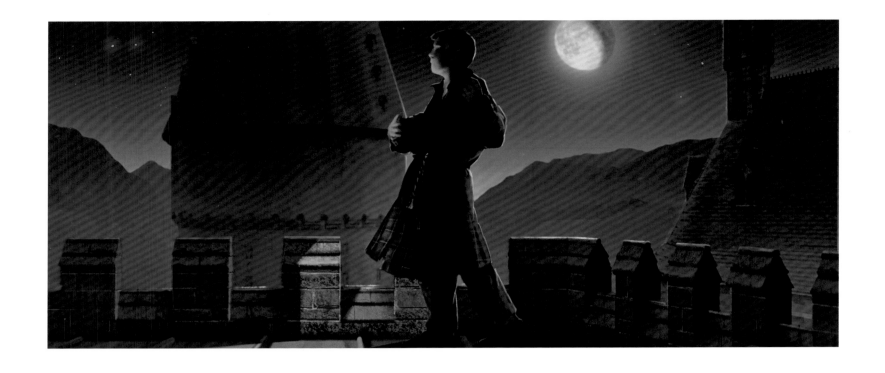

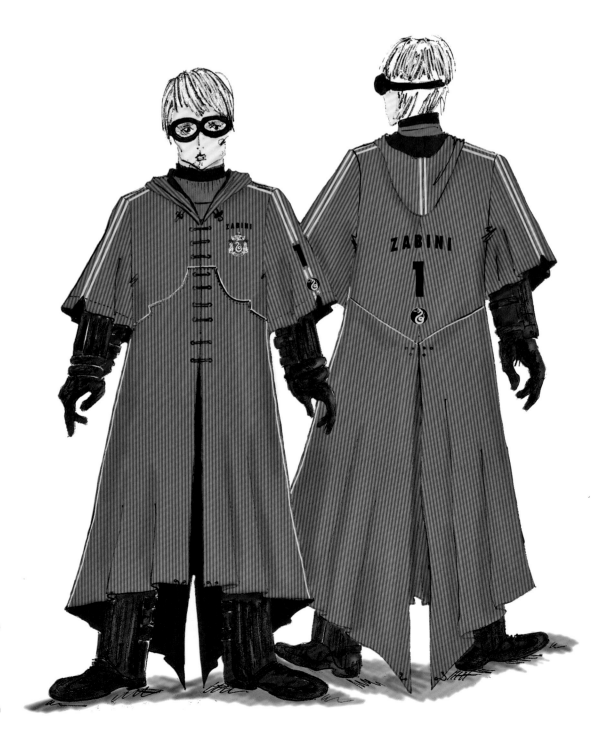

TOP: As a possible scene for *Harry Potter and the Goblet of Fire*, Andrew Williamson depicts Neville Longbottom practicing the waltz atop Hogwarts castle for the Yule Ball.

RIGHT: The Slytherin team's green and black Quidditch uniforms. Designed by Jany Temime and drawn by Mauricio Carneiro for *Harry Potter and the Half-Blood Prince*.

OPPOSITE: Entrepreneurs Fred and George Weasley wear sharp suits after they open Weasleys' Wizard Wheezes in Diagon Alley in *Harry Potter and the Half-Blood Prince*. Design by Jany Temime, drawn by Maurico Carneiro.

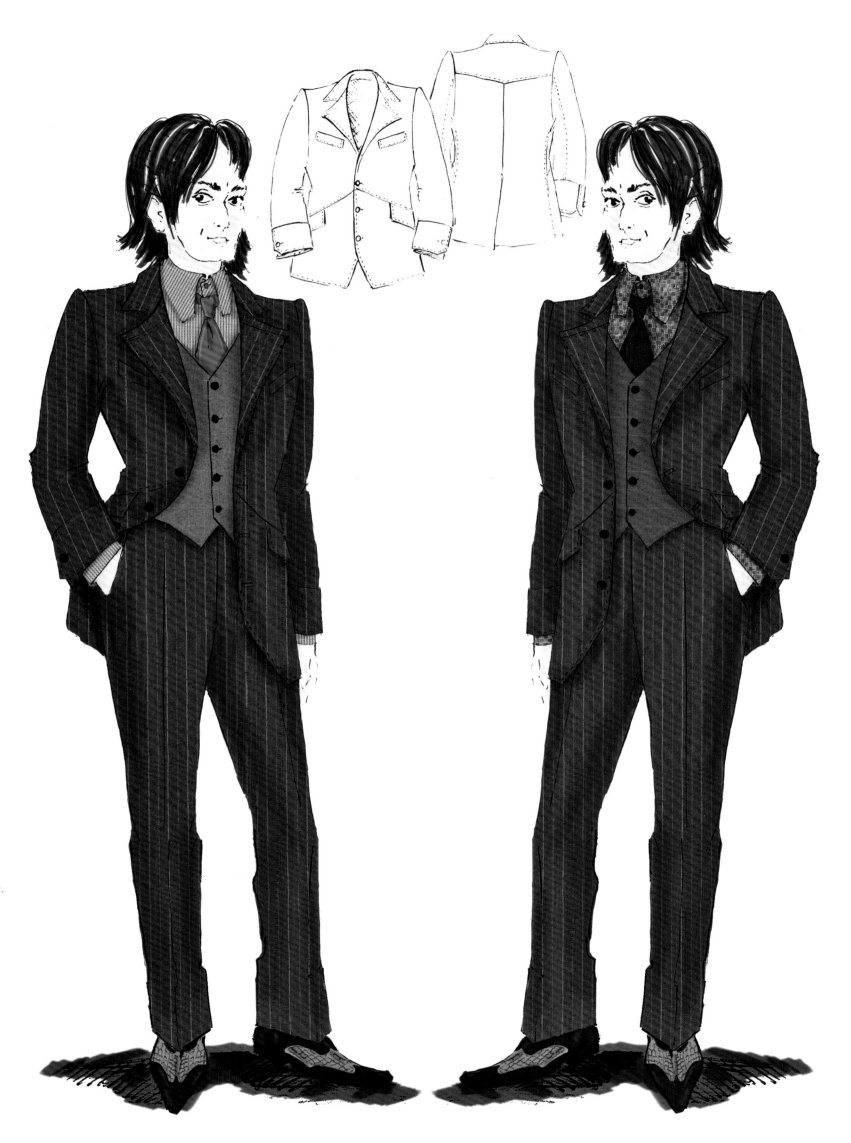

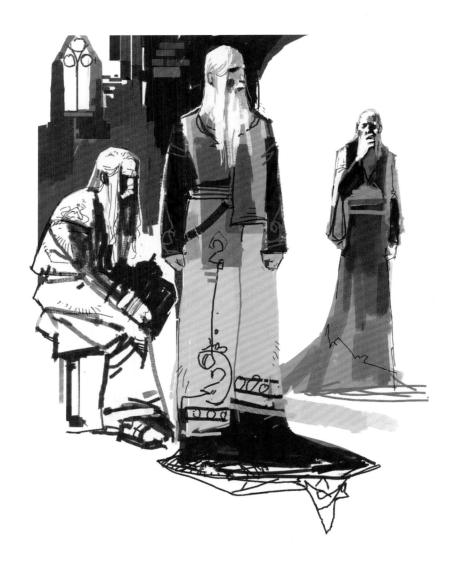

THIS PAGE: Depictions of Dumbledore by Dermot Power.

OPPOSITE: As Harry Potter looks on, Albus Dumbledore cradles his phoenix, Fawkes, who has been reborn from the ashes. Concept art by Adam Brockbank for *Harry Potter and the Chamber of Secrets*.

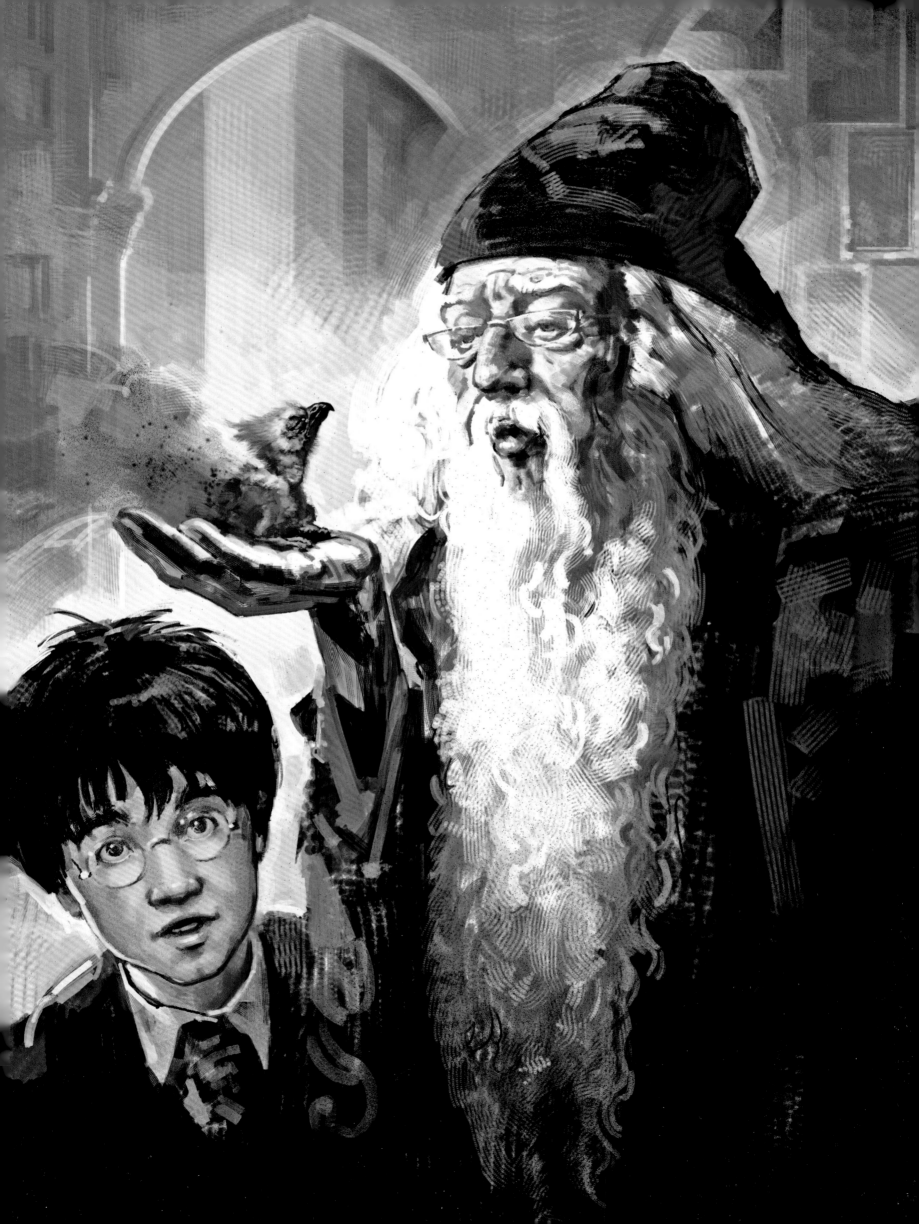

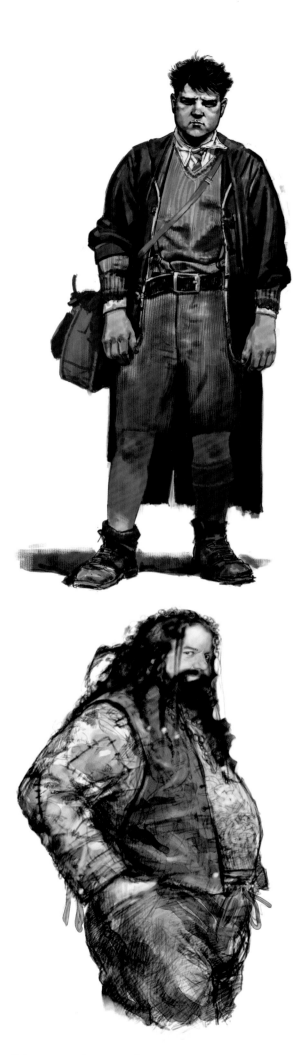

Rubeus Hagrid, Keeper of Keys and Grounds at Hogwarts.

ABOVE AND OPPOSITE: Paul Catling paints a hairy Hagrid for *Harry Potter and the Sorcerer's Stone*.

TOP AND RIGHT: Adam Brockbank gave Hagrid a haircut to portray the younger version seen in *Harry Potter and the Chamber of Secrets*.

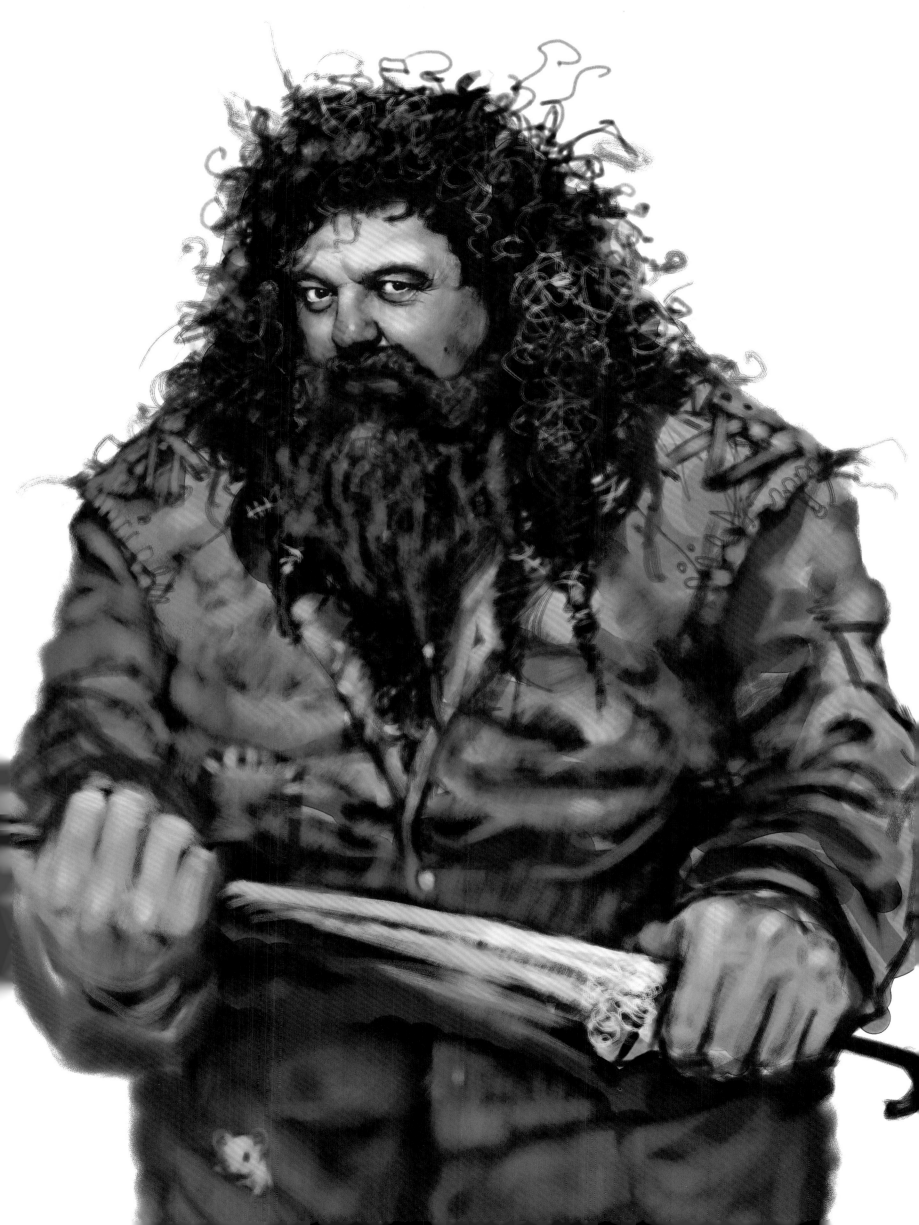

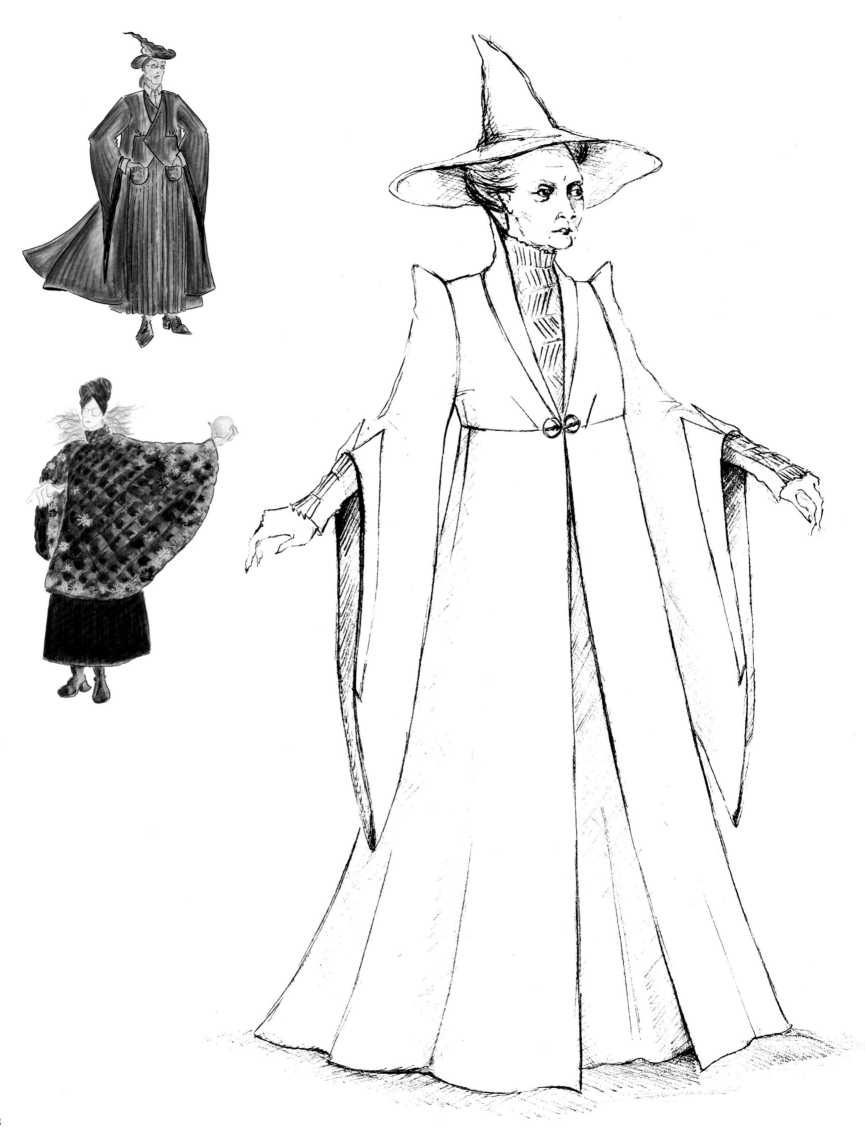

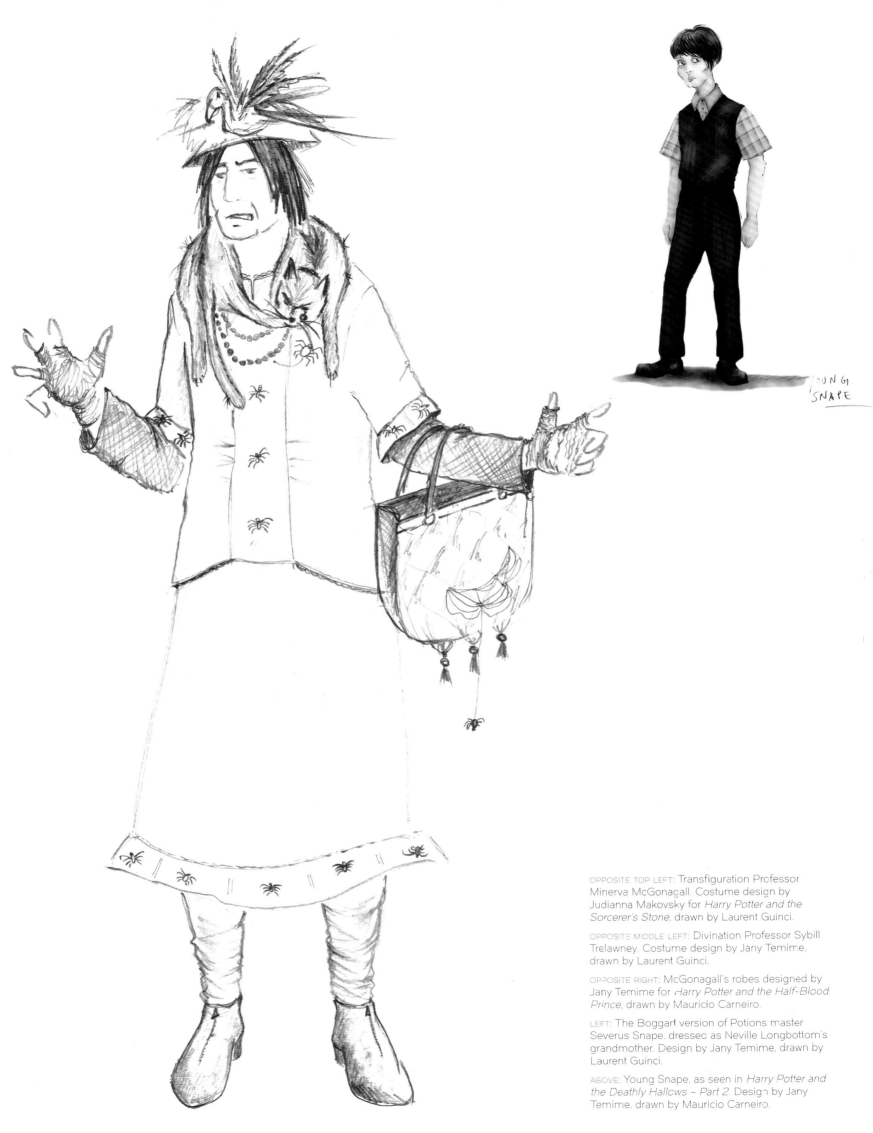

OPPOSITE TOP LEFT: Transfiguration Professor Minerva McGonagall. Costume design by Judianna Makovsky for *Harry Potter and the Sorcerer's Stone*, drawn by Laurent Guinci.

OPPOSITE MIDDLE LEFT: Divination Professor Sybill Trelawney. Costume design by Jany Temime, drawn by Laurent Guinci.

OPPOSITE RIGHT: McGonagall's robes designed by Jany Temime for *Harry Potter and the Half-Blood Prince*, drawn by Mauricio Carneiro.

LEFT: The Boggart version of Potions master Severus Snape, dressed as Neville Longbottom's grandmother. Design by Jany Temime, drawn by Laurent Guinci.

ABOVE: Young Snape, as seen in *Harry Potter and the Deathly Hallows – Part 2*. Design by Jany Temime, drawn by Mauricio Carneiro.

YOUNG SNAPE

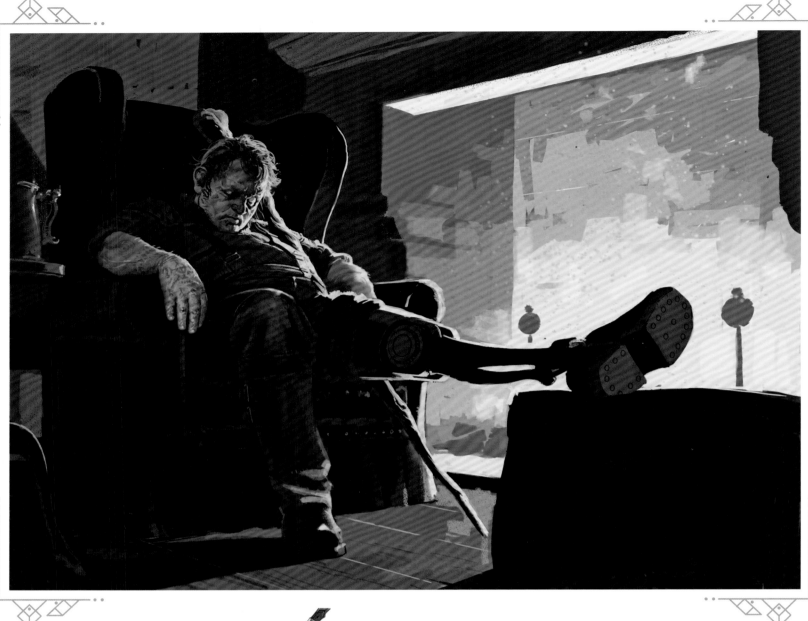

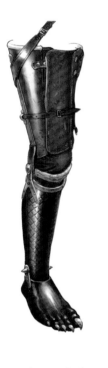

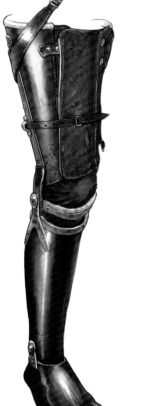

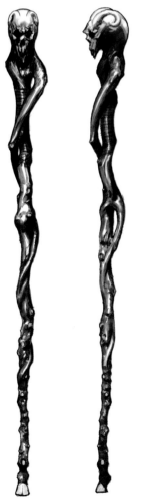

TOP: Alastor "Mad-Eye" Moody rests before a blazing fire in a scene by artist Adam Brockbank not realized for *Harry Potter and the Goblet of Fire*.

ABOVE: Brockbank offers detailed concept suggestions for Moody's prosthetic leg (*left*) and walking staff (*right*).

OPPOSITE: Paul Catling portrays Moody's transformation back into Barty Crouch Jr., who used Polyjuice Potion for the deception in *Harry Potter and the Goblet of Fire*.

GHOSTS OF HOGWARTS

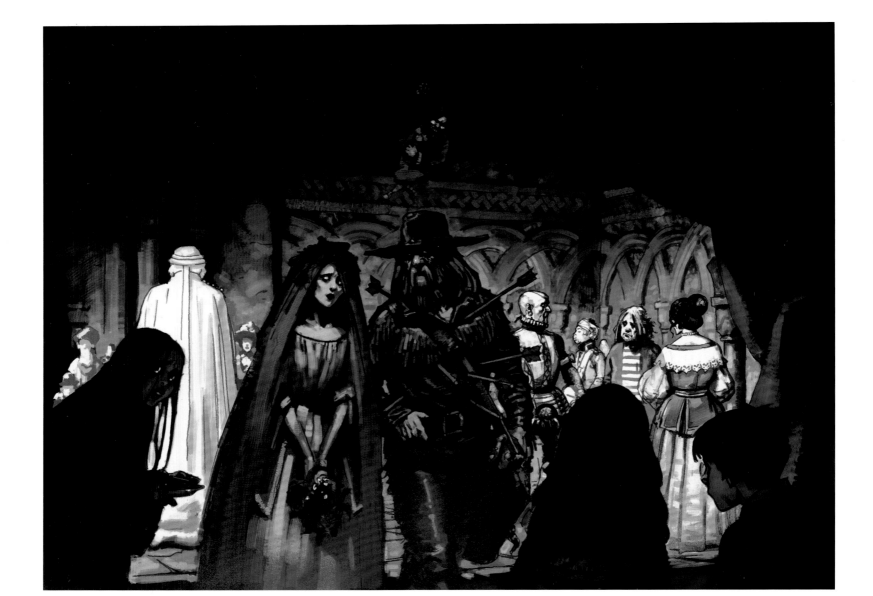

ABOVE AND OPPOSITE TOP: In the book *Harry Potter and the Chamber of Secrets*, Nearly Headless Nick invites Harry Potter to his "Deathday Party." Adam Brockbank portrayed the scene, which did not make it into the film.

OPPOSITE BOTTOM LEFT AND RIGHT: The medieval dresses of Helena and Rowena Ravenclaw, as designed by Jany Temime for *Harry Potter and the Deathly Hallows – Part 2*, drawn by Mauricio Carneiro. Rowena's scenes were eventually cut from the film.

OPPOSITE MIDDLE: Peeves the poltergeist never made it to the movie screen. Character art by Paul Catling for *Harry Potter and the Sorcerer's Stone*.

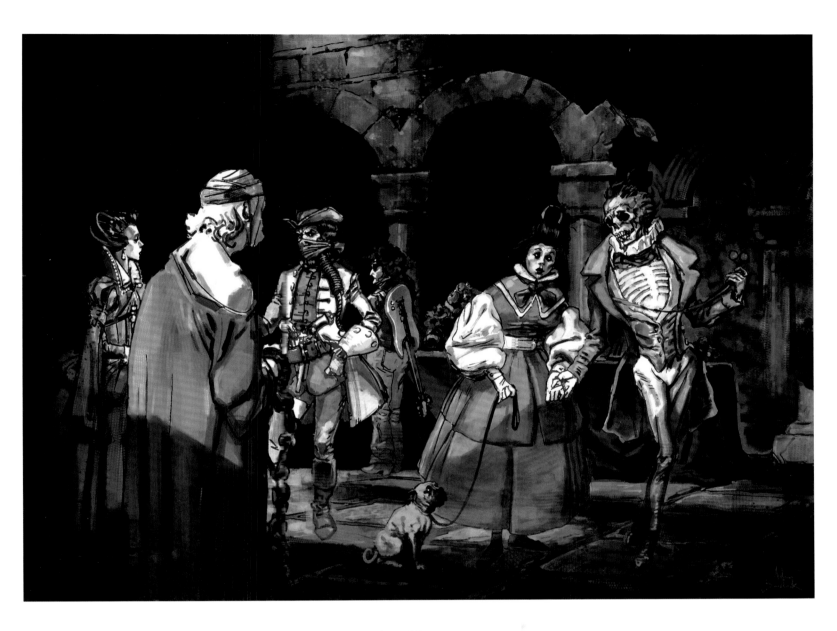

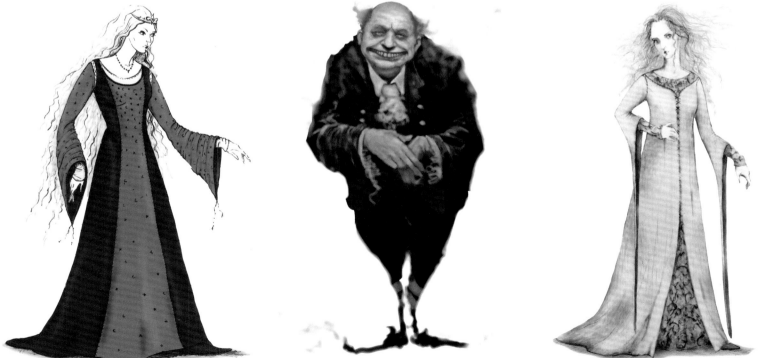

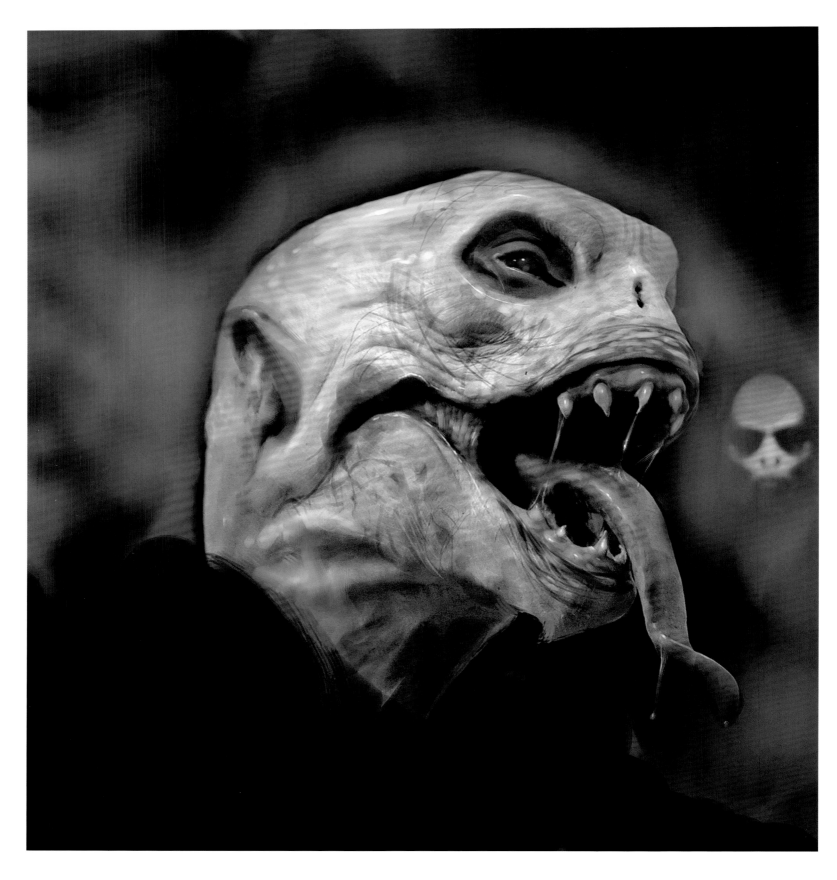

ABOVE: Visual development art by Paul Catling for *Harry Potter and the Sorcerer's Stone* shows Voldemort appearing on the back of Professor Quirrell's head.

OPPOSITE: Voldemort returns to his corporeal form in *Harry Potter and the Goblet of Fire* in a series of concepts by Paul Catling.

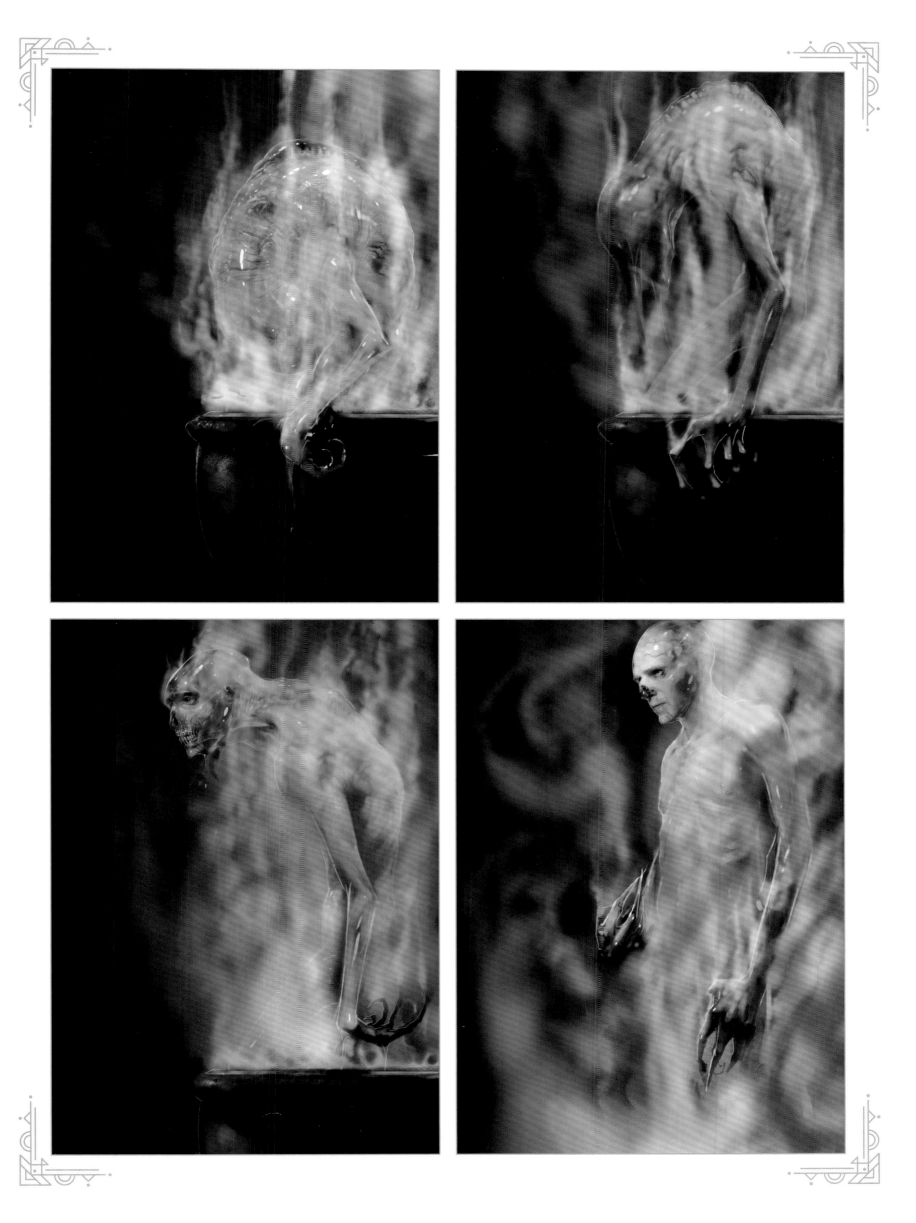

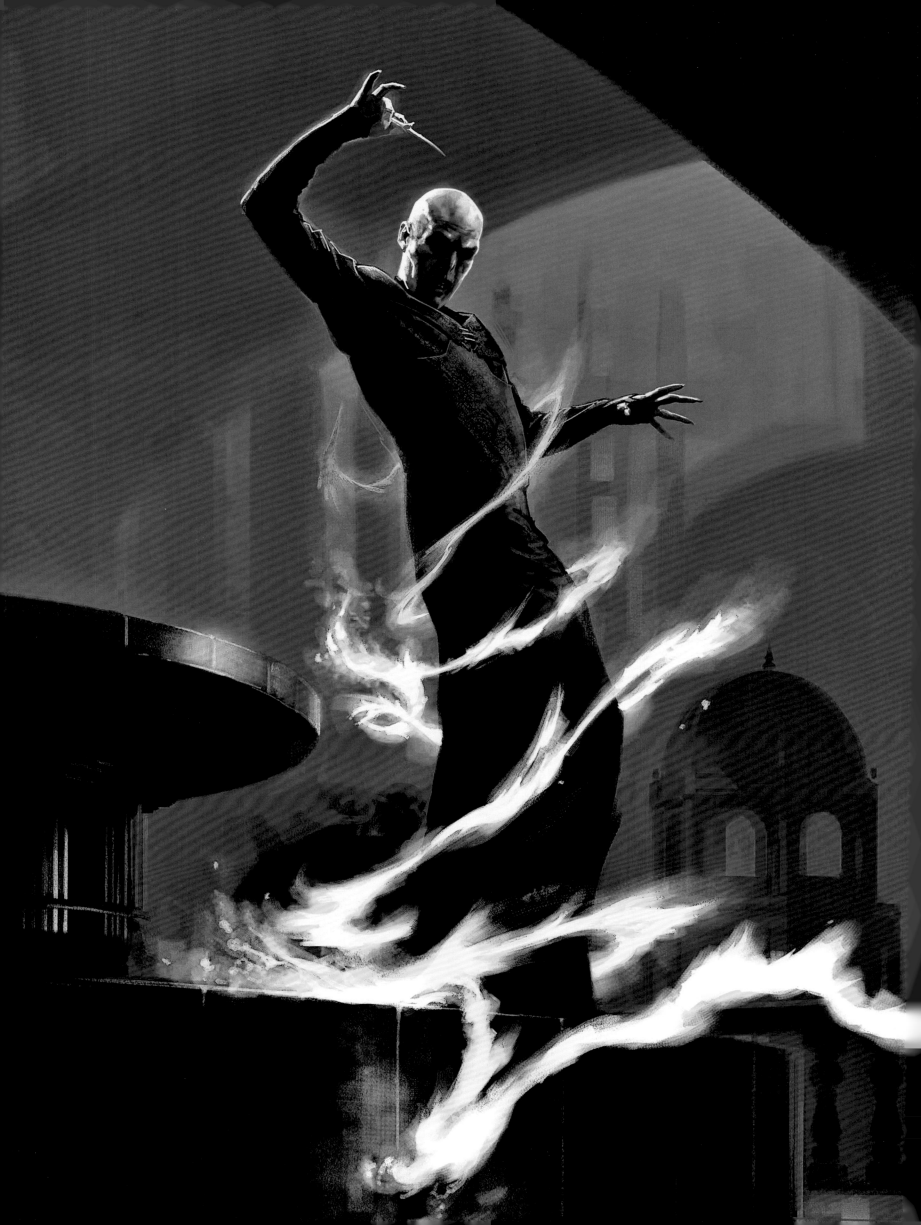

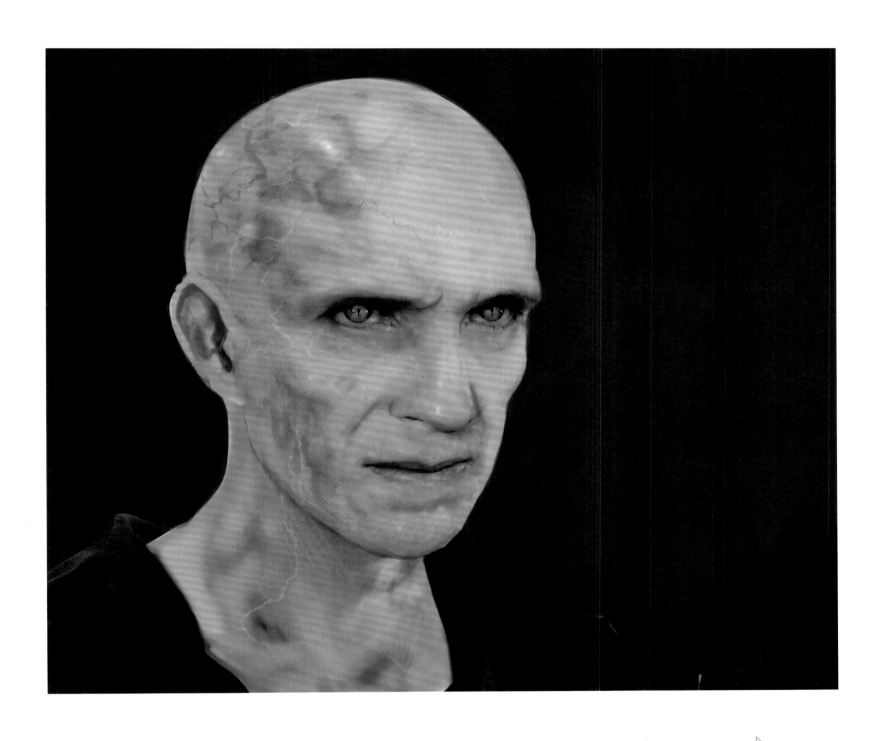

"It was foolish of you to come here tonight, Tom.
The Aurors are on their way."

–Professor Dumbledore, *Harry Potter and the Order of the Phoenix*

OPPOSITE: Artwork by Adam Brockbank of Voldemort surrounded by a lasso of fire cast by Dumbledore as they battle in the Ministry of Magic in *Harry Potter and the Order of the Phoenix*.

ABOVE: Concept art by Paul Catling of Ralph Fiennes as Voldemort for *Harry Potter and the Goblet of Fire*.

PAGE 148: Voldemort is surrounded by his Death Eaters in *Harry Potter and the Goblet of Fire*, in a scene depicted by Paul Catling.

PAGE 149: The Dark Mark extends over a town in artwork by Andrew Williamson for *Harry Potter and the Deathly Hallows – Part 2*.

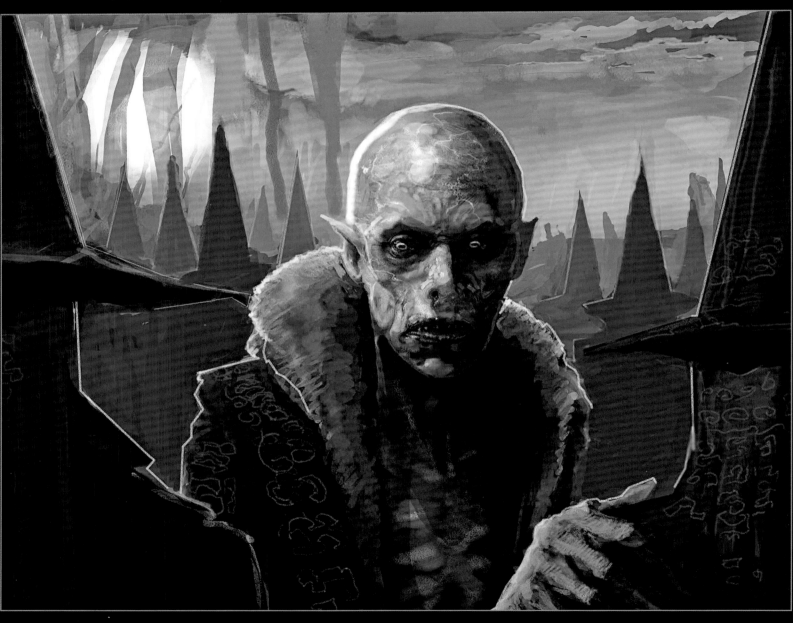

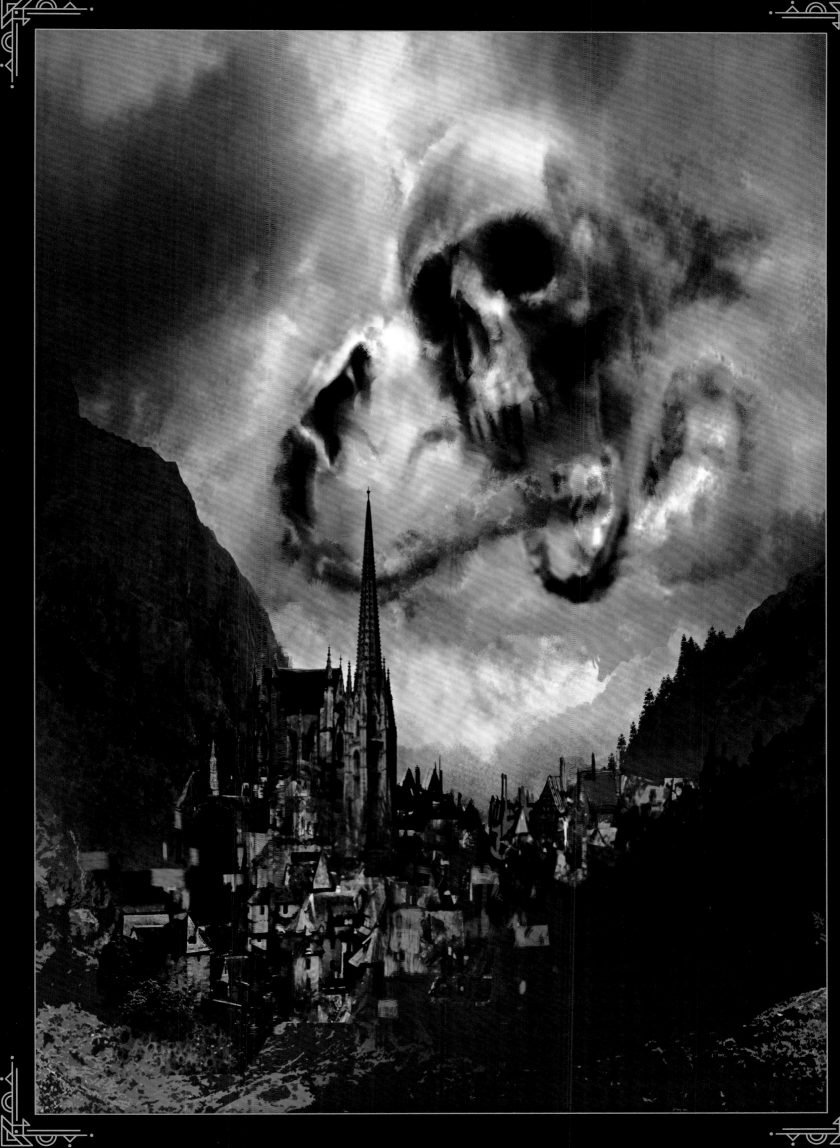

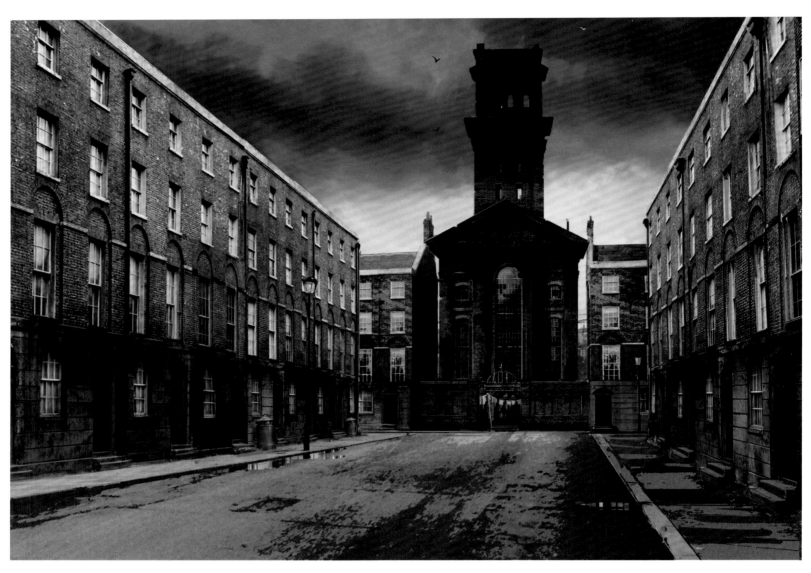

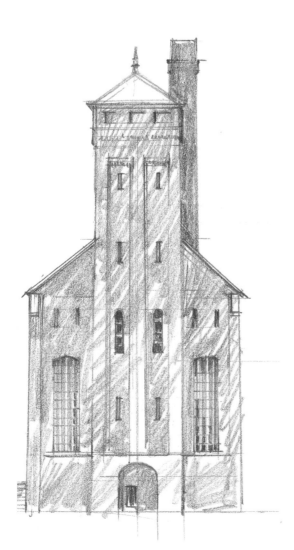

TOP: Wool's Orphanage, where Tom Riddle was raised until Dumbledore found him, painted by Andrew Williamson for *Harry Potter and the Half-Blood Prince*.

LEFT: A preliminary sketch of the orphanage.

ABOVE: Tom Riddle as a child. Costume design by Jany Temime for *Half-Blood Prince*. Drawn by Mauricio Carneiro.

OPPOSITE TOP: Dermot Power portrays the demise of Tom Riddle as Harry Potter destroys the diary Horcrux in *Harry Potter and the Chamber of Secrets*.

OPPOSITE BOTTOM: Harry Potter views an altered memory of Professor Slughorn's in the Pensieve in *Harry Potter and the Half-Blood Prince*. Artwork by Andrew Williamson.

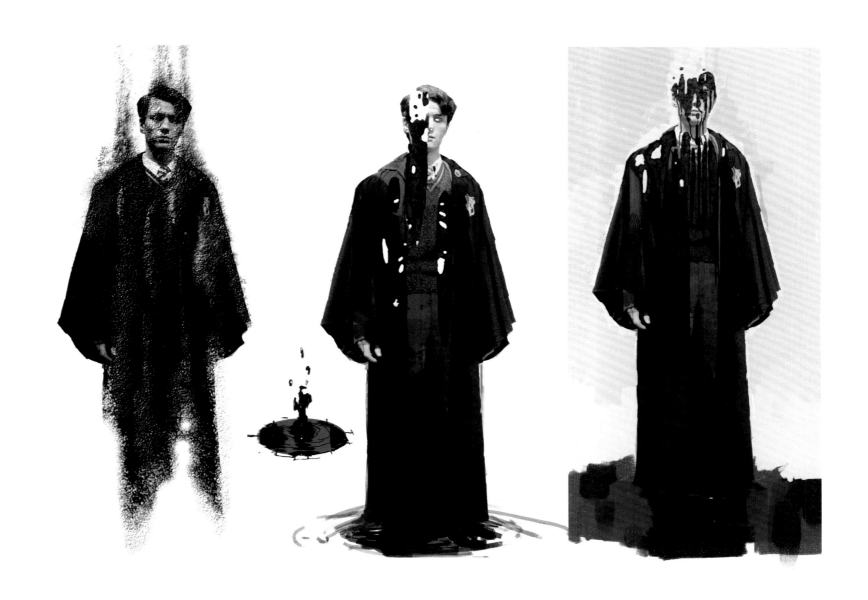

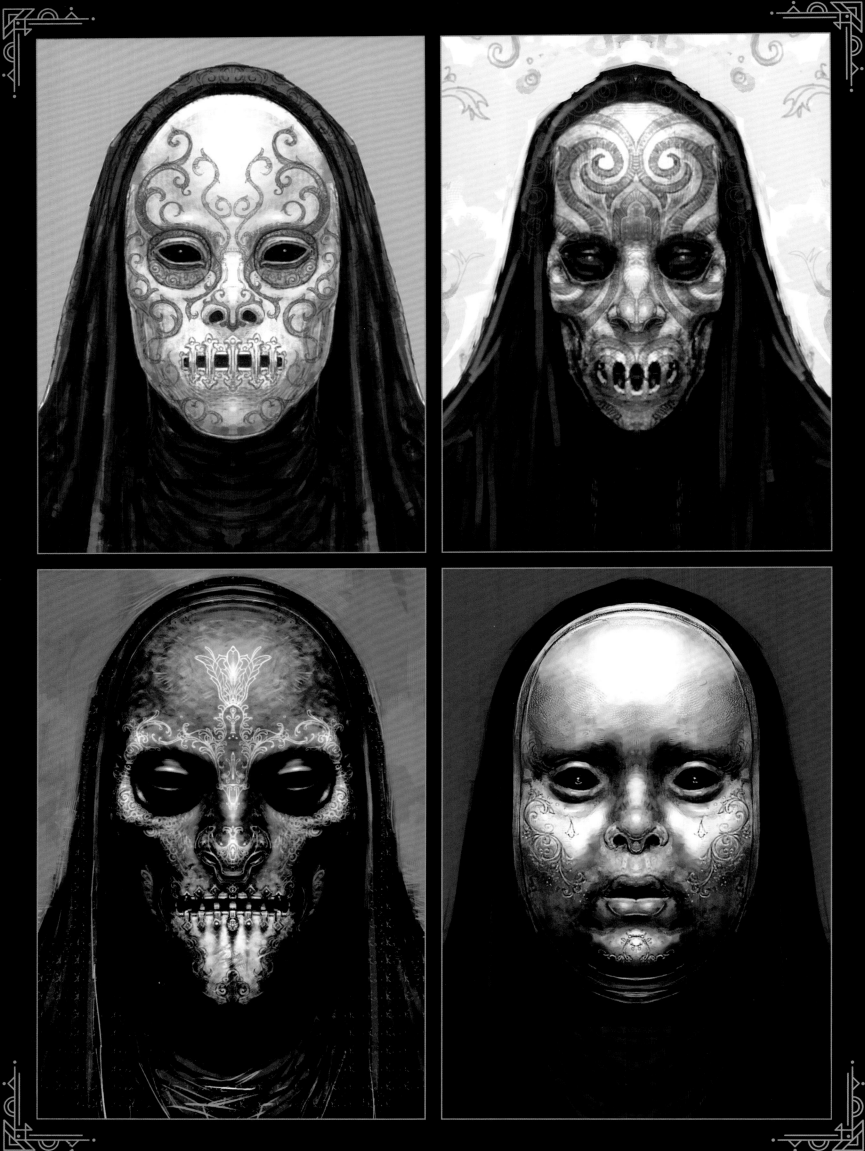

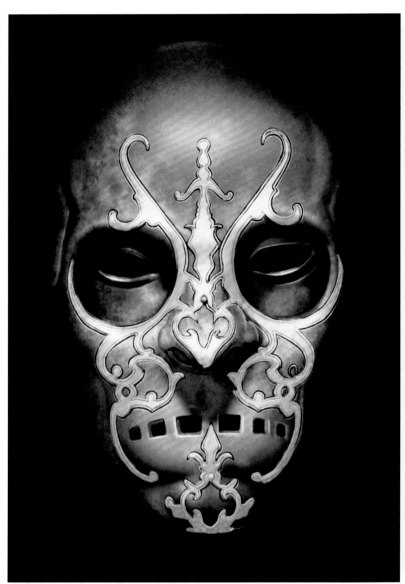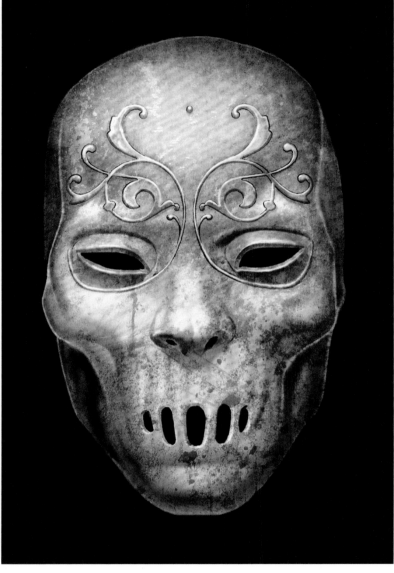

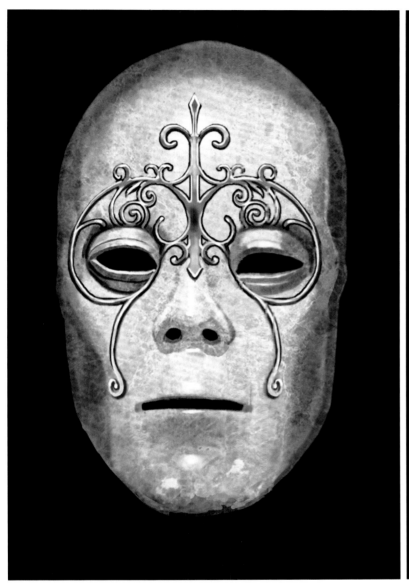
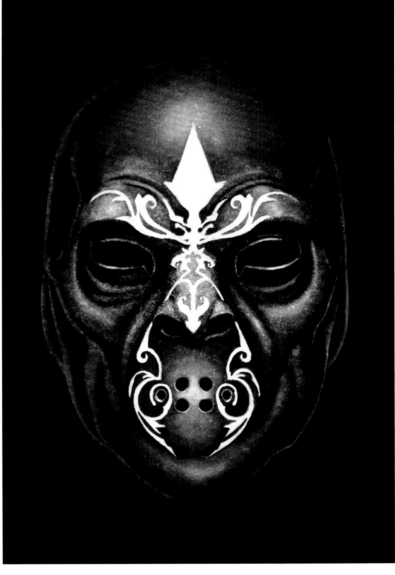

THE TRIWIZARD TOURNAMENT

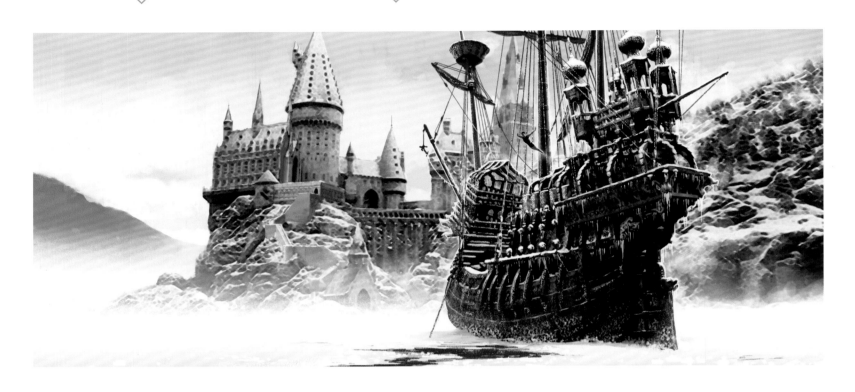

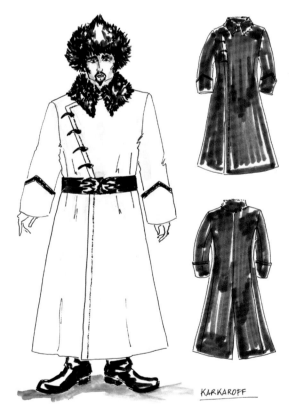

KARKAROFF

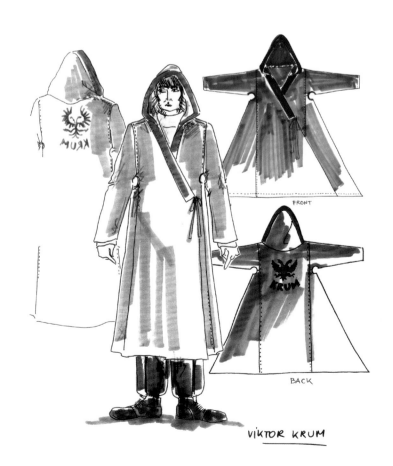

FRONT

BACK

VIKTOR KRUM

One of three wizarding schools competing for the Triwizard Tournament in *Harry Potter and the Goblet of Fire* was Durmstrang Institute. Their ship surfaced from beneath the Black Lake.

TOP: Adam Brockbank anchored the Durmstrang ship in a wintry clime.

ABOVE AND RIGHT: Costume designs for Headmaster Igor Karkaroff (*left*) and champion Viktor Krum (*right*) reflect the school's cold location. Costume design by Jany Temime, drawn by Mauricio Carneiro.

OPPOSITE: The Durmstrang ship rests upon a placid Black Lake in artwork by Geoffrey Huband.

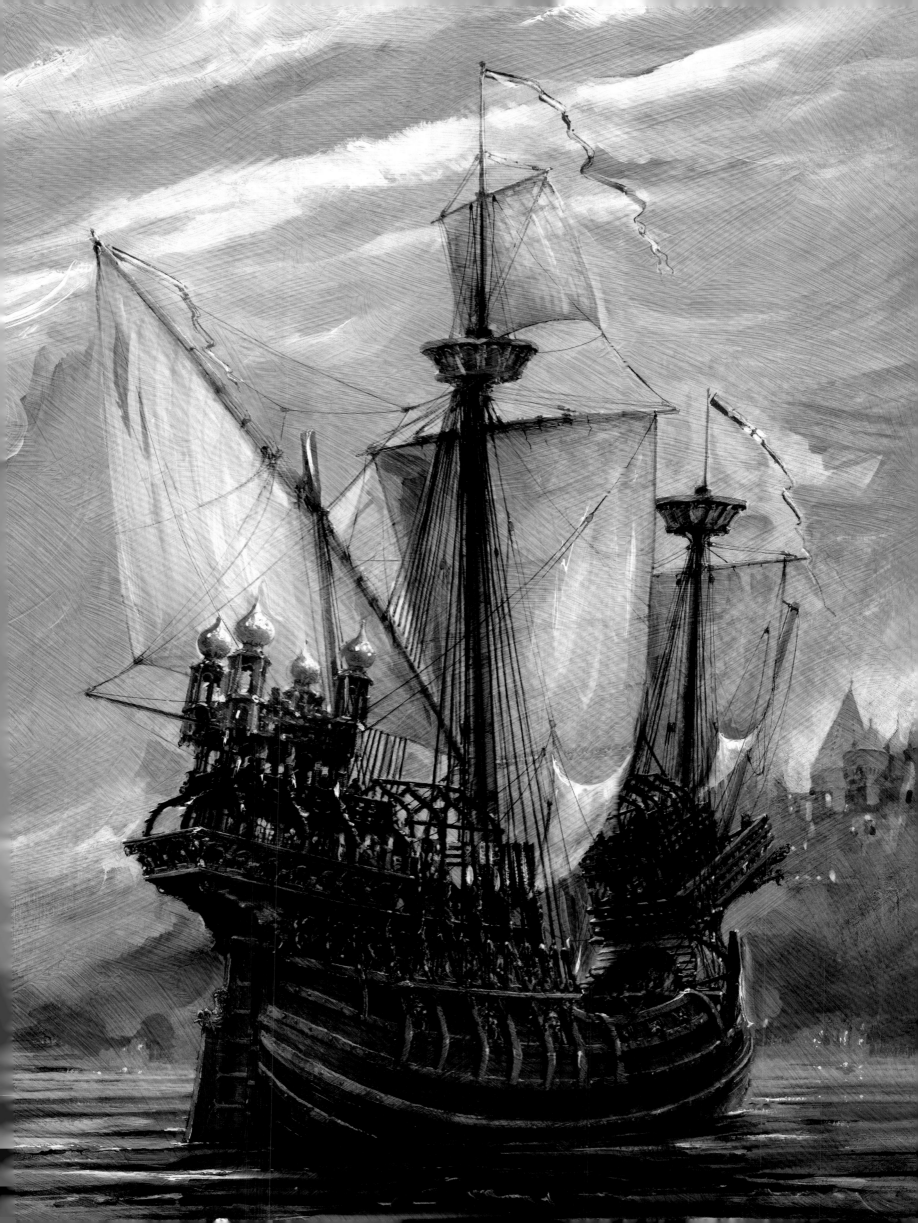

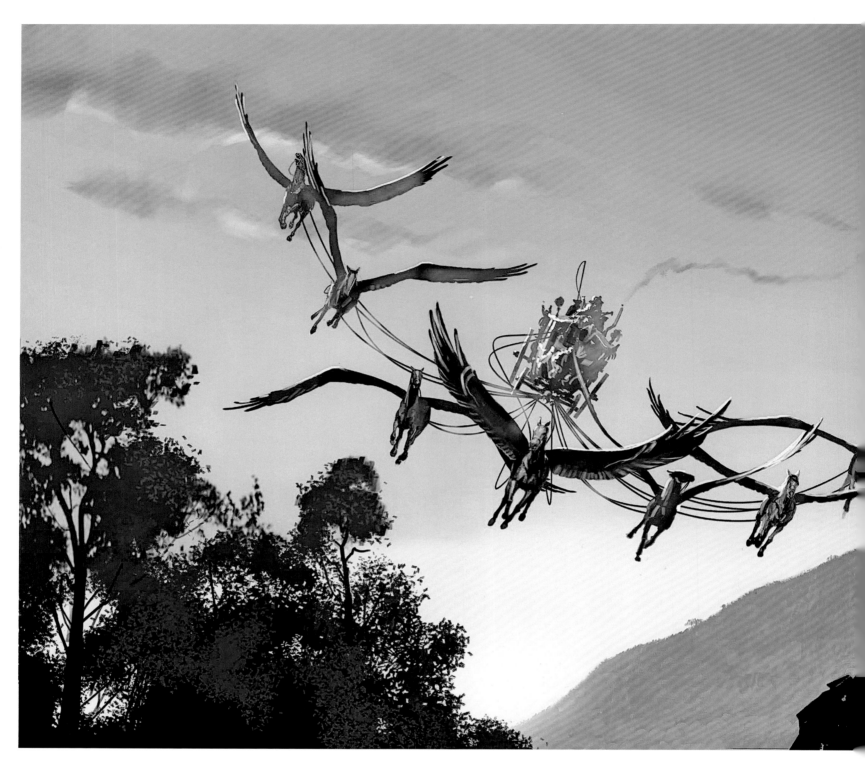

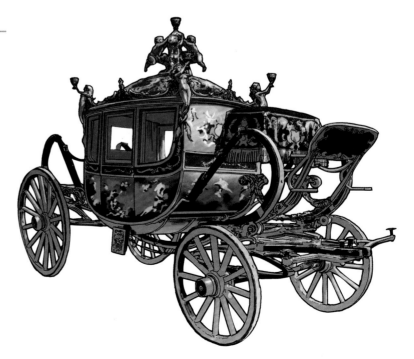

ABOVE: The Beauxbatons candidates arrive in a flying coach. Artwork by Andrew Williamson.

RIGHT: Concept artist Adam Brockbank illustrates a detailed version of the carriage.

OPPOSITE BOTTOM LEFT TO RIGHT: Headmistress Madame Olympe Maxime wore high collars of fur or feathers; Beauxbatons champion Fleur Delacour wears the appropriately colored "French blue" uniform of the school; the outfits for Rita Skeeter, the *Daily Prophet* reporter, always matched the Triwizard task she was reporting on. Costume designs by Jany Temime, drawn by Mauricio Carneiro.

PAGE 160 AND PAGE 161, BOTTOM: Harry Potter swallowed Gillyweed for the second task, which caused him to grow gills and webs between his fingers. Artwork by Dermot Power for *Harry Potter and the Goblet of Fire*.

PAGE 161, TOP: Hufflepuff champion Cedric Diggory used a Bubble-Head Charm underwater, as pictured by Adam Brockbank.

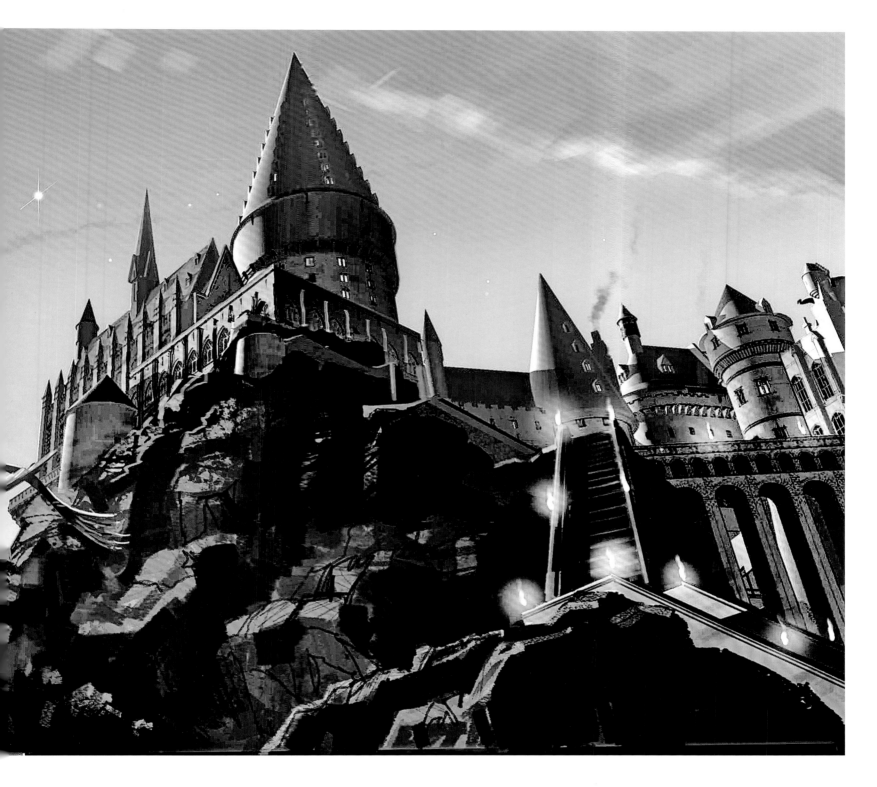

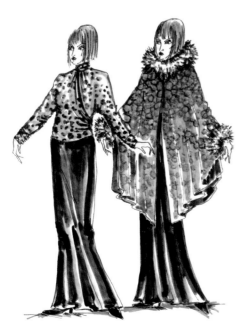

Madame Maxime

Beauxbaton girls

Rita Skeeter

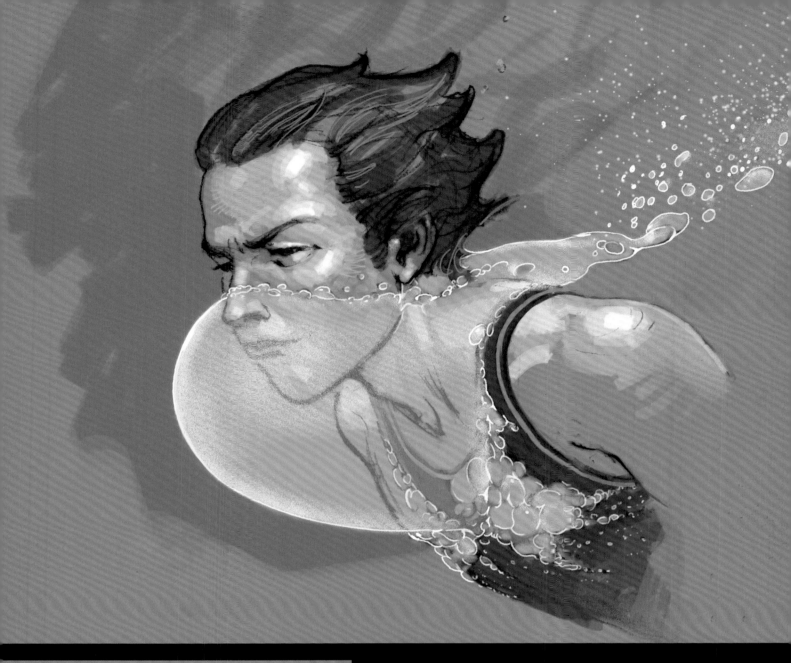

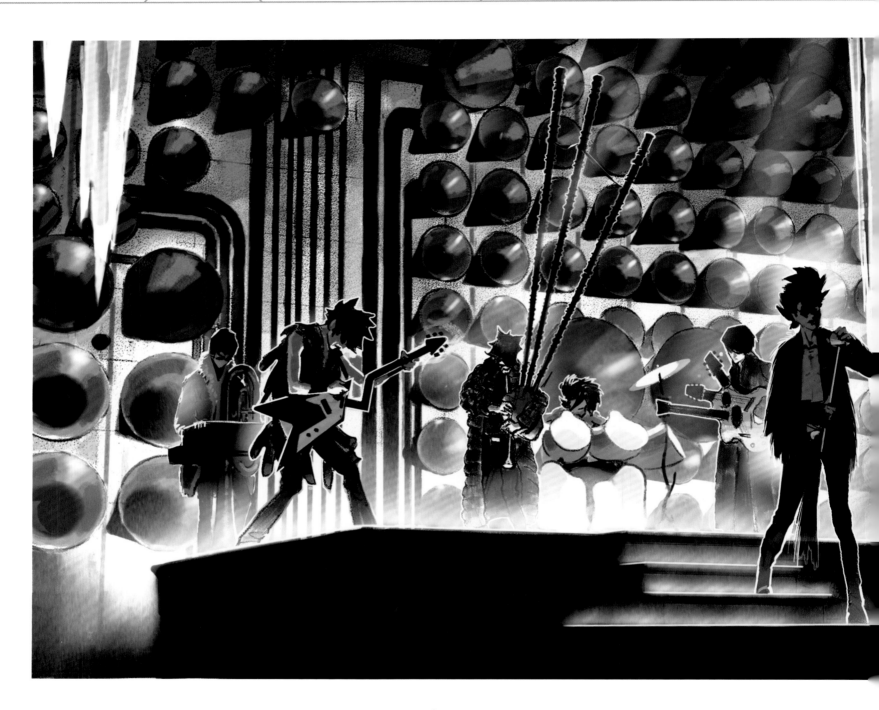

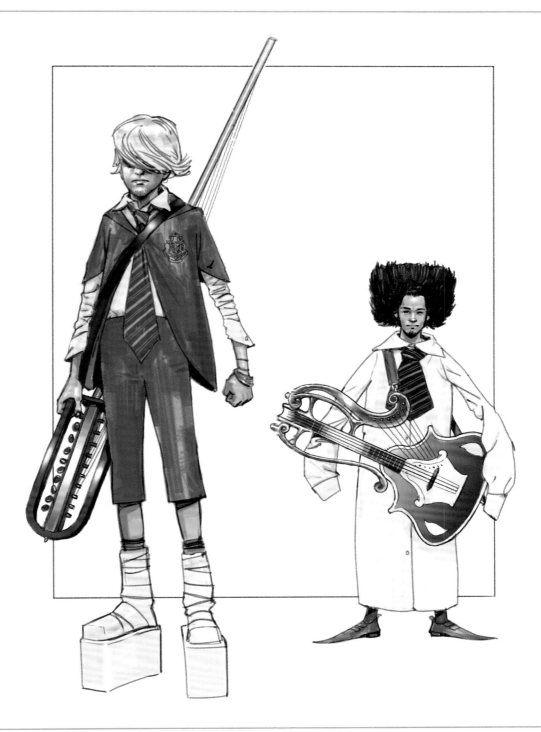

THESE PAGES: The Yule Ball ended with music by a wizard rock band featuring unique instruments. Artwork by Adam Brockbank.

163

THE MARAUDERS

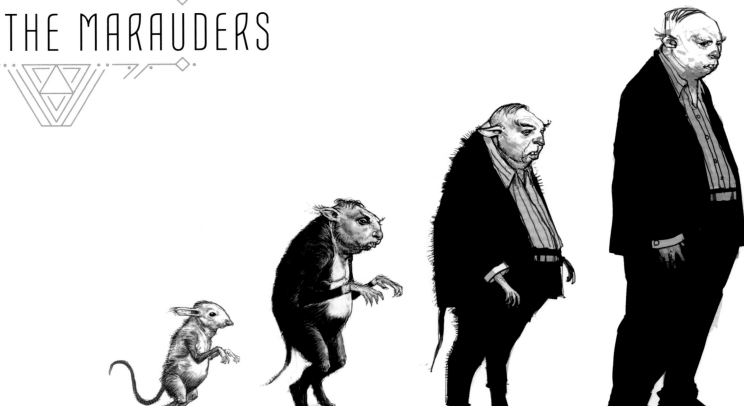

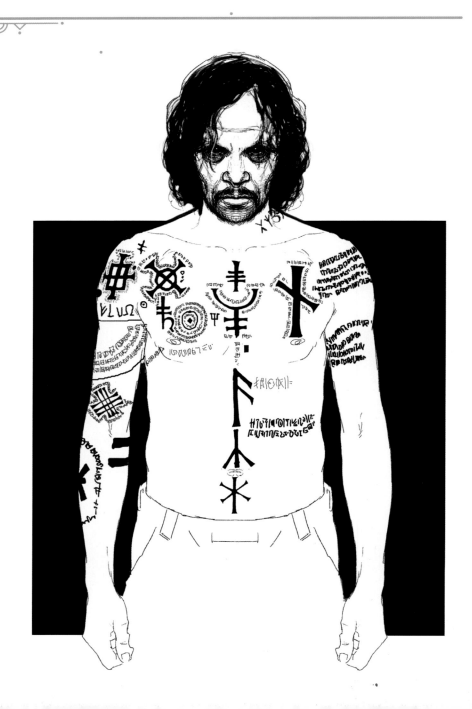

TOP: Adam Brockbank demonstrates how Animagus Peter Pettigrew, also known as Wormtail, transforms from rat to human.

RIGHT: Azkaban escapee Sirius Black was covered in tattoos. Ink by Adam Brockbank.

OPPOSITE: The Marauders, including James Potter, torment classmate Severus Snape in a flashback seen in *Harry Potter and the Half-Blood Prince*. Artwork by Andrew Williamson.

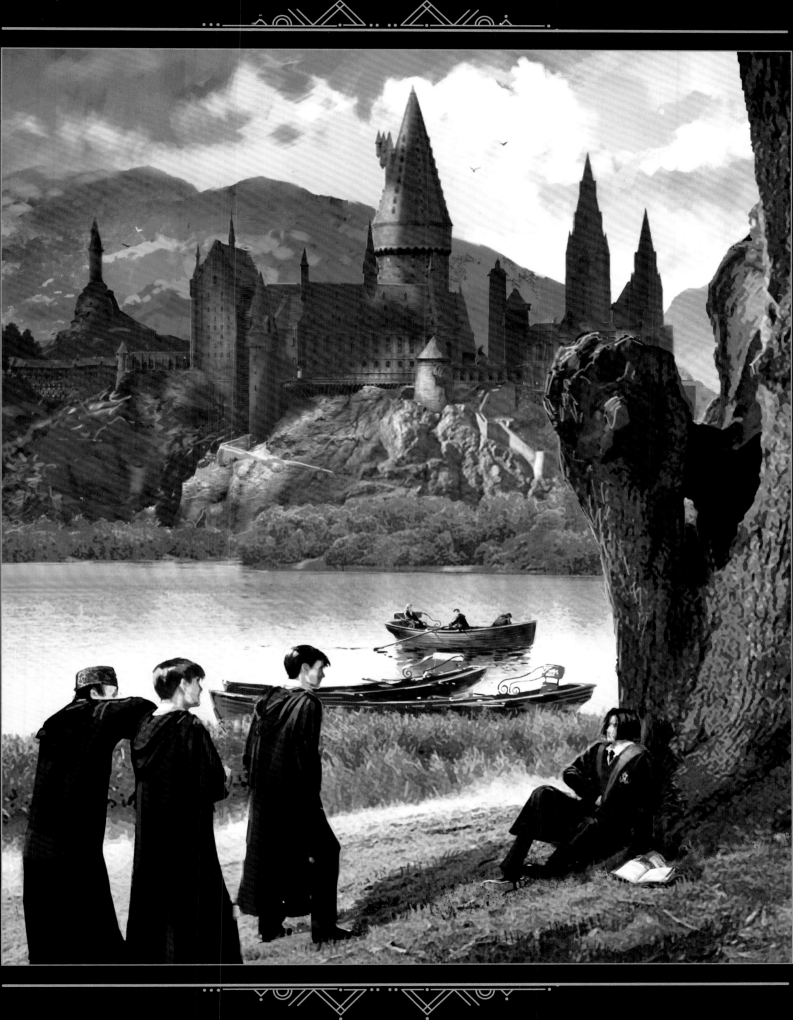

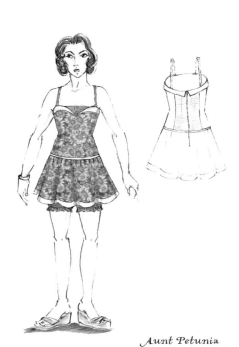

Aunt Petunia

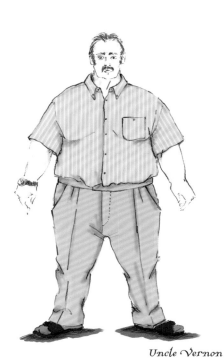

Uncle Vernon

TOP LEFT AND ABOVE: Costume designs by Jany Temime for Aunt Petunia and Uncle Vernon, drawn by Mauricio Carneiro.

TOP RIGHT AND OPPOSITE: Dermot Power showcases the different stages of Vernon Dursley's sister, Marge, as she expands and floats away after she provokes Harry Potter into inadvertently casting a spell in *Harry Potter and the Prisoner of Azkaban*.

THE ORDER OF THE PHOENIX

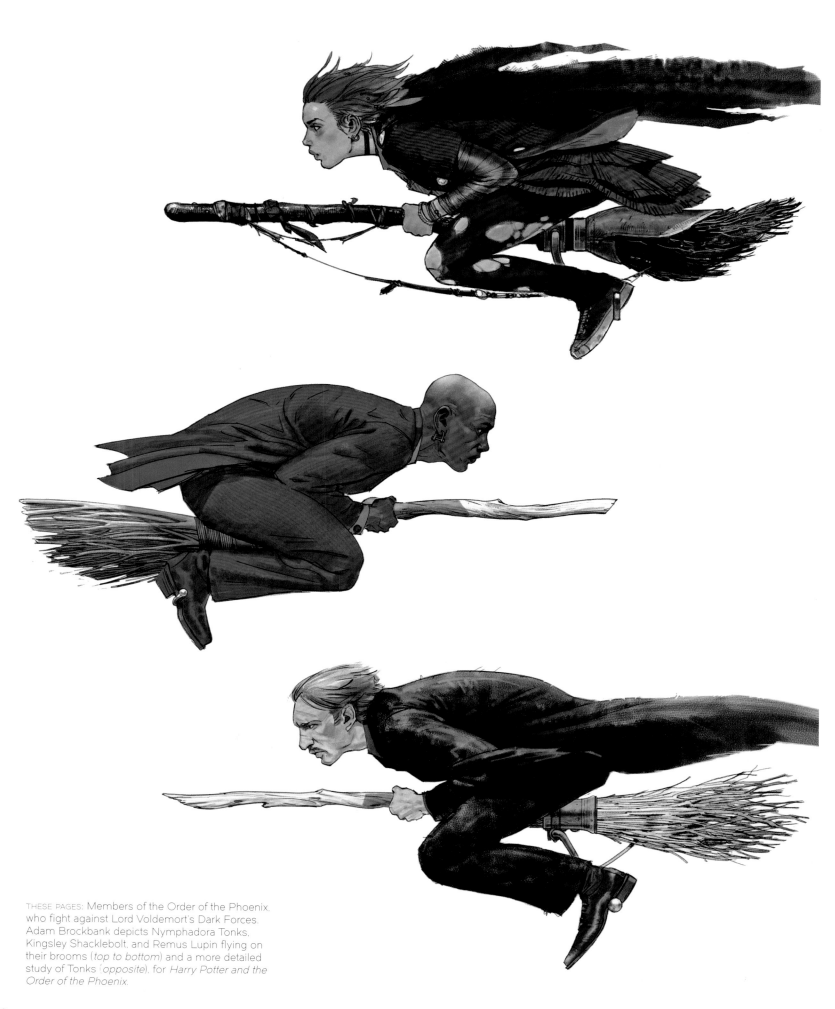

THESE PAGES: Members of the Order of the Phoenix, who fight against Lord Voldemort's Dark Forces. Adam Brockbank depicts Nymphadora Tonks, Kingsley Shacklebolt, and Remus Lupin flying on their brooms (*top to bottom*) and a more detailed study of Tonks (*opposite*), for *Harry Potter and the Order of the Phoenix*.

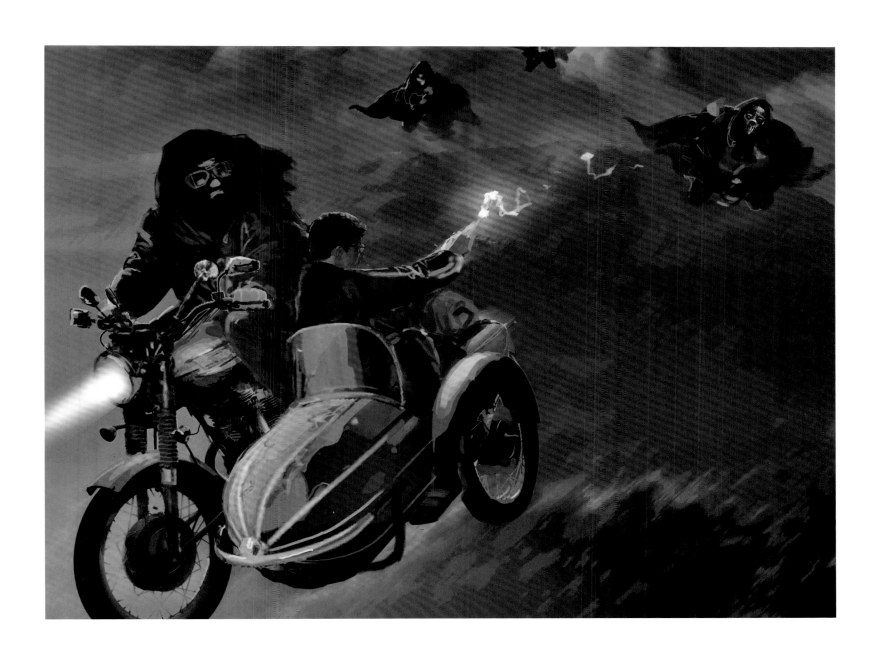

"Hold tight, Harry."

—Rubeus Hagrid,
Harry Potter and the Deathly Hallows - Part 1

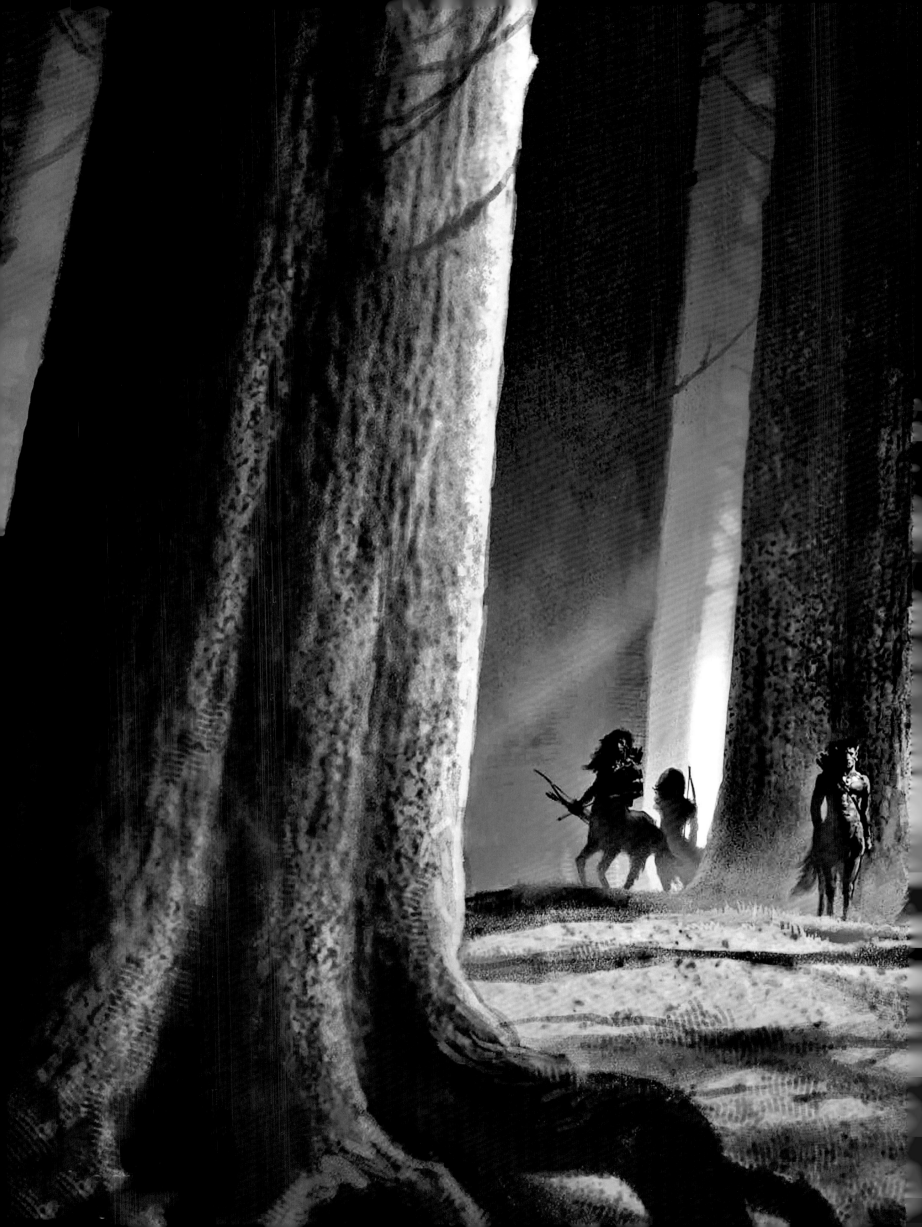

CHAPTER 3
MAGICAL CREATURES

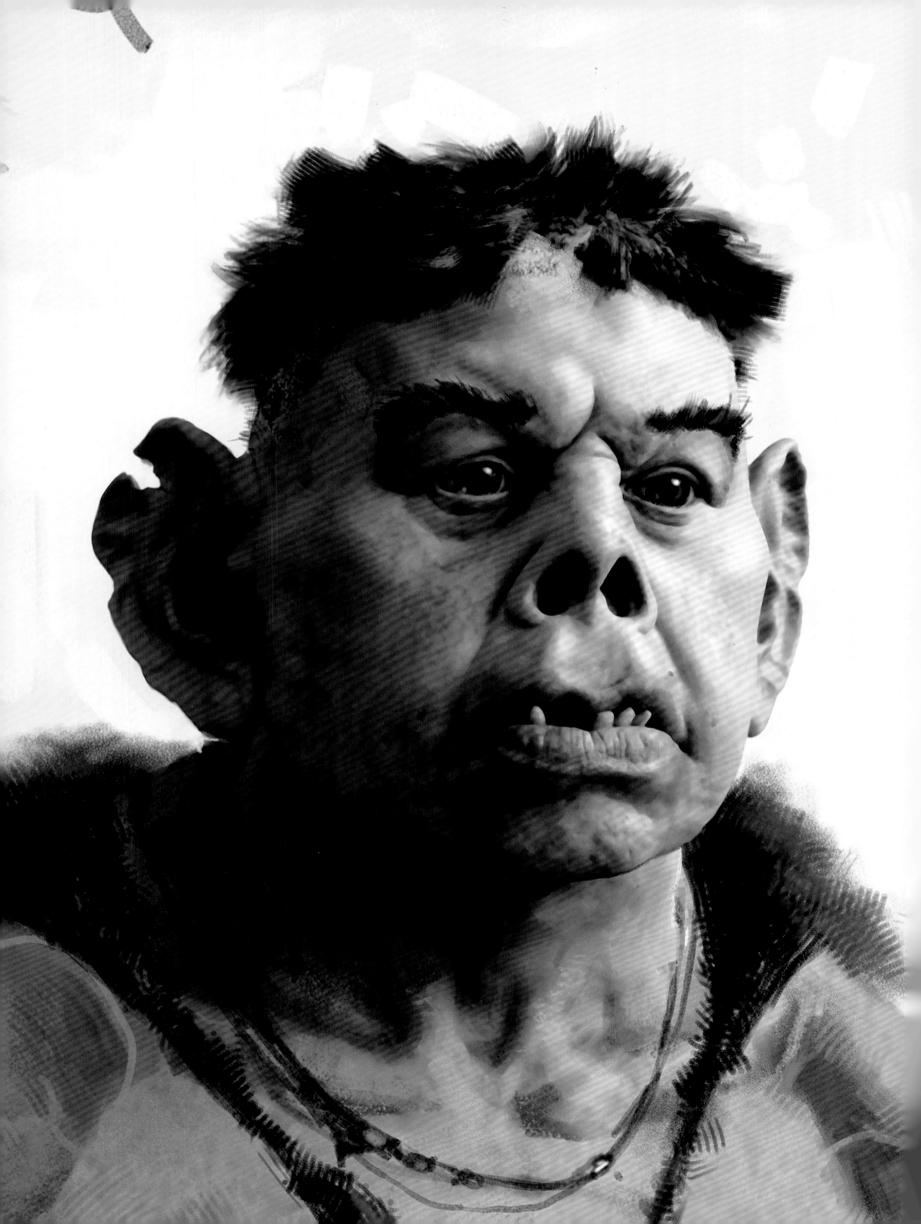

Wizards and Muggles may get most of the focus in the films, but the wizarding world wouldn't be nearly as enchanting without the myriad of fantastic beasts that dwell within it. From giants and merpeople to Grindylows and Hippogriffs, the on-screen origins of all these magical creatures can be traced back to creature effects designer Nick Dudman and his team.

"We start off very early on with creature design work," Dudman says. "Myself and lots of other people will have ideas when we first read the book . . . But we start with preliminary drawings and concepts done through the art department."

Many of the species featured in the books are entirely new creations that dwell only within the wizarding world, allowing the artists free rein to explore Rowling's vision without any preconceived notions. However, there are also many classic mythological beasts that play important roles in the series, including werewolves and dragons. This created a unique challenge for the design team—to reimagine these centuries-old creature concepts in a way that felt distinctive to these films.

"I think the main problem with things like dragons is that your audience thinks that they know exactly what a dragon looks like," Dudman says. "And so the task isn't so much to create a dragon but rather to create a new look for a dragon that is fresh and interesting but doesn't break the brief that people have in their heads."

In some cases, the greatest challenge came simply from finding a way to take a time-tested mythological monster that has been traditionally depicted in two dimensions and update them in way that would effectively translate to a three-dimensional design. One such creature was the centaur, an ancient creature in which Dudman found a number of anatomical inadequacies that required rethinking.

"We've approached it slightly differently," Dudman says, "and I feel that what we've got is not half a man, half a horse—it's a totally separate creature that fulfills the brief of a centaur perfectly, but it looks like a single object. It doesn't look like some man and horse sewn together, like an object made up of two separate things. And we put a lot of thought into that."

The unified design of the centaur in some ways reflects the creature design process as a whole, taking the best that each member of the team has to offer and combining it into the highest-quality end result.

"The original design is no one person's thing," Dudman says. "Our concept artist produces a range of designs, and then Stuart Craig, myself, and anyone else who's involved all tie that together, and it evolves as it goes. So it's not a case of looking back and saying, at what point did it look like the way I thought it would look? It's a group effort."

That effort continued in a highly collaborative way long after the concept design was approved, as an enclave of more than a hundred artisans—including sculptors, mold makers, painters, and animators— worked together to bring each of these fantastic beasts to life.

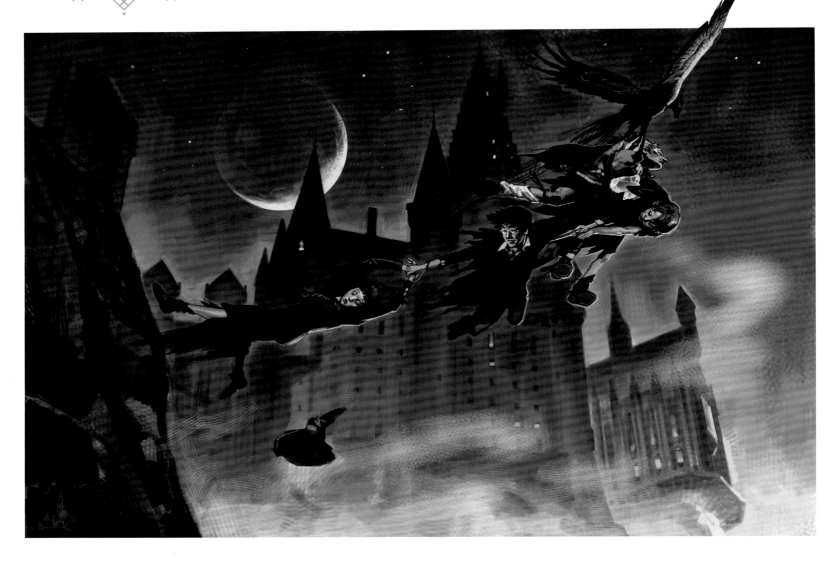

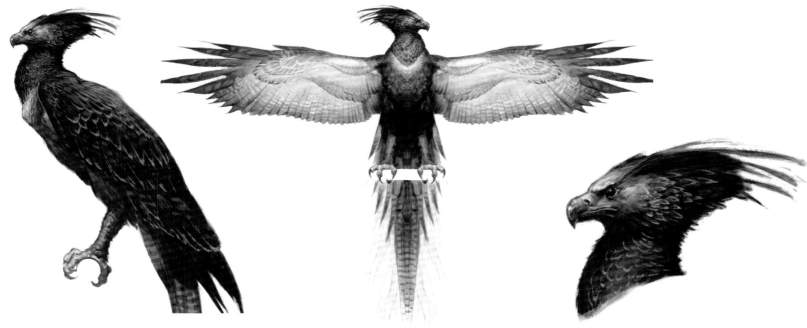

ABOVE AND OPPOSITE: Feather and color studies of Dumbledore's phoenix, Fawkes, by Adam Brockbank for *Harry Potter and the Chamber of Secrets.*

TOP: Brockbank depicts Fawkes rescuing Professor Lockhart, Harry Potter, and Ron Weasley from the *Chamber of Secrets.*

PAGE 178: Harry Potter is comforted by Hedwig, his owl, in artwork by Dermot Power for *Chamber of Secrets.*

PAGE 179, TOP RIGHT: Hedwig carries away a message in *Harry Potter and the Goblet of Fire* by Adam Brockbank.

PAGE 179, BOTTOM RIGHT: Detailed sketches of owl types for *Harry Potter and the Half-Blood Prince* by an unknown artist.

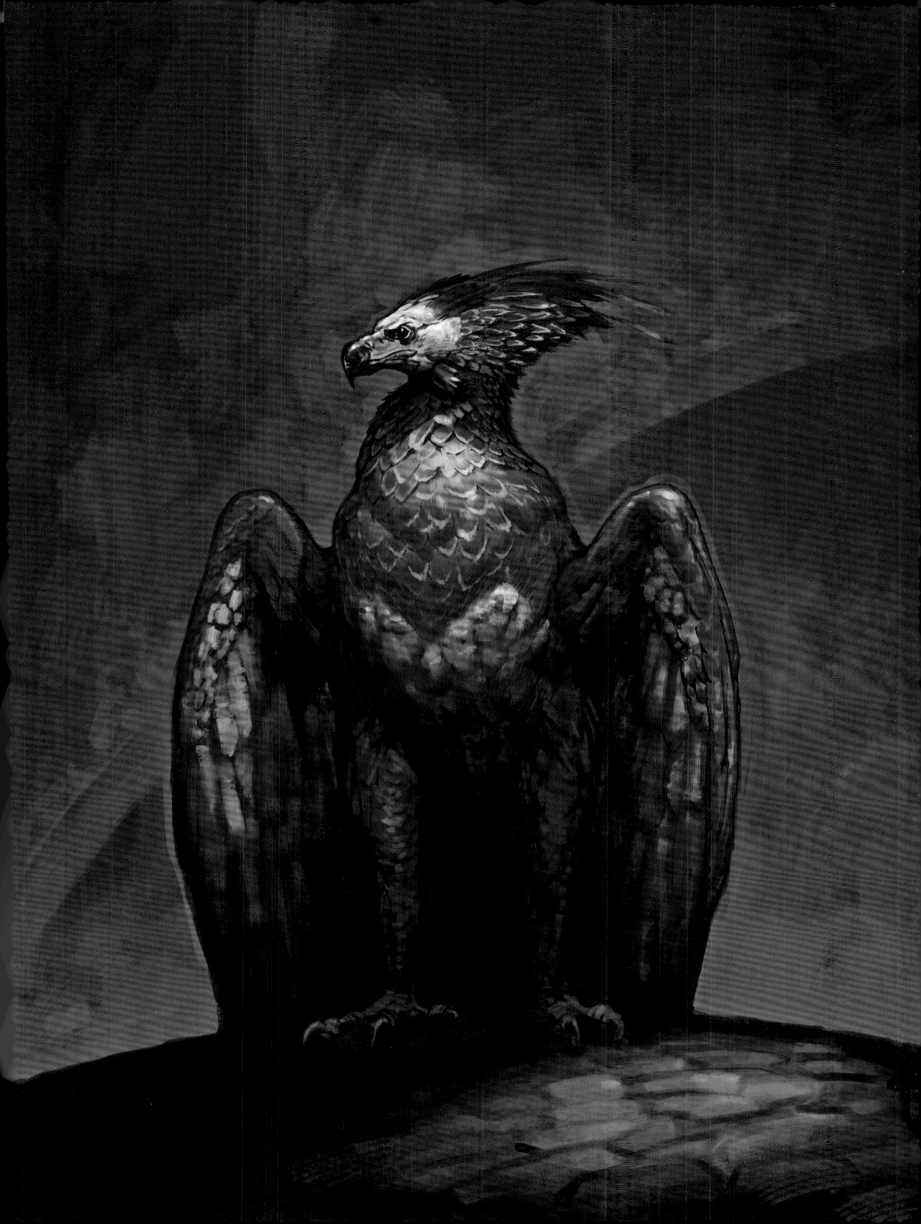

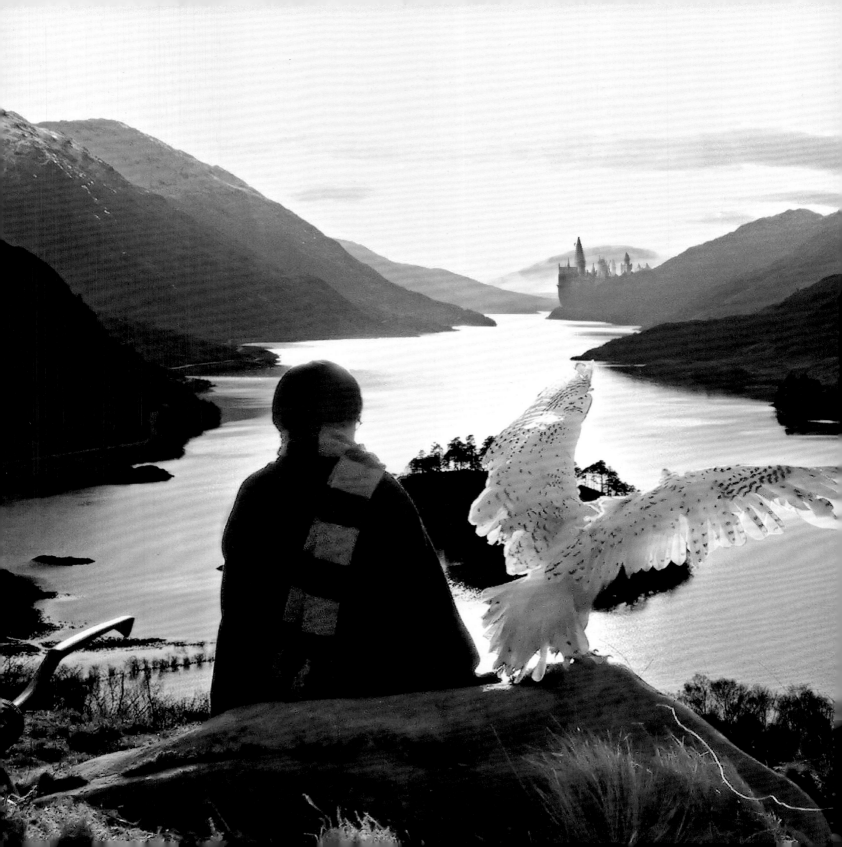

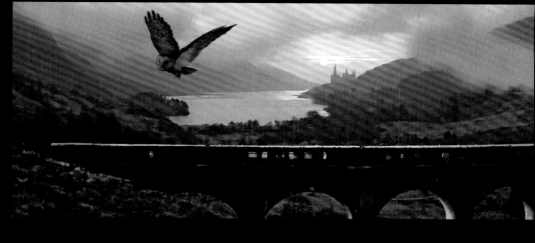
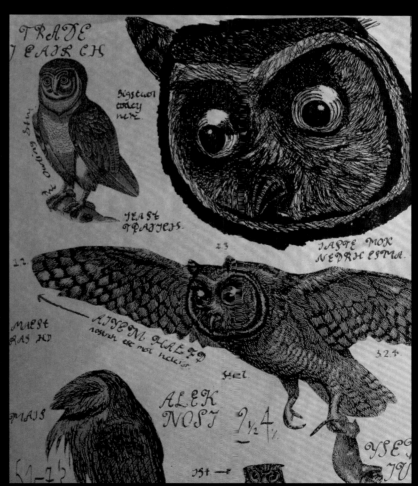

THE FORBIDDEN FOREST

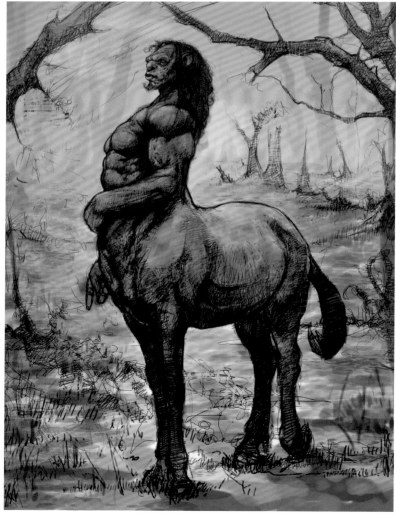

The centaurs are a unique and seamless composite of human and horse.

RIGHT, BELOW LEFT, AND OPPOSITE: Bane, one of the centaur leaders, in studies by Adam Brockbank for *Harry Potter and the Order or the Phoenix.*

BELOW RIGHT: Centaur by Paul Catling for *Harry Potter and the Sorcerer's Stone.*

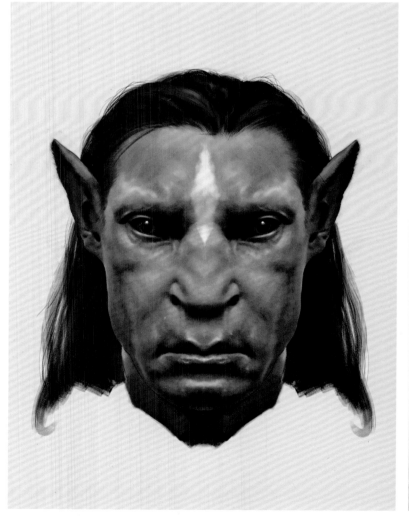

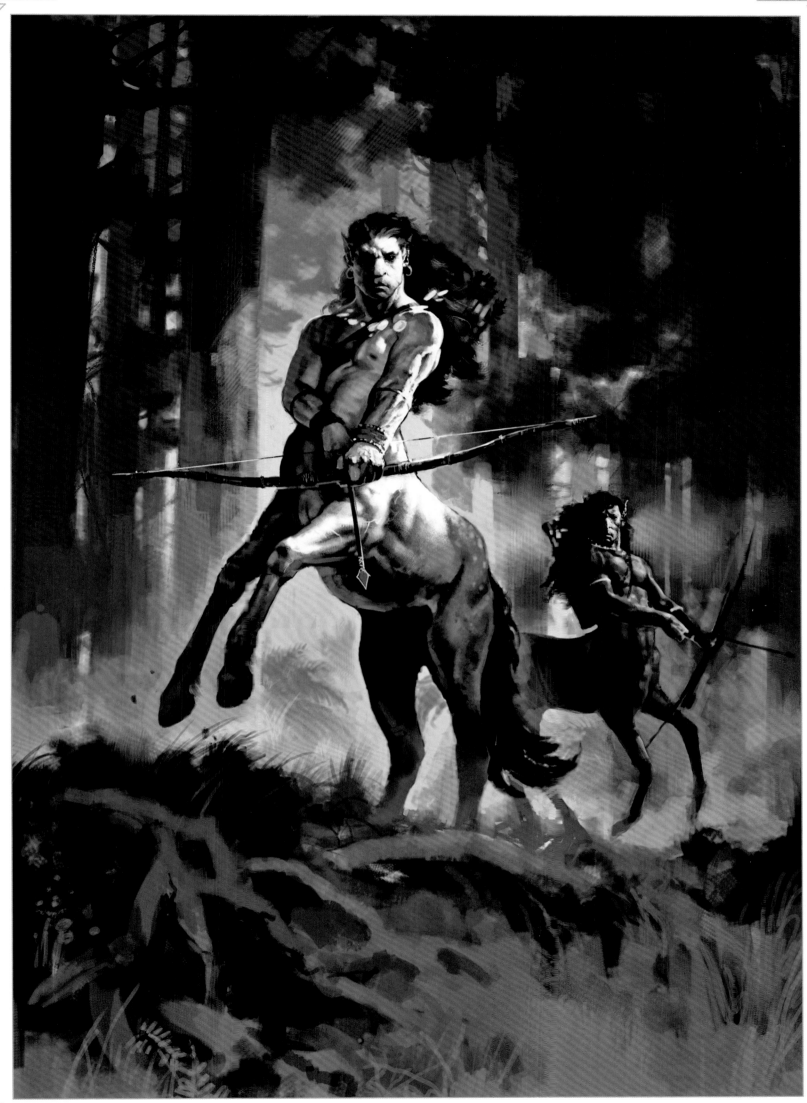

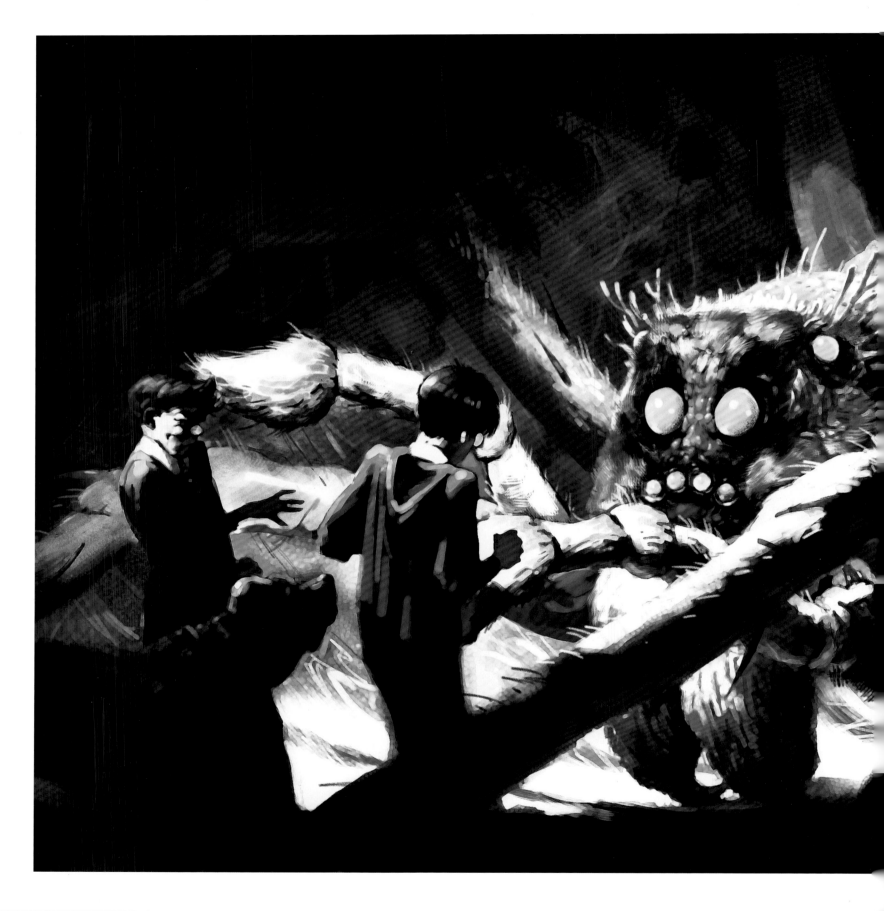

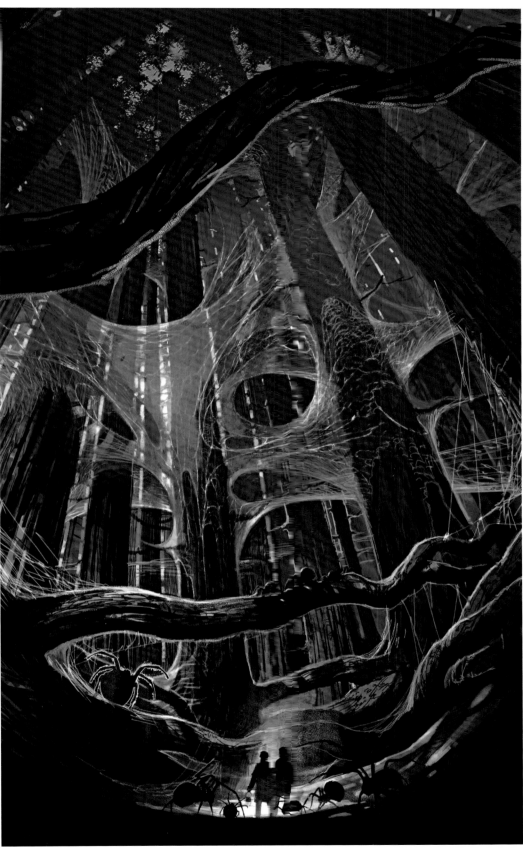

In a scene deleted from the script of *Harry Potter and the Chamber of Secrets*, gnomes invade the Weasleys' garden. Gnome studies by Adam Brockbank (*opposite and top right*) and Paul Catling (*left and top left*).

FOLLOWING PAGES: Artwork by Adam Brockbank for *Harry Potter and the Order of the Phoenix* for the scene in which Grawp picks up Hermione.

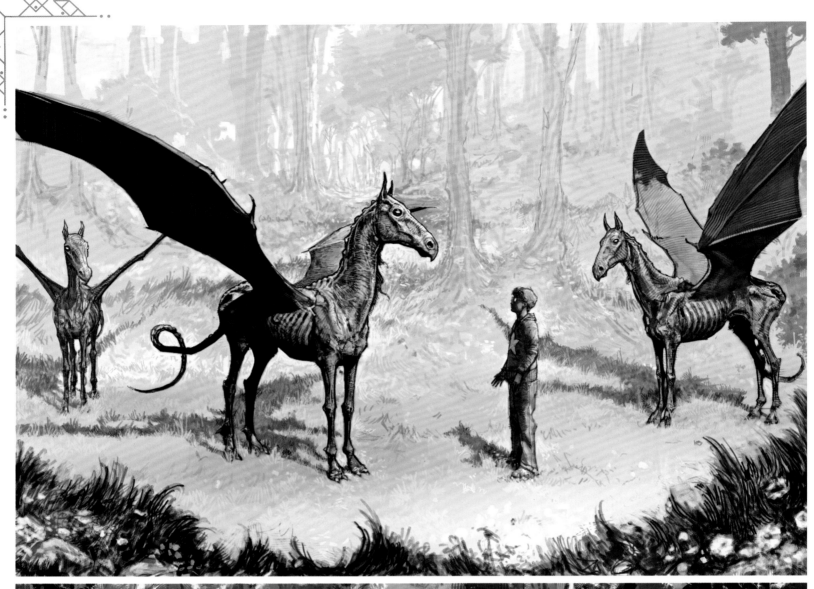

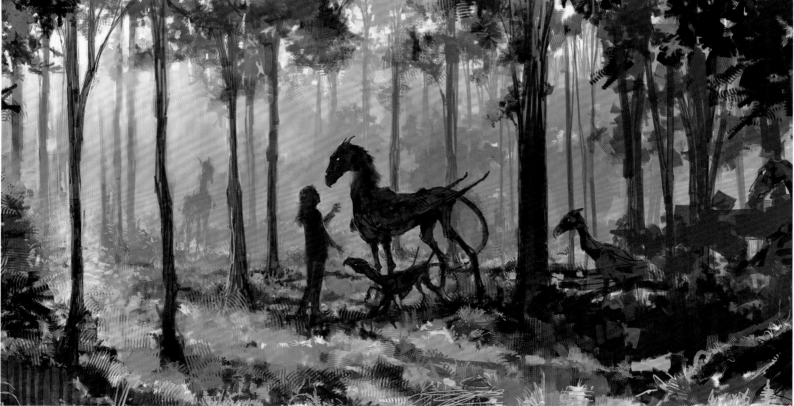

THIS PAGE: Thestrals appear in *Harry Potter and the Order of the Phoenix* but only to those who have witnessed death. Rob Bliss illustrated Thestrals with Harry Potter and Luna Lovegood.

OPPOSITE: Rob Bliss provides a stunning profile of the regal creature.

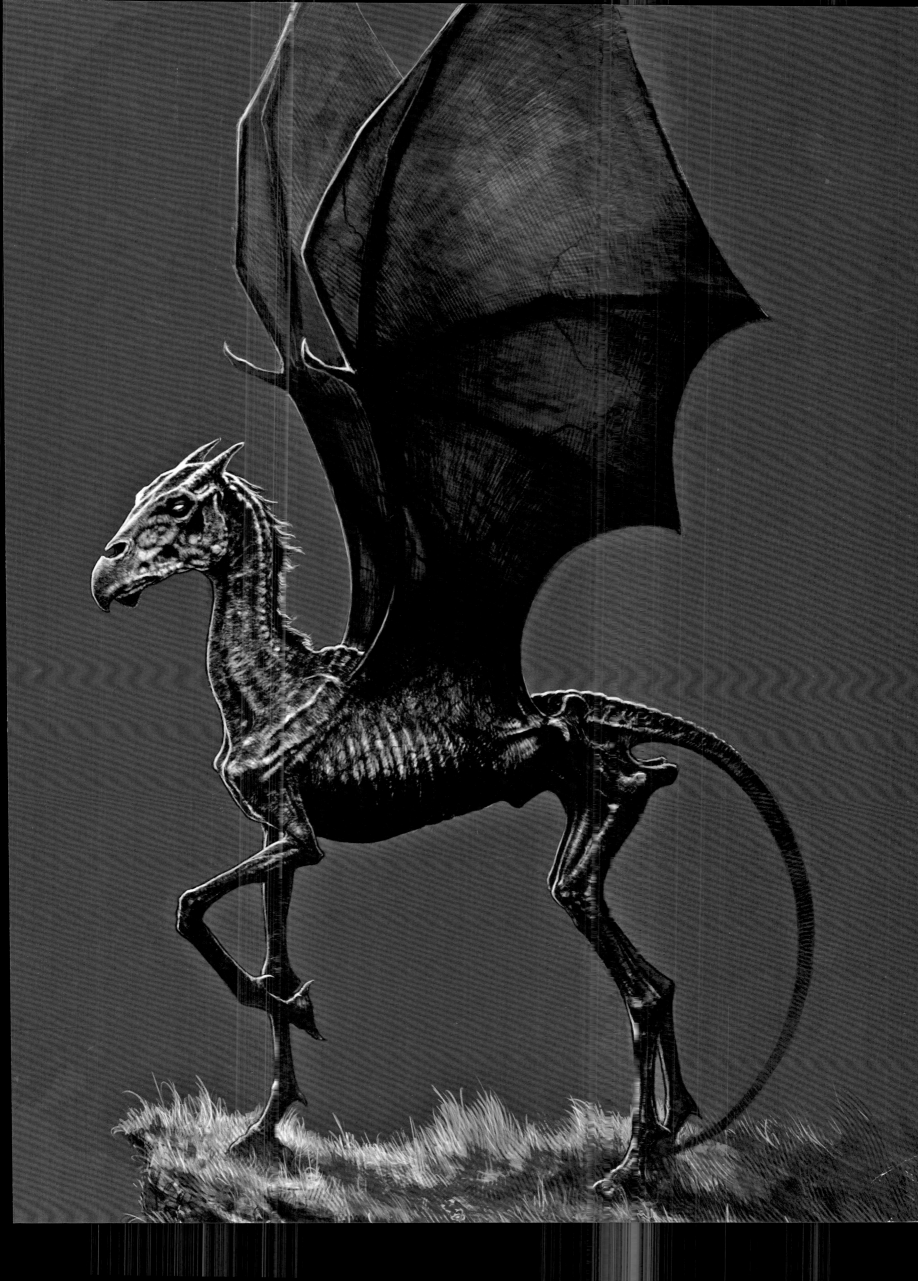

THESE PAGES: Artist Rob Bliss portrays the members of
Dumbledore's Army flying on Thestrals to the Ministry of
Magic, hoping to save Sirius Black, Harry's godfather, in
Harry Potter and the Order of the Phoenix.

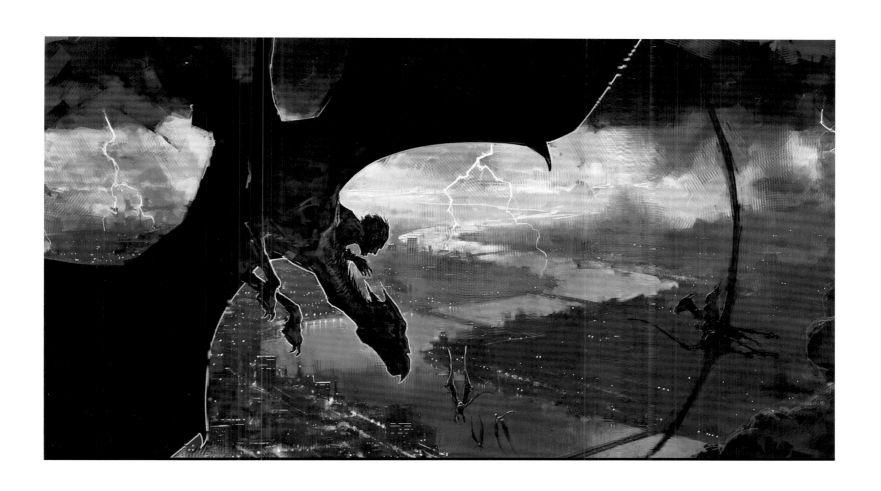

THE BLACK LAKE

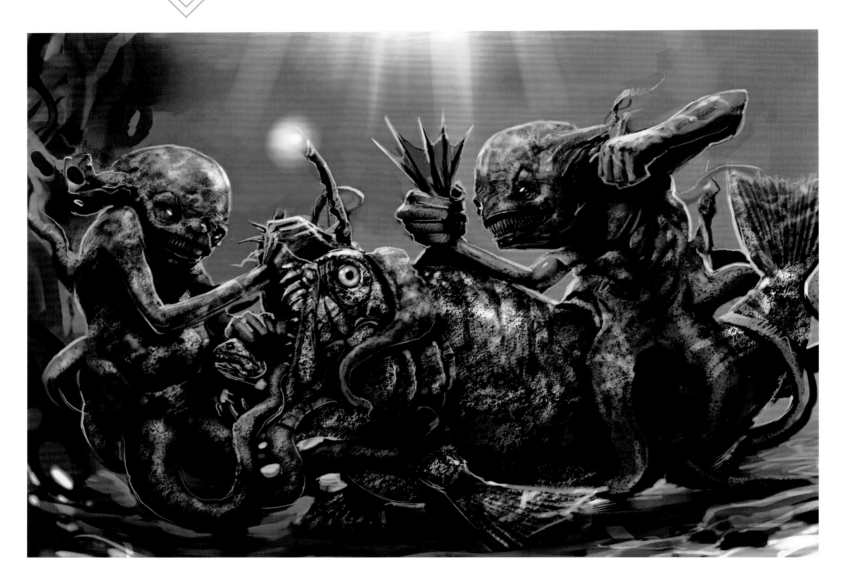

THESE PAGES: Harry Potter ran into some trouble with Grindylows, impish creatures who live in the Black Lake, during the second task of the Triwizard Tournament, in *Harry Potter and the Goblet of Fire*. Visual development art by Paul Catling.

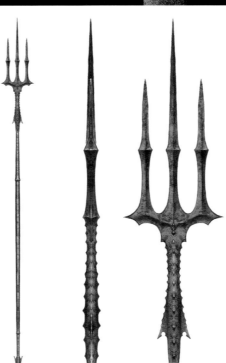

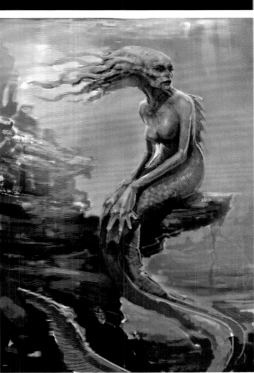

The merpeople's in requested for the second task of
the Triwizard Tou in *Harry Potter and the Goblet of Fire*.

OPPOSITE AND TOP: Adam Brockbank po Harry getting aid from a merperson—
a scene that did not occur in fi —and a merperson with tentacled hair.

ABOVE Visual development art by Dermot Power.

ABOVE MIDDLE: Studies o people's tridents by Adam Brockbank.

ABOV Visual development art by Paul Catling.

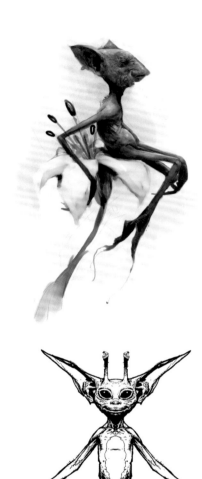

Professor Gilderoy Lockhart unleashes Cornish pixies in his classroom in *Harry Potter and the Chamber of Secrets*.

ABOVE LEFT: Study of Cornish pixie anatomy by Rob Bliss.

TOP LEFT, ABOVE RIGHT, AND OPPOSITE: Visual development of the Cornish pixies by unknown artists.

THESE PAGES: The Hippogriff Buckbeak was
introduced in Hagrid's Care of Magical Creatures
class in *Harry Potter and the Prisoner of Azkaban*.
Dermot Power illustrates Buckbeak's feathers
and wingspan (*opposite bottom*), and shows how
Harry with Hermione (*above*), and Harry with Sirius
(*opposite top*), fly and sit atop the creature.

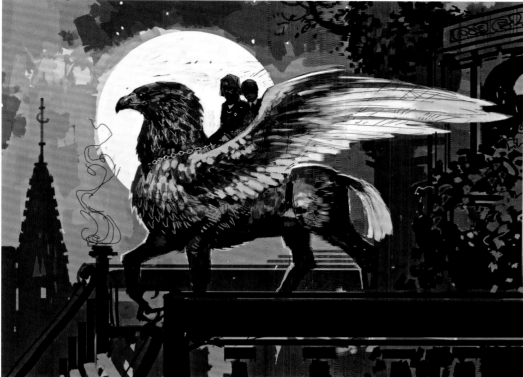

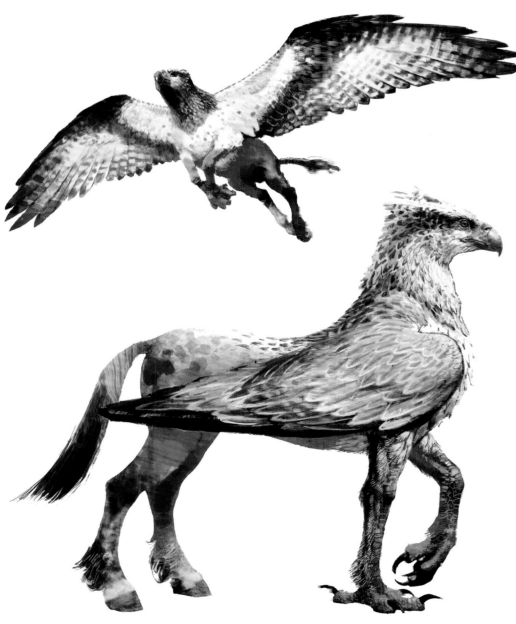

DRAGONS

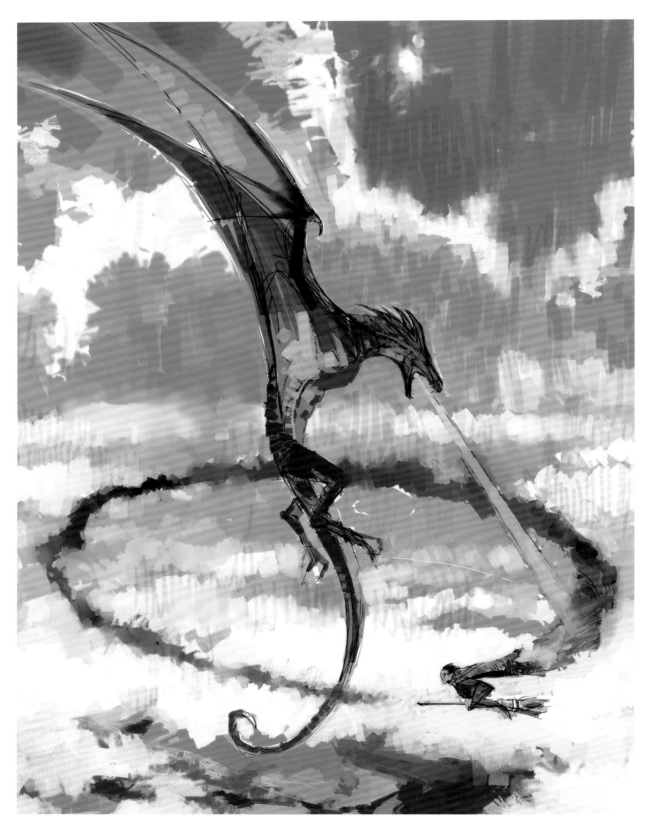

The first task of the Triwizard Tournament involves dragons in *Harry Potter and the Goblet of Fire*.

ABOVE: Harry Potter narrowly avoids dragon flames in artwork by Dermot Power.

OPPOSITE: Paul Catling's visual development of the Hungarian Horntail, the dragon assigned to Harry.

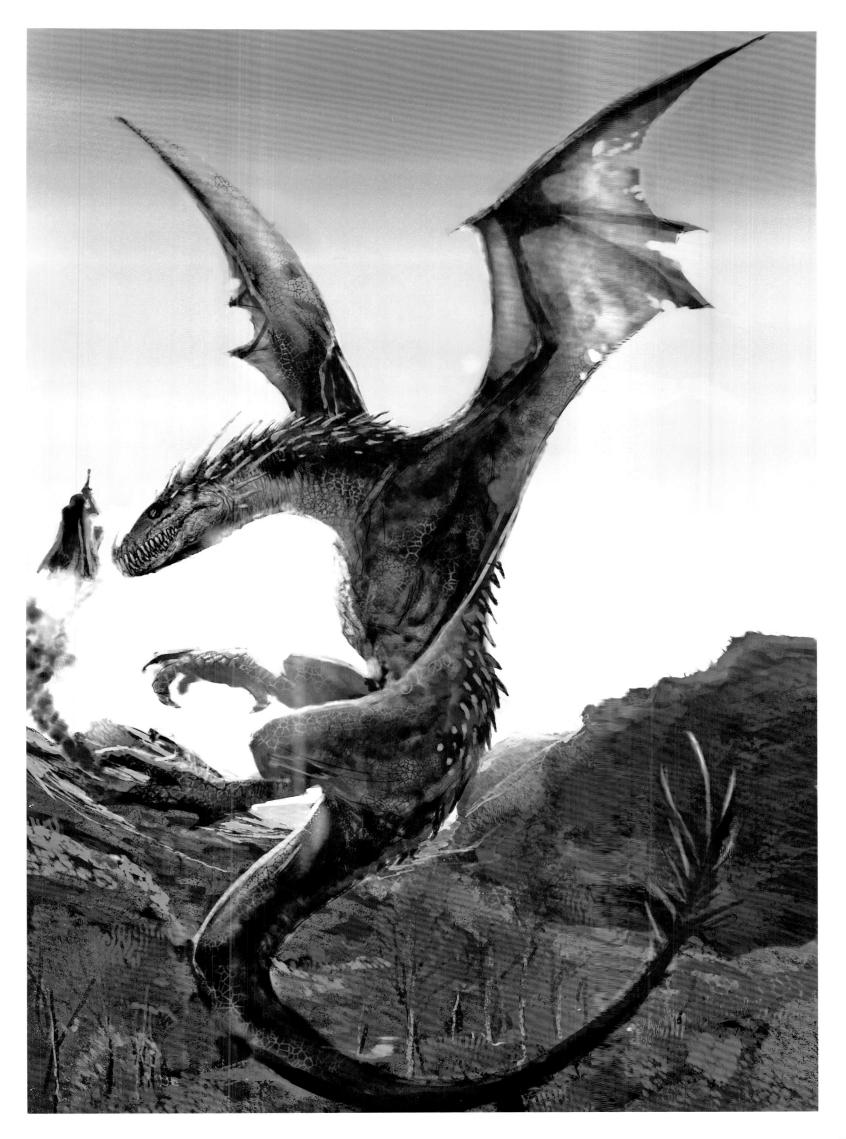

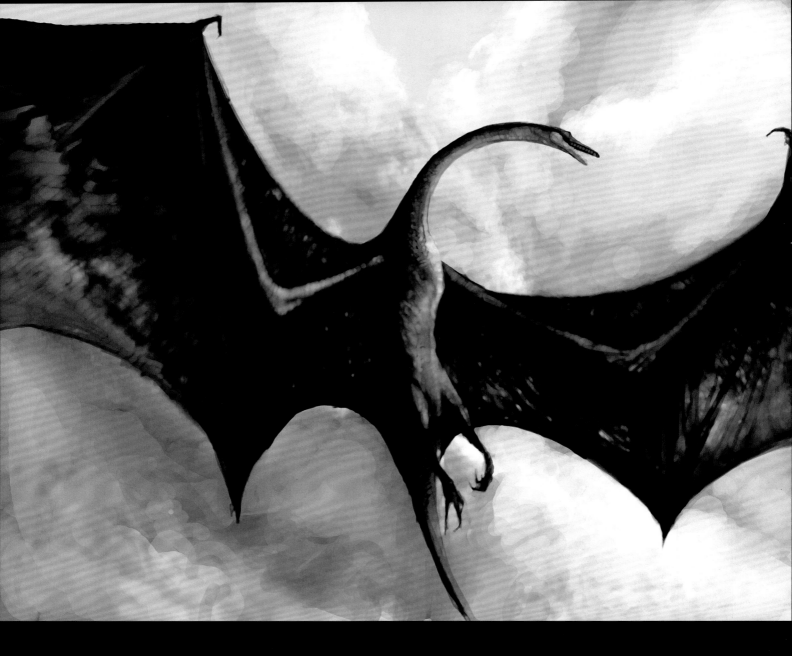

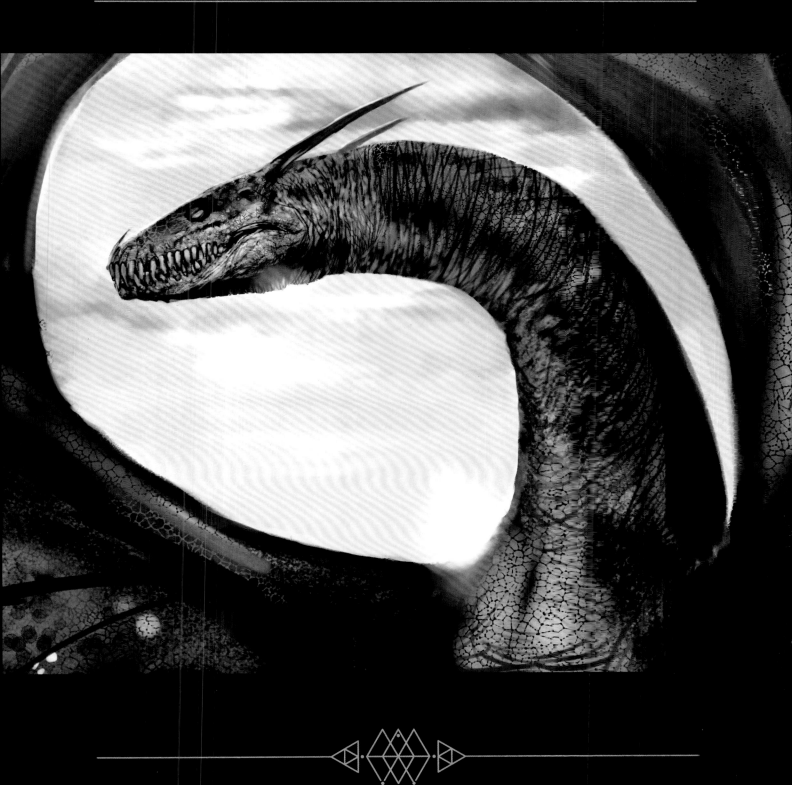

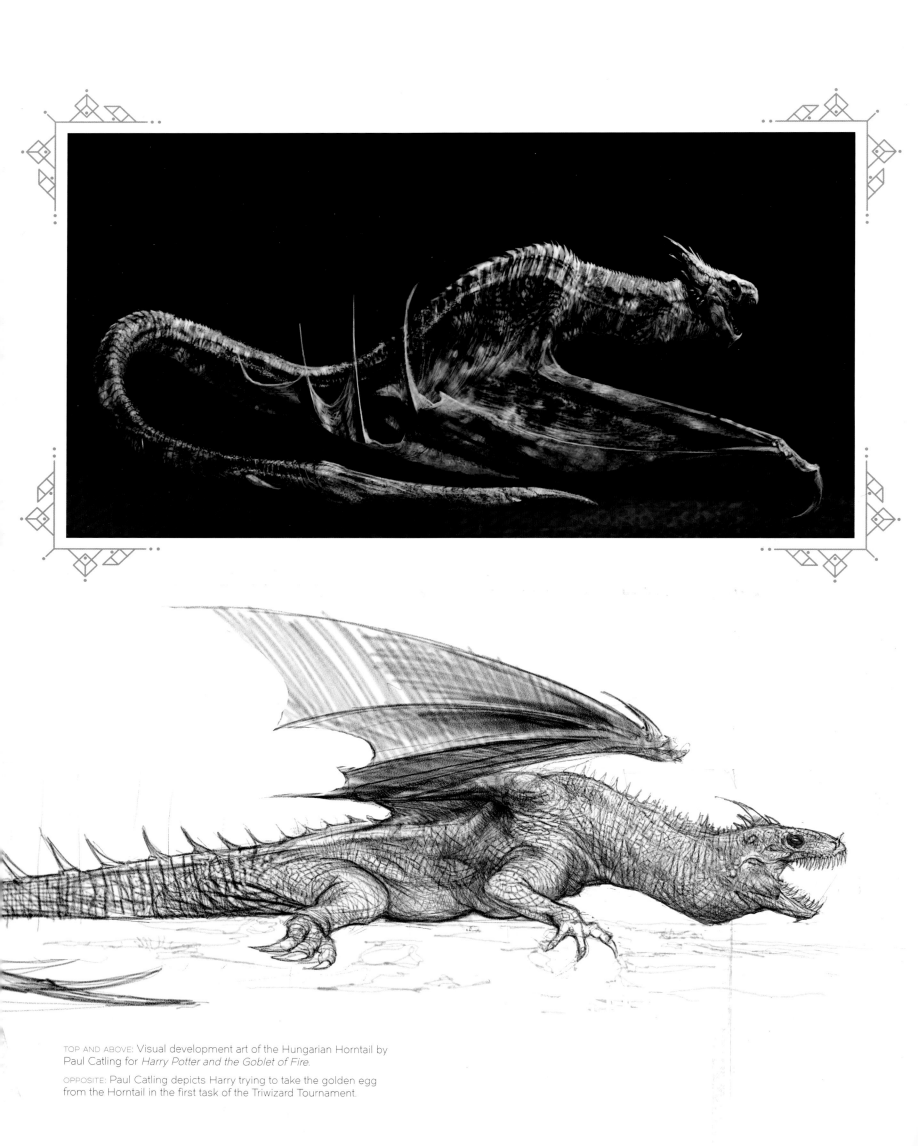

TOP AND ABOVE: Visual development art of the Hungarian Horntail by Paul Catling for *Harry Potter and the Goblet of Fire*.

OPPOSITE: Paul Catling depicts Harry trying to take the golden egg from the Horntail in the first task of the Triwizard Tournament.

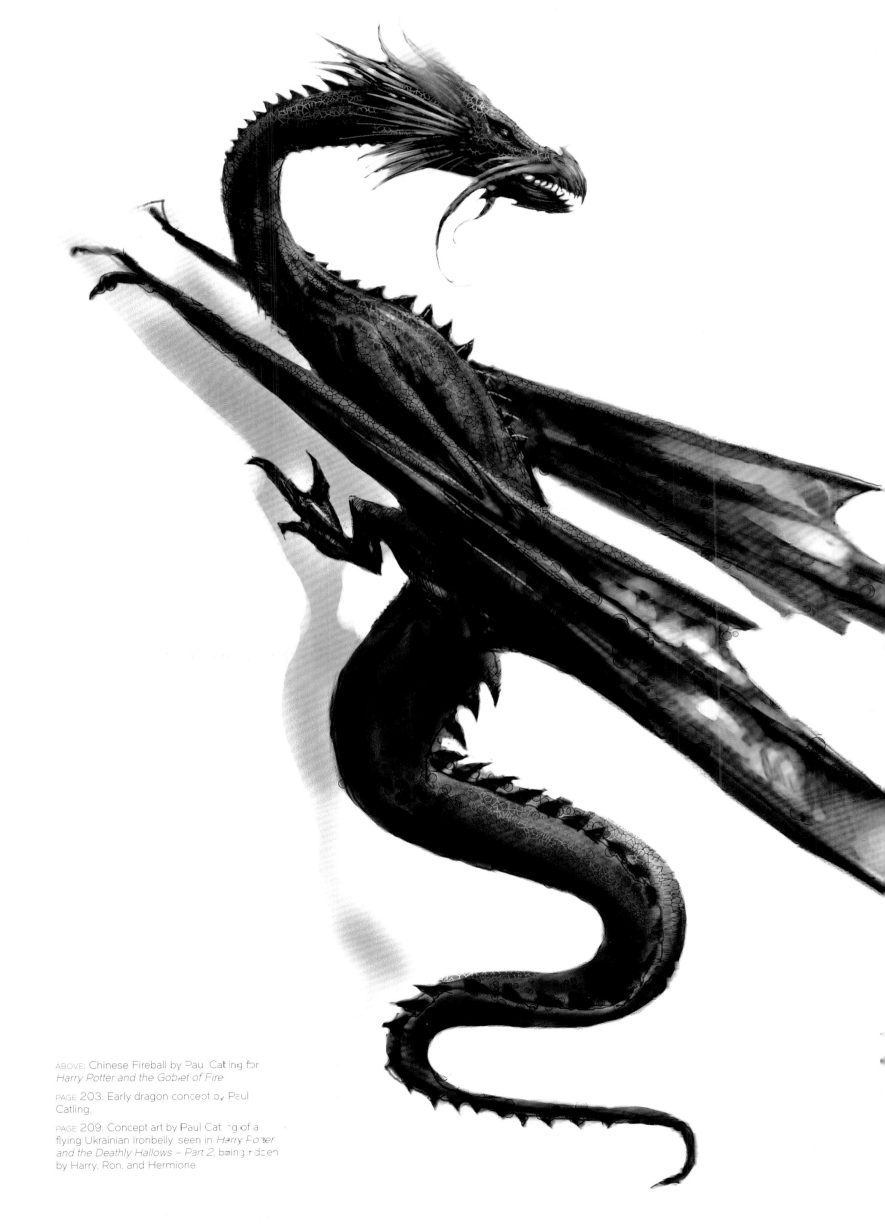

ABOVE: Chinese Fireball by Paul Catling for *Harry Potter and the Goblet of Fire*

PAGE 203: Early dragon concept by Paul Catling.

PAGE 209: Concept art by Paul Catling of a flying Ukrainian Ironbelly, seen in *Harry Potter and the Deathly Hallows – Part 2*, being ridden by Harry, Ron, and Hermione.

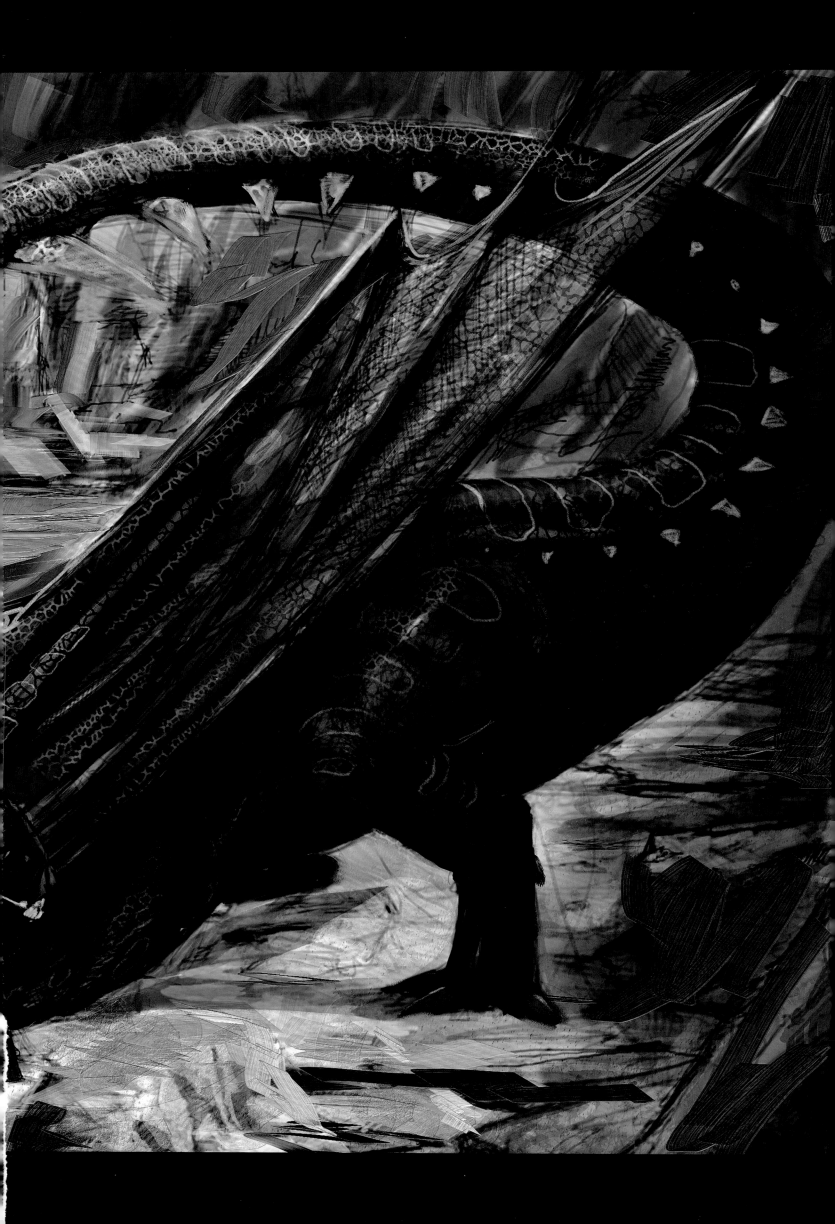

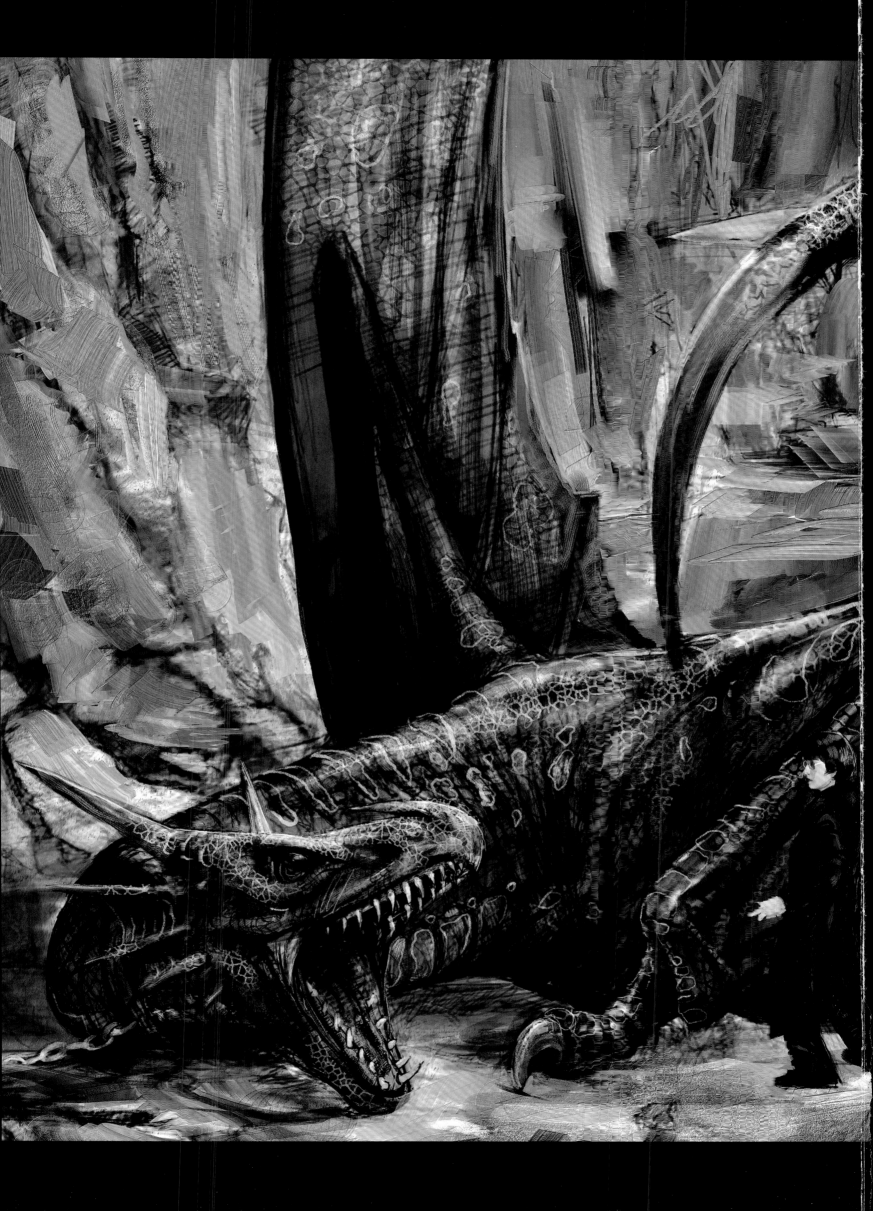

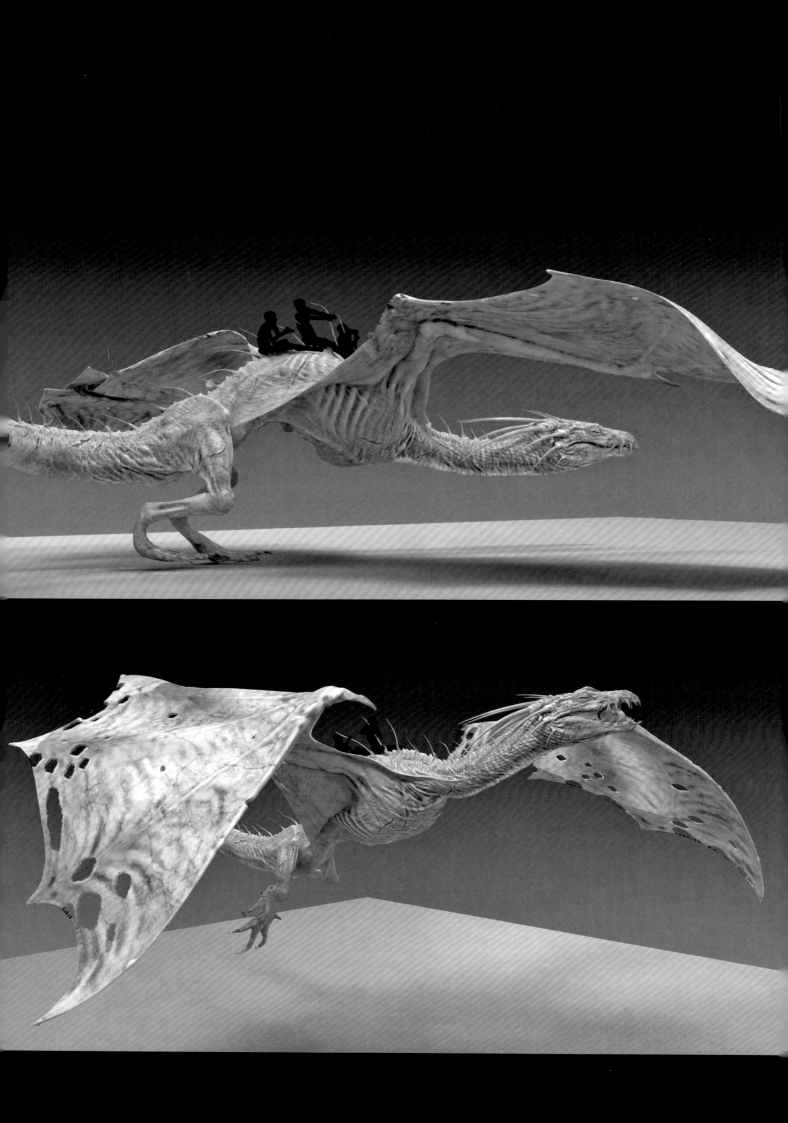

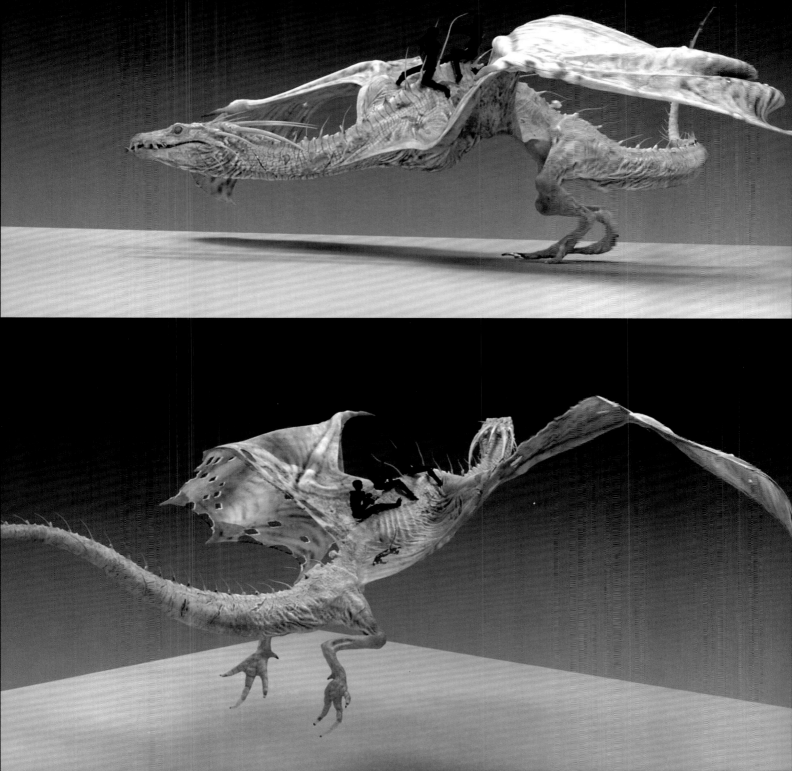

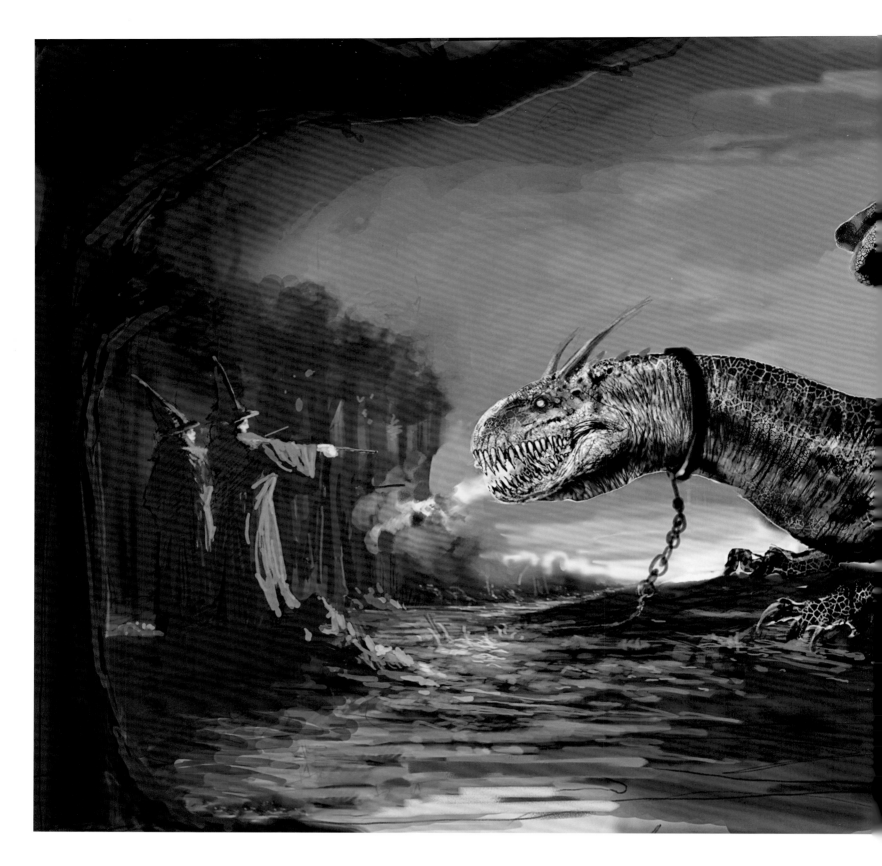

PAGES 207–208: Paul Catling depicts an early concept of the Chinese Fireball for *Goblet of Fire,* and studies of the Ukranian Ironbelly with the silhouetted figures of Harry, Ron, and Hermione sitting atop it for *Harry Potter and the Deathly Hallows – Part 2.*

THESE PAGES: Color studies of the dragons in the first task by Paul Catling for *Harry Potter and the Goblet of Fire* include (*opposite bottom left*) a Hungarian Horntail, (*opposite bottom right*) the Chinese Fireball, and (*above*) a Welsh Green being guarded by two wizards.

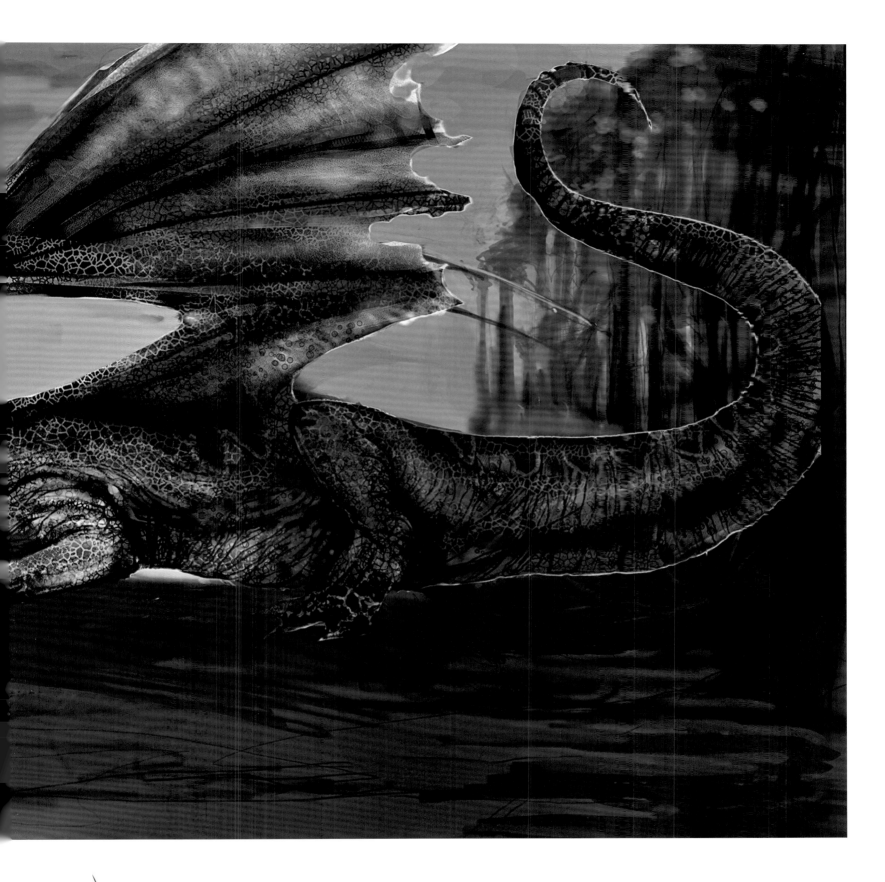

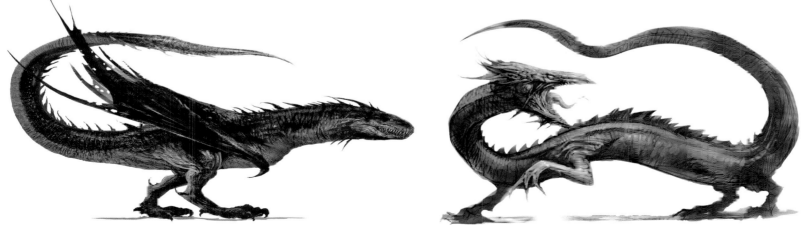

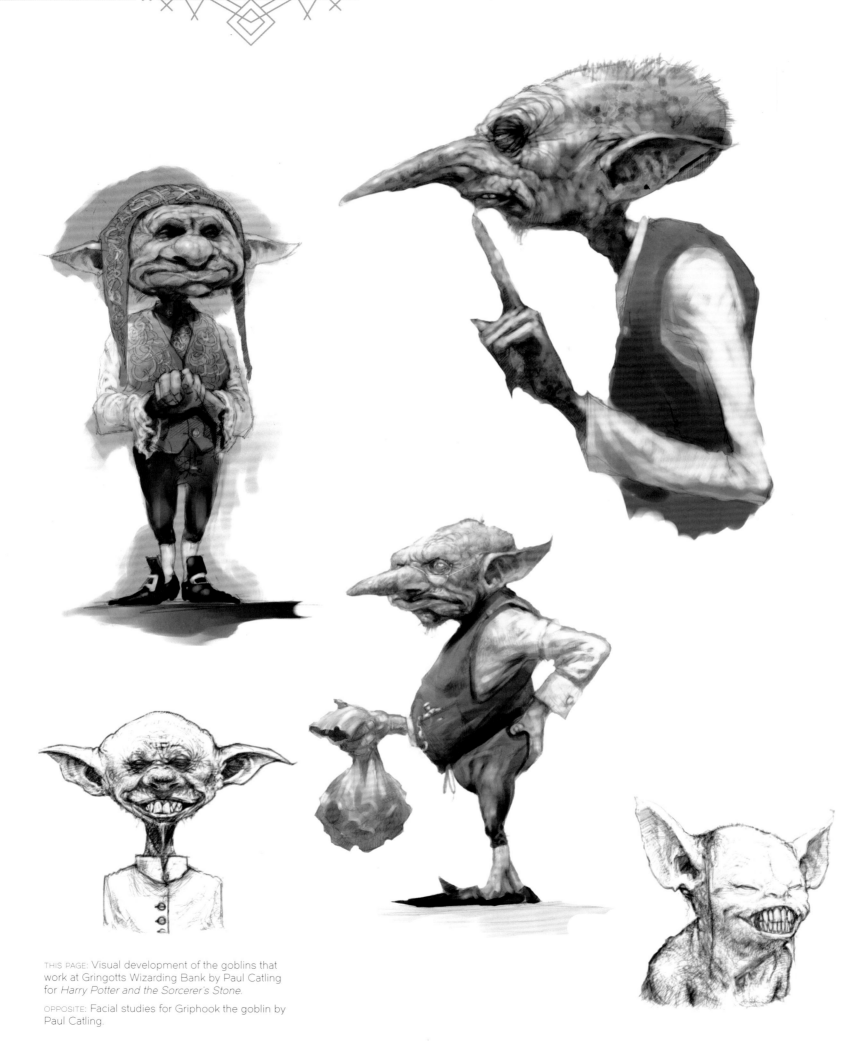

THIS PAGE: Visual development of the goblins that work at Gringotts Wizarding Bank by Paul Catling for *Harry Potter and the Sorcerer's Stone.*

OPPOSITE: Facial studies for Griphook the goblin by Paul Catling.

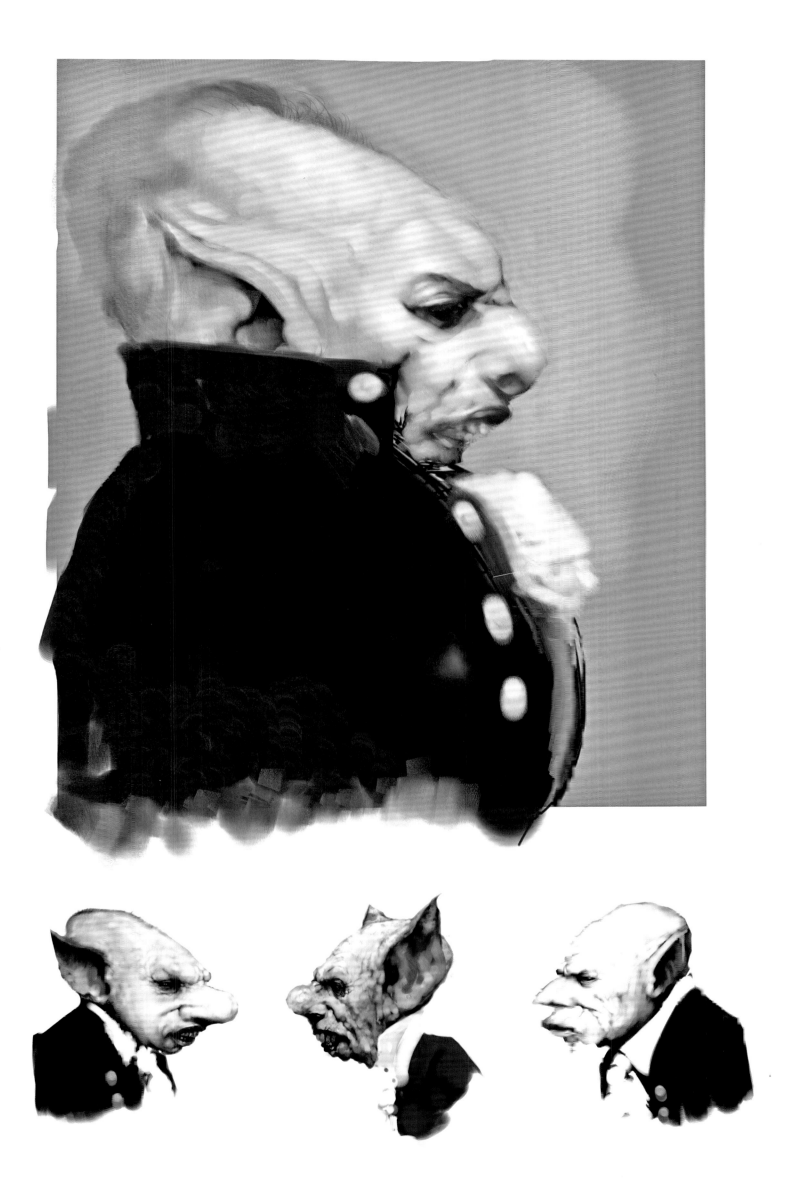

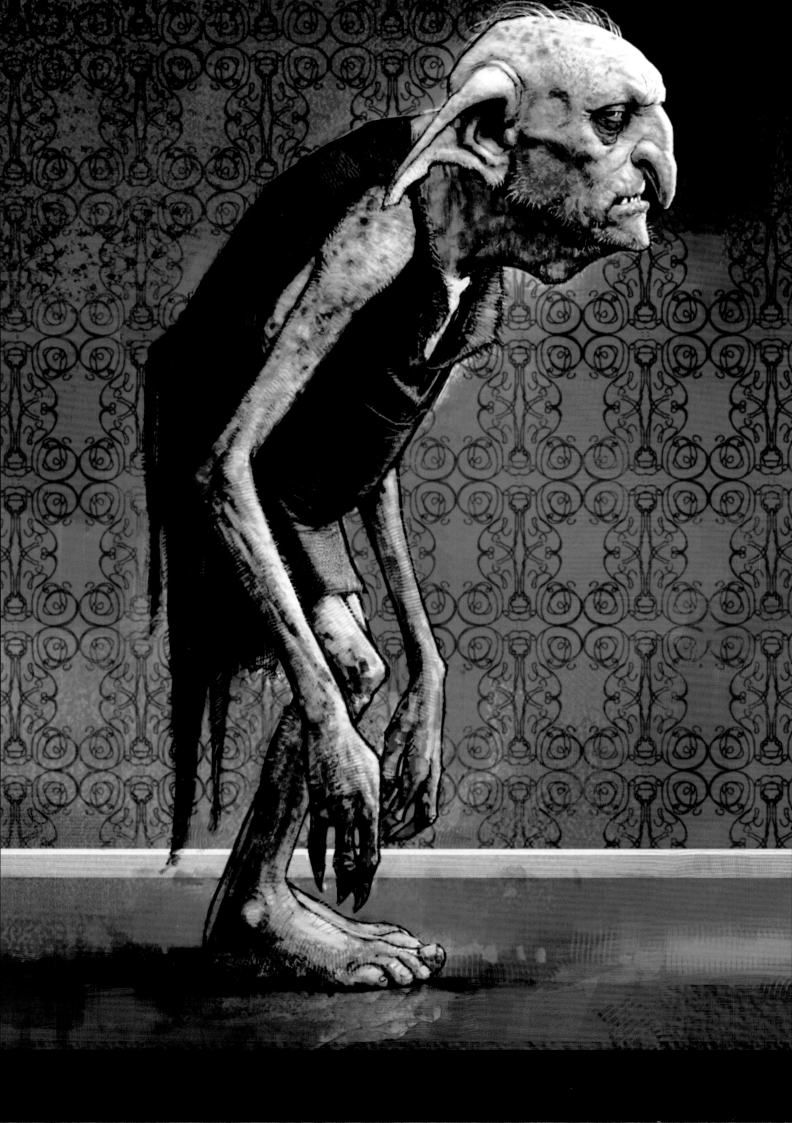

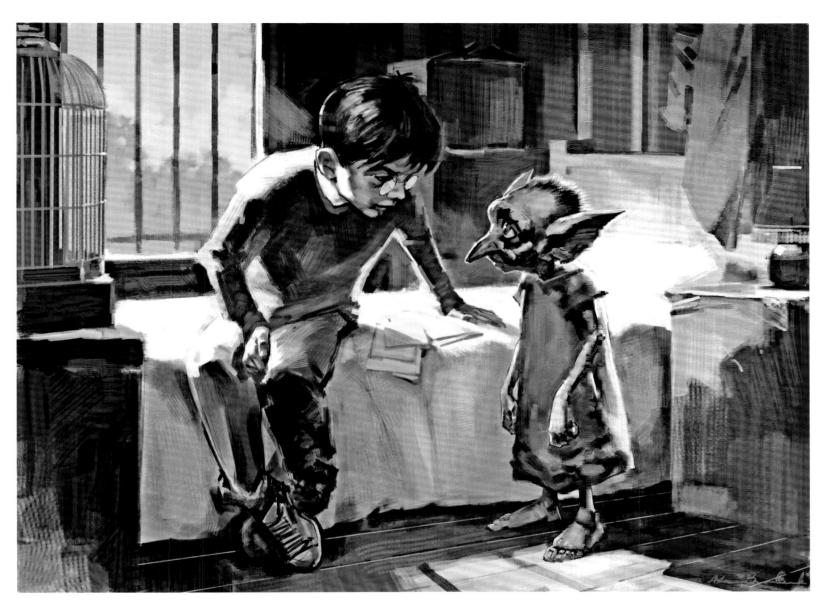

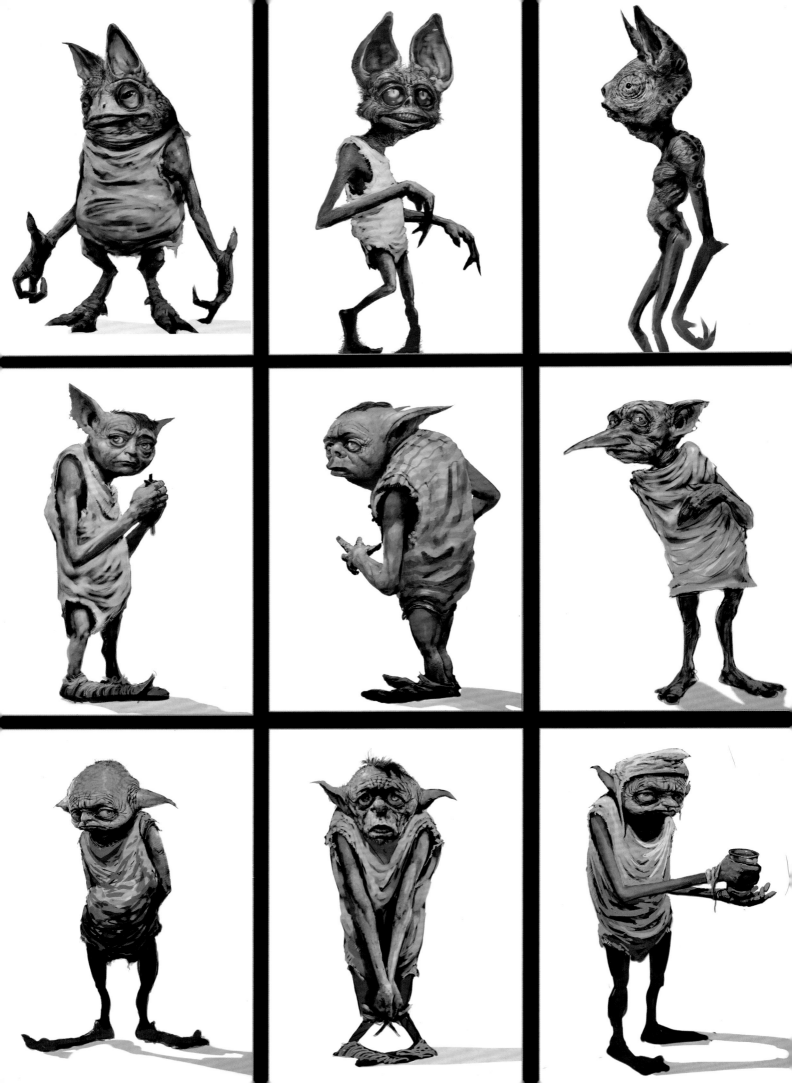

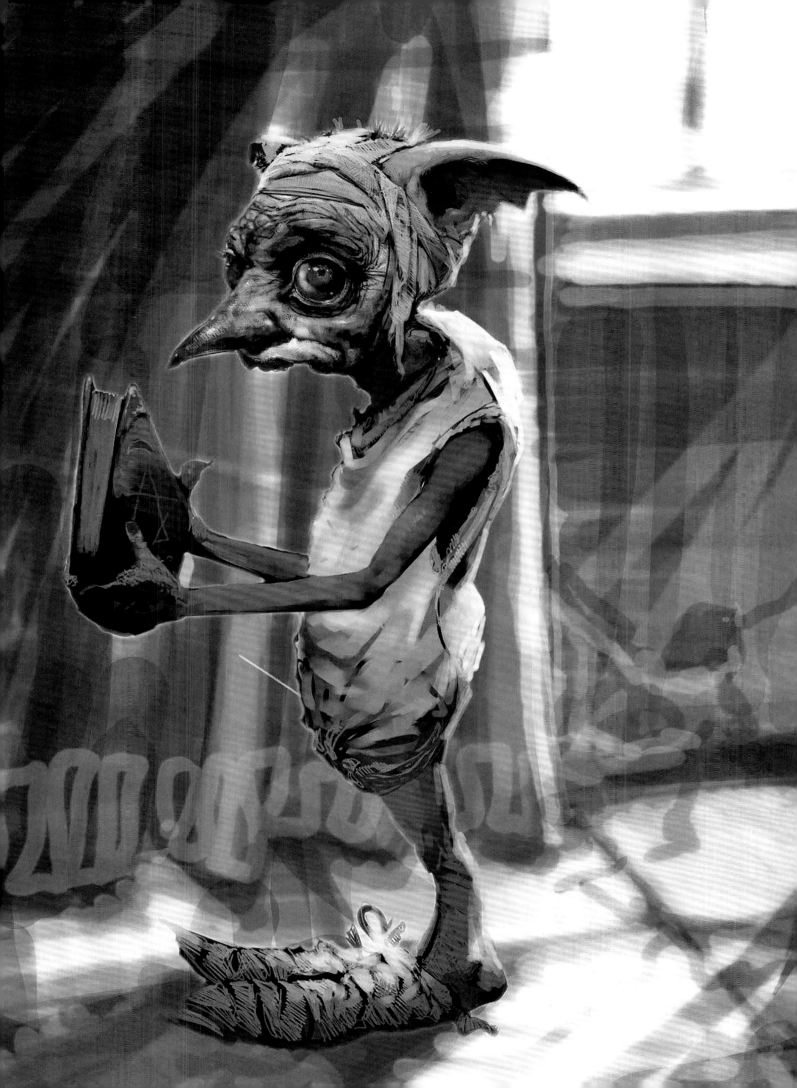

DARK CREATURES

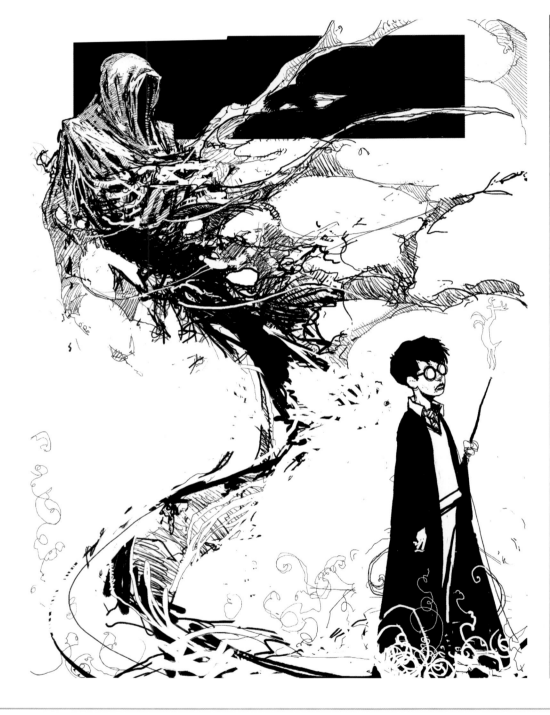

Harry Potter first encounters Dementors—Dark creatures that can drain a human's soul—in *Harry Potter and the Prisoner of Azkaban.*

ABOVE: Rob Bliss's concept sketch of a Dementor coming up behind Harry for *Prisoner of Azkaban.*

OPPOSITE: A painting of Harry attacked by the Dementors in a Quidditch game by Adam Brockbank during the events of *Prisoner of Azkaban.*

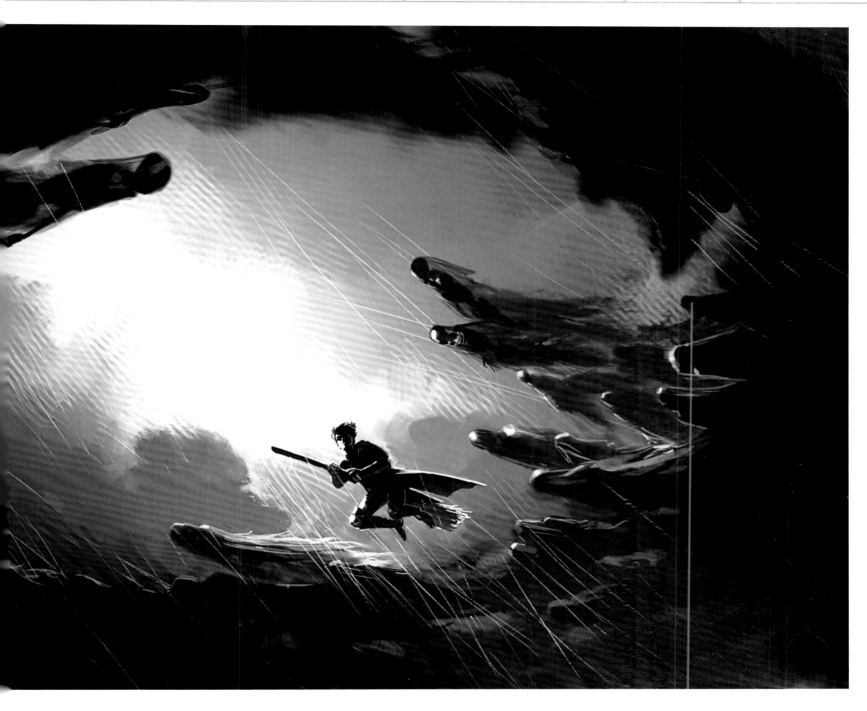

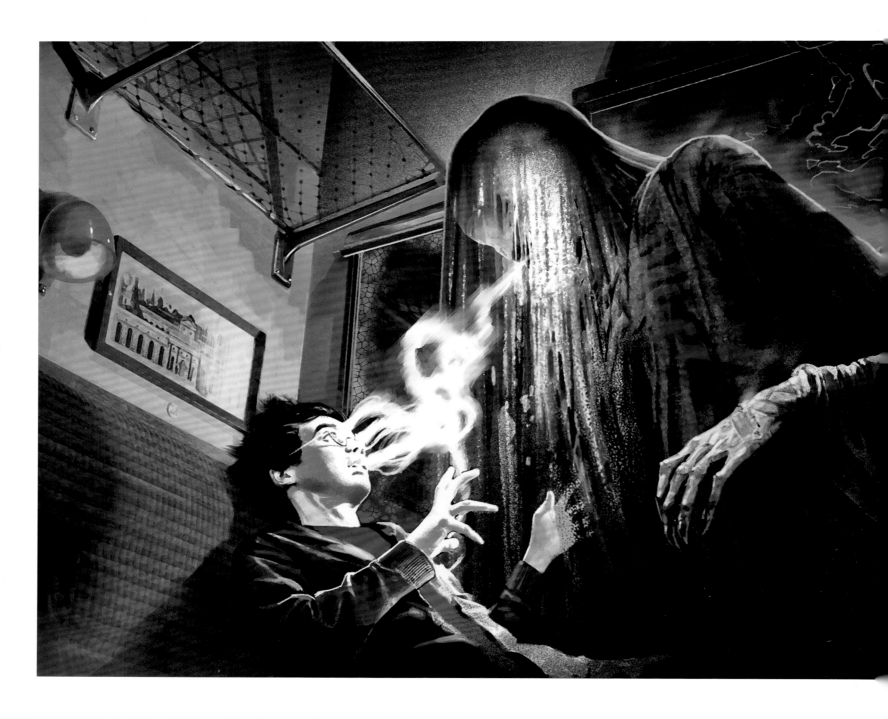

ABOVE: A Dementor attempts to give Harry Potter the "Dementor's Kiss" in artwork by Adam Brockbank for *Harry Potter and the Prisoner of Azkaban*.

OPPOSITE: Dementor studies by Rob Bliss for *Prisoner of Azkaban*.

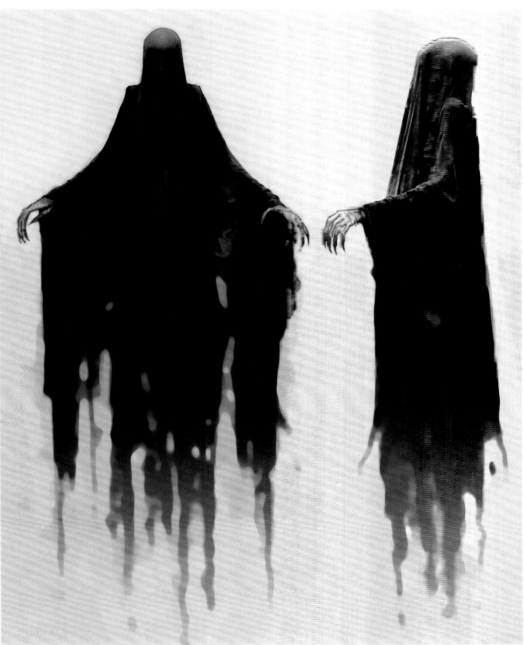

PAGE 222: Portraits of Voldemort with his snake, Nagini, a faithful companion and Horcrux, by Paul Catling for *Harry Potter and the Goblet of Fire*.

PAGE 223, TOP AND MIDDLE: Ron and Hermione return to the Chamber of Secrets in *Harry Potter and the Deathly Hallows - Part 2* to get a fang from the Basilisk's skeleton. Art by Adam Brockbank, who has Hermione retrieving the fang, which Ron did in the film.

PAGE 223, BOTTOM: The Basilisk, who can kill with a stare, by Rob Bliss for *Harry Potter and the Chamber of Secrets*.

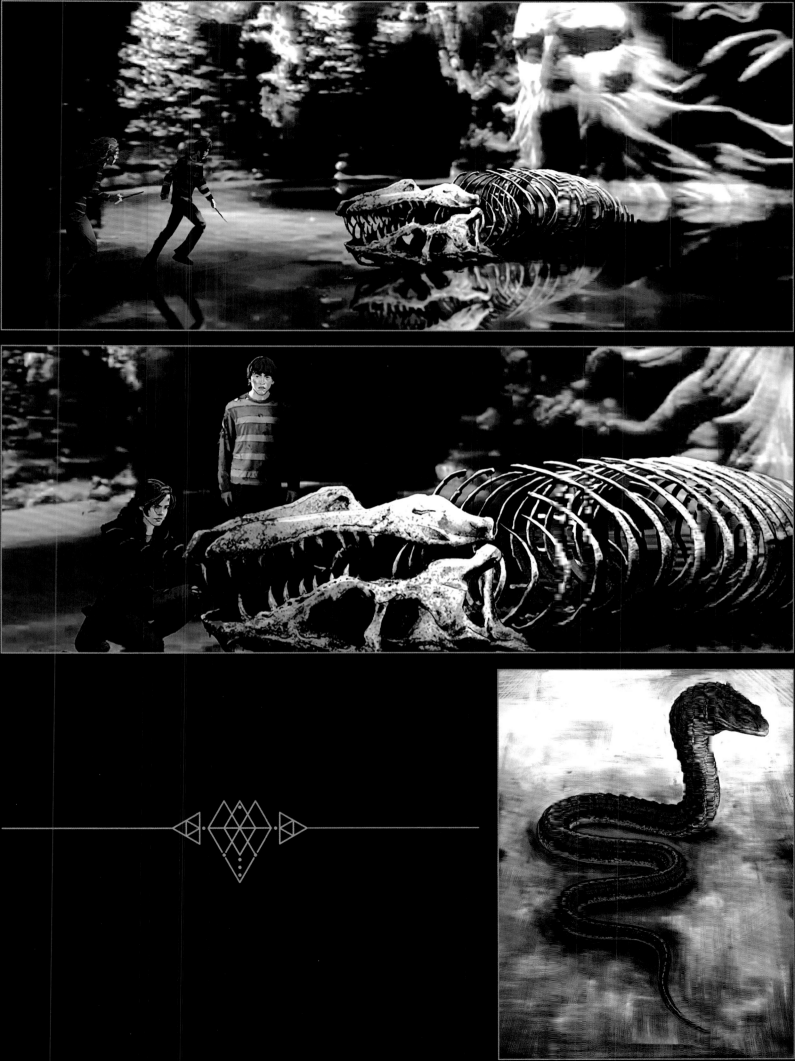

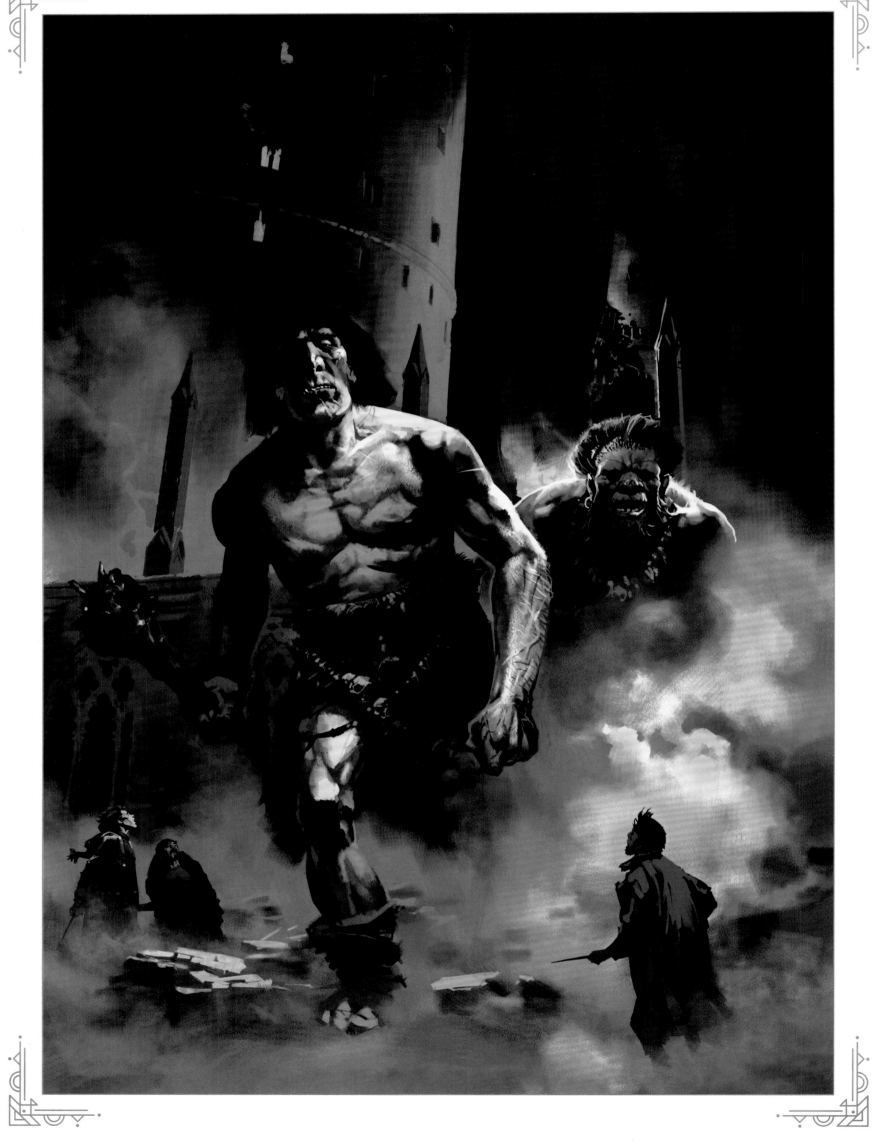

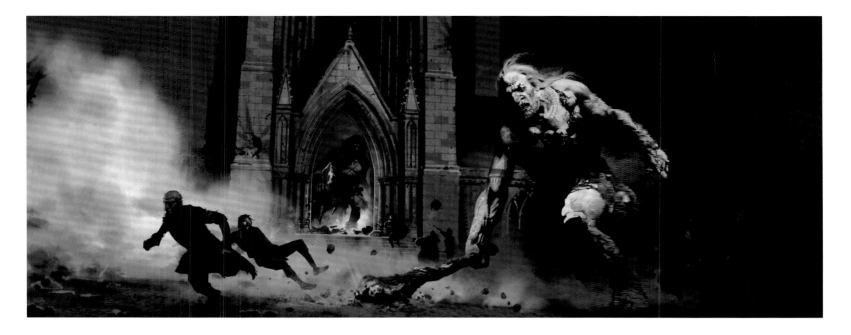

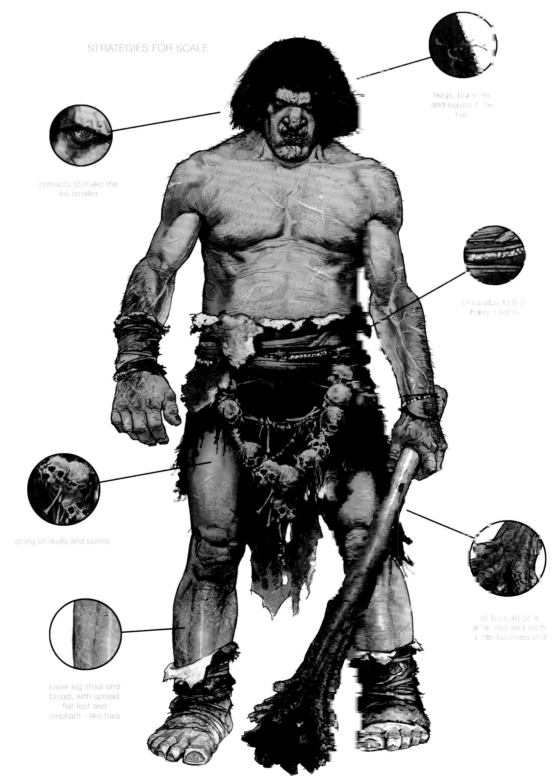

STRATEGIES FOR SCALE

contacts to make the
iris smaller

twigs, branches
and leaves in the
hair

crooked, rotting
fangs, teeth

string of skulls and bones

club could be a
small tree with roots
at the business end

lower leg stout and
broad, with spread
flat feet and
elephant-like toes

PAGE 224: The Inferi, corpses reanimated
by a Dark wizard, were placed in the
Horcrux cave by Voldemort to protect
Slytherin's locket in *Harry Potter and
the Half-Blood Prince*. *(clockwise from
top left)* Adam Brockbank depicts an
Inferius climbing onto the cave's crystal
rocks; Harry attempts to stop the Inferi,
by Adam Brockbank; a swarm of Inferi
by Rob Bliss, inspired by Gustave Doré
illustrations; a decomposing Inferus by
Adam Brockbank.

Voldemort employed giants to aid his
Dark forces in the Battle of Hogwarts in
*Harry Potter and the Deathly Hallows –
Part 2*.

OPPOSITE AND TOP: Students and
professors flee from attacking giants in
artwork by Adam Brockbank.

RIGHT: An ultimate guide to giants by
Adam Brockbank.

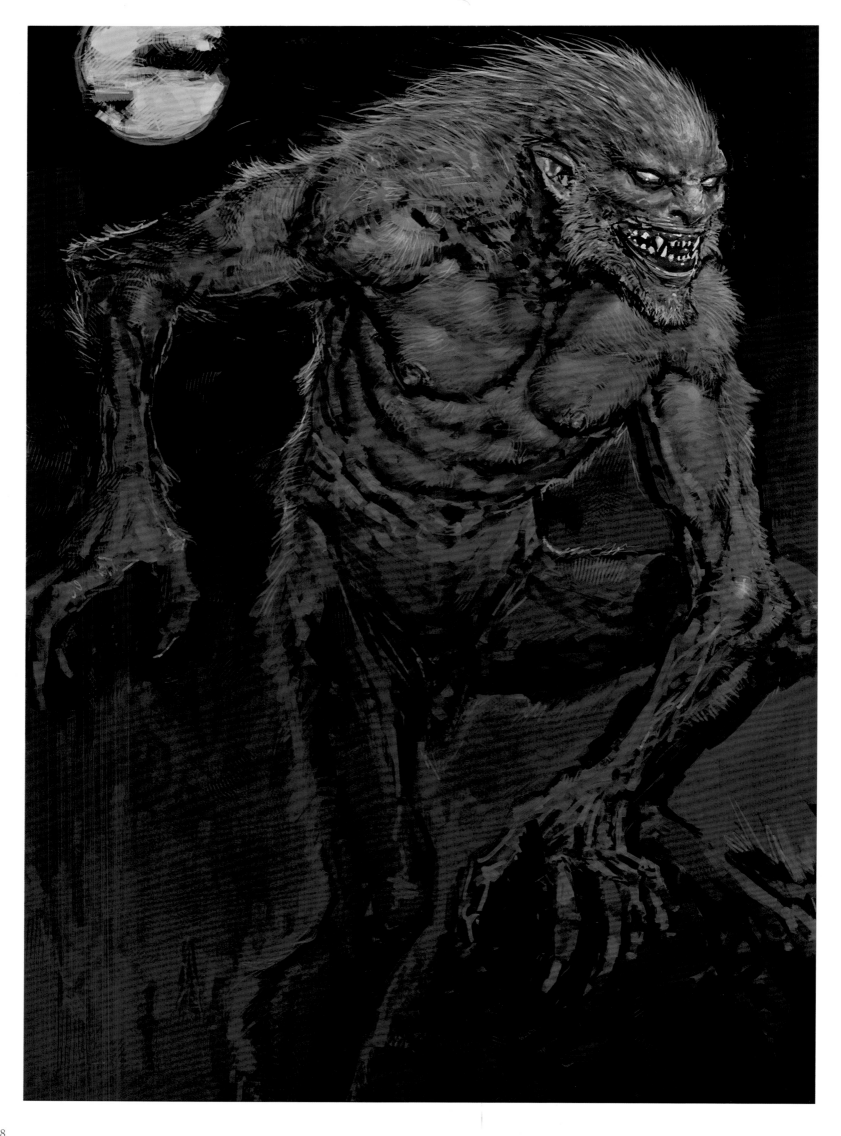

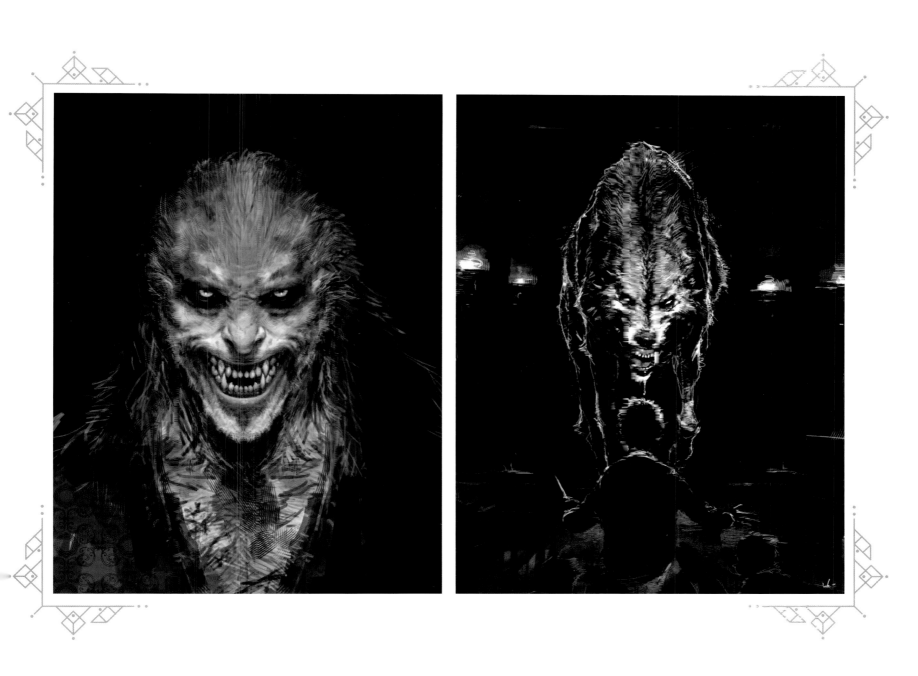

OPPOSITE AND ABOVE LEFT: Studies of Fenrir Greyback, who seemed perpetually caught between man and were-wolf, by Rob Bliss for *Harry Potter and the Half-Blood Prince*.

ABOVE RIGHT: Harry Potter fends off the werewolf during the Battle of Hogwarts in artwork created by Rob Bliss for *Harry Potter and the Deathly Hallows – Part 2*, but the encounter did not happen in the film.

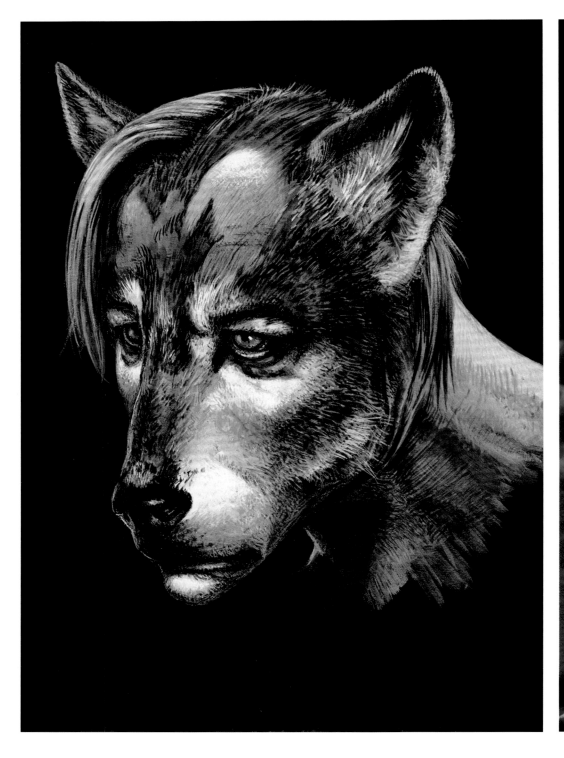
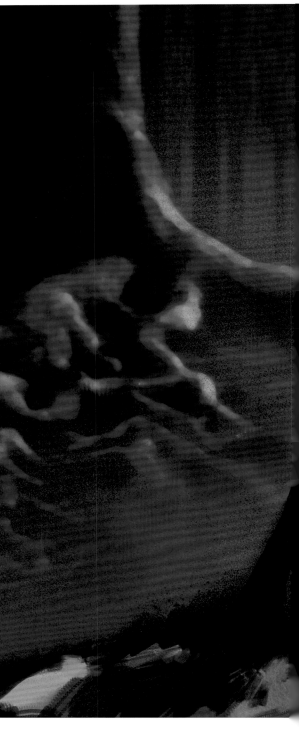

Visual development art for the werewolf form of
Remus Lupin, former Defense Against the Dark
Arts professor, as seen in *Harry Potter and the
Prisoner of Azkaban*.

ABOVE: Artist Wayne Barlowe illustrates the man
trapped within the creature.

OPPOSITE: Adam Brockbank portrays the final
transformation of Lupin into an emaciated, hairless
animal, evoking sympathy for his plight.

In *Harry Potter and the Deathly Hallows – Part 1*, Harry is helped by a doe Patronus that guides him to the location of the Sword of Gryffindor. He does not know this is the Patronus of Severus Snape.

ABOVE: Andrew Williamson portrays the moment when Harry first sees the Patronus.

OPPOSITE: The light from the Patronus shines on the trees around it. Concept art by Adam Brockbank.

PAGE 234, LEFT: Possible Patronuses were developed for the students learning the Patronus Charm in *Harry Potter and the Order of the Phoenix*. The chandelier-swinging monkey is by Adam Brockbank.

PAGE 235: Luna Lovegood casts her hare Patronus. Artwork by Adam Brockbank.

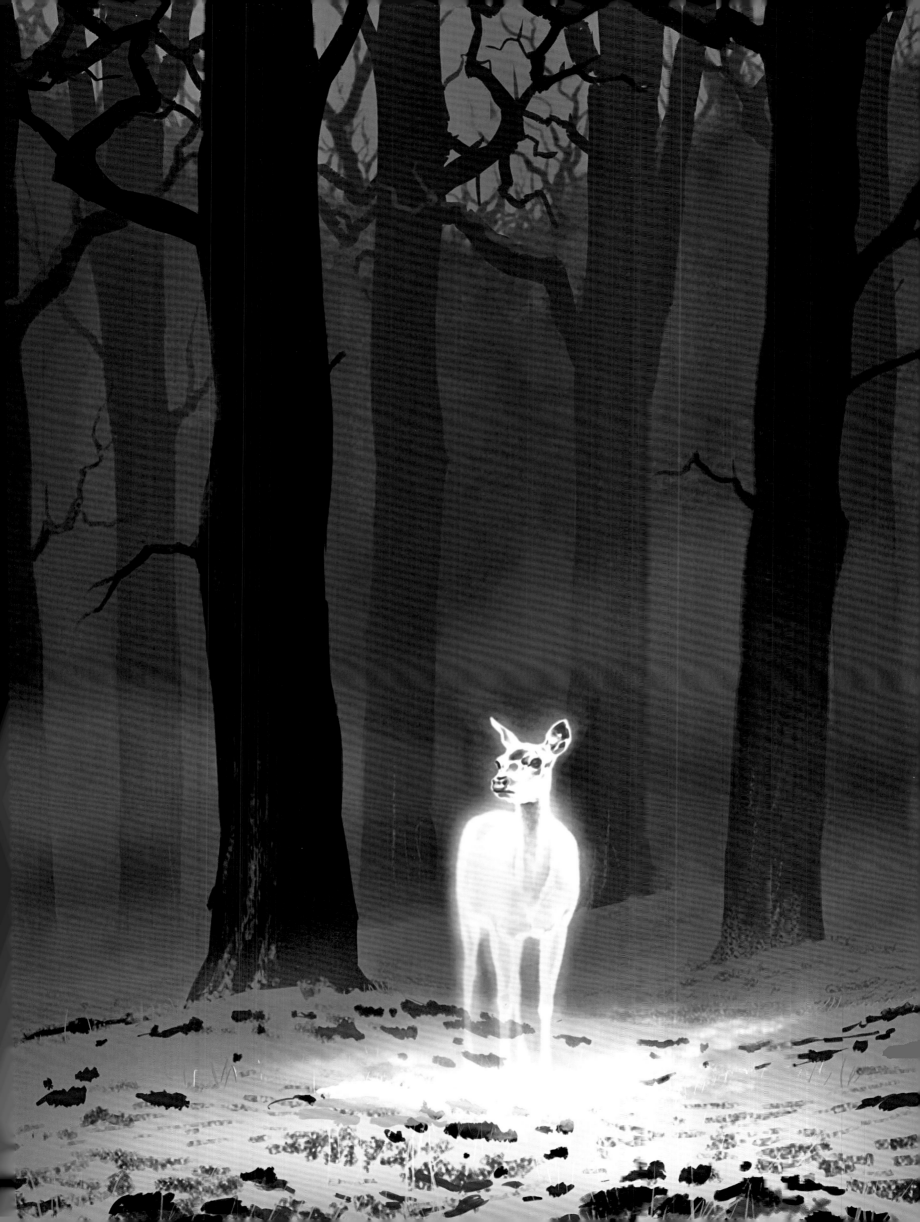

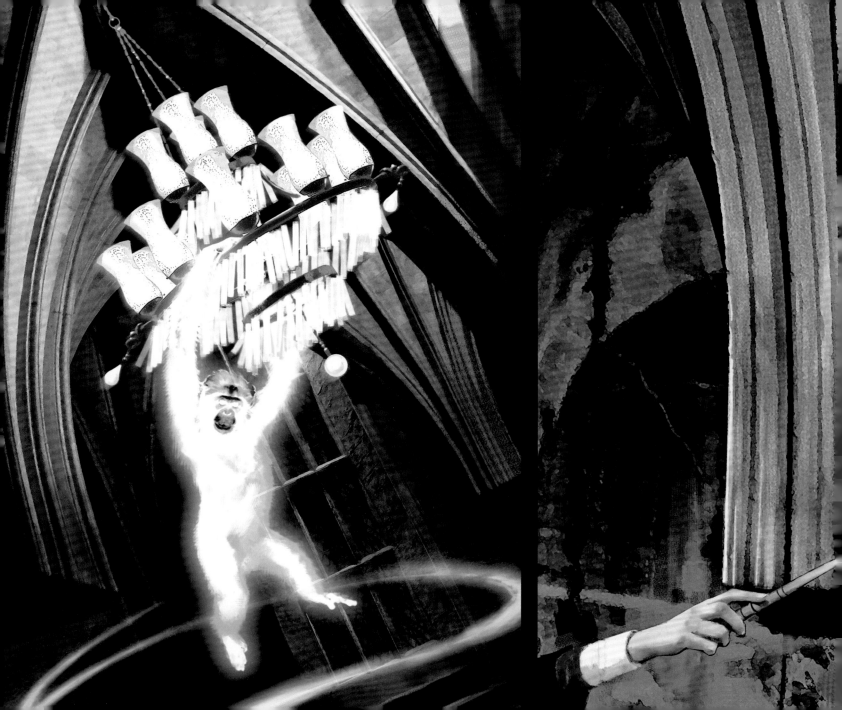

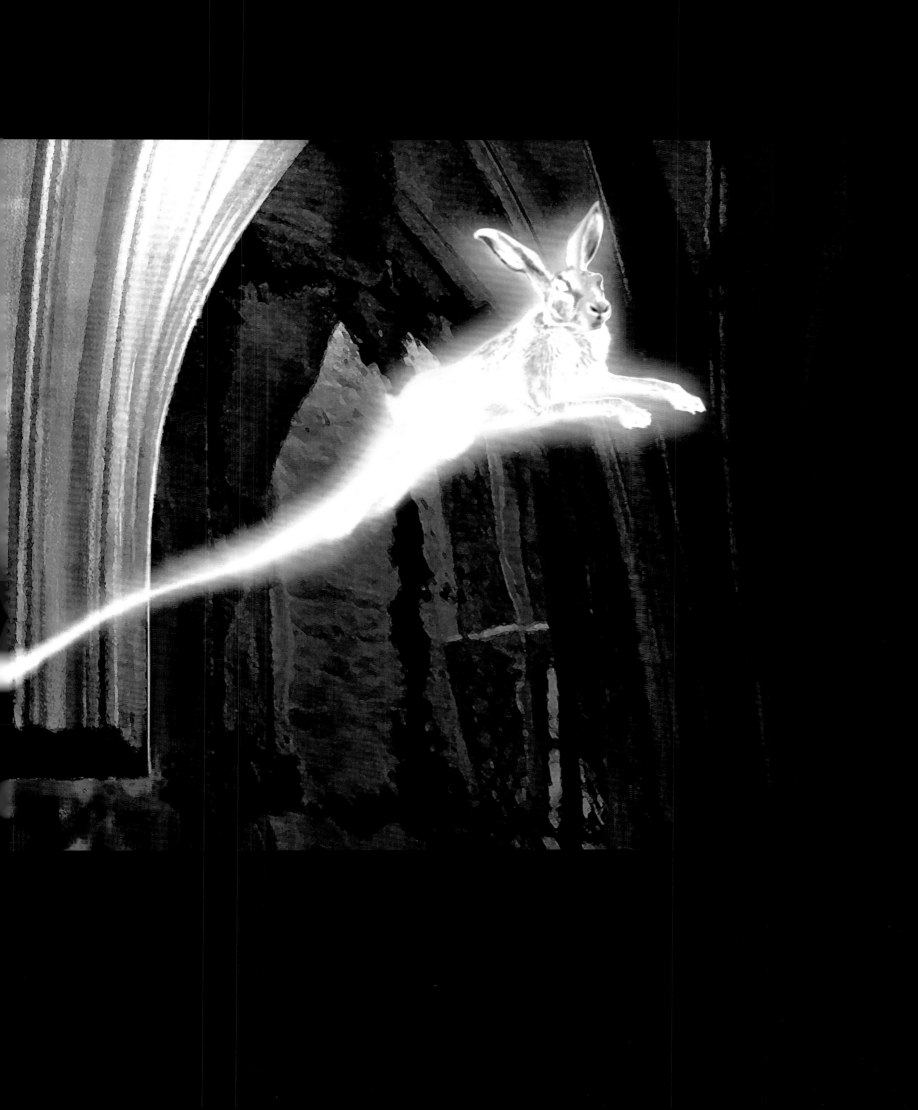

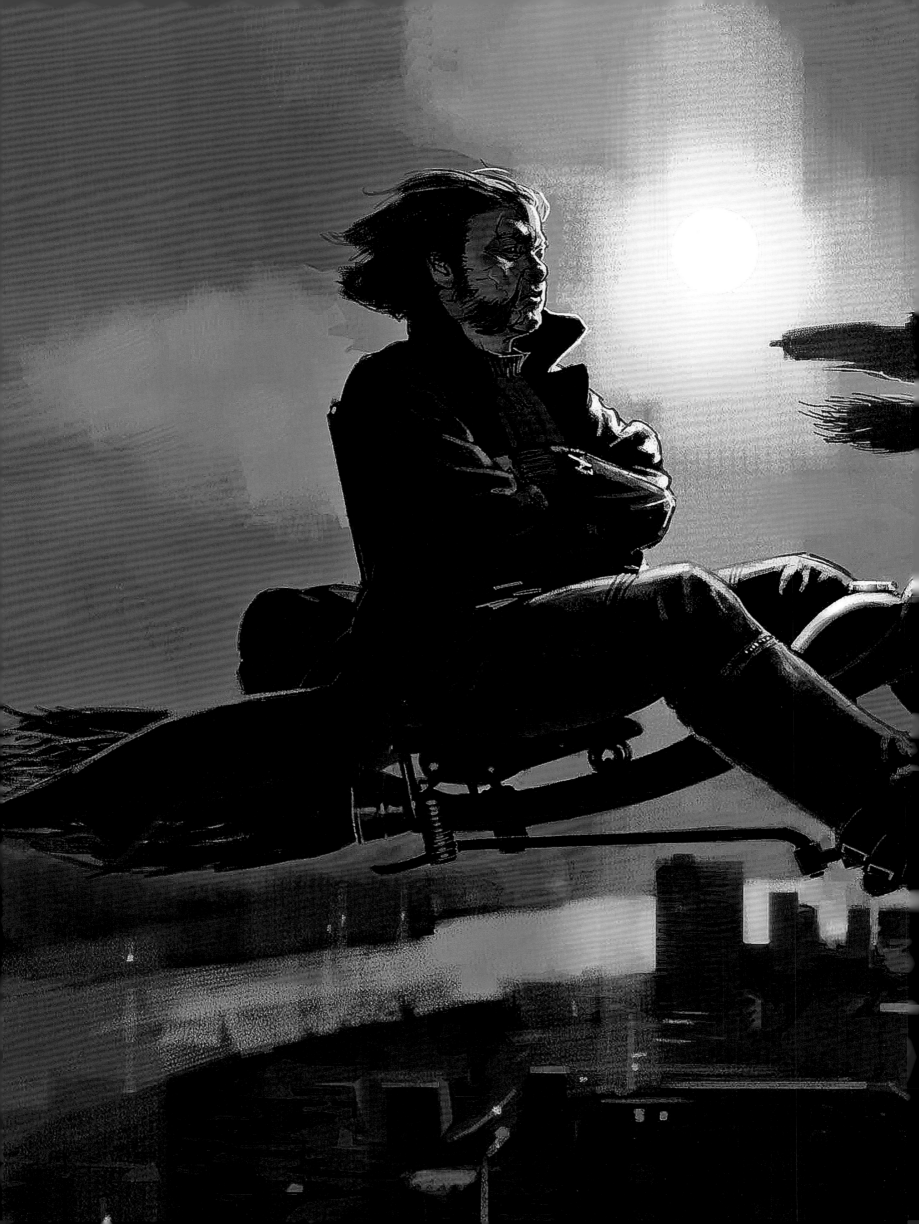

CHAPTER :
ART FACTS

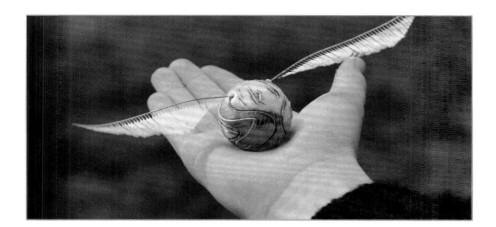

The hallowed halls of Hogwarts are populated by far more than just wizards, witches, and ghosts. Every inch of the school—as well as the wizarding world that lies beyond it—is filled with a collection of carefully crafted props that help bring this fantasy realm closer to reality.

Creating exploratory concept art for each individual prop was the first vital step to locking down the look of the important artifacts. Every prop had to have its own personality that not only stayed true to the spirit of the books but also looked good and functioned well on screen. It was up to the team of talented concept designers to make sure that no one would ever mistake a winged key for the Golden Snitch. When it came to design, it was the minor details that often made the biggest differences.

The prop design team would scour the series of books for any visual direction provided by Rowling herself to use as the foundation of their sketches and technical drawings. Fortunately, many of the most important artifacts were often described by the author in great detail.

"It is amazing how many times we're just stuck for inspiration about something," set decorator Stephenie McMillan said, "and we think, 'Okay, we'll just go back to the book again and see what's in there.' And inevitably we come out with something."

Some items, however, were left open to wider interpretation, such as *The Monster Book of Monsters*—a terrifying tome assigned to the students of Hagrid's Care of Magical Creatures class. The book went through a number of early design iterations that offered uniquely grotesque elements, many of which were incorporated into the unforgettable version that was eventually chosen to appear on screen.

In some cases, when an artifact was intrinsically linked to a specific individual, the artists had to attempt to put themselves into that character's head in order to determine how their personality would influence the appearance of their personal props. For instance, each of the young wizards' wands was painstakingly designed to perfectly match its master.

It is this level of attention and insight from the earliest moments of the design process that allowed significant artifacts like Lord Voldemort's Horcruxes to become immediately identifiable as something far greater than any other book, ring, locket, cup, or tiara that might be alongside them in a scene.

And those other items were abundant. There were literally tens of thousands of props filling some of the more popular settings in the films, and each one had to be carefully conceived and crafted to make sure that they fit within their assigned corner of the wizarding world.

Thanks to the prop department' respect for the source material and their uncompromising attention to detail, each individual prop achieved its ultimate purpose—to contribute to the believability and authenticity of the world in which it is found.

"It's just a movie prop," Stuart Craig says, "but you look at it and it has spectacular detail. So it's that kind of richness you get from that kind of detail . . . It all helps that illusion."

QUIDDITCH

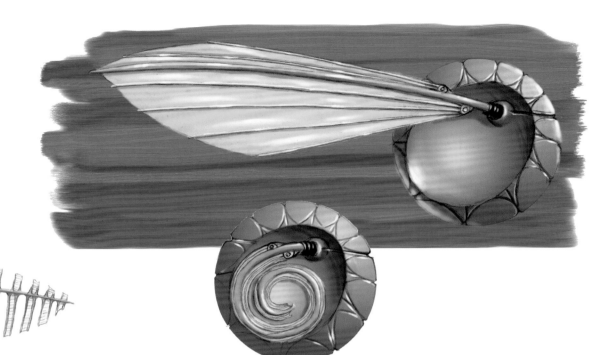

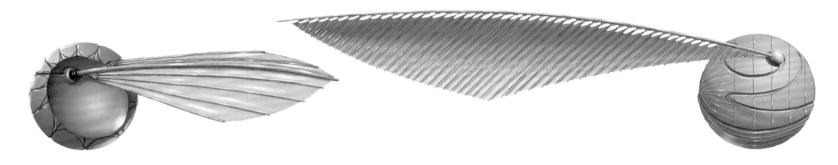

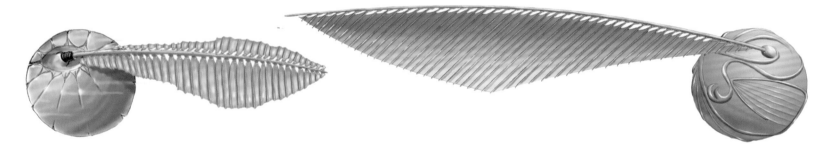

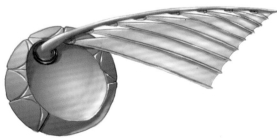

THIS PAGE: Visual development of the Golden Snitch by Gert Stevens of varied wing and body designs for *Harry Potter and the Sorcerer's Stone*, along with the final Golden Snitch prop (*right*).

OPPOSITE, TOP TO BOTTOM: Visual development art of Quaffles; Bludger arm guards and bats; and Bludger balls, all designed by Stuart Craig and illustrated by Gert Stevens.

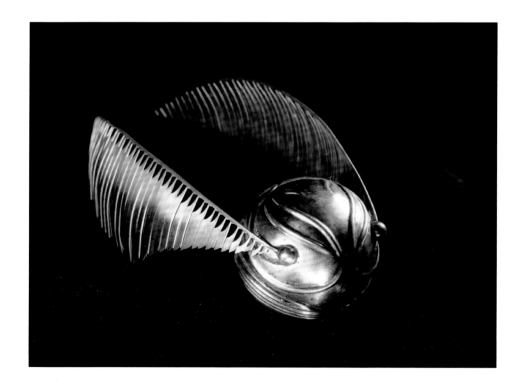

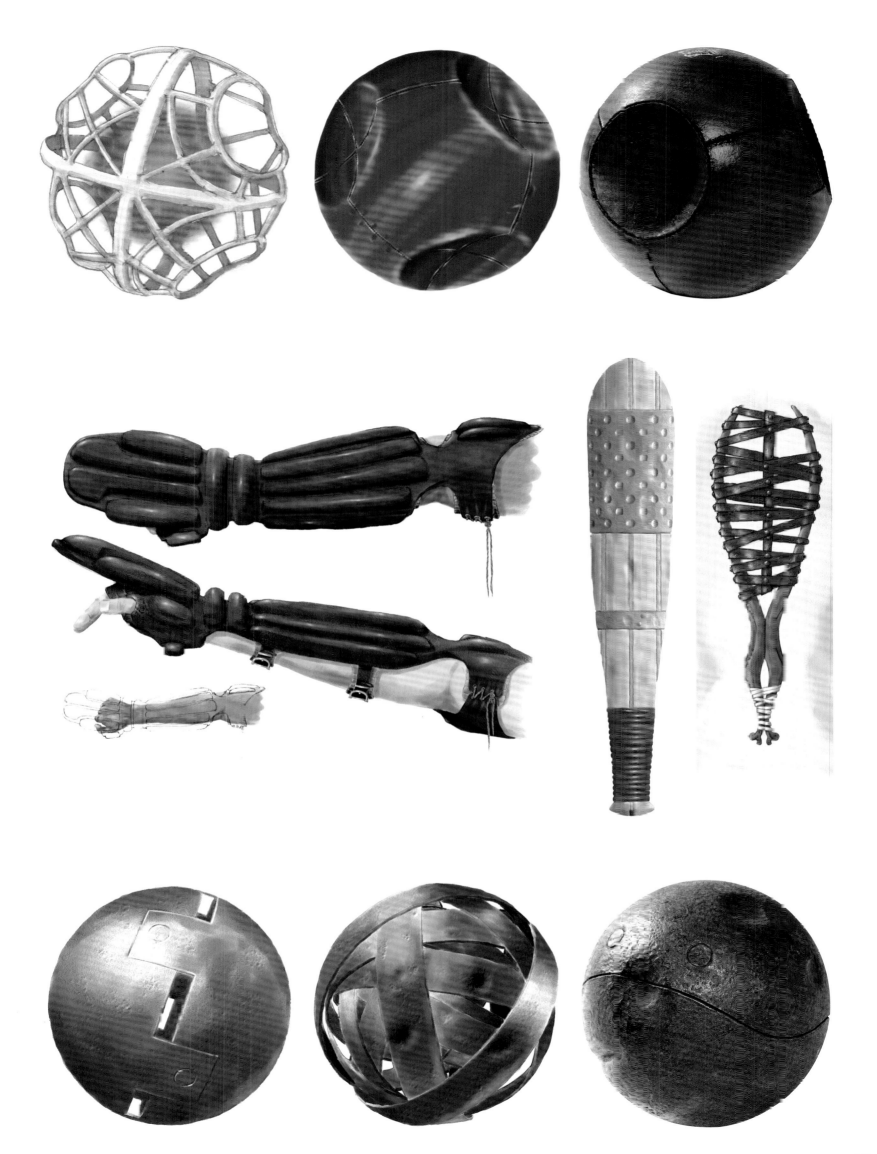

BROOMS

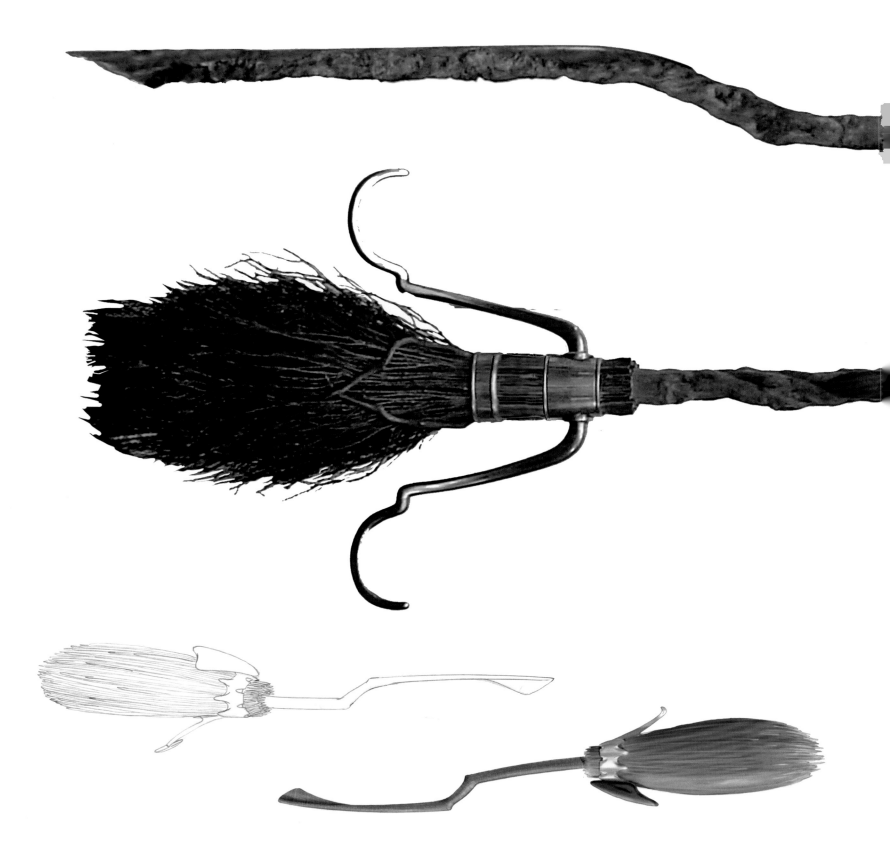

TOP AND MIDDLE: The Firebolt broom, sent to Harry Potter by Sirius Black after his Nimbus 2000 is destroyed in *Harry Potter and the Prisoner of Azkaban*.

OPPOSITE TOP RIGHT: A sampling of finishes and textures for the Firebolt by Dermot Power.

OPPOSITE BOTTOM AND ABOVE: Other broom concepts include colored bristles and a dragon head at the top of the handle.

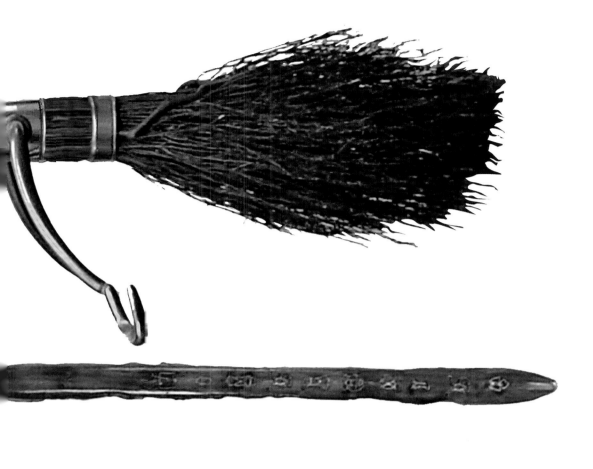

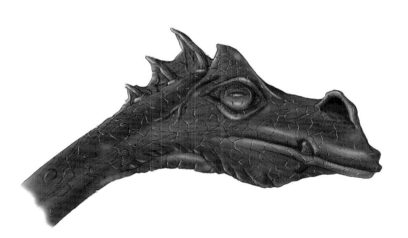

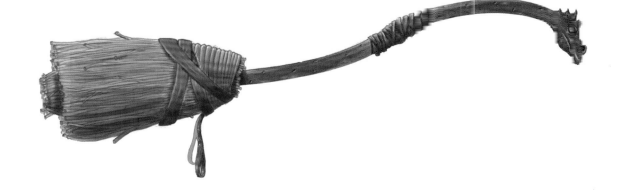

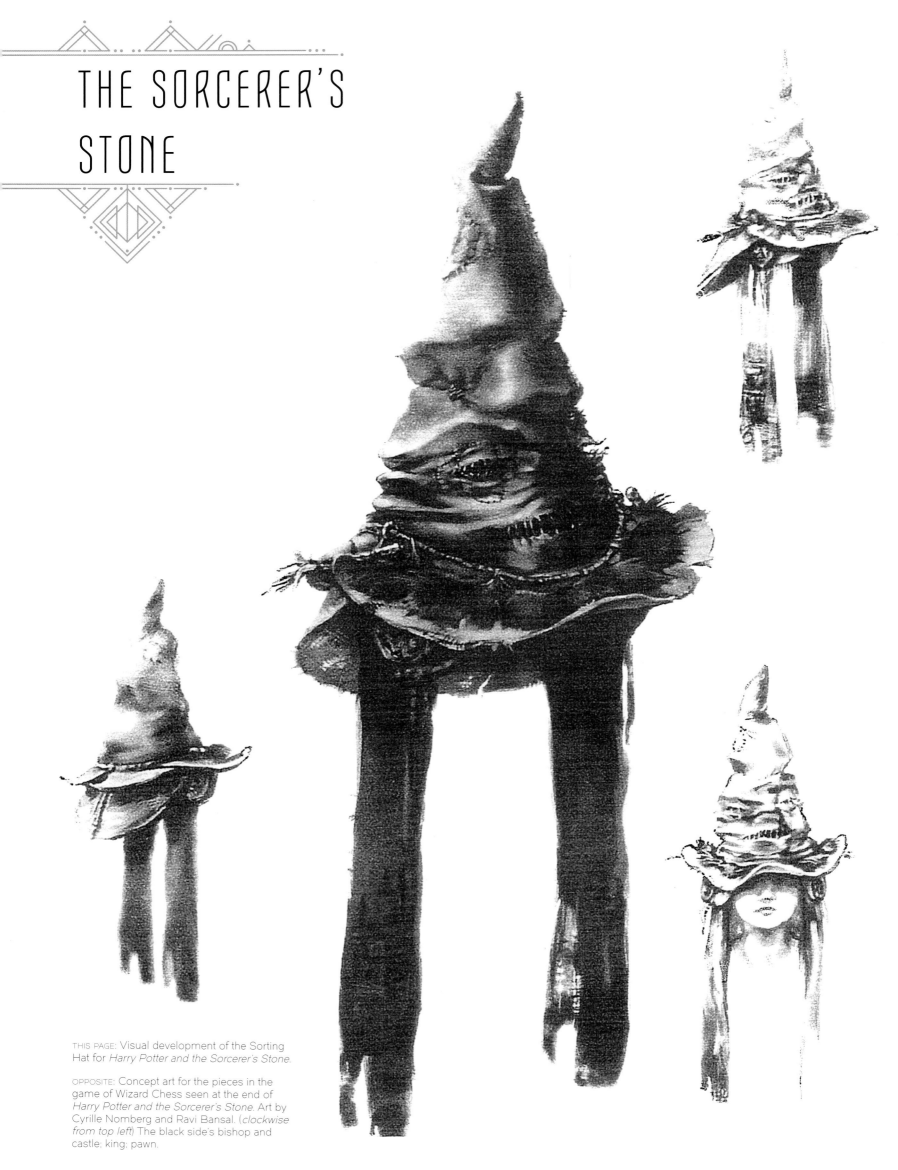

THE SORCERER'S STONE

THIS PAGE: Visual development of the Sorting Hat for *Harry Potter and the Sorcerer's Stone*.

OPPOSITE: Concept art for the pieces in the game of Wizard Chess seen at the end of *Harry Potter and the Sorcerer's Stone*. Art by Cyrille Nomberg and Ravi Bansal. (*clockwise from top left*) The black side's bishop and castle; king; pawn.

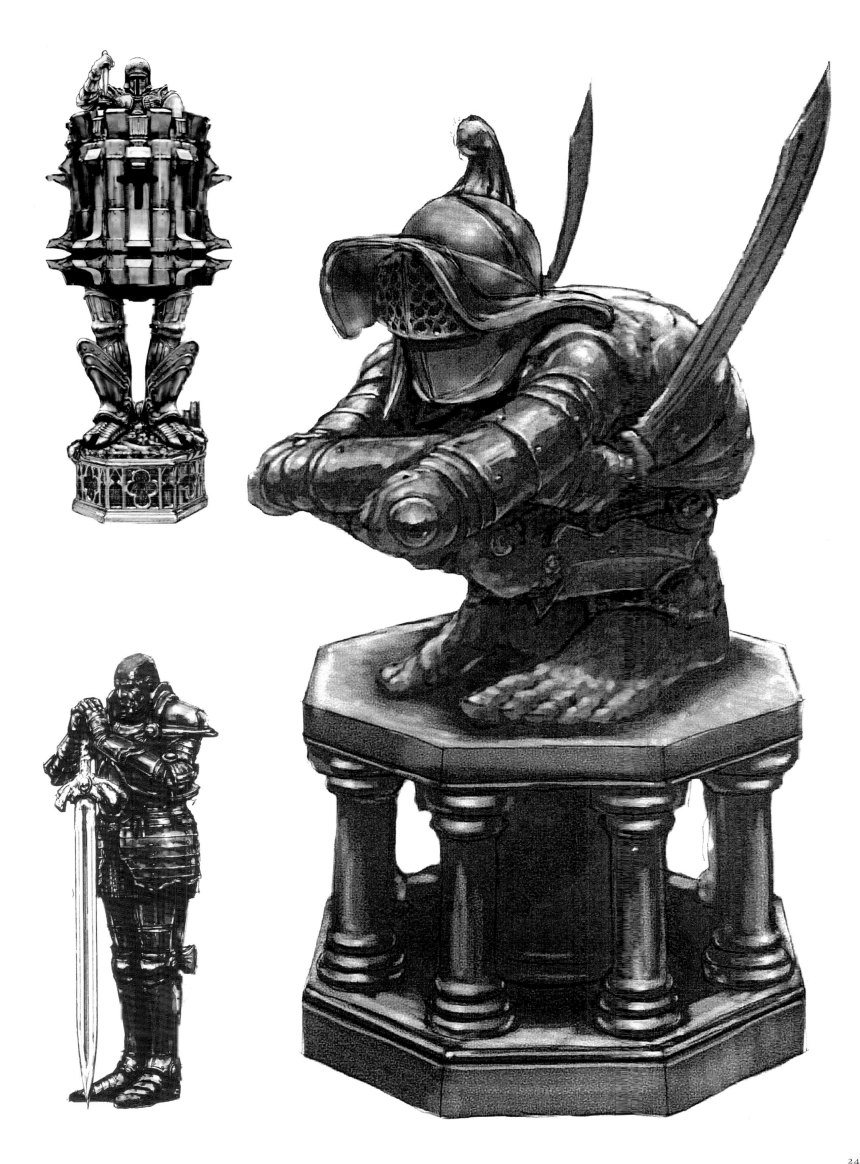

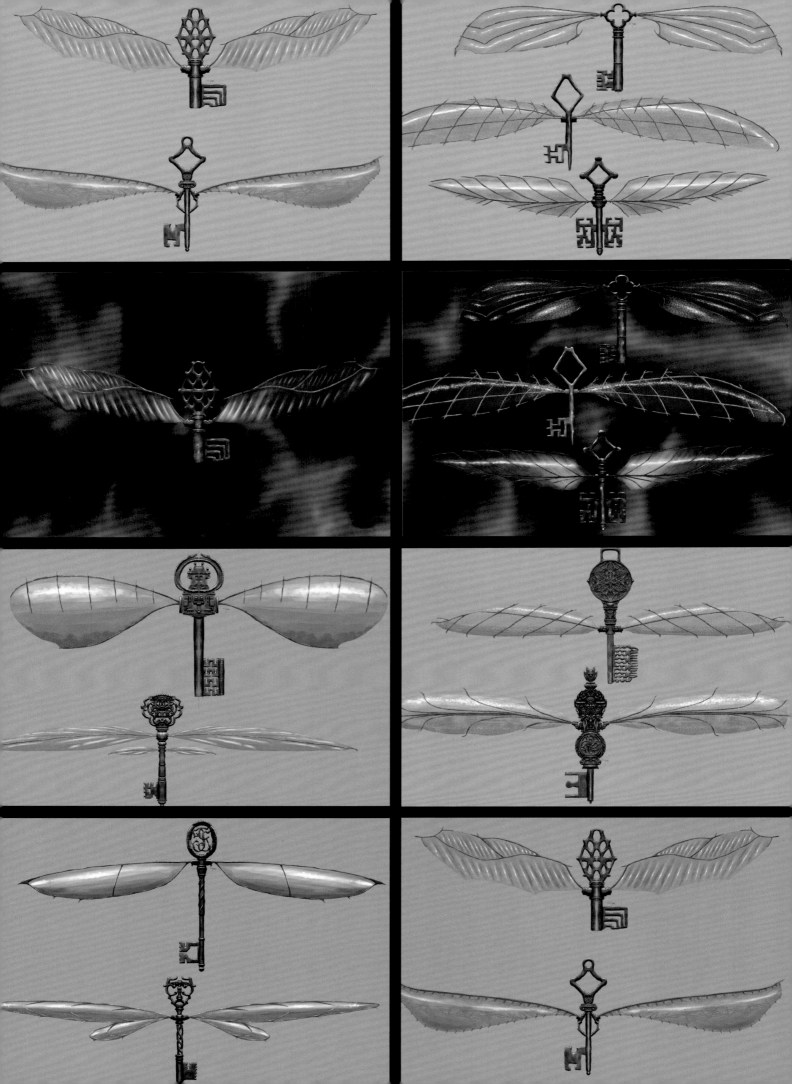

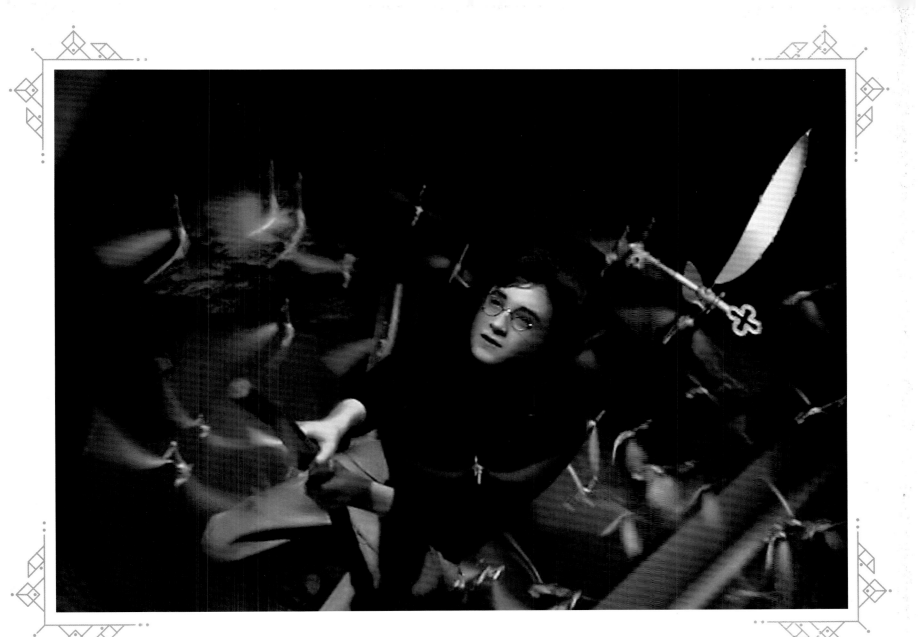

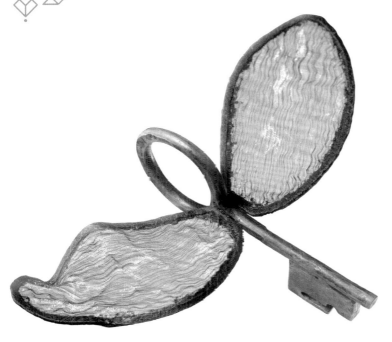

Harry must find the correct winged key that will open a door to the next test in *Harry Potter and the Sorcerer's Stone*.

OPPOSITE: Concept art for the winged keys by Gert Stevens.

TOP: Harry (Daniel Radcliffe) pursues the key on broomstick in a film still from *Sorcerer's Stone*.

ABOVE AND RIGHT: The prop key and the prop Sorcerer's Stone.

THE TRIWIZARD TOURNAMENT

The Goblet of Fire reveals the champions who will participate in the Triwizard Tournament in *Harry Potter and the Goblet of Fire*.

BELOW: Visual development by Adam Brockbank of the Goblet surrounded by an age line cast by Dumbledore.

RIGHT: The sculpted prop for the Goblet of Fire.

FAR RIGHT: The Triwizard Cup, given to the Tournament's winner.

OPPOSITE TOP: Adam Brockbank envisioned drums to be played by the Durmstrang students upon their entrance.

OPPOSITE BOTTOM: The golden egg, which reveals a clue to the second task. Development art by Miraphora Mina.

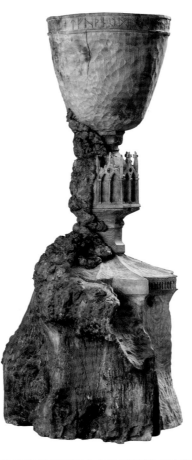

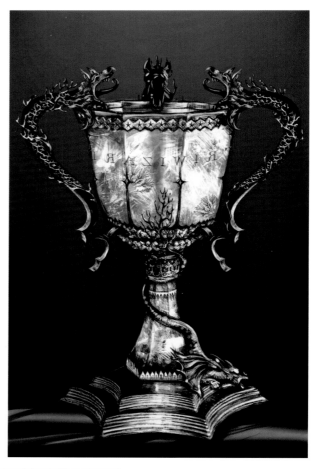

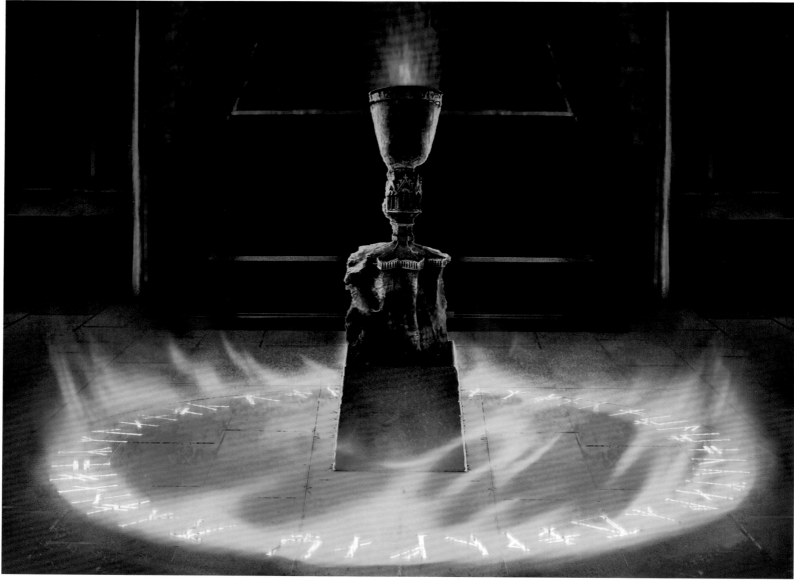

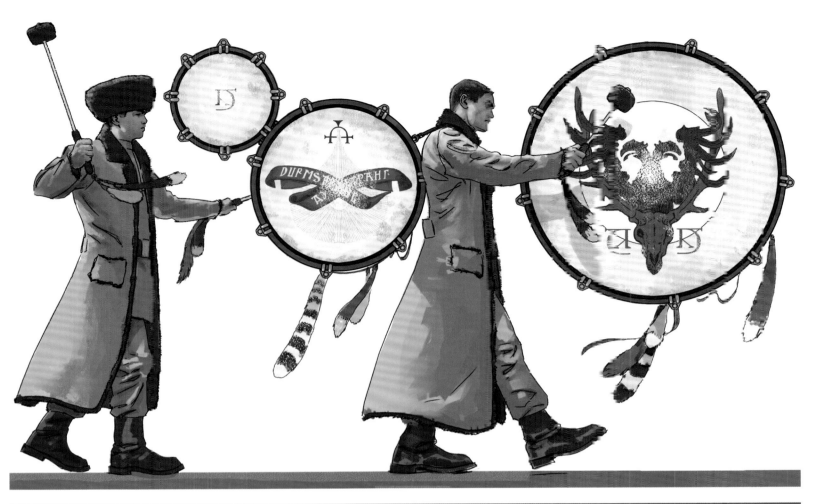

DARK OBJECTS

Draco Malfoy attempts to fix a Vanishing Cabinet in *Harry Potter and the Half-Blood Prince*, using a bird to test its worthiness.

ABOVE LEFT: Three views of the bird's cage by Rob Bliss.

ABOVE RIGHT: The final prop birdcage.

OPPOSITE: The Vanishing Cabinet, hidden in the Room of Requirement. Concept painting by Andrew Williamson.

Hermione reads *The Tale of the Three Brothers* in *Harry Potter and the Deathly Hallows – Part 1*, which may explain the origin of the Deathly Hallows.

ABOVE: Death. Concept art by Dale Newton, who supervised the animated tale.

OPPOSITE TOP: The three brothers arrive at the river where they will bargain with Death. Art by Ben Hibon, director of the animated sequence.

OPPOSITE MIDDLE: The brothers magically conjure a bridge. Art by Dale Newton.

OPPOSITE BOTTOM: Alexis Liddell's color key of the second brother's fate when he uses the Resurrection Stone.

PAGES 254–255: Development art of the first brother by Dale Newton.

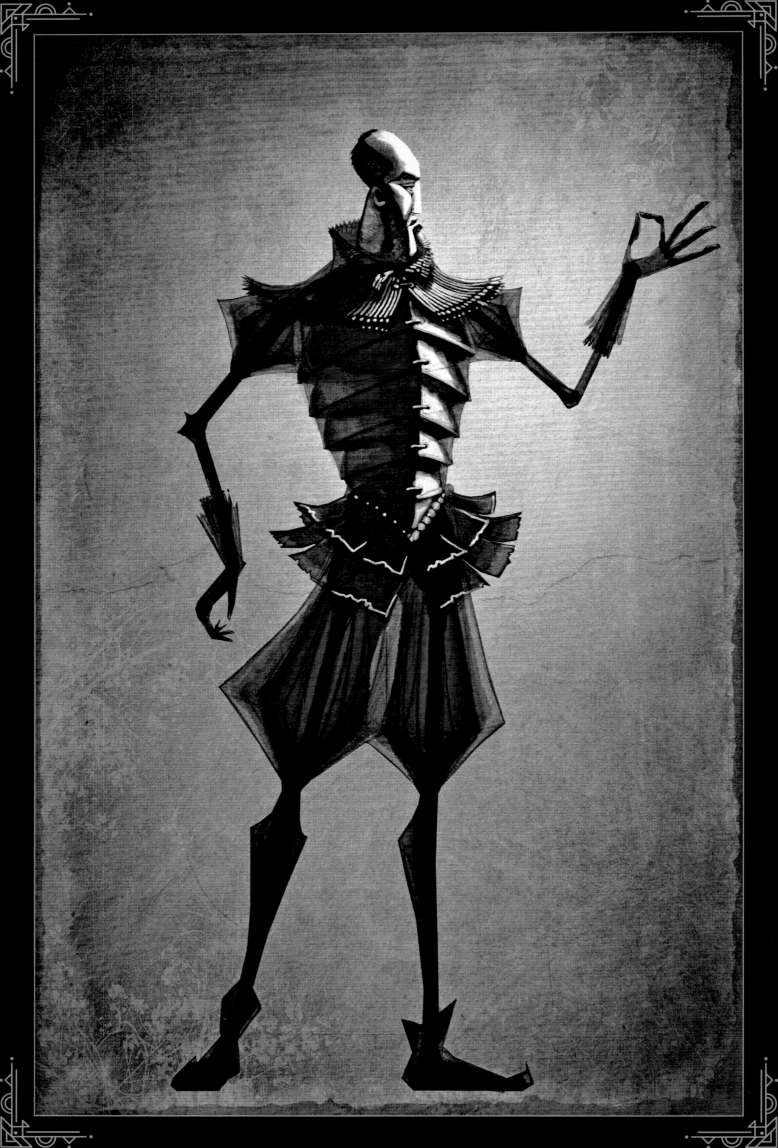

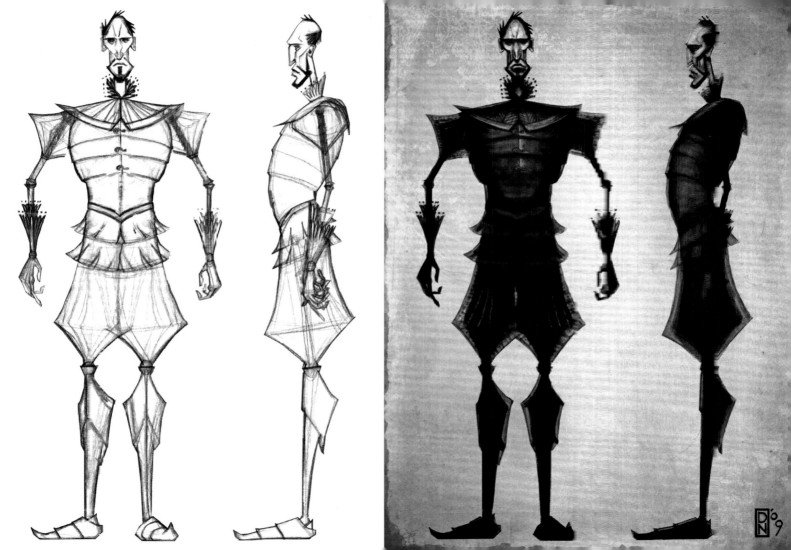

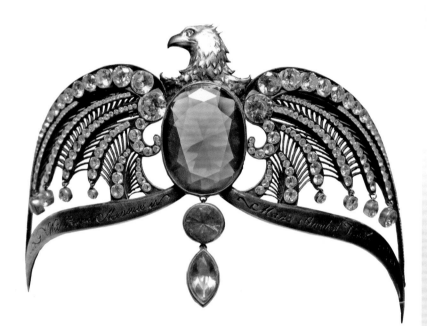

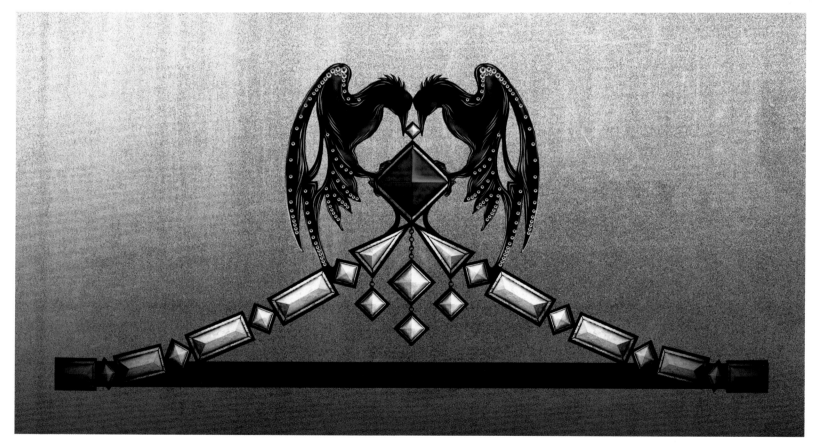

Lord Voldemort purposely created six Horcruxes in a quest for immortality, seen throughout the Harry Potter films.

TOP LEFT: The prop of Ravenclaw's diadem used in *Harry Potter and the Deathly Hallows – Part 2.*

TOP RIGHT AND ABOVE: An early concept of Ravenclaw's diadem by Miraphora Mina, and a prop version to be seen atop a bust in the Lovegood House in *Harry Potter and the Deathly Hallows – Part 1.* Neither this bust nor this diadem were used in the movie.

OPPOSITE: Concept art by Adam Brockbank of the bust of Rowena Ravenclaw and a stylized similar diadem seen in *Deathly Hallows – Part 1.*

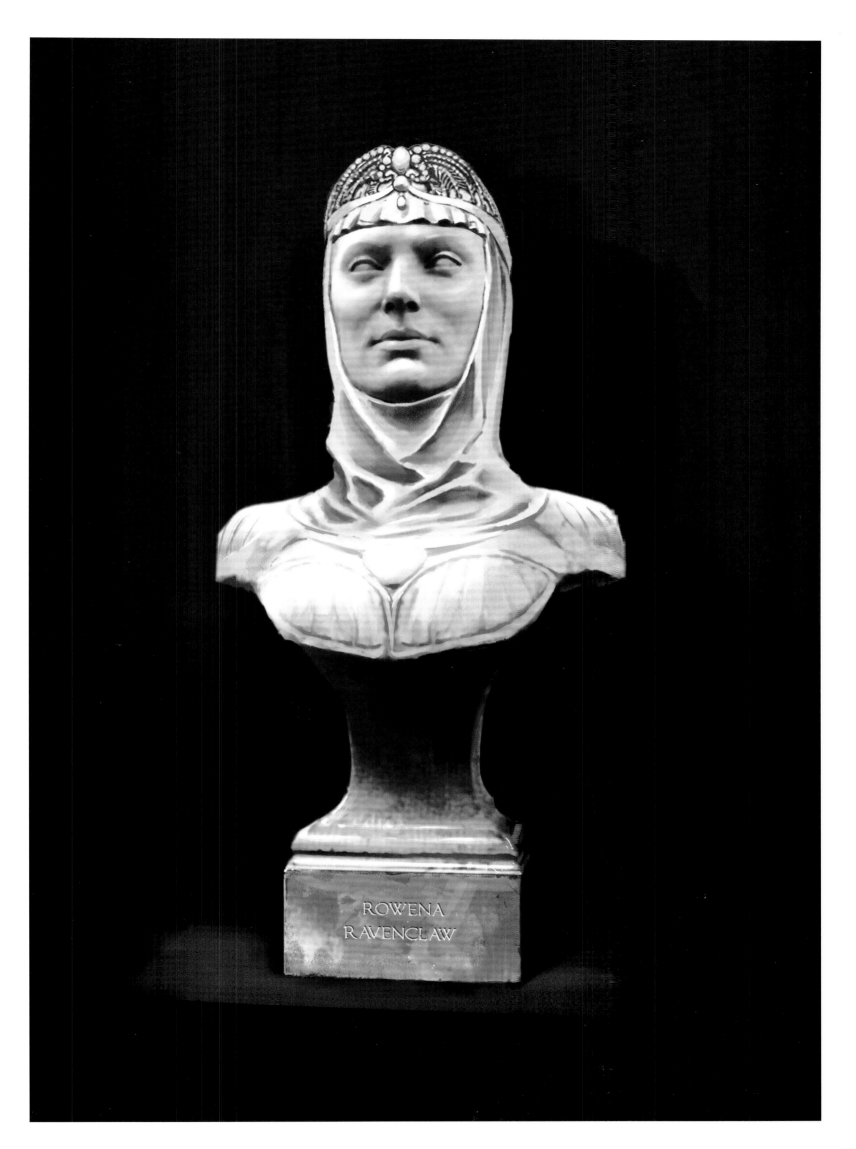

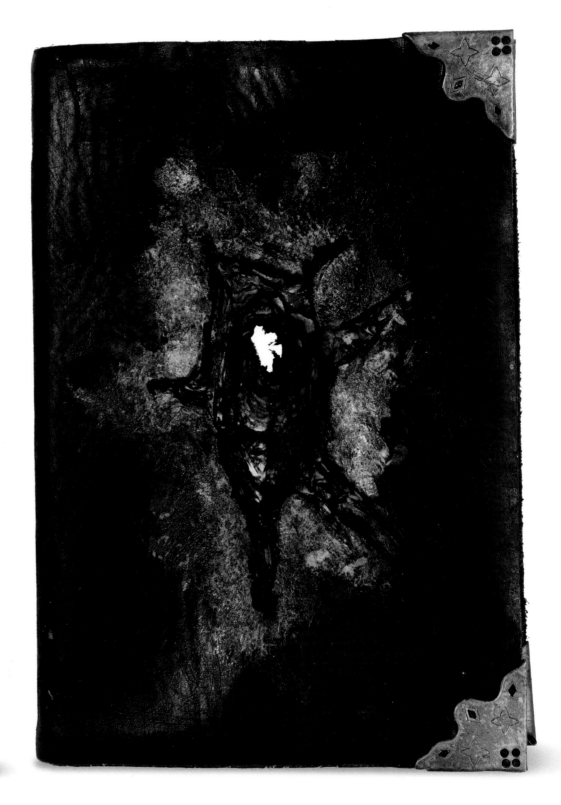

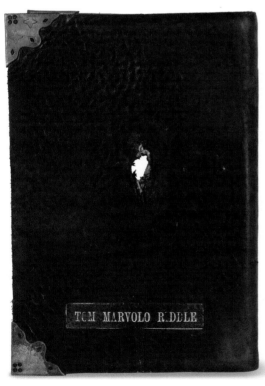

TOM MARVOLO RIDDLE

ABOVE: Prop reference shots of Tom Riddle's diary after being destroyed by a Basilisk tooth in *Harry Potter and the Chamber of Secrets*.

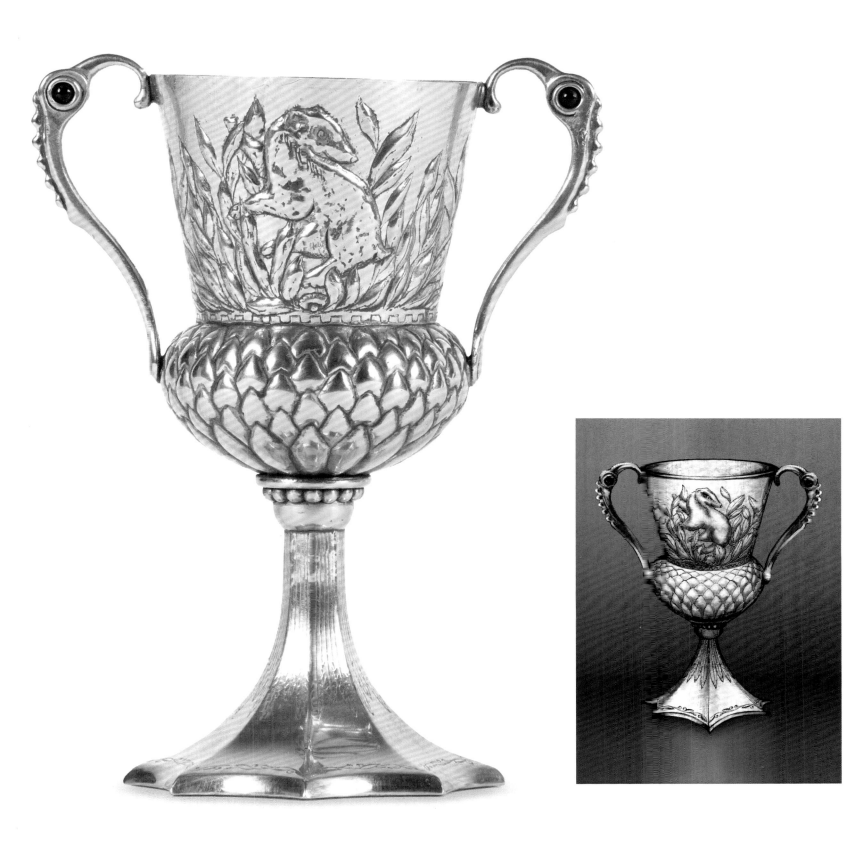

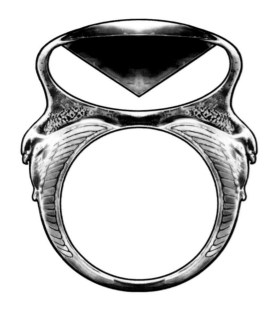

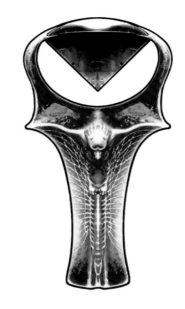

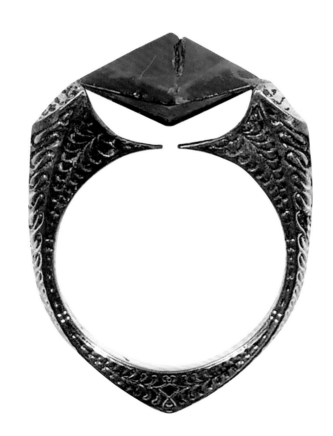

TOP: Visual development art by Adam Brockbank of Marvolo Gaunt's ring, which was turned into a Horcrux and also held the Resurrection Stone, one of the Deathly Hallows.

ABOVE RIGHT: The final ring prop as seen in *Harry Potter and the Half-Blood Prince* and *Harry Potter and the Deathly Hallows – Part 2.*

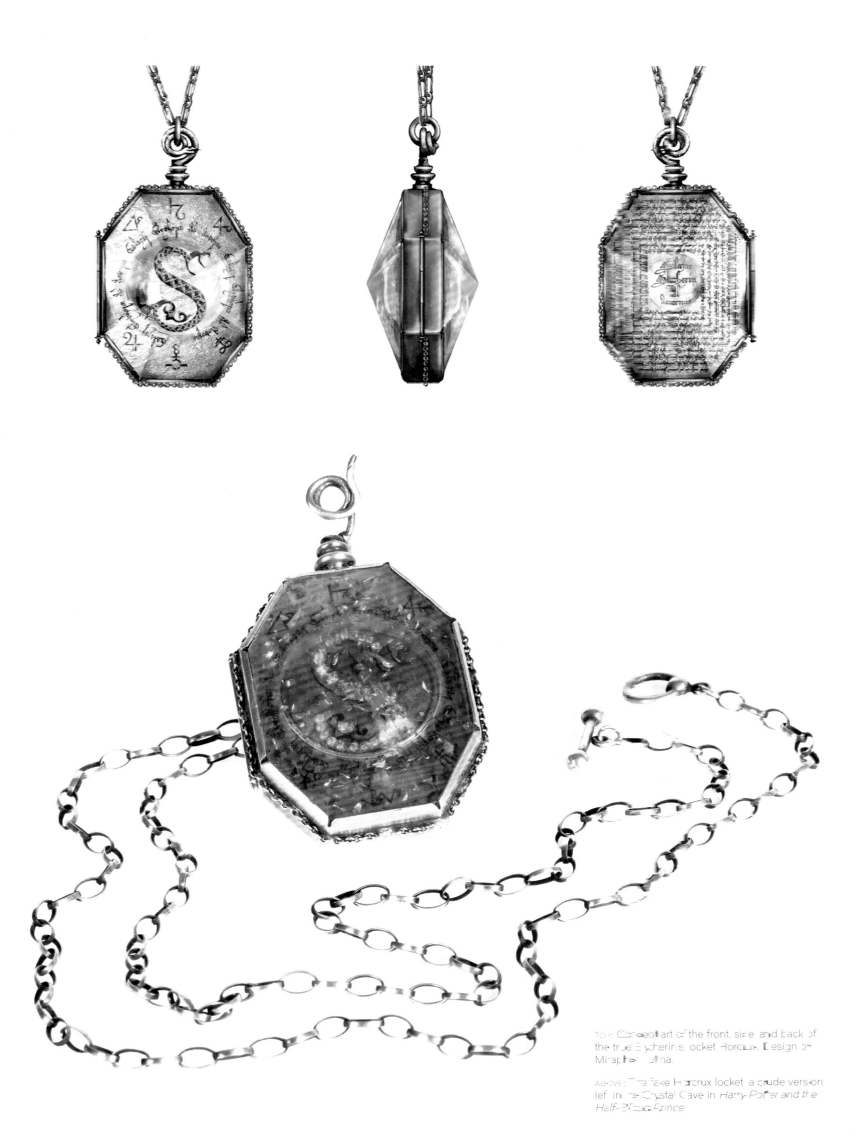

TOP: Concept art of the front, side, and back of the true Slytherin's locket Horcrux. Design by Miraphora Mina.

ABOVE: The fake Horcrux locket, a crude version left in the Crystal Cave in *Harry Potter and the Half-Blood Prince*.

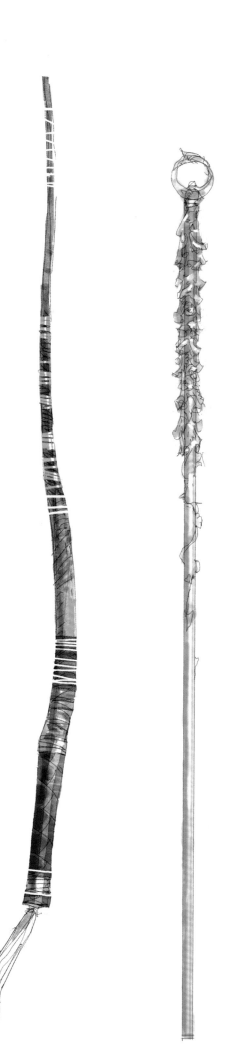

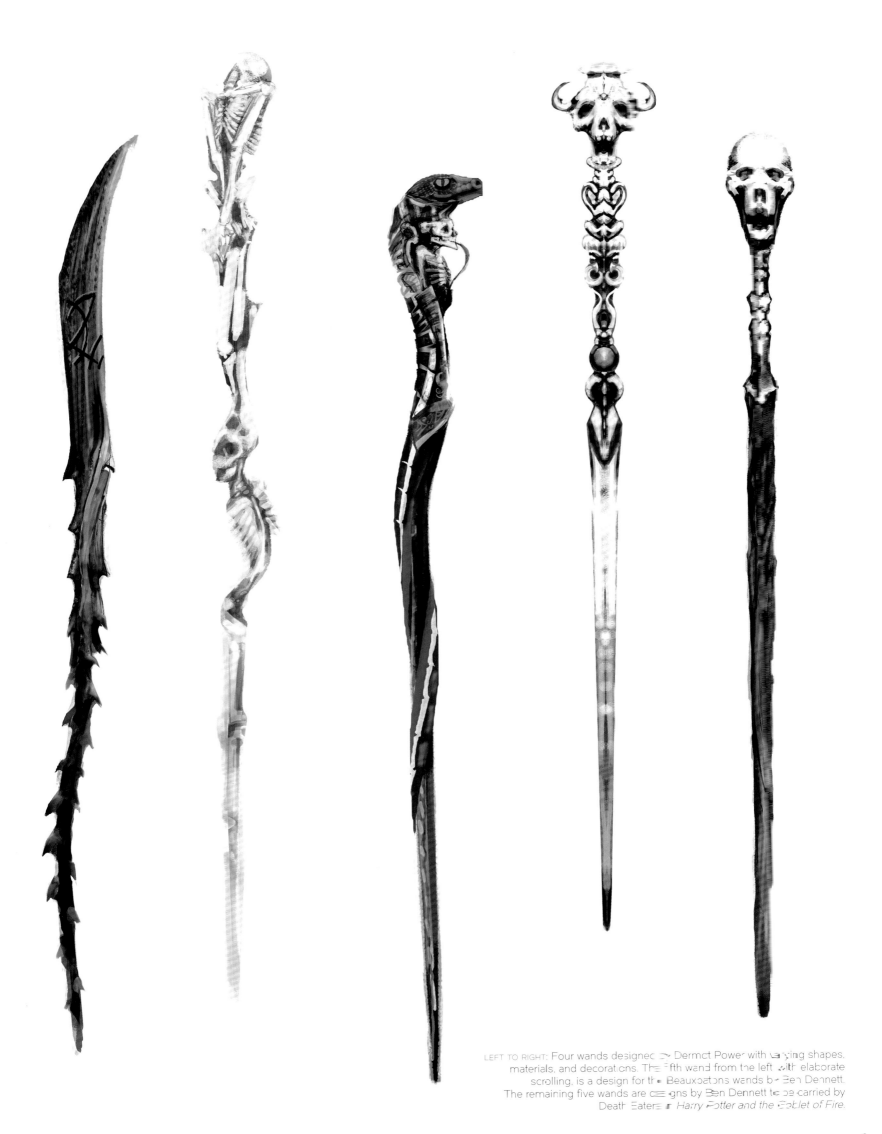

LEFT TO RIGHT: Four wands designed by Dermot Power with varying shapes, materials, and decorations. The fifth wand from the left, with elaborate scrolling, is a design for the Beauxbatons wands by Ben Dennett. The remaining five wands are designs by Ben Dennett to be carried by Death Eaters in *Harry Potter and the Goblet of Fire*.

HOGWARTS
PORTRAITS

TOP AND RIGHT: Concept art by Adam Brockbank of the painting of Sir Cadogan, who sincerely tries to protect Hogwarts in *Harry Potter and the Prisoner of Azkaban*.

ABOVE: For one of the moving portraits, Dermot Power painted a concept of a witch flying into a foggy landscape.

OPPOSITE: Development art by Dermot Power of the second Fat Lady, played by Dawn French, who guards the Gryffindor Common Room in *Harry Potter and the Prisoner of Azkaban*.

PAGES 266–267: Portraits of wizards and witches line the walls of Hogwarts, created by artists in the art, props, and set decoration departments.

ATHAL, BATHEL, NOTHE, JHORAM ASEY, CLEYUNGIT, GABELLIN

SEMENEY, BAL

MECLAP,

NERO

*

PALCIN, PLEGAS

HEAN

ARARNA, AYLA, PEREMIES, LEVESSO

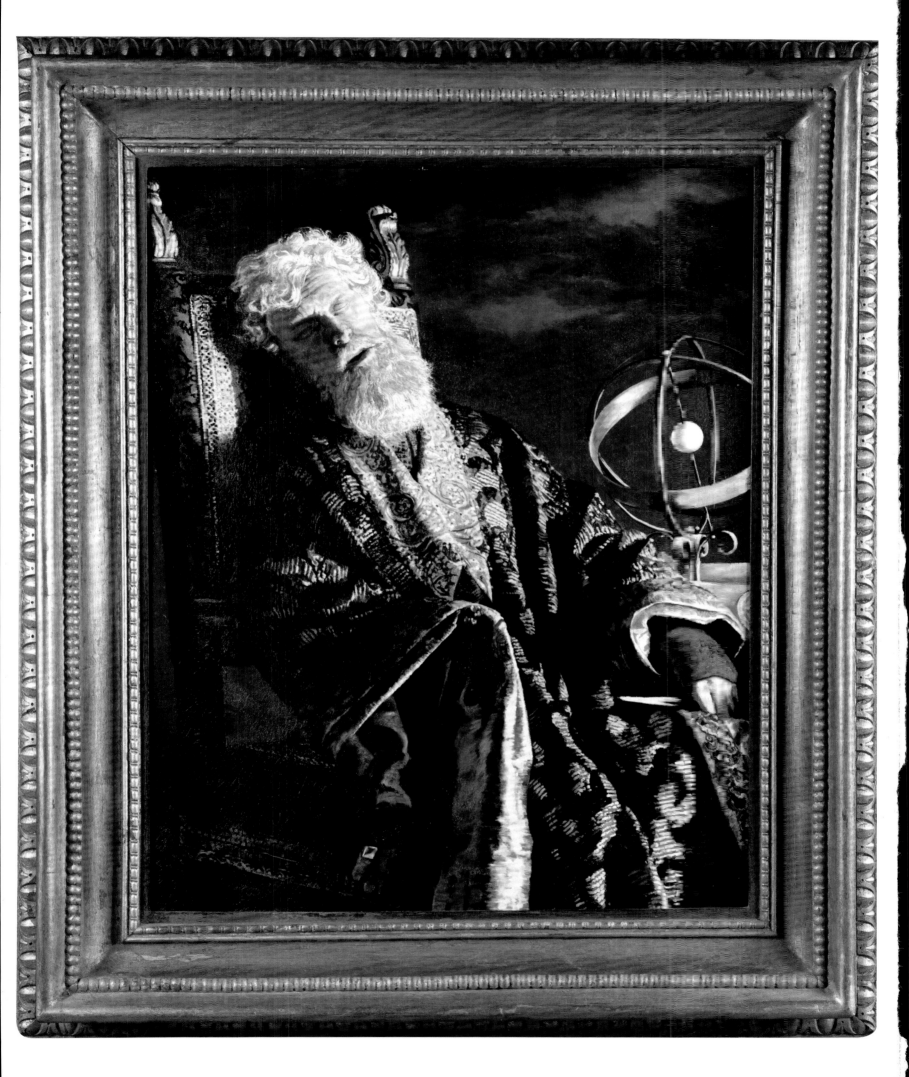

Loco et Tempore. Nil Sine Deo

De omni re scibili et quibusdam aliis

Aurora 96

gg

3

PVNCTA RECTA

WEASLEYS'
WIZARD WHEEZES

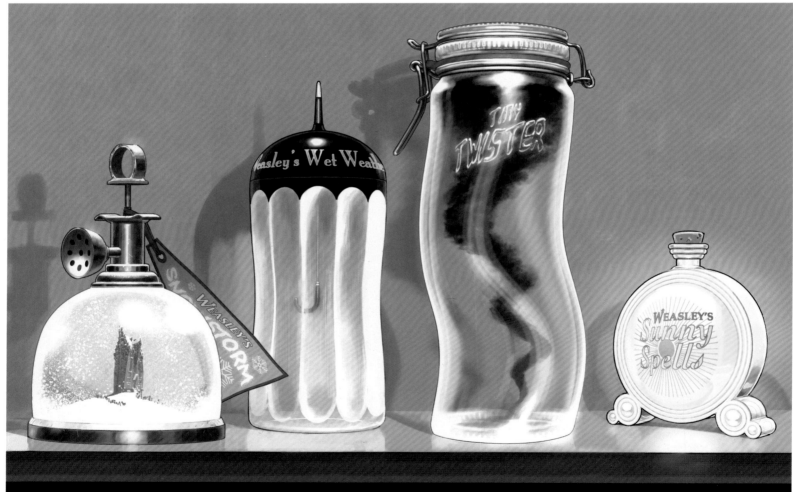

PAGES 268–275: Portraits lined the walls of Hogwarts castle and were seen throughout the Harry Potter films, a collaboration of the set decoration, props, and art departments. Some were based on famous paintings through the ages. Others featured portraits of production crew members.

The Weasley twins opened Weasleys' Wizard Wheezes, featuring jokes, sweets, and other magical fare, on Diagon Alley in *Harry Potter and the Half-Blood Prince*. Concept art by Adam Brockbank. These items included: (*top left*) a Dolores Umbridge-inspired cyclist on a tightrope tin toy; (*top right*) Extendable Ears; and (*above*) Weather in a Bottle.

OPPOSITE: The shop exterior features one of the twins continuously pulling a rabbit out of his top hat.

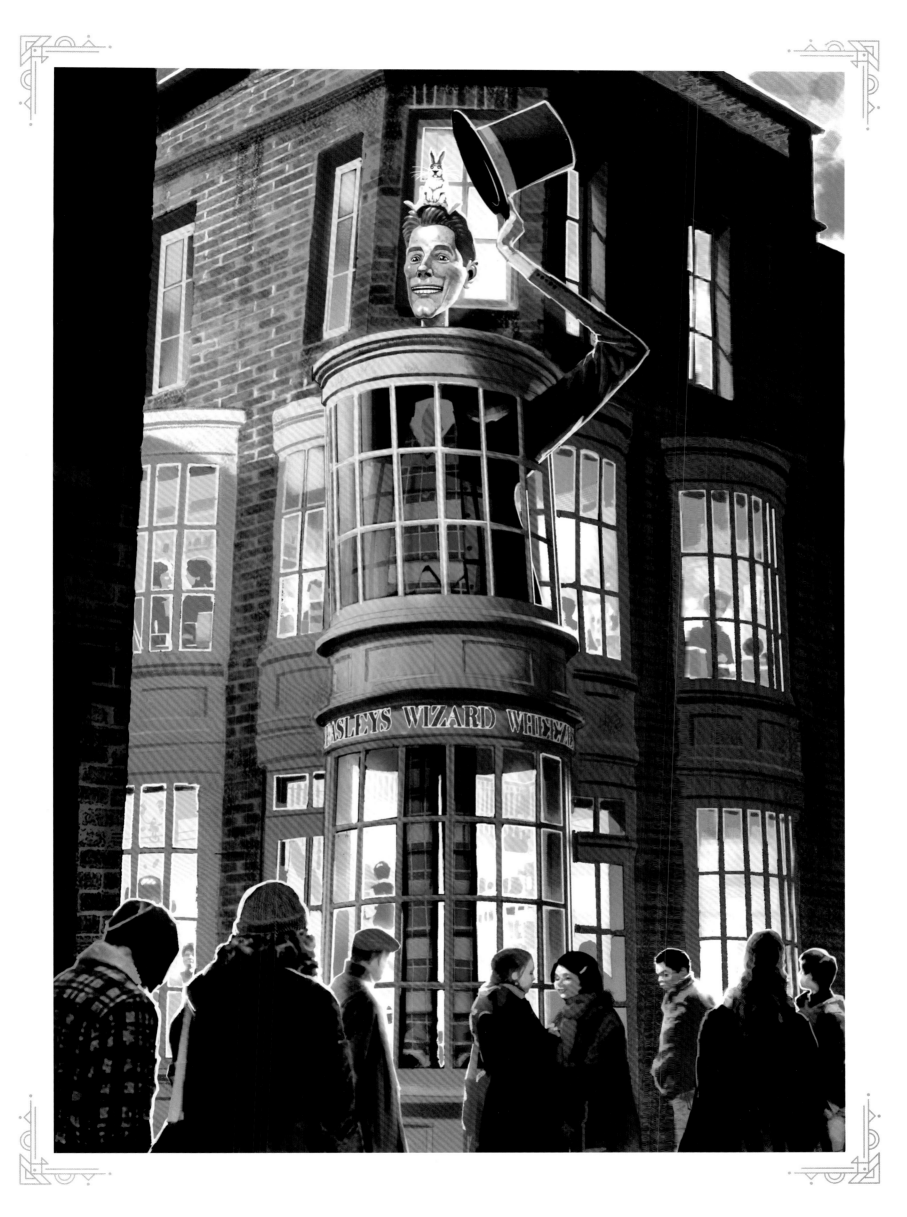

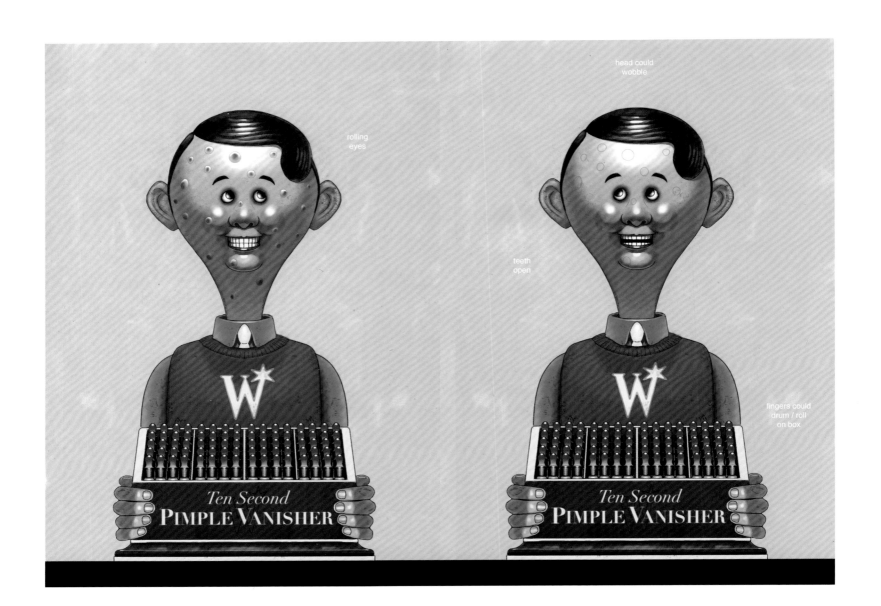

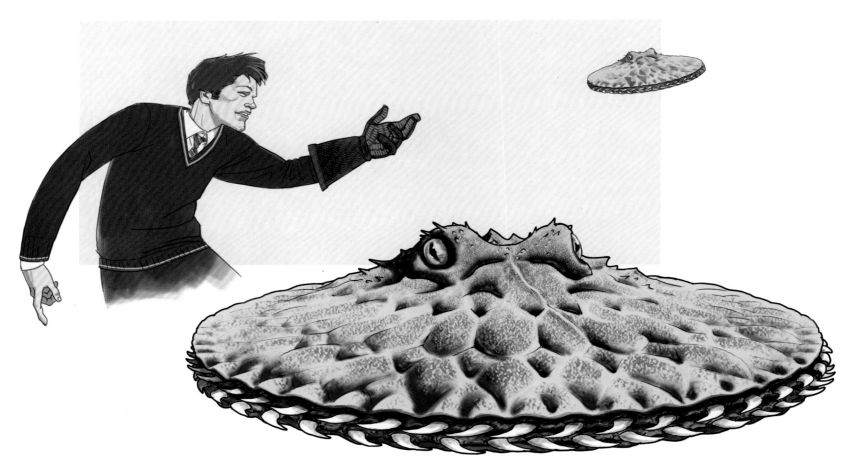

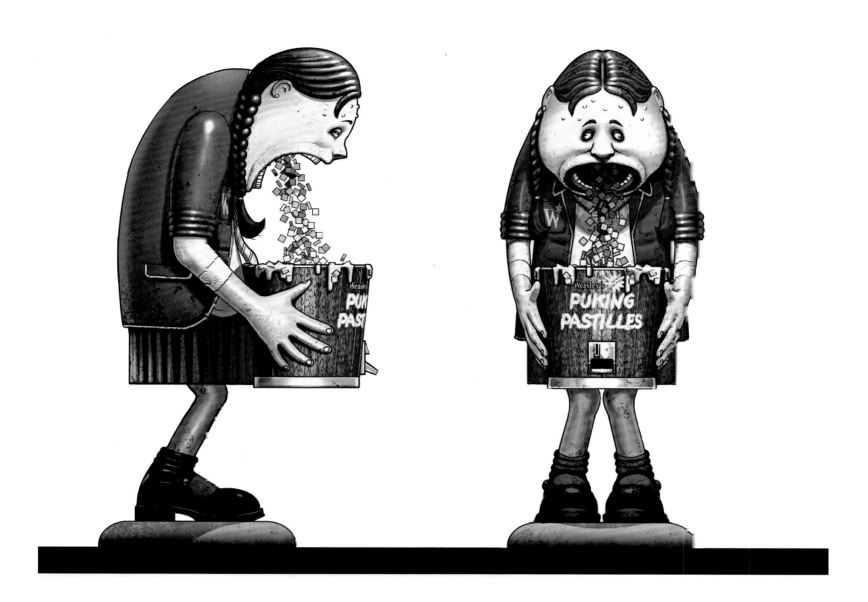

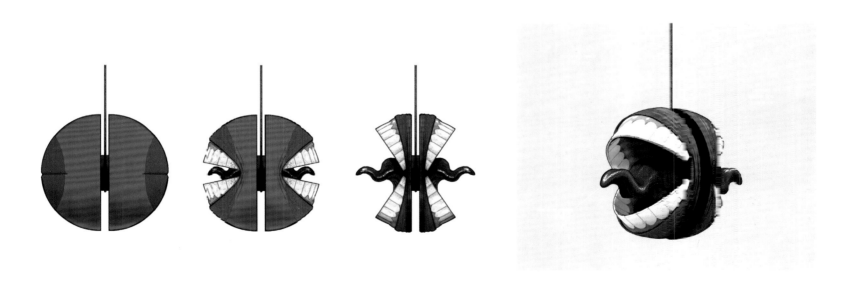

Concept art by Adam Brockbank of Weasley wares for *Harry Potter and the Half-Blood Prince*.

OPPOSITE TOP: A life-size display for the Ten-Second Pimple Vanisher.

OPPOSITE BOTTOM: Other popular toys include the Fanged Frisbee.

TOP: A larger-than-life Puking Pastilles display.

ABOVE: The Screaming Yo-Yo.

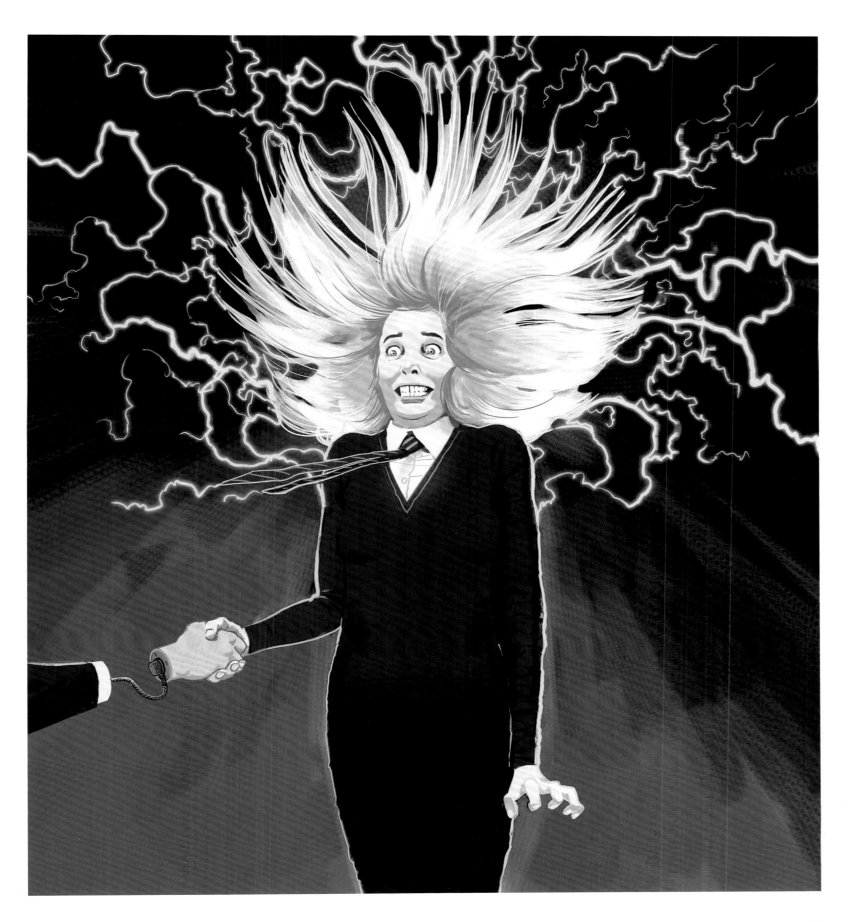

OPPOSITE: A WonderWitch product display by Adam Brockbank contains love potions and charms for young witches.

ABOVE: An interpretation of a Muggle practical joke is featured in the Electric Shock Shake Art by Adam Brockbank.

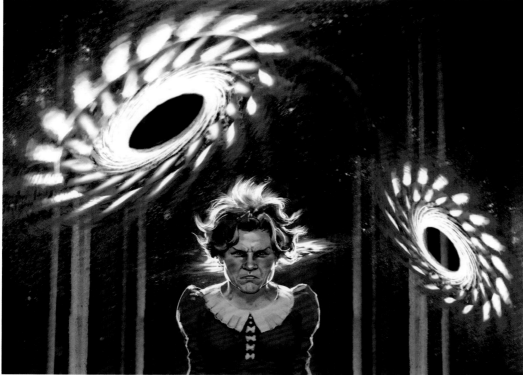

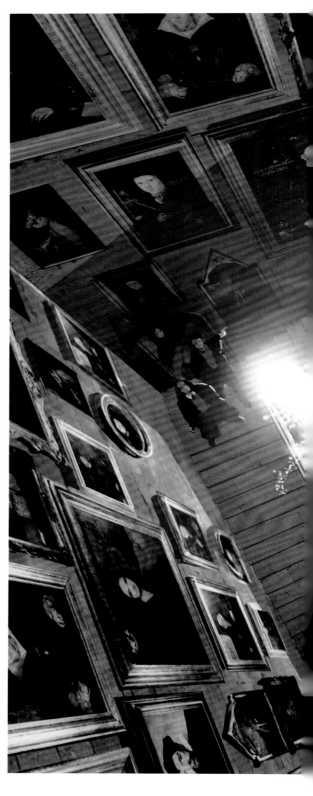

The Weasley twins are well-known for their fireworks. In *Harry Potter and the Order of the Phoenix*, they interrupted the fifth-years' O.W.L. exams, monitored by Dolores Umbridge, with a dazzling (and destructive) display.

TOP LEFT AND ABOVE: Concept art by Adam Brockbank of an Asian-style dragon firework and flashy spinners.

OPPOSITE: Andrew Williamson shows the Weasley twins flying through the moving staircases of Hogwarts before they make their exit from the school.

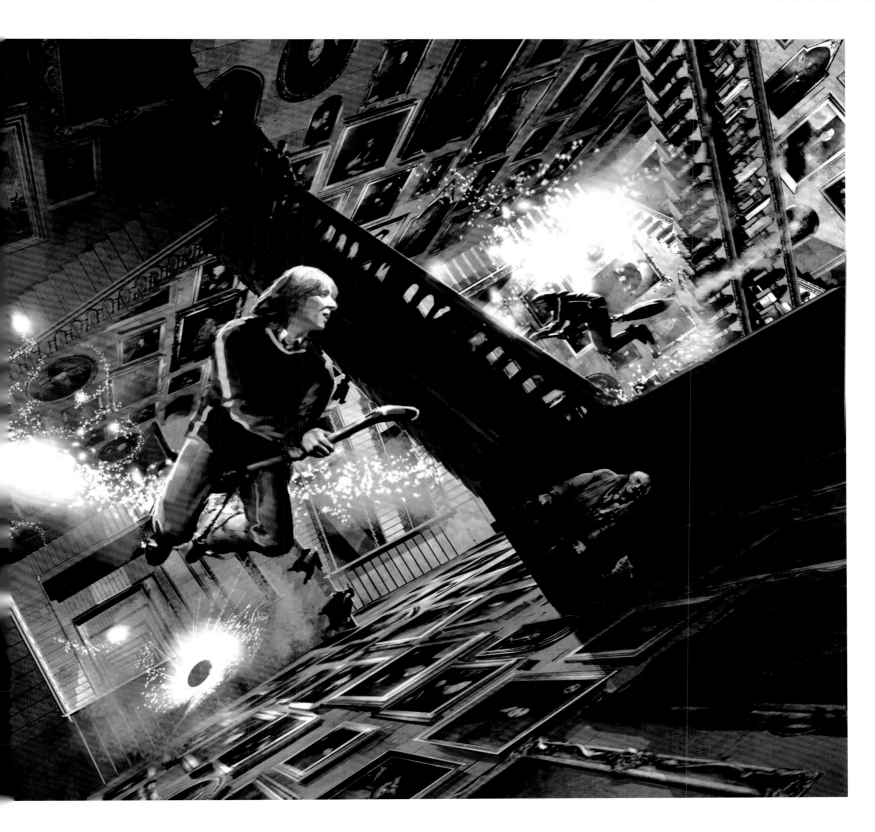

WIZARDING INVENTIONS

Ron and Harry fly to Hogwarts in Arthur Weasley's magical flying Ford Anglia in *Harry Potter and the Chamber of Secrets* when they can't get on the Hogwarts Express, and they land in the Whomping Willow on the castle grounds.

THIS PAGE: Visual concepts of the Willow-bashed car by Dermot Power.

OPPOSITE: Dermot Power illustrates the car approaching the Whomping Willow in a monochromatic landscape.

THIS PAGE: A wand checker in the Ministry of Magic created by Adam Brockbank for *Harry Potter and the Order of the Phoenix.*

OPPOSITE: Adam Brockbank also envisioned a house-elf-driven floor polisher.

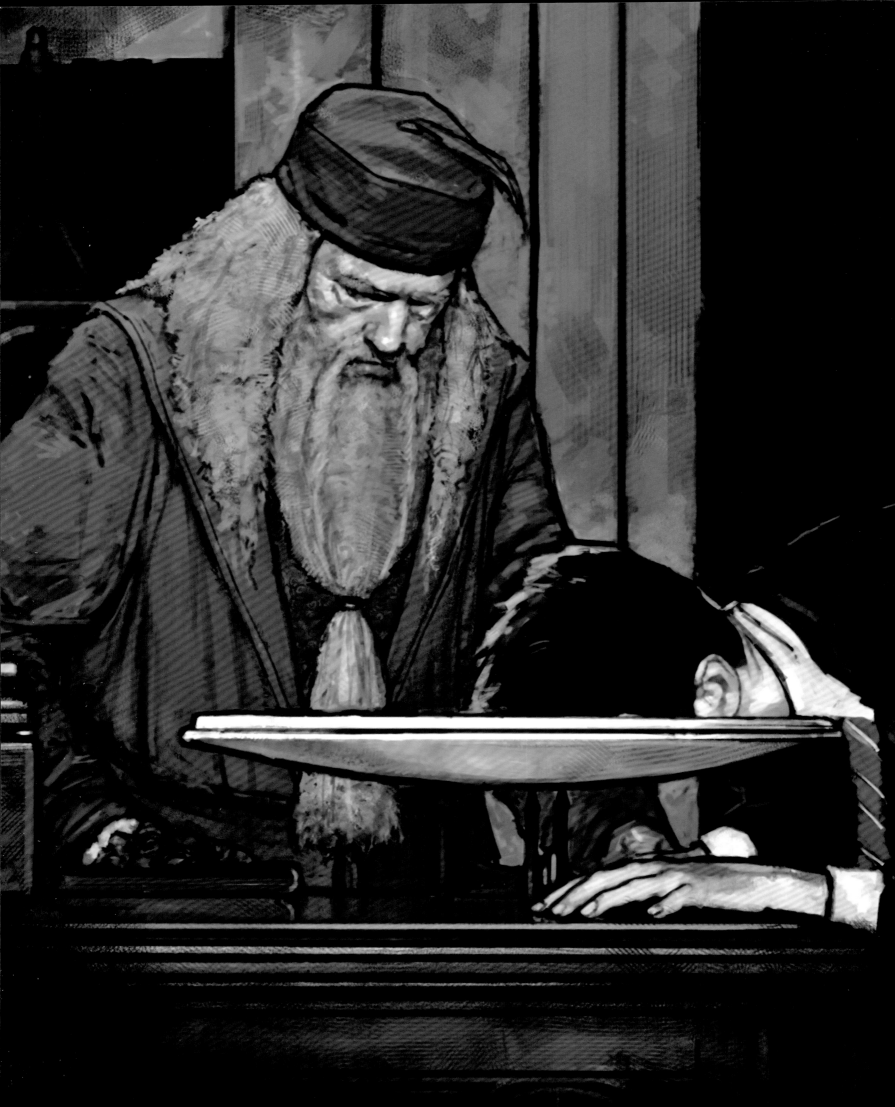

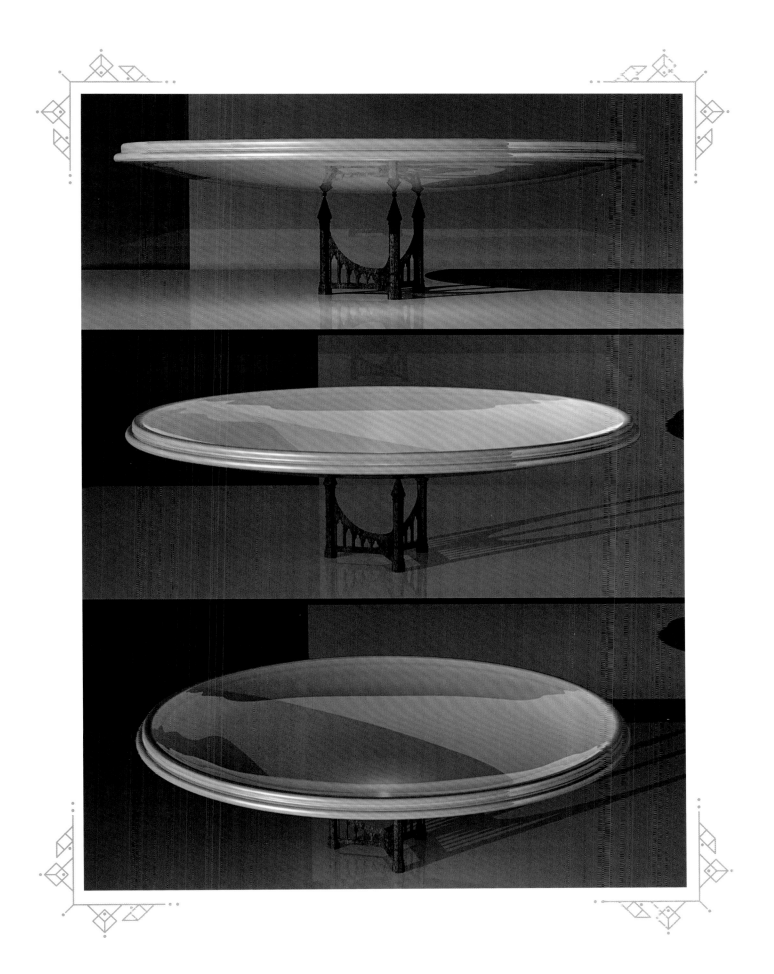

The Pensieve is a way to view memories gathered from a wizard's mind. For *Harry Potter and the Half-Blood Prince*, the Pensieve was supported by a three-legged stand.

OPPOSITE: Art by Rob Bliss shows Dumbledore watching Harry as he views a memory of Tom Riddle.

ABOVE: Three views of the Pensieve platform by Rob Bliss.

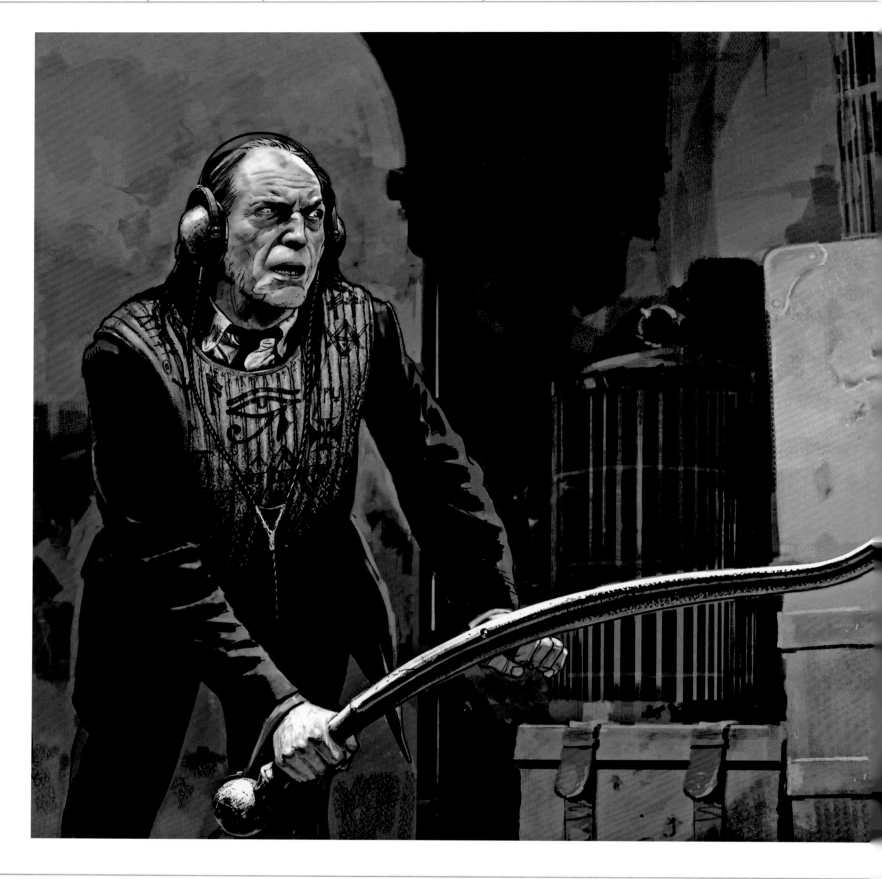

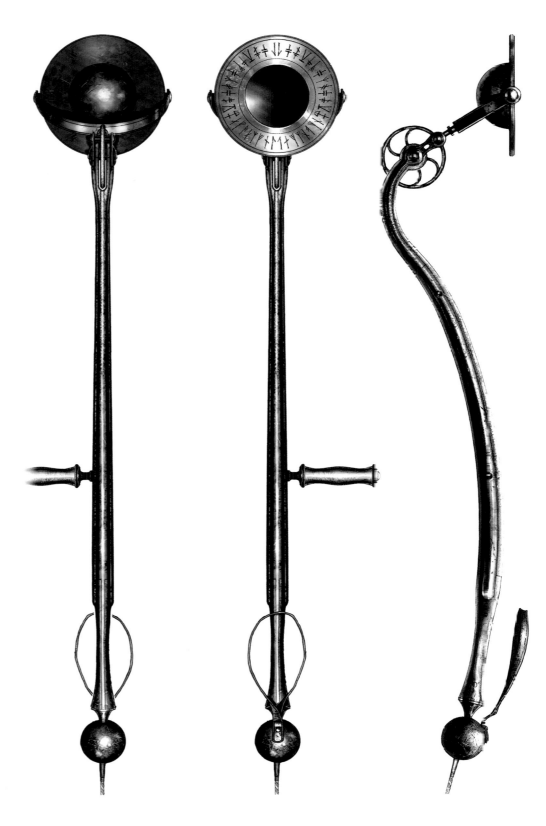

OPPOSITE AND ABOVE: Hogwarts employs Dark Detectors when Voldemort's return threatens the students in *Harry Potter and the Half-Blood Prince*. Here, Adam Brockbank illustrates and details the Secrecy Sensor, used by Argus Filch to check the returning students.

PAGE 292: An Underwater Viewing Scope was proposed so that students and professors could watch the second task of the Triwizard Tournament in *Harry Potter and the Goblet of Fire*. Paul Catling details the scope's viewing system.

PAGE 293: Dermot Power illustrates the scopes as they could be used under the Black Lake's surface.

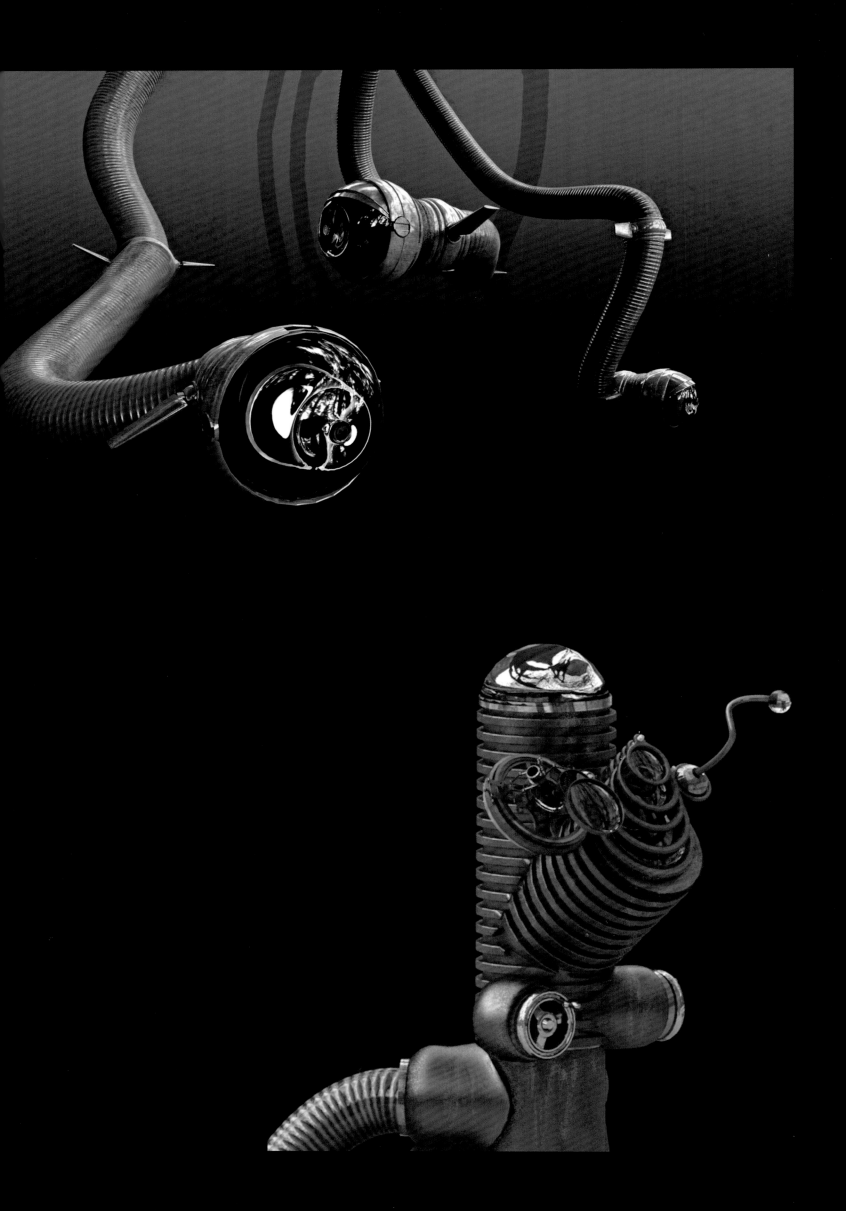

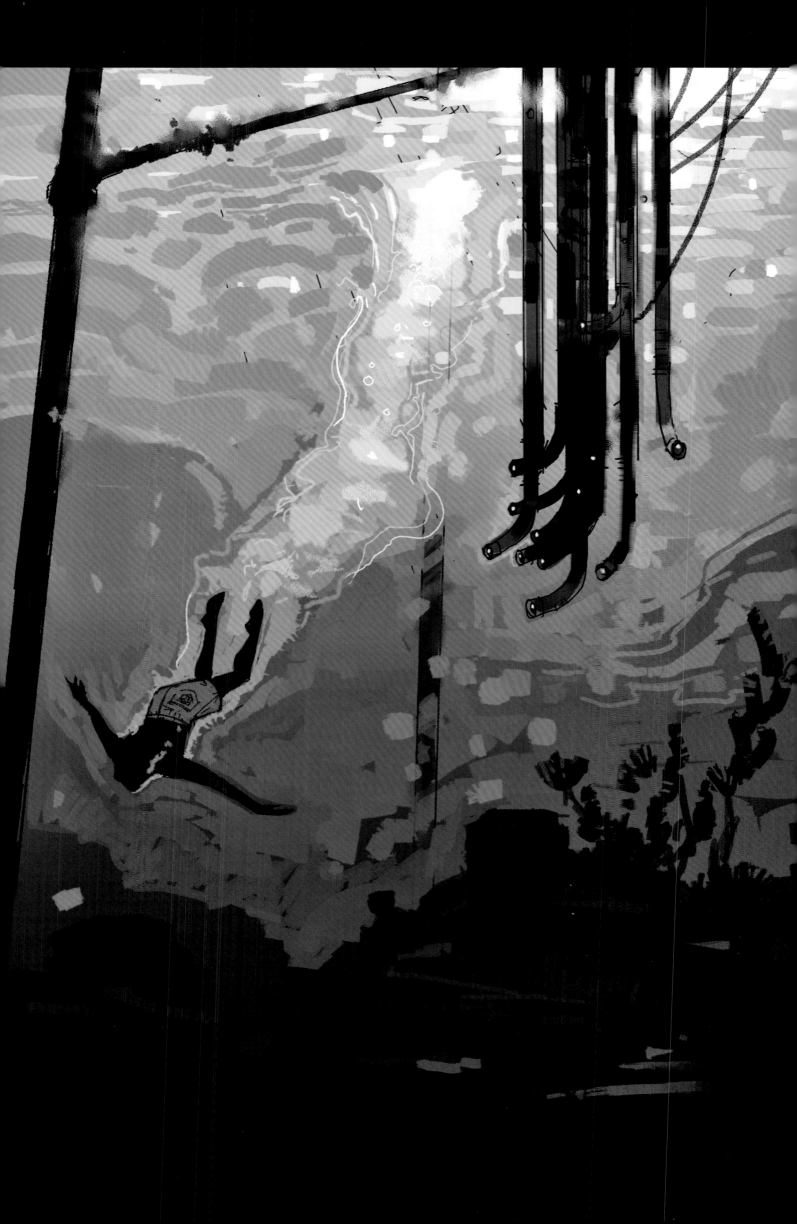

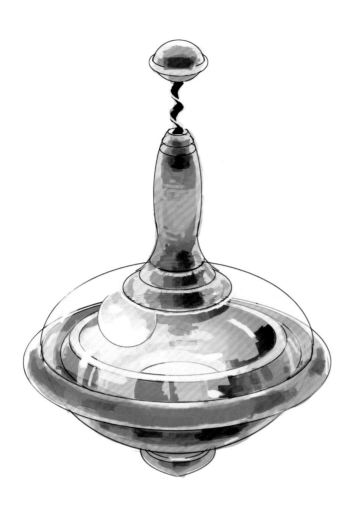

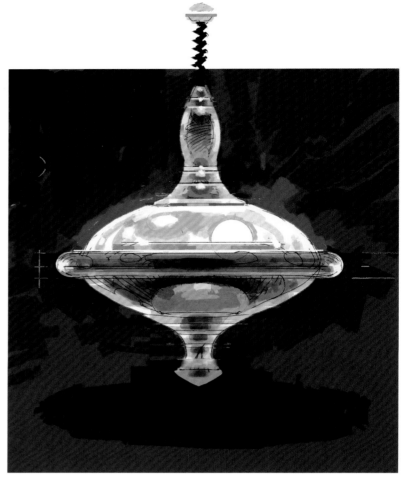

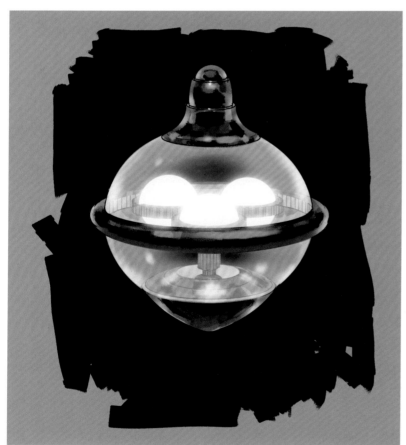

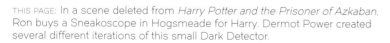

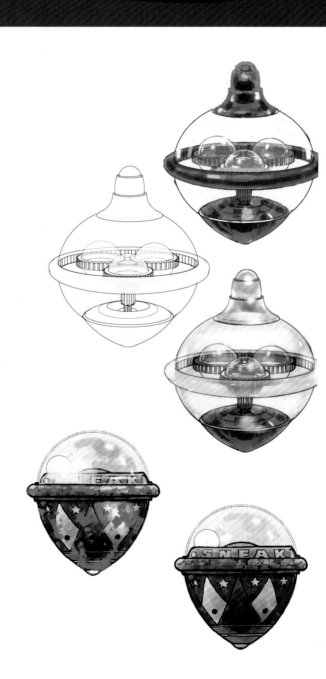

THIS PAGE: In a scene deleted from *Harry Potter and the Prisoner of Azkaban*, Ron buys a Sneakoscope in Hogsmeade for Harry. Dermot Power created several different iterations of this small Dark Detector.

OPPOSITE: The time-extending Time-Turner is used by Hermione in *Prisoner of Azkaban* to increase her class load. Concept art by Dermot Power was inspired by Miraphora Mina's brief that the jewelry had to have a spinning element.

PAGE 296: The wizard's wireless prop that broadcasts in the Gryffindor common room in *Harry Potter and the Order of the Phoenix*.

PAGE 297: Artwork by Adam Brockbank of the wizard's wireless.

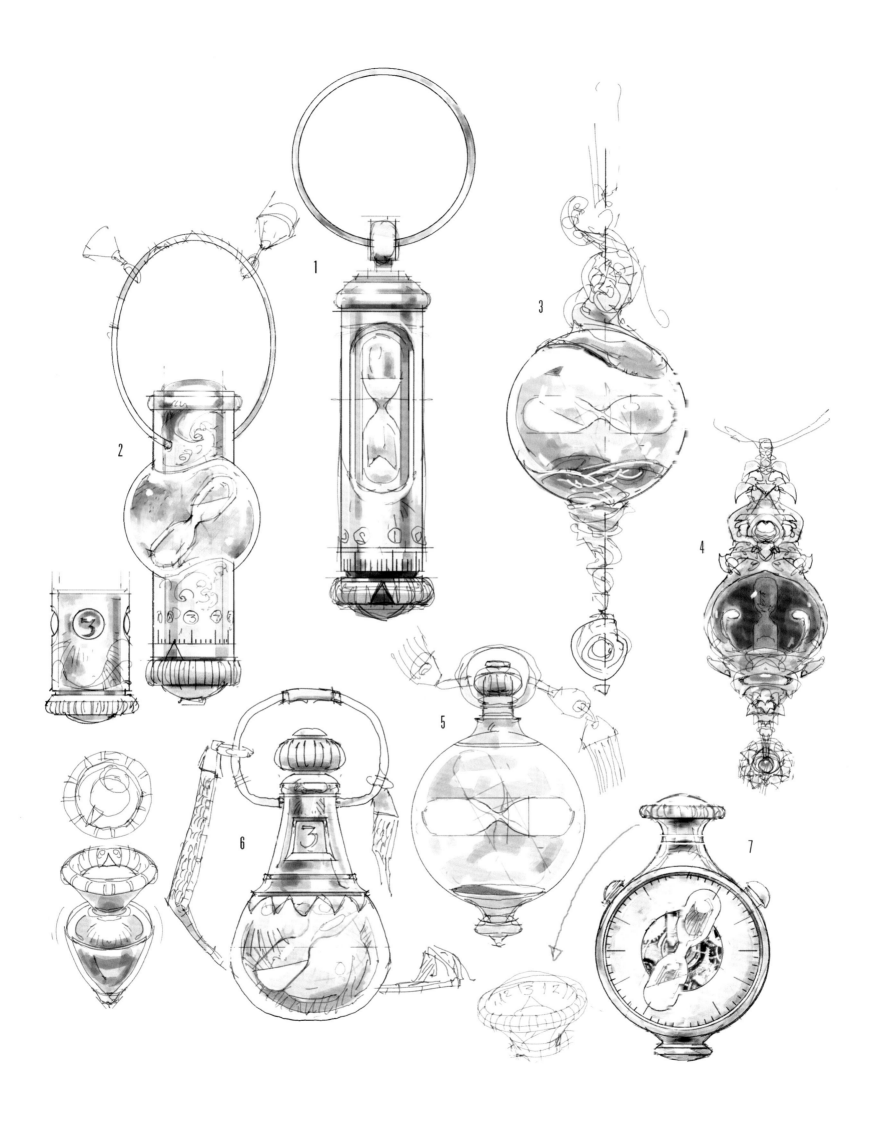

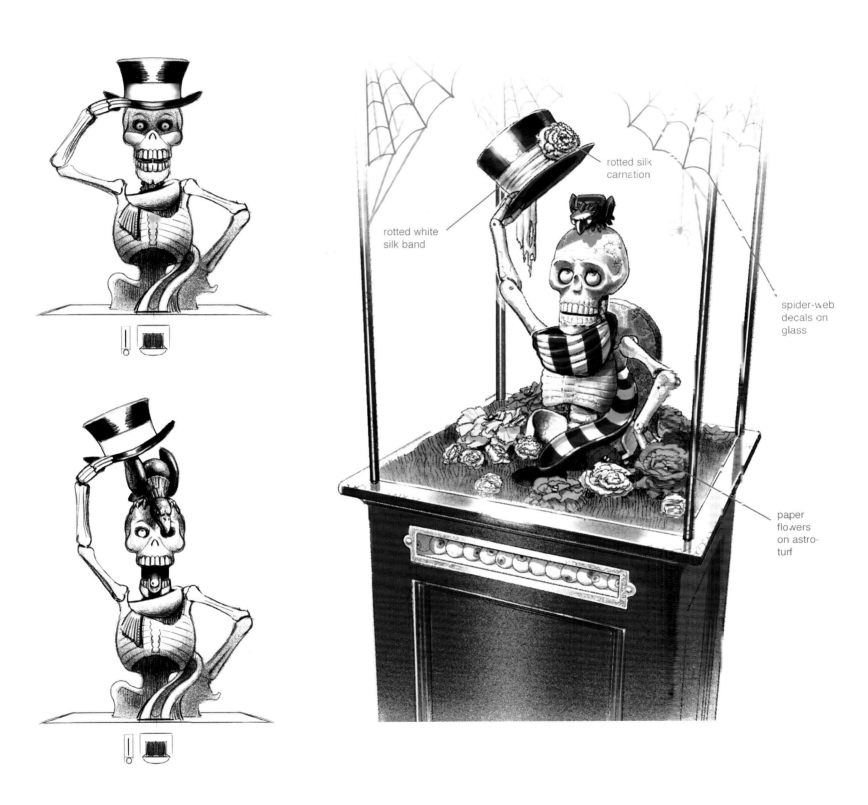

rotted silk
carnation

rotted white
silk band

spider-web
decals on
glass

paper
flowers
on astro-
turf

OPPOSITE: Several clocks hang on the walls of The Burrow in *Harry Potter and the Chamber of Secrets*, designed by Adam Brockbank (top left, top middle and bottom left) and Cyrille Nomberg (bottom middle and right).

ABOVE: Concept art by Adam Brockbank for *Harry Potter and the Prisoner of Azkaban* of the top-hatted skeleton at Honeydukes who dispenses eyeball-decorated candies.

CHAPTER 5
GRAPHIC ART OF THE WIZARDING WORLD

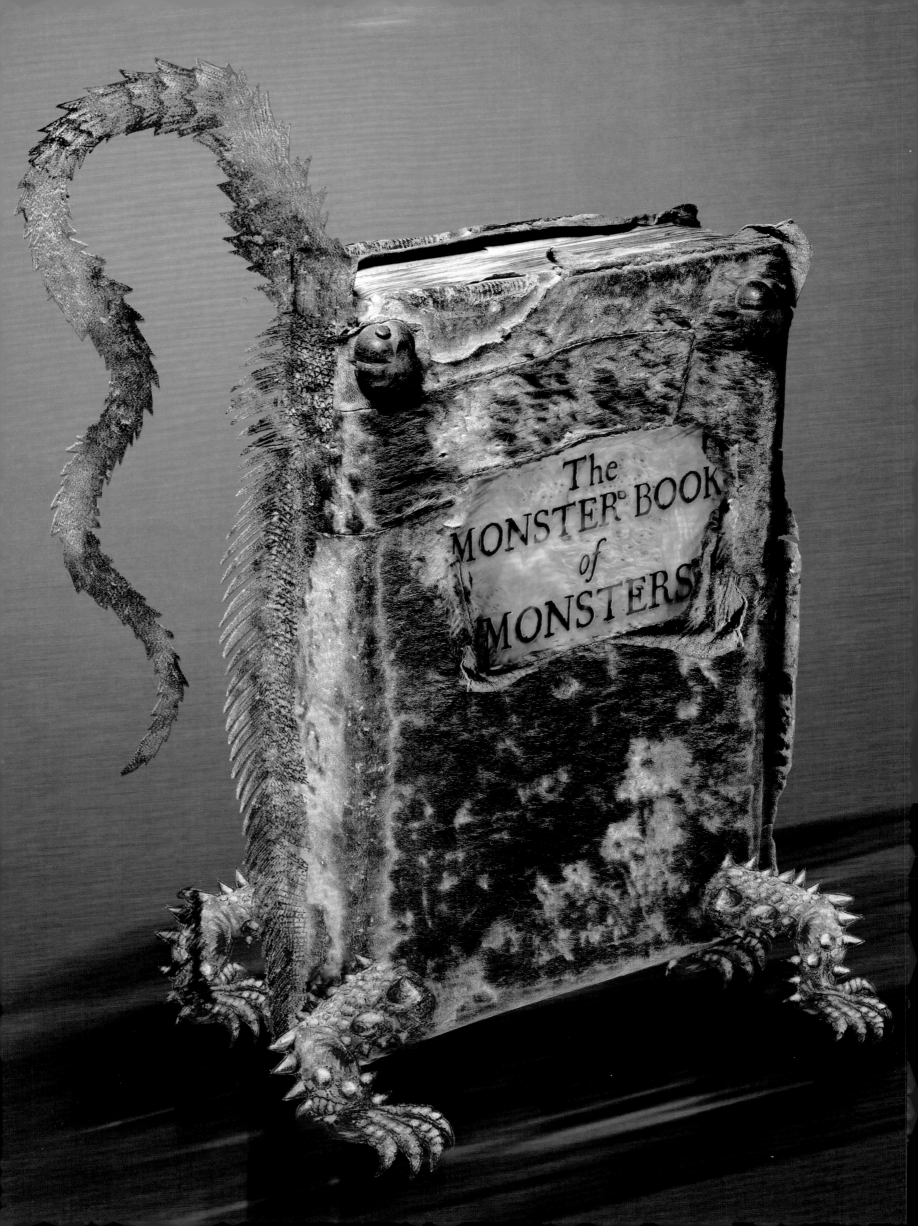

While the sets, characters, creatures, and props may be the most recognizable on-screen aspects of the wizarding world, ensuring that viewers were truly immersed in the experience required that every fine detail be planned meticulously. From newspapers and posters to book covers and jar labels, what may have seemed like everyday items each needed to be custom-designed to make sure that they fit within the flavor of the films.

This monumental task fell to the film's graphic arts department, headed by designers Miraphora Mina and Eduardo Lima. Their unique vision provided the distinct elements that gave the wizarding world its singular voice.

"You need a spell written in a book," Stuart Craig says, "then Mira will do it. You need a book jacket design, then, indeed, she does it. The packaging for Bertie Bott's Every Flavour Beans. There are countless examples of graphic arts used here."

Some of the department's painstaking designs were so vital to the wizarding world that they often became as instantly identifiable as the characters themselves. No one would mistake the gothic, text-heavy pages of *The Daily Prophet* newspaper for its lighter and more whimsical counterpart, *The Quibbler*, for instance. And while those distinct differences in style may have been clearly informed by the story and its characters, their contrasting visual identities were flawlessly executed thanks to this team of designers.

Mina created another essential element of graphic design featured at the forefront of the films: the Marauder's Map, an artifact that allowed its owners to view every aspect of Hogwarts—from secret passages to the current whereabouts of the school's inhabitants—in real time. With a location as complex as Hogwarts, this highly detailed hero prop could have ended up as a jumble of visual information indecipherable on screen. Thanks to Mina and her team, the Marauder's Map was designed in a way that made it just as easy to read for viewers as it was for Harry himself.

Of course, not all of the graphic arts team's work was showcased quite so prominently. In fact, the bulk of what they produced was barely ever seen at all.

"There's some great skill," Craig says "some great detail buried in this film."

That buried detail came in many forms. Countless books with fully realized cover designs were shuffled to the bottom of a stack or relegated to a dusty shelf in the Headmaster's office. Jars full of potions and magical ingredients lined the walls of classrooms with their intricate, hand-drawn labels just out of focus. Every Chocolate Frog and every Wizard Wheeze sold in Diagon Alley came wrapped in precisely planned packaging that was quickly and casually tossed aside to obtain the treats held within.

Perhaps the real treat, though, was how the bold designs of Mina and Lima were so seamlessly integrated into the wizarding world in a way that enhanced scenes without distracting from them. The subtle artistry of the graphic arts department was part of the true magic in the films all along.

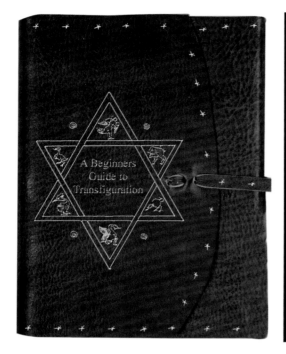

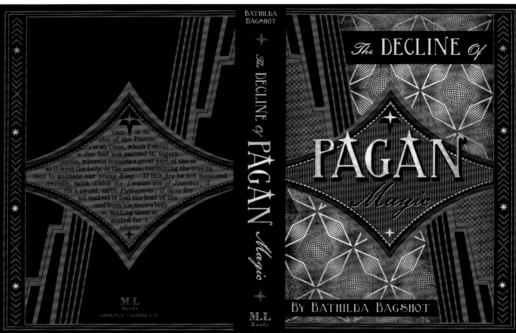

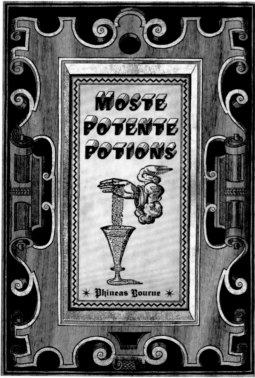

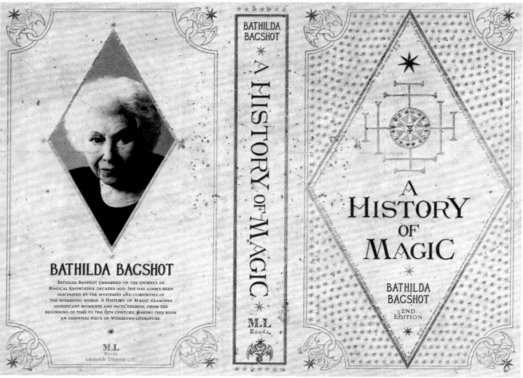

The graphics department of Miraphora Mina, Eduardo Lima, and Lauren Wakefield bound the textbooks for each year's Hogwarts curriculum.

CLOCKWISE FROM TOP LEFT: *A Beginner's Guide to Transfiguration* for first years; *The Decline of Pagan Magic*, seen in Bathilda Bagshot's house; *The History of Magic*, required for first years; *Moste Potente Potions*, used by Hermione to create Polyjuice Potion.

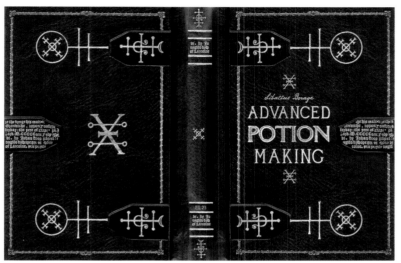

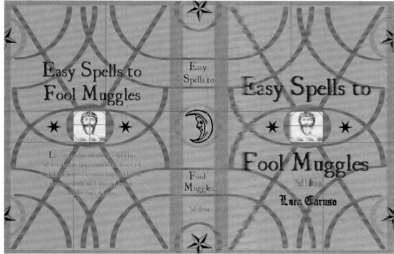

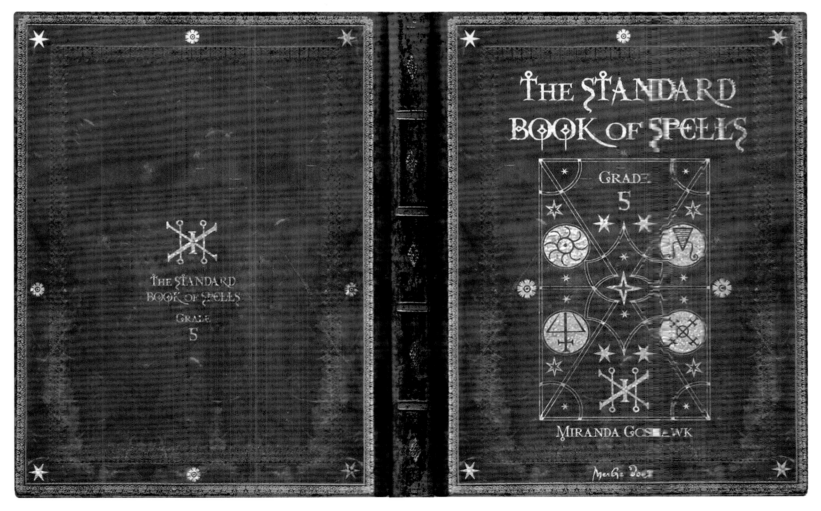

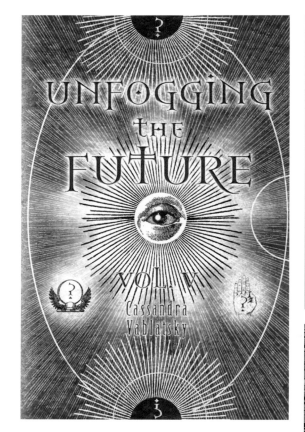

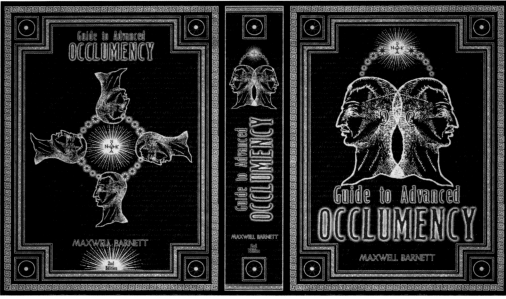

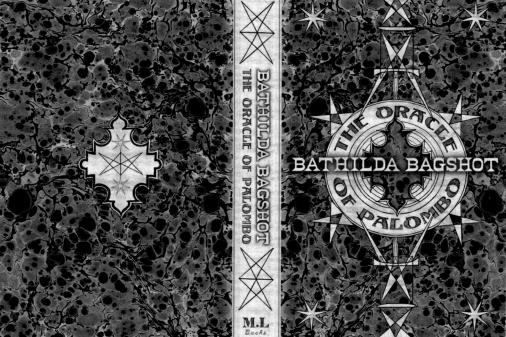

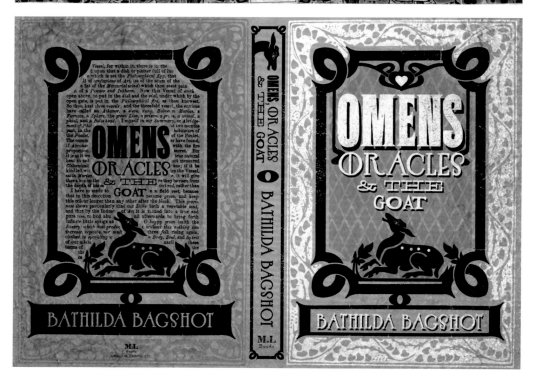

CLOCKWISE FROM TOP LEFT: *Unfogging the Future*, for third-year Divination; *Guide to Advanced Occlumency*, seen in Professor Snape's classroom; *The Oracle of Palombo* and *Omens, Oracles & the Goat*, both seen in Bathilda Bagshot's house.

TOP LEFT: *Defence Against the Dark Arts*, required for third-year students at Hogwarts.

TOP RIGHT: An unknown tome.

ABOVE LEFT: *The Dark Forces: A Guide to Self-Protection*, required for first-year students at Hogwarts, seen in *Harry Potter and the Sorcerer's Stone*.

ABOVE RIGHT: *Secrets of the Darkest Art*, housed in the Restricted Section of the Hogwarts Library throughout the films.

OPPOSITE: Various books held by Hermione Granger throughout the film series or carried in her enchanted bag in *Harry Potter and the Deathly Hallows – Part 1*.

PAGES 310–311, CLOCKWISE FROM TOP LEFT: *Travels with Trolls*, one of Gilderoy Lockhart's many (questionable) real-life adventure books; unknown book, possibly for Durmstrang students; *Quidditch Teams of England and Ireland*, and *Flying with the Cannons*, seen in Harry's bedroom; *Ancient Runes Made Easy*, carried in Hermione's bag in *Deathly Hallows – Part 1*; *Triwizard Tragedies*, carried by Hermione at the Triwizard Tournament.

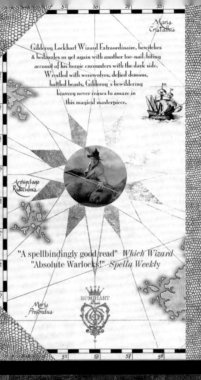

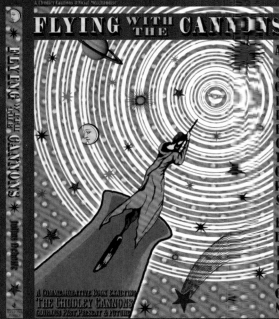

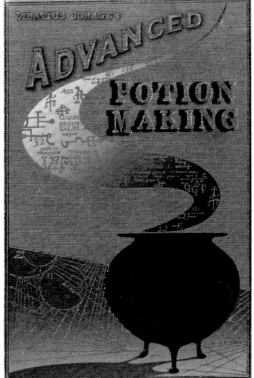

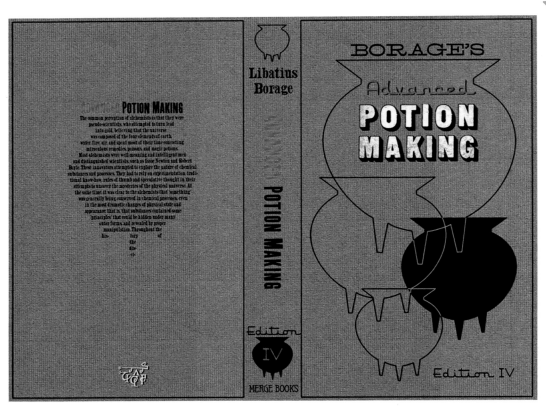

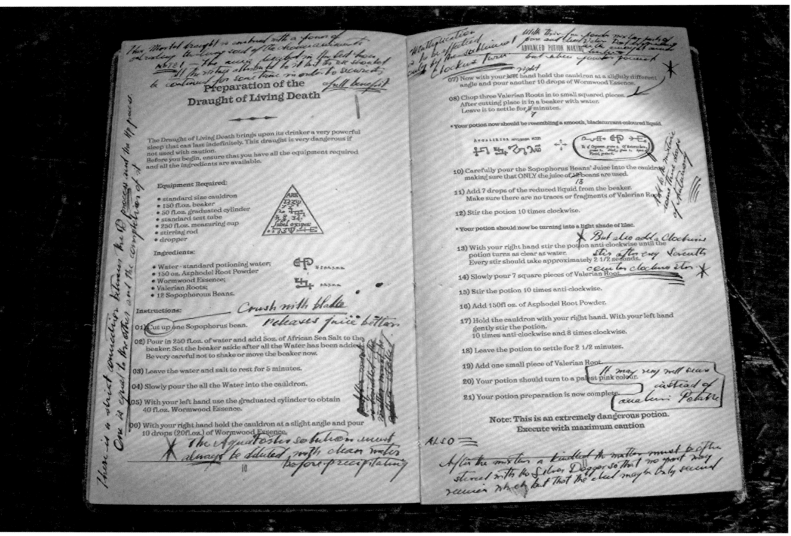

TOP: Two versions of *Advanced Potion Making*, with the newer one on the left grabbed by Ron Weasley in *Harry Potter and the Half-Blood Prince*.

ABOVE: Harry Potter's older copy contained the notes of the Half-Blood Prince.

THE FOUNTAIN OF FAIR FORTUNE

High on a hill in an enchanted garden, enclosed by tall walls and protected by strong magic, flowed the Fountain of Fair Fortune.

THE TALES OF BEEDLE THE BARD

The Tale
* of the *
Three Brothers

There were once three brothers who were travelling along a lonely, winding road at twilight.

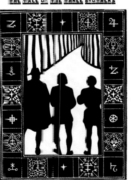

THE TALE OF THE THREE BROTHERS

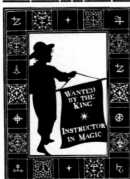

BABBITTY RABBITTY AND HER CACKLING STUMP

WANTED BY THE KING
INSTRUCTOR IN MAGIC

The King caused proclamations to be read in every village and town across the land.

THE TALES OF BEEDLE THE BARD

The Wizard
* and the *
Hopping Pot

Rather than reveal the true source of his power, he pretended that his potions, charms and antidotes sprang from the little cauldron he called his lucky cooking pot.

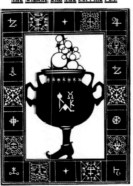

THE WIZARD AND THE HOPPING POT

THIS PAGE: *The Tales of Beedle the Bard*, which Dumbledore bequeaths to Hermione in *Harry Potter and the Deathly Hallows – Part 1*, featured elaborate cutouts at each chapter's opening.

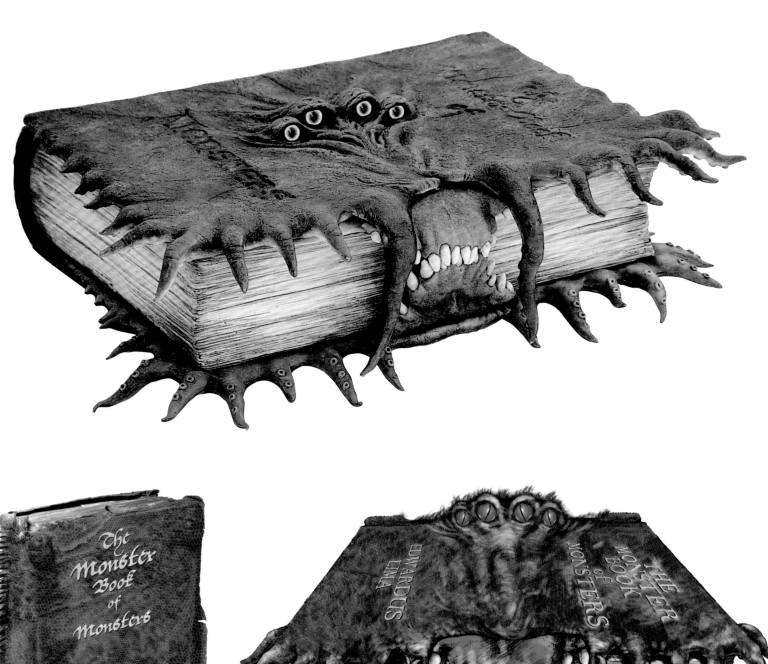

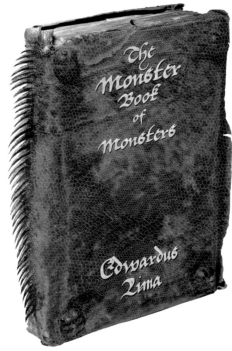

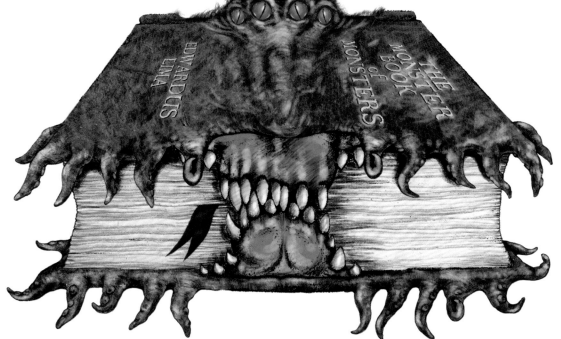

The Monster Book of Monsters was used for the Care of Magical Creatures class in *Harry Potter and the Prisoner of Azkaban*.

TOP: Rob Bliss added four eyes to the center of the book cover.

ABOVE: Concepts by Miraphora Mina included moving the eyes to the spine, and spines on the spine.

OPPOSITE: Suggested monsters for the book's content include a Mandrake by Dermot Power (*top right*), and a troll, gnome, and other unknown creatures drawn by Rob Bliss.

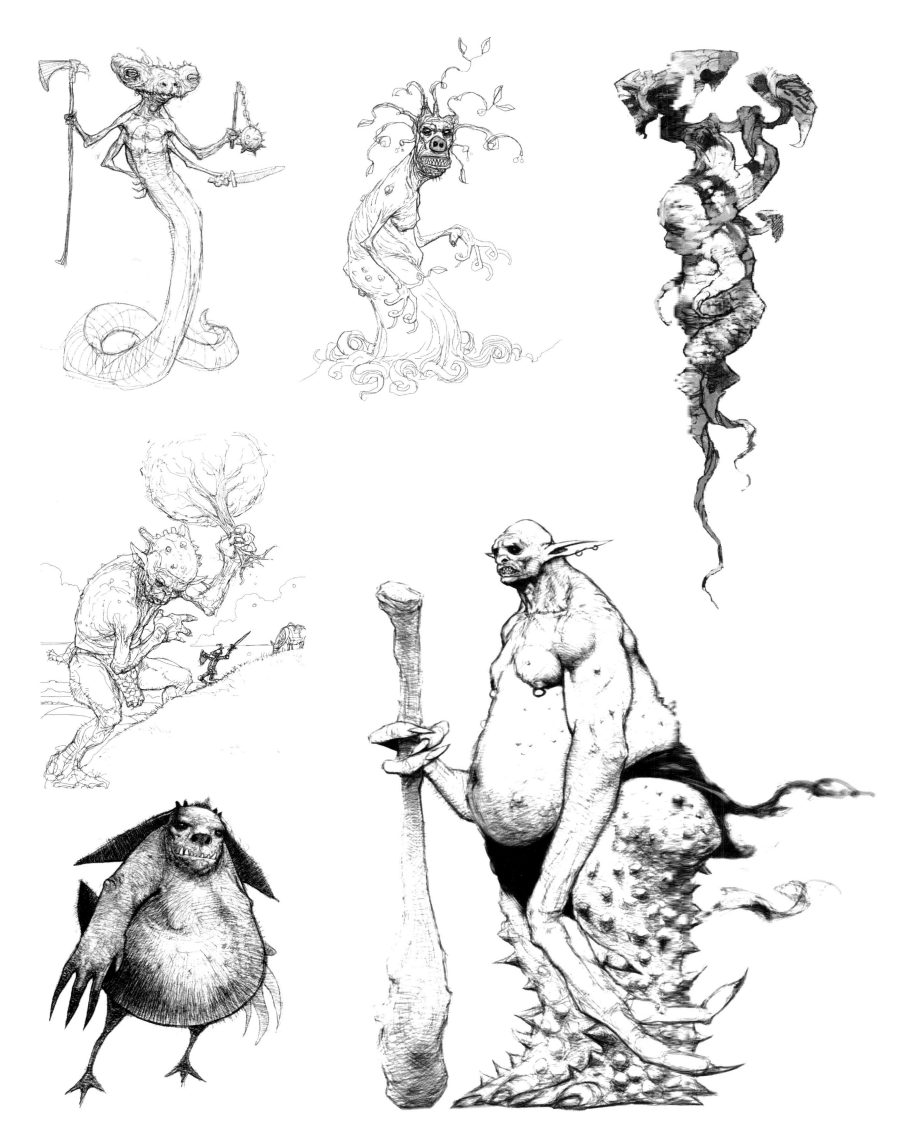

SCHOOL DOCUMENTS

To: Mr. H. Potter,
The Cupboard under the Stairs,
4, Privet Drive,
Little Whinging,
Surrey

Dear *Mr. Potter*......

We are pleased to inform you that you have been accepted at Hogwarts School of Witchcraft and Wizardry.

Students shall be required to report to the Chamber of Reception upon arrival, the dates for which shall be duly advised.

Please ensure that the utmost attention be made to the list of requirements attatched herewith.

We very much look foward to receiving you as part of the new generation of Hogwarts' heritage.

Draco Dormiens Nunquam Titillandos

M. McGonagall

Professor McGonagall

HOGWARTS SCHOOL of WITCHCRAFT & WIZARDRY
Headmaster: Albus Dumbledore, D.Wiz., X.J.(sorc.), S.of Mag.Q.

FIRST YEAR STUDENTS WILL REQUIRE:

1. Three sets of plain work robes
2. One plain pointed hat for day wear
3. One pair of dragon-hide gloves

AND THE FOLLOWING SET BOOKS:

1. 'The Standard Book of Spells' by Miranda Goshawk
2. 'One Thousand Magical Herbs and Fungi' by Phyllida Spore
3. 'A History of Magic' by Bathilda Bagshot
4. 'Magical Theory' by Adalbert Waffling
5. 'A Beginner's Guide to Transfiguration' by Emeric Switch
6. 'Magical Drafts and Potions' by Arsenius Jigger
7. 'Fantastic Beasts and where to find them' by Newt Scamander
8. 'The Dark Forces: A Guide to Self-Protection' by Quentin Trimble

ALL STUDENTS MUST BE EQUIPPED WITH:

1. One Wand
2. One standard 'Size 2' pewter cauldron
...and may bring, if they desire, either an owl, a cat, or a toad.

Lucinda
Lucinda Thomsonicle-Pocus,
Chief Attendant of Witchcraft Provisions

HOGWARTS SCHOOL of WITCHCRAFT & WIZARDRY
Headmaster: Albus Dumbledore, D.Wiz., X.J.(sorc.), S.of Mag.Q.

TOP: Harry Potter's acceptance letter to Hogwarts and his first-year class supply list, delivered by owl post in *Harry Potter and the Sorcerer's Stone*.

BELOW: A partially filled-in O.W.L. exam, taken by fifth-years in *Harry Potter and the Order of the Phoenix*.

OPPOSITE LEFT: A page of Hermione's homework, for *Harry Potter and the Half-Blood Prince*.

OPPOSITE RIGHT: An administrative form for *Half-Blood Prince* includes a box where students can report taking a "Bludger to the Head."

Ancient Runes

Case 12 : **Runic Transliteration**

Hermione Granger

Ancient runes provide a key to understanding the lives and beliefs of the ancient Runemasters who created them, and they have much to teach us about a way of life that is still connected to the wizarding community today.

ᛗ ᛁᛉᚯ ᛗ ᛉ ᛈ ᛗ ᛗ ᚦᛃᛋ ᛗ ᛁᛉᚯ ᛗ

01. Without using your runic dictionary, please interpret the meaning of the following runes :

ᚦ	�	ᚱ	ᚲ
Fig. 63 (8)	*Fig.* 91 (38)	*Fig.* 88 (33)	*Fig.* 77 (21)
The full charm is to deflect	spell was of 1152	'shield' linkes on the spell 'protect'	the Protego

ᛗ ᛁᛉᚯ ᛗ ᛈ ᛈ ᛗ ᛗ ᚦᛋ ᛗ ᛁᛉᚯ ᛗ

02. Please transliterate the meaning of the ancient Beorc rune:

The earliest recorded example of the charm dates back to the 3rd century. A contemporary tapestry shows wizards using the charm to escape capture from invading enemy forces indicated by the blue glow. Wizard historians are divided upon whether this source is reliable.

✳ Avada Kedavra · as it is unblockable. ᛗ ᛁᛉ ᛗ ᛈ ᛈ ᛗ ᛗ ᚦᛋ ᛗ ᛁᛉᚯ ᛗ

03. Please fill in the missing runes in this runic *Table of the Moon.*

2 (ref: Wizarding Archive of 1152.)

573915

Hogwarts School of Witchcraft and Wizardry

STUDENT ACCIDENT REPORT FORM

1. Name:_____

2. House:_____ Sex: M ☐ F ☐ Age:____ Year____

3. Time of accident: Hour____ a.m. ____ p.m. Date:_____

DESCRIPTION OF ACCIDENT:

How did it happen? What was student doing? Where was student? Specify any hexes involved.

DESCRIPTION OF INJURY:

PROFESSOR IN CHARGE:_____

LOCATION:

Owlery
Great Hall
Corridor
Classroom
Dormitory
Common Room
Quidditch Pitch

INJURY:

☐ Broken Arm ☐
☐ Fractured Pelvis ☐
☐ Missing Limb ☐
☐ Under Curse ☐
☐ Bludger to the Head ☐
☐ Quaffle to the Groin ☐
☐ Fever ☐

SIGNED: Nurse:_____ Professor_____

DATE: _____

Form 573905 (Rev 12/02. N. 84)
Hogwarts Administration Department

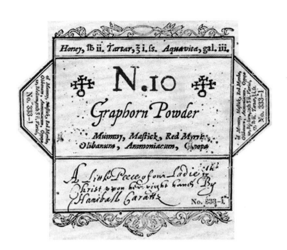

Honey, ℔ ii. Tartar, ℥ i. ſs. Aquavita, gal. iii.

N.10
Graphorn Powder
Mummy, Maſtick, Red Myrrh, Olibanum, Ammoniacum, Copoa

EXTREMELY POISONOUS

POTION N.07

CONTAINS: POWDERED BAT WINGS A SYRUP OF WILD ONION

№ 66548

L. 150

HS

POTION No.01

Keep Lid Closed at All Times

Reg.0019-0

LIMA · MINA

POLYJUICE POTION NO.
ORIGINAL **1** FORMULAR
Hogwarts Potion Dept.

POLYJUICE POTION NO.
2
Hogwarts Potion Dept.

Concoction
No. 460
(TYPE 7)

Honey, ℔ ii. Tartar, ℥ i. ſs. Aquavita, gal.

Reg. 12-00/ Potions
Hogwarts Apothecary Dept.

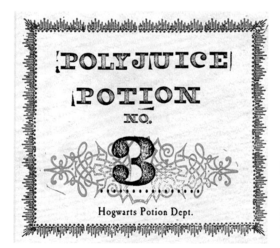

POLYJUICE POTION NO.
3
Hogwarts Potion Dept.

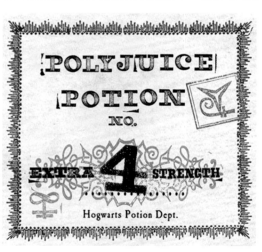

POLYJUICE POTION NO.
EXTRA **4** STRENGTH
Hogwarts Potion Dept.

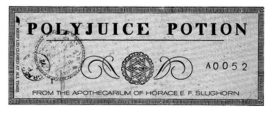

POLYJUICE POTION
A0052
FROM THE APOTHECARIUM OF HORACE E. F. SLUGHORN

THESE PAGES: The graphics department printed or handwrote, cut, and pasted thousands of labels for the potions seen throughout the Harry Potter films.

N°51 *Herbaria*

N°51 *Potio Nimbus*

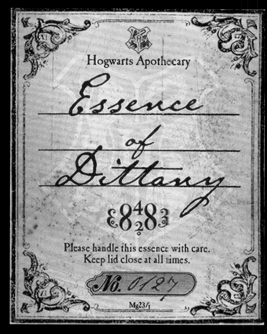

Hogwarts Apothecary

Essence

of

Dittany

Please handle this essence with care.
Keep lid close at all times.

No. 0127

HELLEBORE

JKIO 5009811xm.

FROM THE APOTHECARIUM OF HORACE E. F. SLUGHORN

HELLEBORE

JKIO 5009811xm.

FROM THE APOTHECARIUM OF HORACE E. F. SLUGHORN

Wormwood

Essence

13981

ACONITE

"Monkshood"

(TYPE 1)

EXTREMELY
POISONOUS

No 99810

PEPPERUP
ELIXIR

Alcohol 46 per cent

Type N.125/9

Dose: no more than 7/21 drops per potion
KEEP LID CLOSED AT ALL TIMES

39423

Reg. 00012/345/00998- Potions Association - Ministry of Magic

N. XXIII

*Purifying Concentrate
of*

SPLEENWART

The Diagon Dispensary
since 226

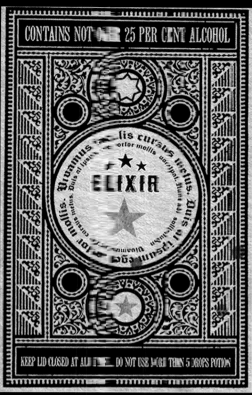

CONTAINS NOT OVER 25 PER CENT ALCOHOL

ELIXIR

KEEP LID CLOSED AT ALL TIMES. DO NOT USE MORE THAN 5 DROPS POTION

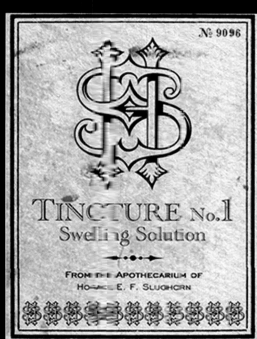

No 9096

TINCTURE No.1
Swelling Solution

FROM THE APOTHECARIUM OF
HORACE E. F. SLUGHORN

N°94 *Nilbum*

FROM THE APOTHECARIUM OF
HORACE E. F. SLUGHORN

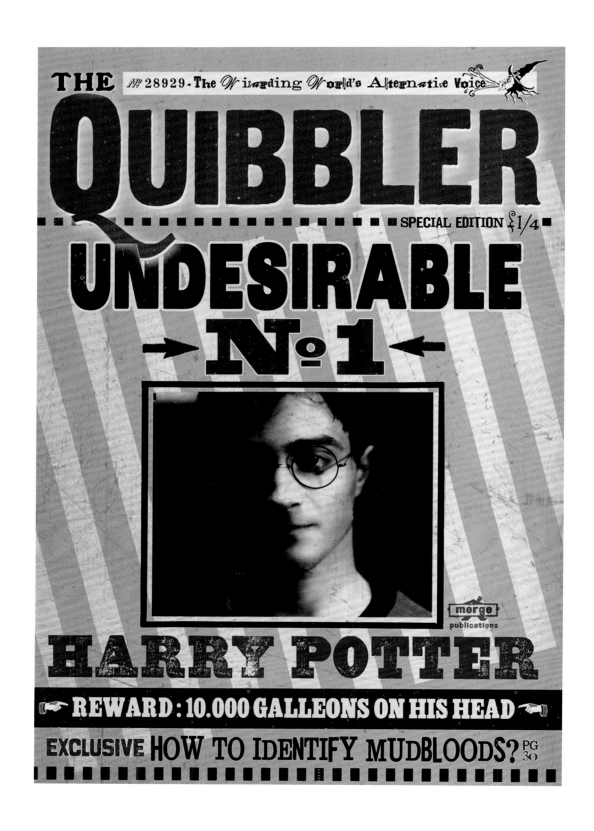

THE №28929 · The *Wizarding World's Alternative Voice*

QUIBBLER

SPECIAL EDITION £1/4

UNDESIRABLE
→ № 1 ←

merge publications

HARRY POTTER

☞ REWARD : 10.000 GALLEONS ON HIS HEAD ☜

EXCLUSIVE HOW TO IDENTIFY MUDBLOODS? PG. 30

THESE PAGES: *The Quibbler*, published by Luna Lovegood's father, was a tabloid-style magazine printed on newsprint paper. It was an active supporter of Harry Potter, despite these front covers, seen in *Harry Potter and the Deathly Hallows – Part 1.*

THE № 24002 · The *Wizarding World's* Alternative Voice

QUIBBLER?

£1/4

HARRY in HIDING

WHERE is the CHOSEN ONE?

The Tent-Fox Mysteries: Special Report by E.Dingbat P.14

POTTER DEFIES MINISTRY INTELLIGENCE YET AGAIN!

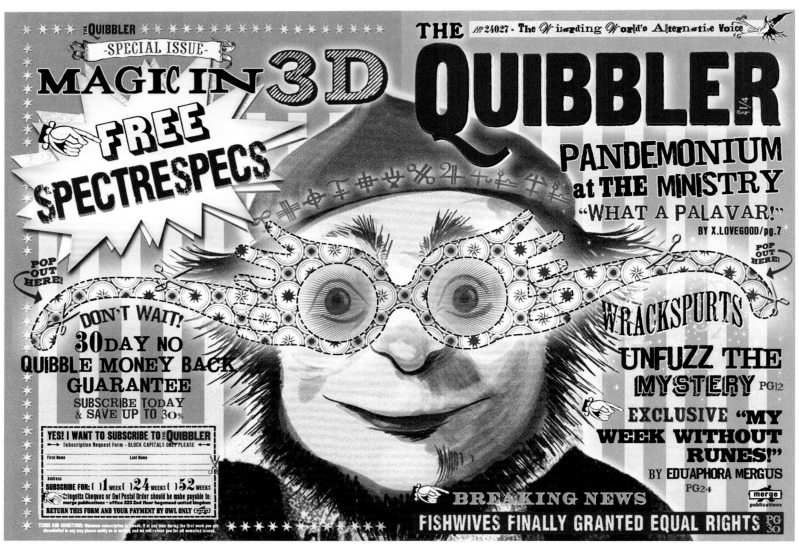

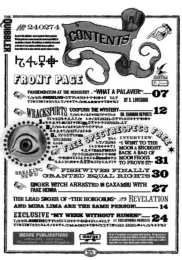

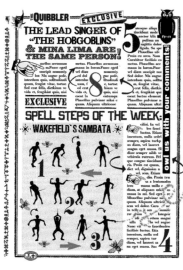

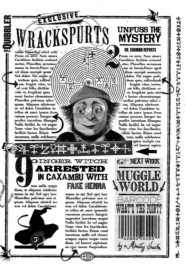

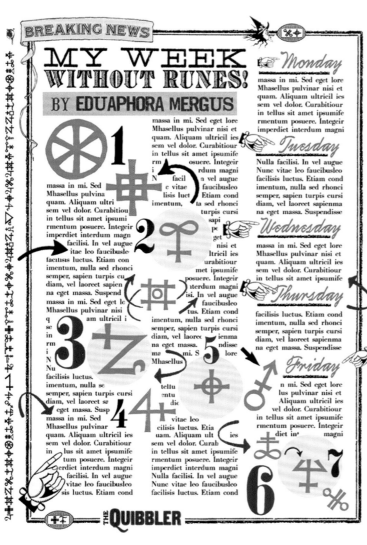
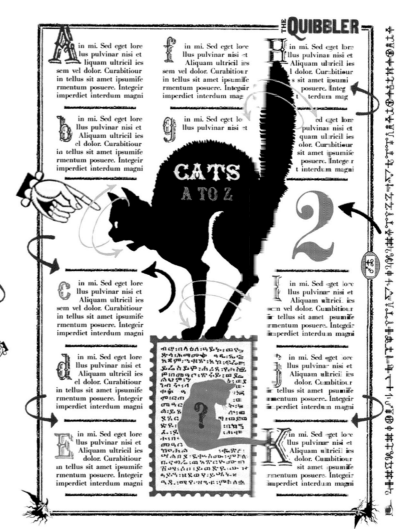

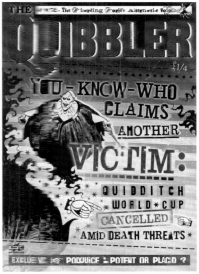

THESE PAGES: Various articles and covers from *The Quibbler*. One issue, for *Harry Potter and the Half-Blood Prince*, offered Spectraspecs, perforated for removal.

PAGES 324–327: *The Daily Prophet*, the wizarding world newspaper seen throughout the Harry Potter films, was taken over by the Ministry of Magic by the time of *Harry Potter and the Order of the Phoenix*. The graphics department was responsible for not only designing the paper but also writing the headlines and articles

The DAILY PROPHET

★ THE WIZARD WORLD'S BEGUILING BROADSHEET OF CHOICE ★

👉 **OFFICIAL GUIDES TO ELEMETARY HOME & PERSONAL DEFENCE WILL BE DELIVERED TO ALL WIZARDING HOMES**
more details page 3

National Weather
south - cloudy & rain 3ᵉ
north - cloudy & rain 7ᵉ
central - cloudy & rain 6ᵉ
London - cloudy & rain 9ᵉ

Zodiac ✴ Aspects
ta - ☺ aries ☾✴✴luna opp-
☺ in- ♈ virgo - com ◯ ⚭ ⚭
♌ sizio-♒ ne pi ♓ sces ☐

FIRST-SECOND EDITION
№ 983018 - London - UK
TODAY ☿ ♀ in Virgo
Letters or vibes to the Editor should be sent only "by owl post" and with a clear mind to The Daily Prophet - UK

✱ 0 23 S. 0 23
♀ 2 44 S. 2 44
✱ 0 20 S. 0 20
☿ 3 35 S. 3 35
♃ 5 28 S. 5 28
✱ 0 49 N. 0 49
♂ 5 38 S. 5 38

SPECIAL EDITION

HE WHO MUST NOT BE NAMED RETURNS

HE WHO MUST NOT BE NAMED HAS RETURNED TO THIS COUNTRY AND IS ONCE MORE ACTIVE

— spells **2** — M. OF MAGIC AFFAIRS **3** — potions **6** — health **7** — BAD NEWS **9**

The DAILY PROPHET

★ THE WIZARD WORLD'S BEGUILING BROADSHEET OF CHOICE ★

10,000 GALLEONS ON BLACK'S HEAD — SEE INSIDE FOR FULL DETAILS PG.3

National Weather
south - cloudy & rain 13c
north - cloudy & rain 07c
central - sunny period 10c
London - cloudy & rain 14c

Zodiac ✶ Aspects
ta - m luna ☾ ☌ virgo opp-
☉ in - ♈ aries - com ○ ⬡ e
o ♌ sizio - ~ ne pi ✶ sees ☺

FIRST–SECOND EDITION
№ 985890 - London - UK
TODAY ☺ in Aquarius
Letters or vibes to the Editor should
be sent only "by owl post" and with a
clear mind to The Daily Prophet - UK

☀ ✶ S. 0 23
♀ ~ S. 2 44
☿ ✶ S. 0 20
♂ ⚹ S. 3 35
♃ ~ S. 5 28
♅ ✶ N. 0 49
♄ ☌ S. 5 38

£1/4c

👉 EXCLUSIVE

MAYHEM AT HIGH SECURITY PRISON

MASS BREAKOUT FROM AZKABAN

MASS BREAKOUT FROM AZKABAN

by r. amorim - security editor

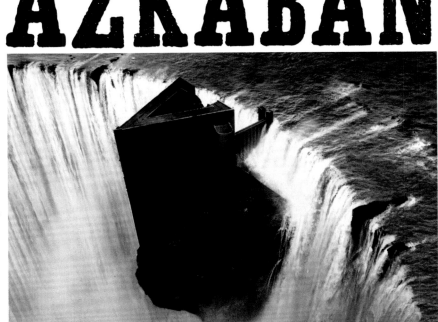

SEVERAL HIGH-SECURITY PRISONERS ESCAPE

F ll Report page 3

BE VIGILANT! SAYS MINISTER

BE VIGILANT! SAYS THE MINISTER

DEMENTORS PAGES 3/5

UNDER SCRUTINY

DEMENTORS UNDER SCRUTINY

❧OBITUARY❧
DUMBLEDORE
REMEMBERED

A HOMAGE TO THE MASTER BY HIS FRIENDS AT HOGWARTS

by Elphias Doge

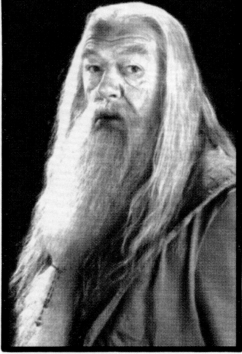

THE WIZARDING WORLD IN MOURNING

by Barnabas Cuffe

A GREAT LOSS

BY PROF. F. FLITWICK

BY PROF. P. SPROUT

BY PROF. TRELAWNEY

IMPORTANT NOTICE for announcements, acknowledgements, adoptions, birthdays, births, deaths, memorial services and in memoriams · please send an owl with all information to The Daily Prophet · Diagon Alley by Monday noon.

☞ OBITUARIES

[decorative filler text, largely illegible]

HOROSCOPE

♒ Aquarius ★

♓ Pisces ★

♈ Aries ★

♉ Taurus ★

♊ Gemini ★

♋ Cancer ★

HOROSCOPE

♌ Leo ★★

♍ Virgo ★★

♎ Libra ★★

♏ Scorpio ★★

♐ Sagittarius ★★

♑ Capricornus ★★

JOBS

E L M

M *[decorative filler text]*

SHARE IT WITH SHAMAN
★★★ fly me an owl! ★★★

TOKEN 374.1
Terms and Conditions Apply

TOKEN 807.1
Terms and Conditions Apply

☞ MAGICAL SYMBOLS GAME

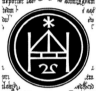

[decorative filler text and magical symbols]

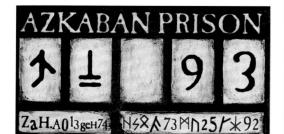

S.P.T to A.P.W.B.D

Dark Lord and

(?)

Harry Potter

AZKABAN PRISON

93

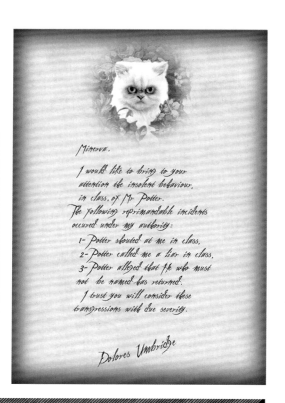

Dear Mr Potter,

The Ministry has received intelligence that at twenty three minutes past six this evening you performed the Patronus Charm in the presence of a Muggle.

As a clear violation of the Decree for the Reasonable Restriction of Underage Sorcery, you are hereby expelled from Hogwarts School of Witchcraft & Wizardry

Hoping that you are well,

Mafalda Hopkirk

MINISTRY of MAGIC

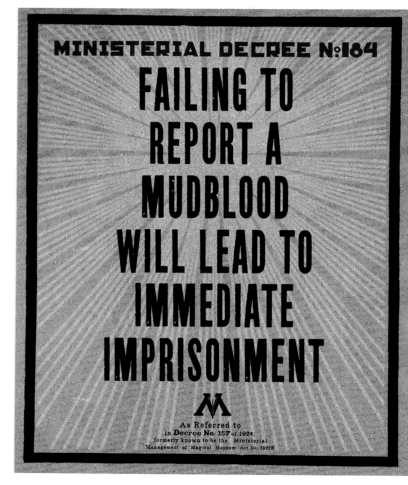

MINISTERIAL DECREE Nº164

FAILING TO REPORT A MUDBLOOD WILL LEAD TO IMMEDIATE IMPRISONMENT

As Referred to
in Decree No. 157 of 1924.
formerly known to be the Ministerial
Management of Magical Mayhem Act No. 192/B

MUDBLOODS & THE DANGERS THEY POSE

PERFECT PURE BLOOD SOCIETY

MINISTRY OF MAGIC
MUGGLE-BORN REGISTRATION COMMISSION

MINISTRY OF MAGIC OFFICIAL GUIDELINES No.34

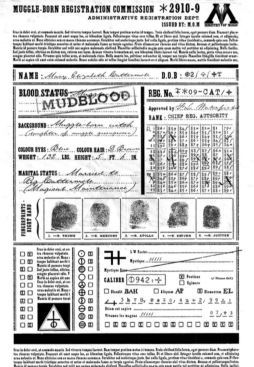

Ephemera and paperwork from the Ministry of Magic.

TOP ROW: Courtroom door plaque; prophecy orb tag; Azkaban prisoner ID; Harry Potter's Underage Sorcery violation notice; letter from Dolores Umbridge to Professor McGonagall; anti-Muggle pamphlet cover.

BOTTOM ROW: Anti-Muggle pamphlet's interior pages; Muggle-Born Registration Commission form.

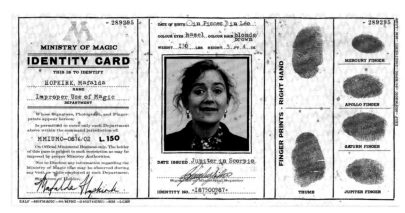

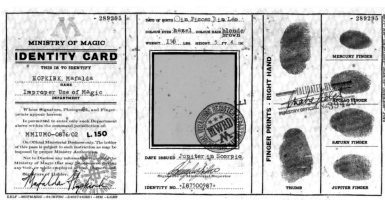

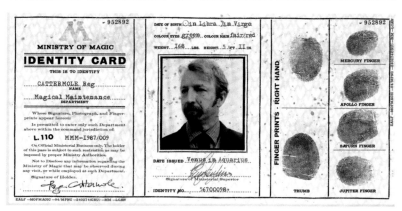

ABOVE: Ministry of Magic ID cards for *Harry Potter and the Deathly Hallows – Part 1.*

TOP RIGHT: Visitor ID badges and the Ministry's letter to Arthur Weasley regarding Harry's trial, from *Harry Potter and the Order of the Phoenix.*

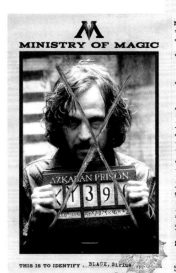
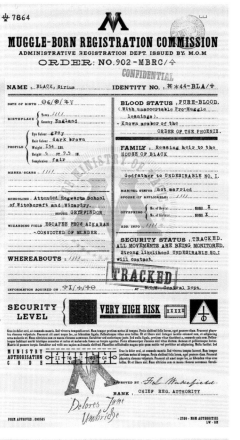
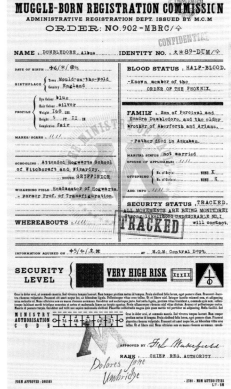
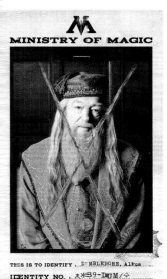

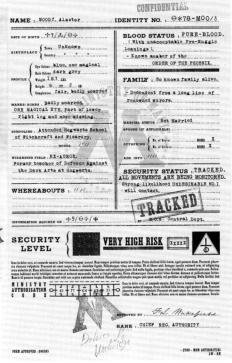
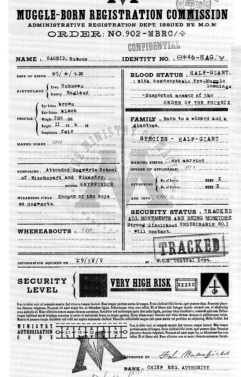

THIS PAGE: Muggle-born Registration Committee dossiers on the member of the Order of the Phoenix for *Harry Potter and the Deathly Hallows – Part 1* created by the graphics department. Deceased members were crossed out.

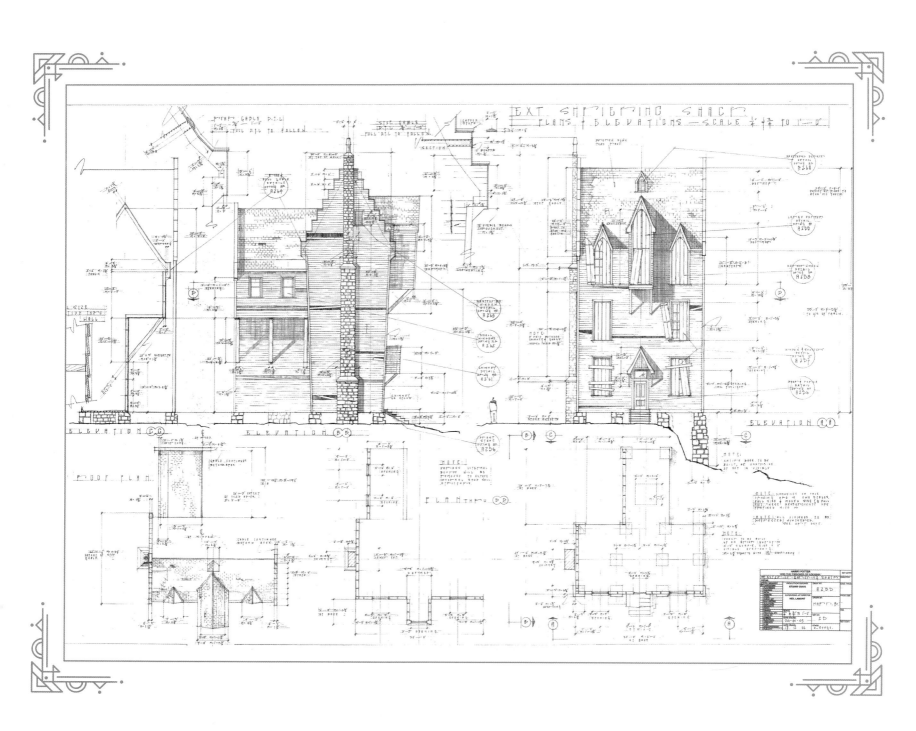

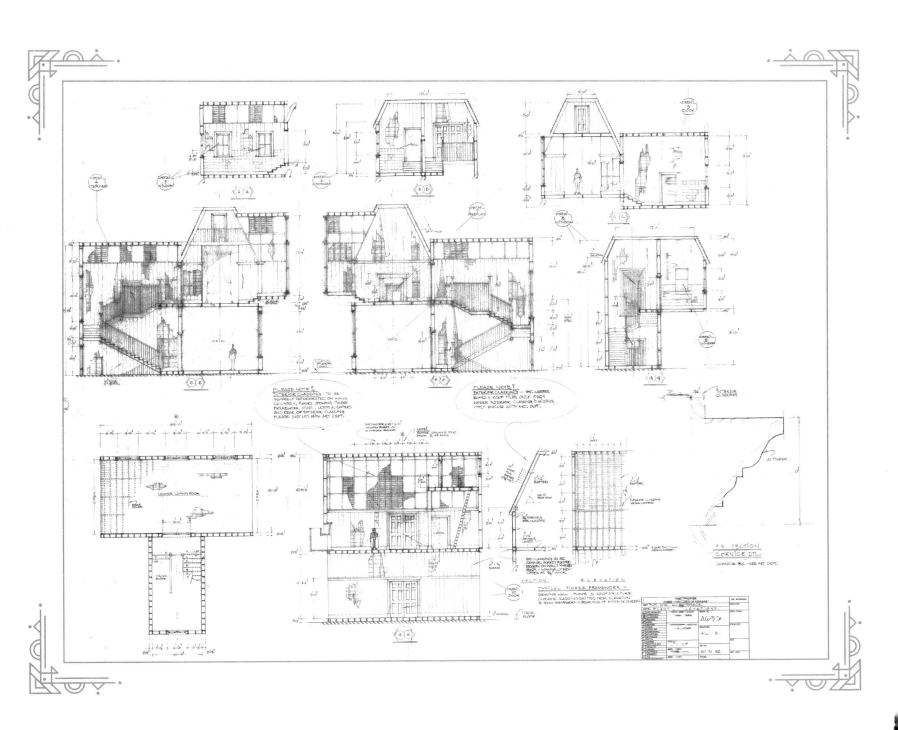

THESE PAGES: Blueprints for the Shrieking Shack in *Harry Potter and the Prisoner of Azkaban* and the Gringotts Wizarding Bank set in *Harry Potter and the Deathly Hallows – Part 2*. A team of draftsmen and women were employed to diagram everything from buildings to brooms.

SECTION A-A

SECTION B-B

NOTE
PLEASE READ WITH DRG N'S.
F174, DRG F192 TO F207
SEE ART DEPT FOR FINISHES

REVISION (B) 11/12/08
PANELS (MARBLE) ADDED.

(B) RE-ISSUED AND REVISED 30/1/09
STAIRS DOWN TO VAULT CHANGED USING
STEEL AND WALL (SEE DRG N'S F196 AND F198)

NOTE
PLEASE READ WITH DRG N'S.
F173 & F192 TO P207
SEE ART DEPT FOR FINISHES

REVISION A. 11/12/08.
PANELS ADDED UNDER WINDOWS
AND END WALLS.

SECTION D-D

PANEL DETAIL
SEE DRG N° F700.

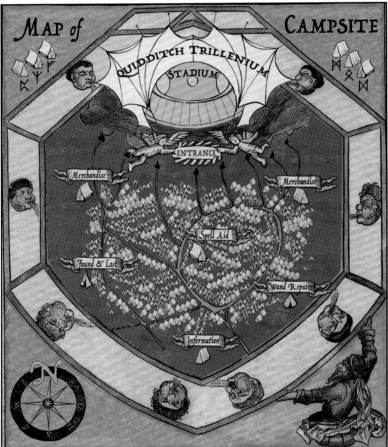

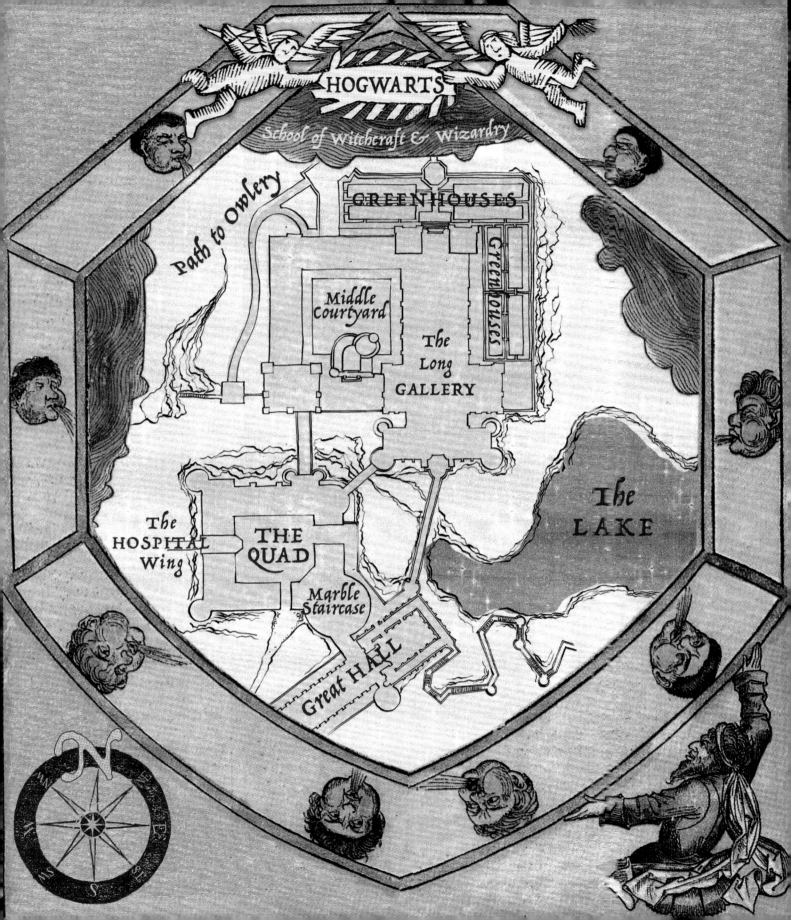

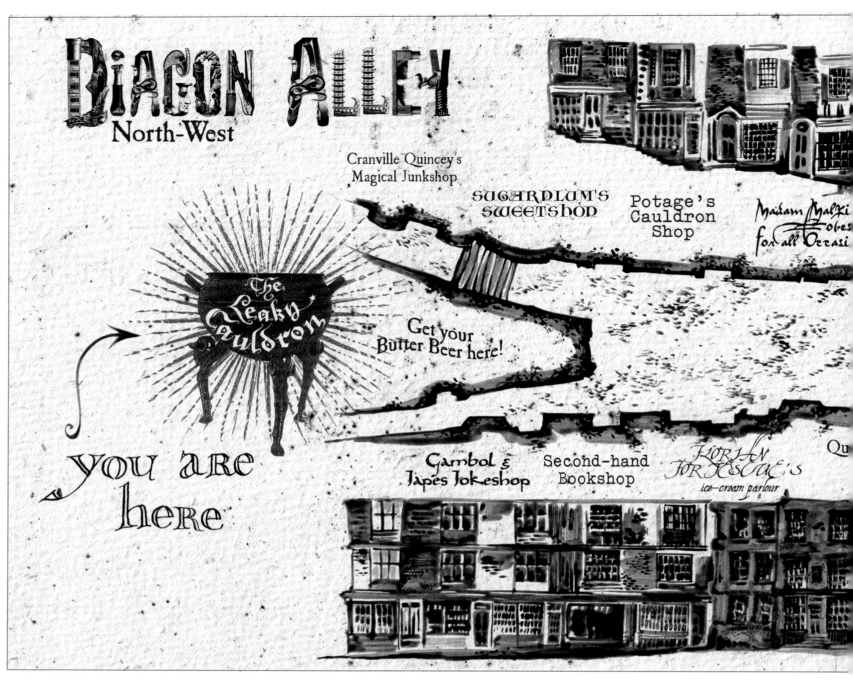

DIAGON ALLEY
North-West

Cranville Quincey's
Magical Junkshop

SUGARPLUM'S
SWEETSHOP

Potage's
Cauldron
Shop

Madam Malkin
Robes
for all Occasi

The
Leaky
Cauldron

Get your
Butter Beer here!

you are
here

Gambol &
Japes Jokeshop

Second-hand
Bookshop

FLORIAN
FORTESCUE'S
ice-cream parlour

Qu

PRECEDING PAGE: Map created by the graphics
department to be used by first-years at Hogwarts.

TOP: Map of Diagon Alley that hangs on the wall
of the Leaky Cauldron.

RIGHT: The Marauder's Map, given to Harry Potter
by the Weasley twins in *Harry Potter and the
Prisoner of Azkaban*.

OPPOSITE BOTTOM LEFT: A map showing Death
Eater sightings in the *Daily Prophet* published for
Harry Potter and the Deathly Hallows – Part 1.

OPPOSITE BOTTOM RIGHT: *The Daily Prophet*'s
weather forecast for Britain, published on page 2
of each issue from *Order of the Phoenix* through
Deathly Hallows – Part 1.

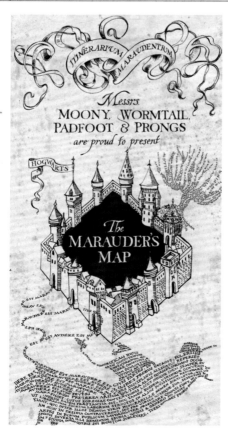

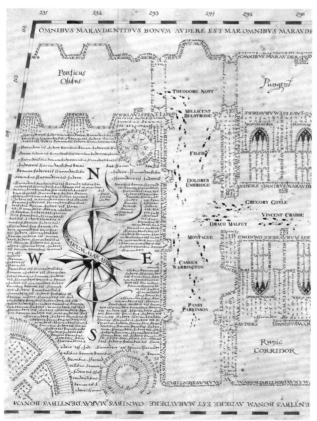

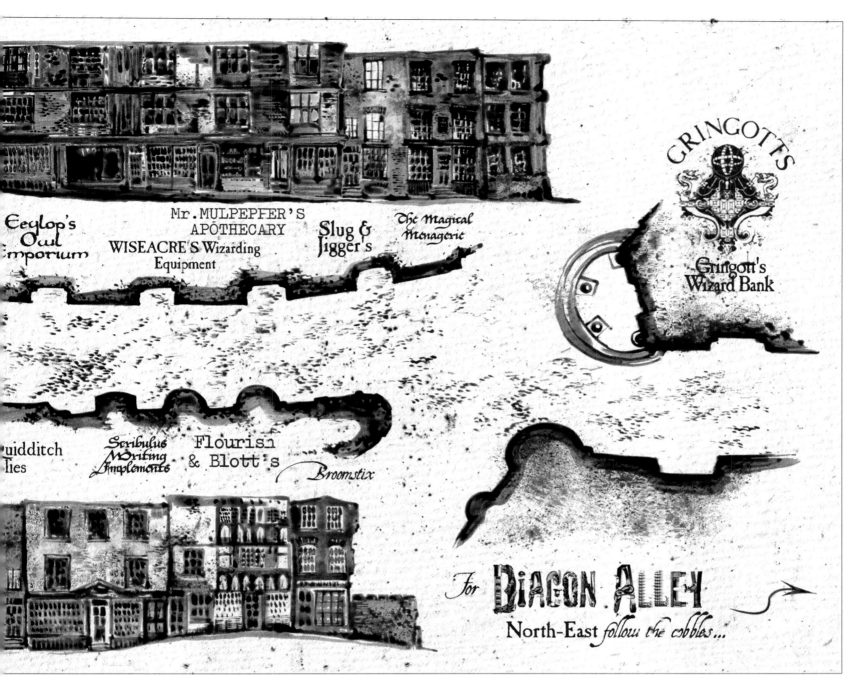

 Eeylop's Owl Emporium

Mr. MULPEPPER'S APOTHECARY

WISEACRE'S Wizarding Equipment

Slug & Jigger's

The Magical Menagerie

GRINGOTTS

Gringott's Wizard Bank

Quidditch Ties

Scribulus Writing Implements

Flourish & Blott's

Broomstix

For DIAGON ALLEY

North-East *follow the cobbles...*

LONDON CENTRAL & ◄ SE ►

FORECAST

HERALDRY

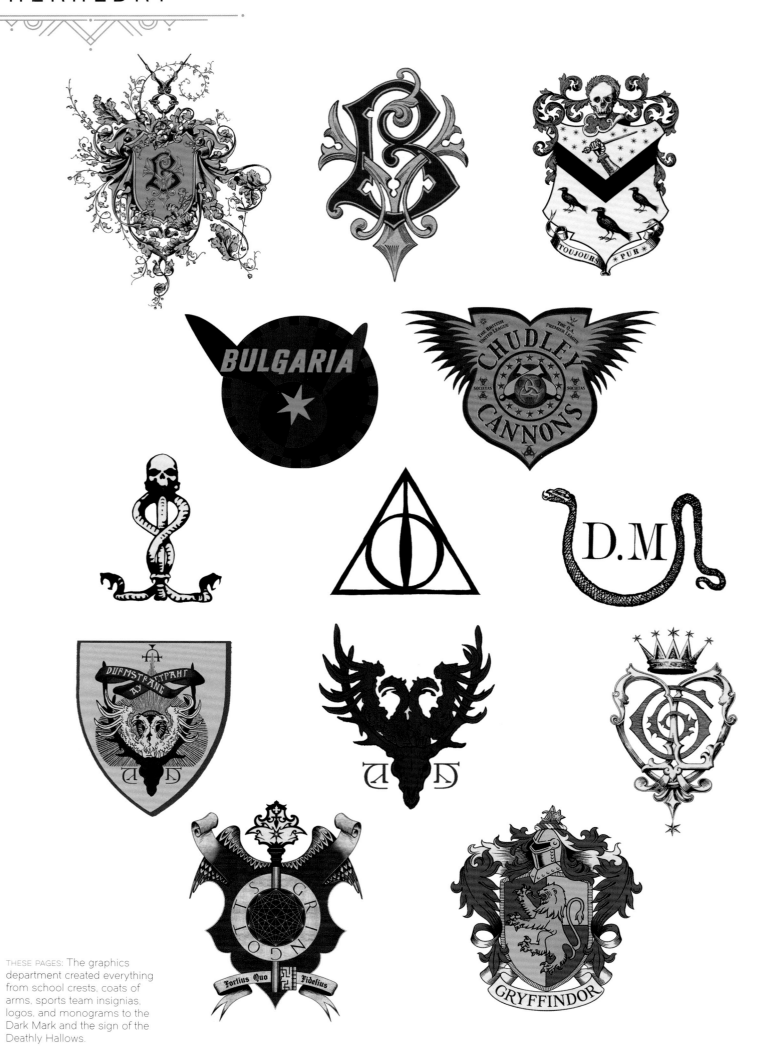

THESE PAGES: The graphics department created everything from school crests, coats of arms, sports team insignias, logos, and monograms to the Dark Mark and the sign of the Deathly Hallows.

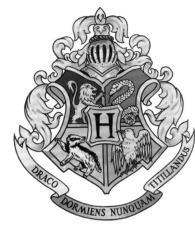

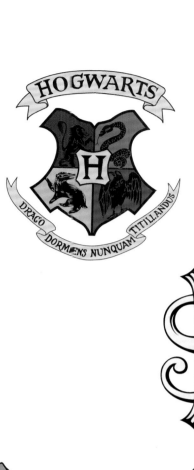

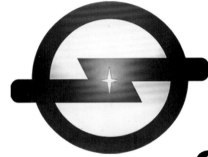

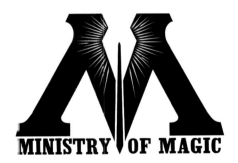

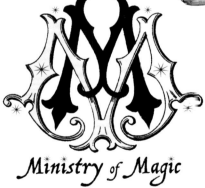

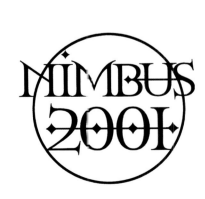

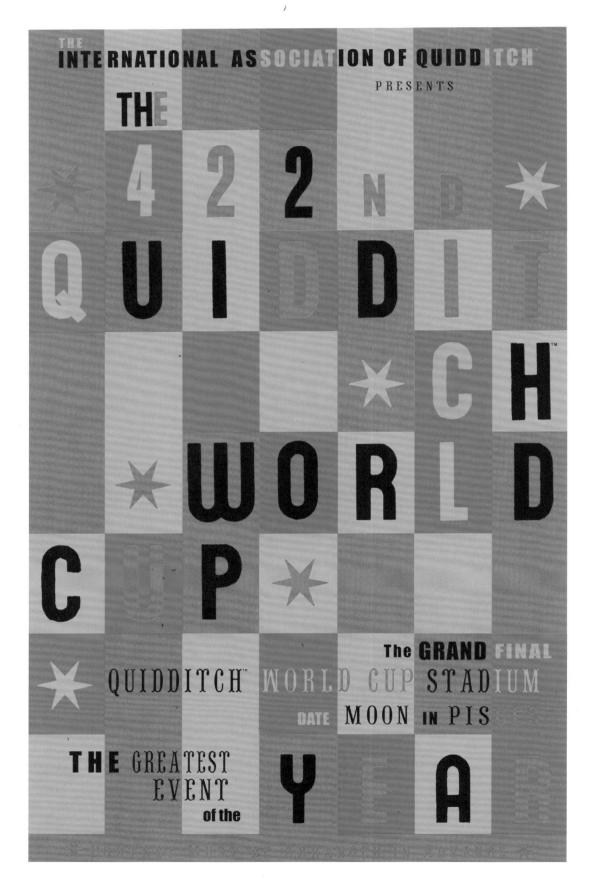

THESE PAGES: Posters for the 422nd Quidditch World Cup, attended by Harry and the Weasleys in *Harry Potter and the Goblet of Fire*.

PAGE 344: Quidditch memorabilia includes flags, programs, tickets, and merchandise.

PAGE 345, TOP: Ephemera for Ron Weasley's favorite team, the Chudley Cannons.

PAGE 345, BOTTOM: Snitch Snatcher! A Quidditch board game played at Hogwarts.

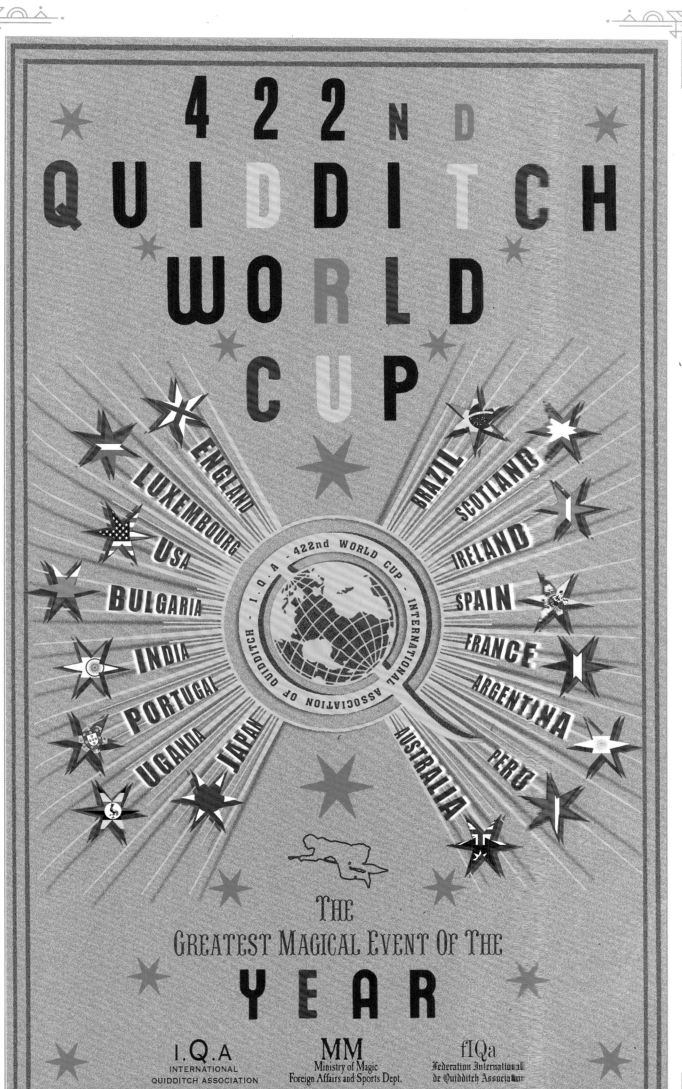

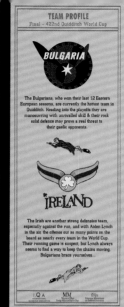
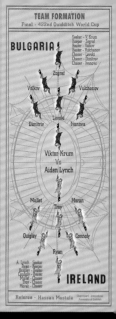

CHUDLEY CANNONS

21 1892 · 1931
TIMES LEAGUE CHAMPIONS · THE JOSEF WRONSKI AWARD FOR EXCELLENT PITCH SKILLS

WE SHALL CONQUER

CHUDLEY CANNONS

INTERNATIONAL QUIDDITCH TOURNAMENT
1972

1789-1892
2 TIMES LEAGUE CHAMPIONS

CHUDLEY CANNONS

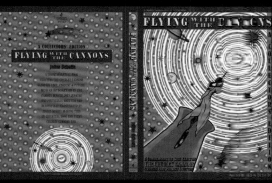

A COLLECTORS EDITION
FLYING WITH THE CANNONS
Julius Detaille

FLYING WITH THE CANNONS

SNITCH-SNATCHER!
The Quidditch Game

DRAPES FRONT PANELS · DRAPES BACK PANEL

DRAPES FRONT PANELS · DRAPES BACK PANEL

DRAPES FRONT PANELS · DRAPES BACK PANEL

TOWER FRONT PANELS · TOWER BACK PANEL

SNITCH-SNATCHER!
The Quidditch Game

Made Exclusively for Quality Quidditch Stores

THESE PAGES: Hundreds of labels and package designs were created, printed, and applied to candy boxes, breakfast cereals, and bottled items, and even pet food and Mrs. Weasley's homemade jam.

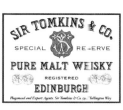

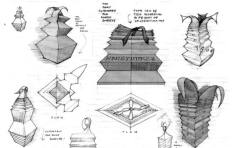

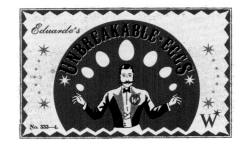

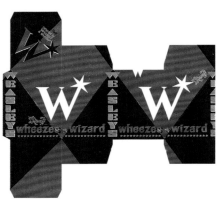

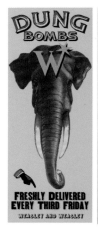

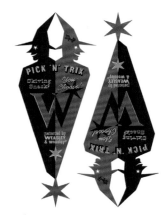

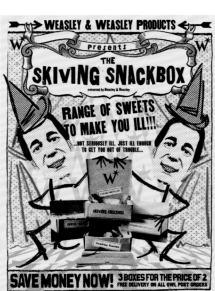

INSTANT DARKNESS POWDER
IMPORTED FROM PERU · IMPORTED FROM PERU

WEASLEY & WEASLEY ANTI-SPELLS PARAPHERNALIA

JINX-OFF

BASIC KIT

W

KIT INCLUDES CLOAK, HAT & GLOVES

MADE IN ENGLAND

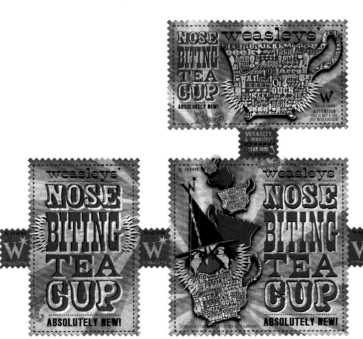

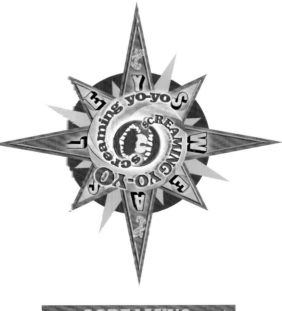

SCREAMING YO YO
endorsed by WEASLEY & weasley

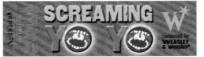

THESE AND FOLLOWING PAGES: Fred and George Weasley became successful entrepreneurs in *Harry Potter and the Half-Blood Prince* with Weasleys' Wizard Wheezes joke and sweet shop. The graphics department needed to create not only product packaging but also order forms, receipts, advertising, and even logos for shopping bags.

349

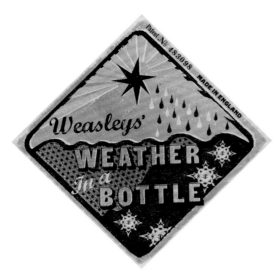

Patent № 483098 MADE IN ENGLAND

Weasleys'
WEATHER
in a
BOTTLE

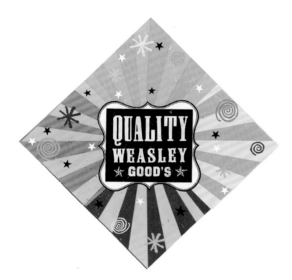

QUALITY
WEASLEY
GOOD'S

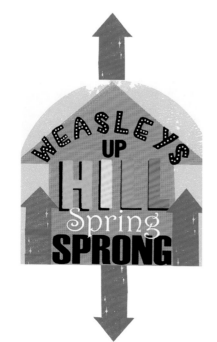

WEASLEYS
UP
HILL
Spring
SPRONG

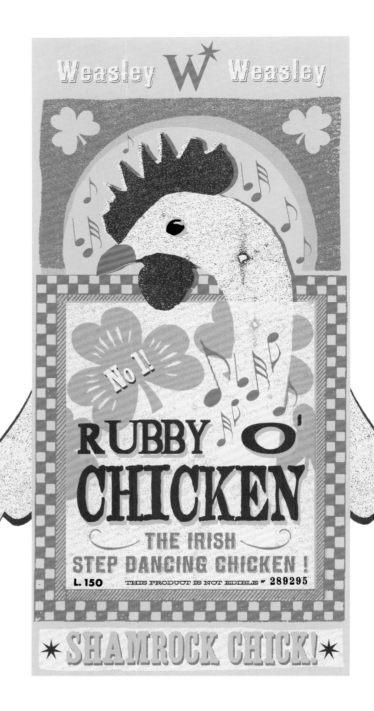

Weasley **W** Weasley

No 1!

RUBBY O'
CHICKEN
THE IRISH
STEP DANCING CHICKEN !

L. 150 THIS PRODUCT IS NOT EDIBLE Nº **289295**

★ **SHAMROCK CHICK!** ★

SHIMMERING
SILVER
Salt Drops

'Shimmering Silver Salt Drops
are a wizarding classic enjoy them
with the best of friends.'
The Daily Prophet

SILVER
SHIMMERING

★ WEASLEY STUFF ★ WEASLEY STUFF ★

Nº **245687**

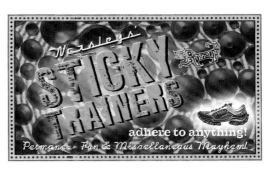

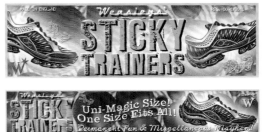

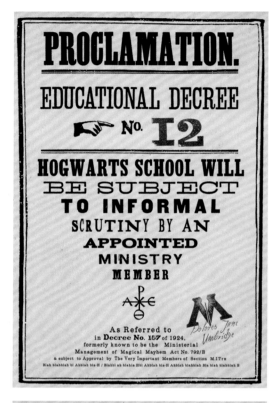

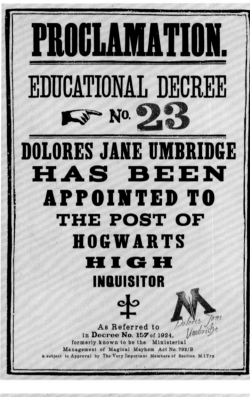

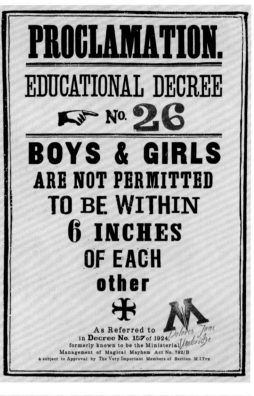

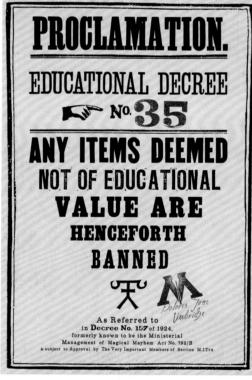

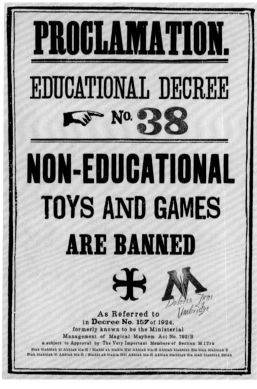

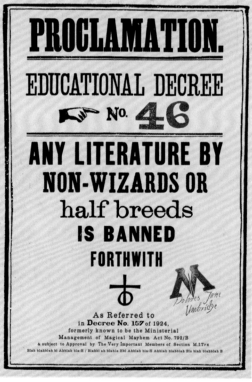

ABOVE: In *Harry Potter and the Order of the Phoenix*, Dolores Umbridge enacted more than a hundred Educational Decrees during her tenure at Hogwarts.

OPPOSITE TOP: Timetable seen at the Hogsmeade Station throughout the films.

OPPOSITE BOTTOM: An alphabet chart seen in the infant Harry's bedroom in Godric's Hollow in *Harry Potter and the Deathly Hallows – Part 1*.

PAGE 354: Sirius Black's wanted poster for *Harry Potter and the Prisoner of Azkaban*.

PAGE 355: The Ministry of Magic's wanted posters for Lucius Malfoy and Harry Potter, seen in *Deathly Hallows – Part 1* and *Part 2*.

HOGSMEADE STATION

TIMETABLE AND FARES

Nº 883Y1 Nº 883Y1

BROOMSTICKS, WANDS OR OTHER WIZARDING ARTEFACTS ARE LEFT UNATTENDED ENTIRELY AT THE COMMUTERS OWN RISK.

Abracadabra A — Broomsticks B — Cauldron C — Dragon D — Eye E — Frog F — Goblin G

Hat H — Invisible I — Jelly Beans J — Keys K — Lightning L — Mushroom M — Niffler N

Owl O — Pumpkin P — Quill Q — Rabbit R — Snake S — Toad T — Unicorn U

Vapour V — Wizard W — Xmas Tree X — Yawn Y — Z

Magic Alphabet

HAVE YOU SEEN THIS WIZARD?

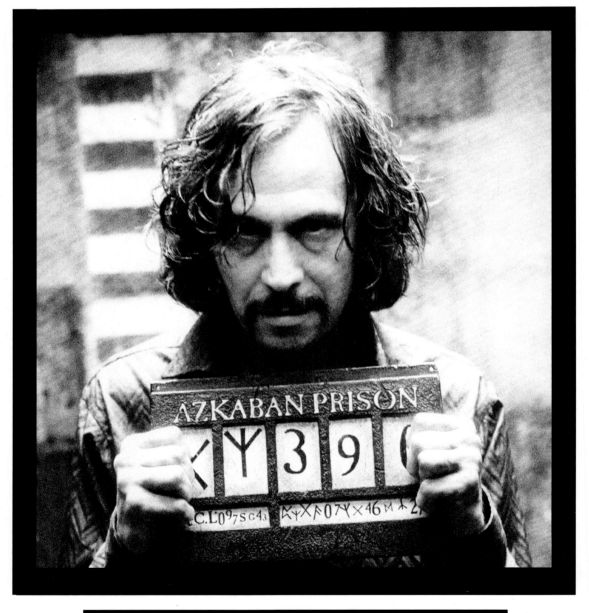

APPROACH WITH EXTREME CAUTION!
★ **DO NOT ATTEMPT TO USE** ★
MAGIC AGAINST THIS MAN!

Any information leading to the arrest of this
man shall be duly rewarded

Notify immediately by owl the Ministry of Magic - WitchWatchers Dept.

CAUGHT

LUCIUS MALFOY

Azkaban 16/No. 94156

CONSTANT VIGILANCE!

DEATH EATERS ARE AMONG US!

★ **REMEMBER: NEGLIGENCE COSTS LIVES** ★

IF YOU HAVE ANY INFORMATION CONCERNING
DEATH EATERS, PLEASE CONTACT YOUR
NEAREST AUROR OFFICE.

MINISTRY OF MAGIC
·AUROR OFFICE·

 REWARD

THE MINISTRY OF MAGIC IS OFFERING A REWARD OF 1.000 GALLEONS
FOR INFORMATION LEADING DIRECTLY TO THE ARREST OF ANY DEATH EATER

DIRECTOR
AUROR OFFICE / INVESTIGATION DEPT.
No. 61042

PRINTED BY THE MINISTRY PRESS · DIAGON ALLEY · ENGLAND · REG 120990/00E.LIMA/00987-000MOM

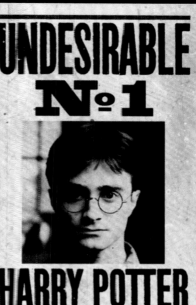

UNDESIRABLE No 1

HARRY POTTER

CONTACT THE MINISTRY OF MAGIC IMMEDIATELY IF YOU
HAVE ANY INFORMATION CONCERNING HIS WHEREABOUTS.
FAILING TO REPORT WILL RESULT IN IMPRISONMENT.

 REWARD
10.000 GALLEONS ON HIS HEAD

USED WIZARDING GADGETS
BATWORTHY junk

BATWORTHY junk

BORGIN & BURKES

EAT IN ◆◆◆◆ *Brews* and *Stews* TAKE AWAY ◆◆◆◆◆

◆ *Brews and Stews*
◆◆◆◆ CAFE ◆◆◆◆
Open Monday to Sunday · 5 am to Midnight

✷ DERVISH & BANGES ✷

♪ ♫ ♪ **DOMINIC MAESTRO'S** MUSIC SHOP

THE HEAVENLY HAGGIS

• **TRADITIONAL SCOTTISH HAGGIS** •
SERVED ALL DAY – EAT IN OR TAKE AWAY

◆ HONEYDUKES ◆

◀ HOME MADE **SWEETS** ◆HONEYDUKES◆ HOME MADE **SWEETS** ▶

J. PIPPIN'S POTIONS *Wholesale & Retail*

J. PIPPIN'S

girls & boys ✷✷✷ **KIDS WITCH** ✷✷✷ *girls & boys*

THE LATEST FASHION FOR KIDS
✷✷ *From 0 to 12 years old* ✷✷

MADAME BORBOLETTA'S *Perms & Cuts*

THESE PAGES: Unique signs hung outside the retail locations in
Diagon Alley and Hogsmeade for the Harry Potter films. The
graphics department used places that had been mentioned
in the books and then supplemented when necessary.

THE MAGIC NEEP
Fresh Produce

THE MAGIC NEEP
Fresh Produce - Everyday

McBLOOM and McMUCK

McBLOOM and McMUCK
Exotic Plants & Flowers

HATS & WIGS — McHazelocks — WIZARDING HEADGEAR — SINCE 1867

Fantastic PETS — PEDRUS PRIDGEON — *Fantastic PETS*

New & Second Hand CAULDRONS — **POTAGES** — New & Second Hand CAULDRONS

since 1842 — Rosalie Teabag — Tea House

Rosalie Teabag — FINEST TEAS & CAKES

SCRIBBULUS

SCRIBBULUS FINEST — PARCHMENTS, INKS & QUILLS

SPINTWITCHES

SPINTWITCHES — SPORTING NEEDS

TOMES & SCROLLS

1768 — TOMES & SCROLLS — 1768
Bespoke Wizarding Bookshop

VLADIMIR PLOT — 24 Hs — Plumbing Supplies

VLADIMIR PLOT - Plumbing Supplies
"We do the dirty job for you" 24 Hs

THE TROLL TAPESTRY

THE BLACK FAMILY TAPESTRY

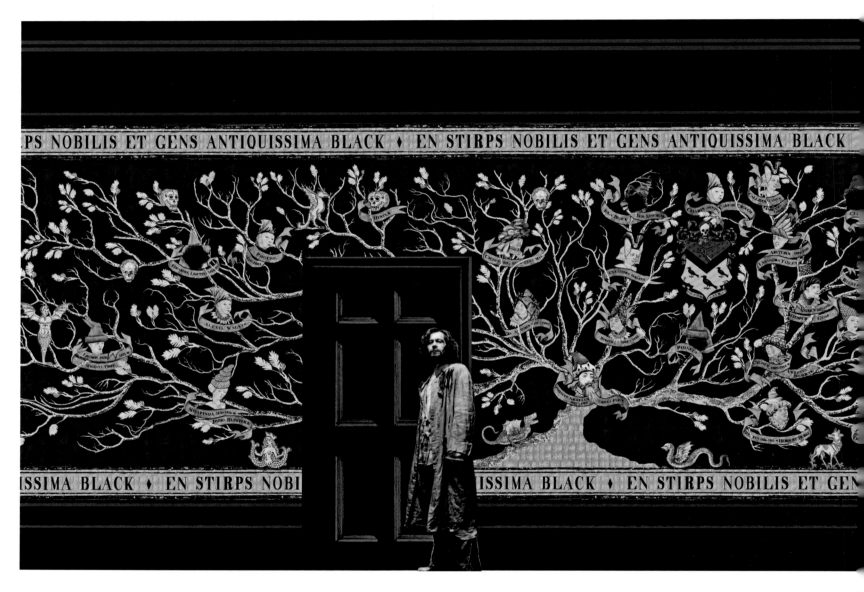

ABOVE: Harry stumbles upon a room in Grimmauld Place covered with a tapestry that displays the family tree of Sirius Black in *Harry Potter and the Order of the Phoenix*. Graphics designer Miraphora Mina laid out the branches and relatives, and set designer Stephenie McMillan found a fabric imitating medieval tapestries that was painted with the images.

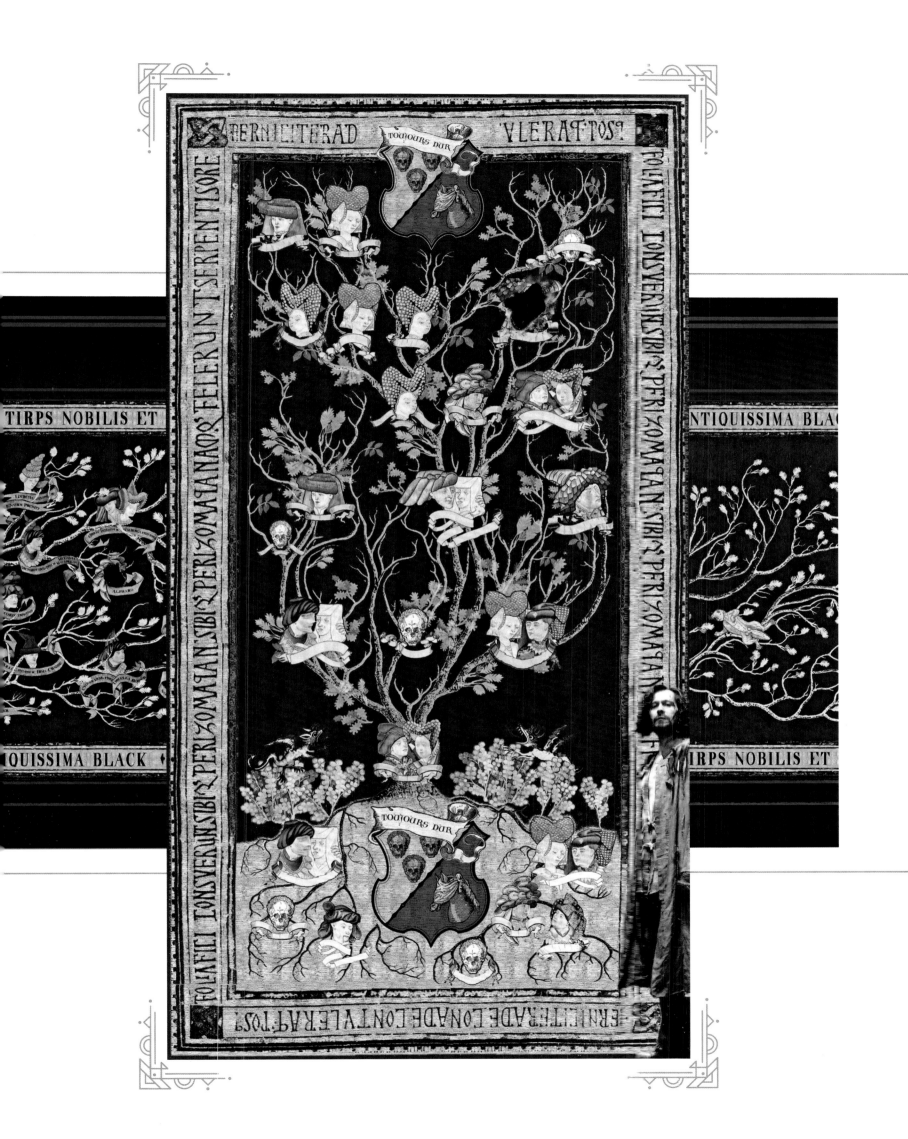

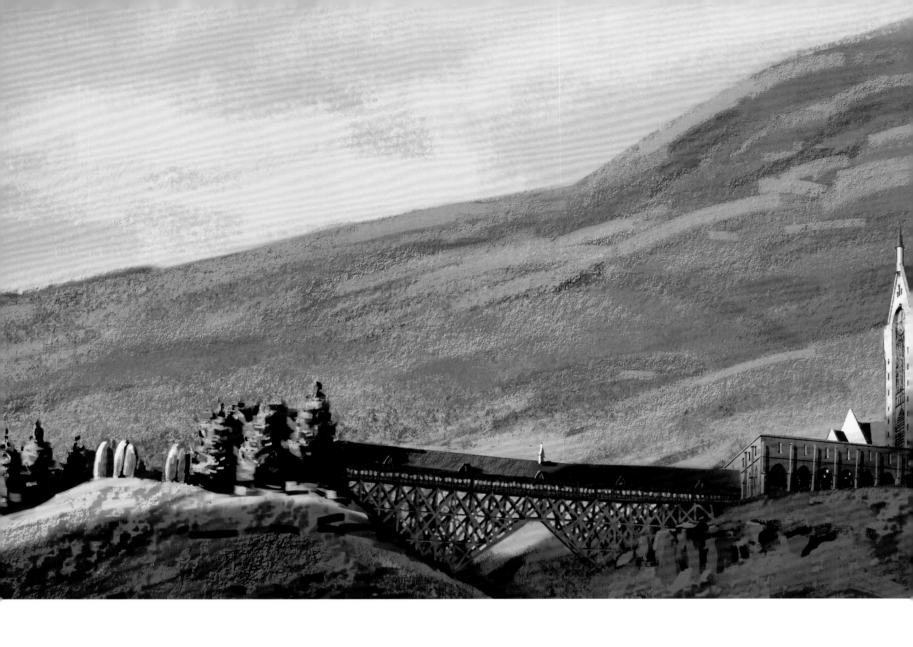

CONCLUSION

TOP: Hogwarts School of Witchcraft and Wizardry.
Concept art by Andrew Williamson for *Harry Potter and the Prisoner of Azkaban.*

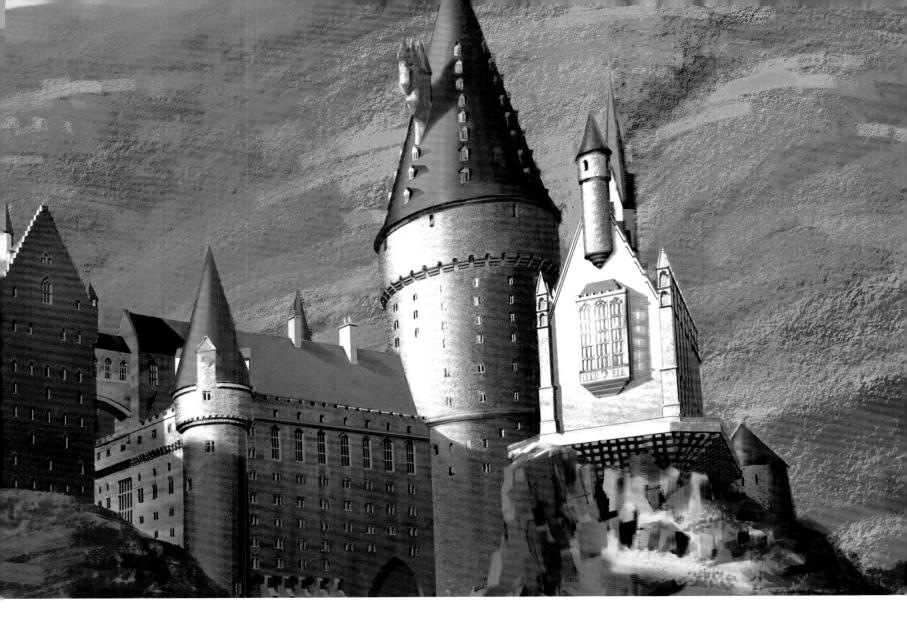

AFTER THE CAMERAS stop rolling on a film, it's not uncommon for the sets to be dismantled and for the costumes and props to be put into storage. After surviving the production of eight films, however, saying goodbye to the wizarding world would not be quite so easy for the fans or the production team. Fortunately, the astounding artistry featured in the franchise found a second life as part of a permanent exhibit: Warner Bros. Studio Tour London—The Making of Harry Potter.

Located adjacent to the working soundstages on Leavesden Studios, where the series was originally filmed, this enormous collection showcases the actual scenery, wardrobe, creatures, and artifacts from the films for thousands of visitors a day. Now every Muggle finally has a chance to stroll down Diagon Alley with a Butterbeer in hand before finally working up the courage to brave the Forbidden Forest.

For those who choose to dig even deeper into the series' magical mythos, graphic designers Miraphora Mina and Eduardo Lima have opened a gallery in Soho, London—The House of MinaLima—that features an extensive four-floor retrospective of their unforgettable design work on the *Harry Potter* series and beyond.

The spirit of the original films is also being kept alive on screen in *Fantastic Beasts and Where to Find Them,* written by J.K. Rowling herself. These five films, slated for release every other year through 2024, are certain to carry on the rich visual tradition of the originals, thanks in great part to the continued collaboration of veteran *Harry Potter* director David Yates and longtime series production designer Stuart Craig.

Nearly two decades after beginning his journey into the wizarding world, Craig realizes more than ever how important the little details can be. Advancements in viewing technology have allowed the audience to explore every nuance of every frame of a film in ultra-high definition from the comfort of their own couches.

"No detail is wasted, in my view," Craig says. "I don't think it ever has been in any era of moviemaking, because what you half saw and what you half understood always played a part. But, as I say, nowadays you can go back and back and back and really analyze what's there."

Anyone who takes the time to analyze this series is likely to agree, though, that the years of hard work performed behind the scenes by hundreds of skilled artists and technicians paid off in creating one of the most fully realized worlds ever captured on film.

"I think the most exciting part is seeing something that's completely artificial being treated as if it's real," creature effects designer Nick Dudman says. "Everything we build is fake. It's a con. And I think somebody in my position gets the same kind of kick as a stage magician does where you know that I'm doing something that isn't real. And I know that you know. But you can't stop believing in it because you're buying into it. And that isn't the result of just my work . . . but I'm contributing a little bit to the fact that you have seen a Hippogriff and they don't exist."

That's a kind of wizardry that would make even Dumbledore proud.

HarperCollins
PUBLISHERS
Since 1817

WB WW

HarperCollins books may be purchased for educational, business, or sales promotional use. For information please e-mail the Special Markets Department at SPsales@harpercollins.com.

First published in 2017 by:

Harper Design
An Imprint of HarperCollinsPublishers
Tel: (212) 207-7000
Fax: (855) 746-6023
harperdesign@harpercollins.com
www.hc.com

Distributed throughout the world by
HarperCollinsPublishers
195 Broadway
New York, NY 10007

Library of Congress Control Number: 2017949040

ISBN: 978-0-06-282075-4

Produced by

INSIGHT
EDITIONS
PO Box 3088
San Rafael, CA 94912
www.insighteditions.com

Publisher: Raoul Goff
Associate Publisher: Vanessa Lopez
Art Director: Chrissy Kwasnik
Designer: Malea Clark-Nicholson
Project Editor: Greg Solano
Managing Editor: Alan Kaplan
Editorial Assistant: Hilary VandenBroek
Production Editor: Elaine Ou
Production Manager: Alix Nicholaeff
Editorial Consultant: Jody Revenson

ROOTS of PEACE REPLANTED PAPER

Insight Editions, in association with Roots of Peace, will plant two trees for each tree used in the manufacturing of this book. Roots of Peace is an internationally renowned humanitarian organization dedicated to eradicating land mines worldwide and converting war-torn lands into productive farms and wildlife habitats. Roots of Peace will plant two million fruit and nut trees in Afghanistan and provide farmers there with the skills and support necessary for sustainable land use.

Manufactured in China by Insight Editions

10 9 8 7 6 5 4 3 2 1